VISUAL THEORY

VISUAL THEORY

Painting and Interpretation

Edited by

Norman Bryson
Michael Ann Holly
Keith Moxey

Polity Press

Published with the assistance of the Getty Grant Program.

First published 1991 by Polity Press in association with Blackwell Publishers Ltd.
Reprinted 1992, 1996

Editorial office:
Polity Press, 65 Bridge Street,
Cambridge CB2 1UR, UK

Marketing and production:
Blackwell Publishers Ltd
108 Cowley Road, Oxford OX4 1JF, UK

ISBN 0 7456 0633 4
ISBN 0 7456 0660 1 (pbk)

A CIP catalogue record for this book is available from the British Library.

Typeset in 10 on 12pt Ehrhardt
by Joshua Associates Ltd, Oxford
Printed in Great Britain by Athenæum Press Ltd, Gateshead, Tyne & Wear

CONTENTS

LIST OF ILLUSTRATIONS

—————————⚬⚬⚬⚬—————————

1 Jacques-Louis David. *The Oath of the Horatii*. Paris, Louvre
2 Sir Joseph Noel Paton. *In Memoriam*. Engraving after the lost original painting
3 Francisco Goya y Lucientes. *And They Are Like Wild Beasts*. Etching and aquatint
4 *Woman Toppling Policeman with Jujitsu Throw*. Photograph
5 Eugène Delacroix. *The Death of Sardanapalus*. Paris, Louvre
6 Jean-Léon Gérôme. *Oriental Slave Market*. Williamstown, Mass., Clark Institute
7 Edouard Manet. *The Ball at the Opera*. Washington, DC, National Gallery of Art, Gift of Mrs Horace Havemeyer
8 André Kertesz. *Dancer's Legs*. Photograph
9 Emily Mary Osborn. *Nameless and Friendless*. Private collection.
10 Augustus Leopold Egg. Number one from the trilogy known as *Past and Present*. London, Tate Gallery
11 Jean-Léon Gérôme. *The Artist and his Model*. Stockton, California, Haggin Collection, Haggin Museum
12 Jules Breton. *The Song of the Lark*. Chicago Art Institute
13 Jean-François Millet. *The Gleaners*. Paris, Louvre
14 Käthe Kollwitz. *Losbruch (Outbreak)*. Etching and aquatint
15 *La Femme emancipée répandant la lumière sur le monde (la Pétroleuse)*. Popular print
16 Diego Velázquez. *The Rokeby Venus*. London, National Gallery
17 Hannah Höch. *Pretty Girl*. Hamburg, S. and G. Poppe Collection
18 Balthus. *Girl with Cat (Thérèse Blanchard)*. Collection Mr and Mrs E. A. Bergman
19 Edward Hopper. *Office at Night*. Minneapolis, Minn., Walker Art Center, Gift of the T. B. Walker Foundation
20 Aaron Siskind. *Chicago 1948*. Photograph. Courtesy Aaron Siskind
21 Ansel Adams. *Evening Cloud, Ellery Lake, Sierra Nevada*. Photograph. Courtesy of the Ansel Adams Publishing Rights Trust
22 After Hans Holbein the Younger. *Henry VIII*. London, National Portrait Gallery
23 *Charles Laughton as Henry VIII*. Film still from *The Private Life of Henry VIII*

PREFACE

THE lectures in this volume were delivered at an Institute on 'Theory and Interpretation in the Visual Arts' which was held at Hobart and William Smith Colleges in July and August of 1987 and which was supported by a generous grant from the National Endowment for the Humanities. The faculty consisted of Svetlana Alpers, Norman Bryson, Michael Holly, Keith Moxey, Michael Podro, and David Summers. The participants at the Institute were drawn equally from art history and other disciplines in the humanities, including anthropology, English, film studies, history, philosophy, psychology, religious studies, studio arts, and women's studies. Some of these participants have contributed to this volume by commenting upon the lectures.

In recent years, there has been an increasing tendency in most of the humanities towards an awareness of the interpretative strategies that constitute their individual disciplines. The Institute sought to promote this examination within the context of art historical studies by locating art history within the context of theoretical debates currently taking place in other fields and by examining interpretative models that might generate the basis for future art historical work.

The editors are grateful to the Getty Grant Program for its generous assistance with the illustration of this volume.

ACKNOWLEDGEMENTS

THE authors and publisher are grateful to the following for permission to reproduce plates:

Plates 1, 5, 12, 25, 37, 59 Musée du Louvre, photograph Réunion des Musées Nationaux; Plate 2 Christopher Wood, photograph The Yale Center for British Art; Plates 3, 4, 8, 15, 17 Harper & Row; Plates 6, 31 Sterling and Francine Clark Art Institute, Williamstown, Massachusetts; Plates 7, 38, 40, 42, 44, 45, 46, 48 National Gallery of Art, Washington; Plate 9 reproduced by kind permission, private collection; Plates 10, 35 The Tate Gallery, London; Plate 11 Haggin Collection, The Haggin Museum, Stockton, California; Plate 12 © 1989 The Art Institute of Chicago. All Rights Reserved; Plate 14 Archiv für Kunst und Geschichte, Berlin; Plates 16, 39, 50, 55, 57, 58 reproduced by courtesy of The Trustees, The National Gallery, London; Plate 18 Mrs Edwin A. Bergman, Chicago © DACS 1989; Plate 19 Collection Walker Art Center, Minneapolis; Plate 20 Aaron Siskind; Plate 21 photograph by Ansel Adams, Courtesy of the Trustees of the Ansel Adams Publishing Rights Trust, all rights reserved; Plate 22 National Portrait Gallery, London; Plate 23 Korda Films/Central Independent Television. Photograph British Film Institute; Plate 28 Charles and Paulette Henneghien; Plate 29 Kunsthistorisches Museum, Vienna; Plate 30 Fogg Art Museum, Harvard University, Cambridge, Massachusetts, Friends of Art, Archaeology and Music, and Alpheus Hyatt Fund; Plate 34 © The Frick Collection, New York; Plate 36 Collection, The Museum of Modern Art, New York. Gift of Mr and Mrs Ben Heller; Plate 41 by Permission of the Governors of Dulwich Picture Gallery; Plate 43 The Metropolitan Museum of Art, Rogers Fund, 1909 (09.181.7); Plate 47 Photographie Giraudon; Plate 49 Musée Picasso, photograph Réunion des Musées Nationaux © DACS 1989; Plate 51 Gemäldegalerie Staatliche Museen Preussischer Kulturbesitz, Berlin (West); Plates 52, 61 Rijksmuseum-Stichting; Plate 56 Graphische Sammlung Albertina, Vienna; Plate 60 Duke of Sutherland Collection, on loan to the National Gallery of Scotland; Plates 62–67 Private Collection, photograph © Marlborough Fine Art (London) Limited; Plate 69 The Nelson-Atkins Museum of Art, Kansas City; Plate 70 The Mansell Collection, London; Plate 71 C M Dixon; Plate 72 Neg./Trans. no. 326909 Courtesy Department of Library Services American Museum of Natural History. All other illustrations are by courtesy of the contributors.

INTRODUCTION

———————————— ⟨⟨⟨⟨⟩⟩⟩⟩ ————————————

T HE essays in this volume tend to focus on issues of visual representa-
tion. Broadly speaking, two distinct approaches emerge here.
(1) The first position argues that representation is always a matter of
convention, not of essence. It refuses to ground representation either in
perception or in the phenomenological experience of the world. According
to such a view, the work of art is wholly defined by its historical conditions of
origin and reception. (2) The second position seeks, in Aristotelian fashion,
to define an essence of art. By reference to perceptual and/or phenomeno-
logical assumptions putatively shared by all human beings, this approach is
designed to be independent of issues of historical variation. Consequently,
artistic truth is often construed as trans-historical.

The first group would insist that the confrontation between work and
spectator necessitates an act of interpretation. This confrontation prompts a
recognition of the historical gulf separating the horizon of the work from
that of the spectator; it also demands acknowledgement of social difference.
The second group, on the other hand, would not want to characterize their
understanding of representation as anything other than the recognition of
fundamental human facilities exercised by a work of art. The confrontation
between work and spectator encourages an account of psychological
processes which are timeless. At this end of the spectrum, Richard
Wollheim writes as if visual representation were accessible to all spectators
in the same way; at the other end, Linda Nochlin emphasizes that visual
representation continues to exclude half of the members of the society that
generates it.

Nochlin's essay 'Women, Art, and Power' is the clearest example of
'interventionist' commentary in this anthology, for the political charge of
her words is unmistakable: 'There is an analogue between woman's
compromised ability – her lack of self-determining power – in the realm of
the social order and her lack of power to articulate a negative critique in the
realm of pictorial representation.' She emphasizes that one of the most
urgent functions of patriarchal ideology is to mask the power relationships
that structure society in an effort to make them appear natural and eternally
true. Her expressed engagement with contemporary feminist concerns
enables her to range widely over the artistic record of the past – from
Velázquez to Kollwitz, from Victorian history painters to photographers of
the suffragettes – in order to extract historical examples that make an

explicitly ideological point: in all cases 'representations of women in art are founded upon and serve to reproduce indisputably accepted assumptions held by society in general, artists in particular, and some artists more than others, about men's power over, superiority to, difference from, and necessary control of women . . .' (p. 13)

The form of a work of art is as subject to these ideological pressures as is its content. Reigning assumptions are rendered visible not only in the choice of subject matter, but also in a work's visual structure. Artists are guilty, and so too are the cultural attitudes and institutions that engender them. Not even the 'innocent' spectator, male or female, is free from blame, for it has always been the case that symbolic power can be wielded 'only with the complicity of those who fail to recognize either that they submit to it or that they exercise it.' (p. 14) Were this world the utopian one of uncompromising equality between the sexes, the representation of female nudes, for example, would not be so problematic. However, we are far from that state of affairs intellectually, emotionally, and politically, so it is the responsibility of the historian of art to highlight what would otherwise remain hidden behind art's elevated status.

Nochlin does view representation as a matter of convention; for her, of course, there is no unchanging or eternal essence of art. The art of the past must always be subject to reinterpretation. Two possible criticisms of her globalizing account might arise here, however. On the one hand, she might be regarded as insensitive to the nuances of contemporary gender theory, for her narrative, though untraditional, is straightforwardly art historical and focuses on the illustrations themselves without probing the underlying symbolic, linguistic, and institutional structures that give rise to them in the first place. On the other hand, her review is not modulated by historical and social circumstance. She may use widely varying historical examples – both positive and negative in her frame of reference – but the point she is making is by definition a trans-historical one. In no way, however, could her impassioned plea be likened to the ahistorical recitations of analytic philosophy. She minds neither that her interpretative voice is strident nor that her politics are on parade. To be dispassionately objective is to forfeit a commitment to the issues and to banish art to the domain of the unreal and insignificant.

Norman Bryson's essay on 'Semiology and Visual Interpretation' explicitly rejects both perceptualist and phenomenological accounts of representation in favor of a semiotic approach. Bryson argues that these traditional approaches tend to discuss visual representation as if it were constituted by ahistorical constants based either in human perception or in the universal conditions of human experience. As a consequence, they fail to come to terms with the issues of power which are necessarily historically and culturally defined.

Perceptualism always renders art banal, since its view never lifts above ocular accuracy and always renders art trivial, since the making of images seems to go on, according to perceptualism, out of society, at the margins of social concerns, in some eddy away from the flow of power. But one need not think this way: if we consider painting as an art of the sign, which is to say an art of discourse, then painting is co-extensive with the flow of signs through both itself and the rest of the social formation. There is no marginalization: painting is bathed in the same circulation of signs which permeates or ventilates the rest of the social structure. (p. 66)

As Bryson himself acknowledges, this argument would appear to lend support to a social history of art. While this may indeed be the case, he is also anxious to demonstrate that a semiotic view of representation is in fact irreconcilable with a social history based on a traditional Marxist theory of culture. Like the perceptualist and phenomenological accounts of representation, the Marxist view that the cultural 'superstructure' to which painting belongs reflects changes taking place in the economic organization of society, fails to acknowledge the role of power in visual representation. 'If your politics are such that the only changes you recognize are those taking place in the economic sphere, and all the rest are mere swirlings in the cloud of superstructure, then you will not find painting a particularly interesting or forceful instrument. And this will be because power is located exclusively in other agencies than discourse: in capital, in the factory, in the production and distribution of wealth.' (p. 71)

It could be argued that there is something tendentious in Bryson's choice of the 'base/superstructure' model as the basis for social history. Since the advent of structuralism in France in the 1960s, there have been a variety of alternatives, perhaps the most influential of which has been that first proposed by Louis Althusser. In his essay, 'Ideology and Ideological State Apparatuses,' Althusser radically transformed the traditional Marxist notion of ideology and in doing so effectively collapsed the received distinction between social 'superstructure' and 'base.' Althusser argued that ideology was not 'false consciousness,' i.e., that it was not a system of representation developed and disseminated by the dominant classes in order to mask the way in which capitalist control of the means of production determined and manipulated the social experience of all other members of society. Rather than subscribe to a definition of ideology that implied that one set of representations – that of the dominant classes – might be defined as 'false,' and thus opposed to another set of representations – those of the Marxist analyst – that might be called 'true,' Althusser equated ideology with all systems of representation regardless of the social class or interest group that was responsible for manufacturing them. It is evident from the

above that an Althusserian position is a semiotic one. By equating ideology and representation, all sign systems become ideologically freighted. A critique of representation undertaken from this viewpoint would appear to coincide closely with Bryson's insistence that notions of power are an integral part of the semiotic structure of the visual arts.

Bryson concludes his account of representation by contrasting the position of those interpreters who are interested in describing the operations of visual sign systems within a distant historical horizon, that is, those who seek to define the work's 'original meaning,' with those who want to define the ways in which those historical sign systems operate within their own time and are thus more concerned with their 'subsequent interpretation.' Bryson suggests that this distinction is not a necessary one: 'If one chooses to separate "original meaning" from "subsequent interpretation," this is because one's historical horizon, forms of life, and institutions of interpretation enjoin one to do so; if we choose to dissolve the distinction between "original meaning" and "subsequent interpretation," it will be for the same reason. What we do and will do when we interpret is a matter, in other words, entirely in the domain of *pragmatics*.' (p. 73) Semiotics thus possesses no intrinsic program. It is simply a tool which may be used to whatever purpose the interpreter might wish. In closing on this note, Bryson acknowledges the profoundly arbitrary and interested nature of interpretation, a characteristic that tends to remain veiled in those views that insist that representation depends on either a perceptual or phenomenological base.

Rosalind Krauss' essay, 'Using Language To Do Business as Usual,' addresses the ways in which the approach to language based on structural linguistics, one which has dominated recent French critical theory in a variety of disciplines, has been misinterpreted in the context of American art criticism. Krauss cites as an example a lecture delivered by Kirk Varnedoe at a symposium held in conjunction with the Museum of Modern Art's *'Primitivism' in 20th Century Art* exhibition in 1984. According to Krauss, Varnedoe suggested that several early modernist artists conducted '"an enquiry into the basic nature of signs,"' (p. 82) and that they had consequently anticipated Saussure's revolutionary new approach to linguistics. Krauss points out that Varnedoe's description of the ways in which these artists regarded the signs used by non-Western cultures as based on the underlying natural order, bears no relation to the arbitrary quality of the linguistic sign in Saussure's theory: 'nothing in nature decrees that a certain signifier should articulate a certain signified. Thus it is at the heart of the sign that arbitrariness reigns, an arbitrariness that dictates that the operation of the sign is dependent on its total independence of the object world for the establishment of its meaning.' (p.83)

Krauss' second example is drawn from a discussion of Michael Fried's

essay 'Art and Objecthood' which took place at a symposium, convened by the Dia Foundation, called *1967/1987: Theories of Art after Minimalism and Pop*. According to Krauss, Fried claimed that his essay had suggested that the work of art should be viewed not as an object but as a radical differentiation between objects, in the same way that Saussure had proposed that the power of language to signify did not lie in its positive terms but in the difference between its terms. Krauss pointed out that this assertion of the 'literalness' of the work cannot be reconciled with the phenomenological implications associated with aesthetic cognition in the original text.

> I know that opticality is not the term that is contrasted with the literalness in your original argument. Instead your counter-term is 'presentness,' by which you were calling for an experience of intense, abstract presence in relation to the work – an experience which is allegorized as one of pure cognition, a tremendously powerful moment in which one gets the point of the work both instantaneously and forever; so that this explosion of 'getting it' is supposed to lift one out of the temporal altogether.(pp. 90–1)

In both of these examples, Krauss is concerned to prevent the concepts of structural linguistics from being assimilated into a theoretical discourse with which it cannot be reconciled. In criticizing Varnedoe, she seeks to rescue Saussure from incorporation into a form of criticism that appears to depend ultimately on stylistic analysis, while in rejecting Fried's interpretation of his own earlier work as 'literal' rather than 'optical,' she wishes to prevent the absorption of Saussure into a discourse that is essentially phenomenological. In both cases she insists that a semiotic theory of representation must be accepted as a radical alternative to the traditional perceptualist and phenomenological alternatives.

Richard Wollheim's essay, 'What the Spectator Sees,' examines less the production than the reception of the work of art – the conditions of spectatorship, or what Gombrich has called the 'beholder's share.' Yet a rigid separation of the two roles – the maker on one side, the viewer on the other – is exactly what his argument calls into question. One of the most suggestive lines of thought in the essay grows from the observation that viewers are not the first to see the painting, for the painter has been there before them: inside the artist is a spectator, the first spectator of the work. As the artist made the painting, he or she also viewed it, and from a viewpoint that anticipates the viewpoint of those others who will later come to the work and be its audience. Neither the artist nor the viewer exists in complete solitude: imagining the work's future audience, the artist moves away from his or her unique position, and towards the vision of it that others will have; in viewing the work, the spectator discovers or retrieves the experience that

the painter had before the work as its first viewer, and incorporates it as part of the experience of viewing. The intimacy or communion between artist and audience is enabled by the fact that, as viewers, they share the same perceptual powers: the capacity for 'seeing-in,' that is, for seeing the marks on the surface and at the same time seeing those marks as representing something; the capacity for seeing the representation as expressing human emotion; and the capacity for finding visual delight in the representation.

Wollheim's portrayal of the capacities that all viewers have in common stresses the universal perceptual powers that we share as human beings in all times and places, whether we are tribesmen in south-west Africa, or paleolithic hunters, or analytic philosophers. And if the viewer is conceived as this universal human type, then the empathy which enables the artist to move towards the spectator, and the spectator towards the artist, can flow without hindrance. Yet this untroubled empathy may well run into difficulty if we remember that, besides those factors which all human beings have in common, are factors of difference: for example, the differences between one social group and another, differences between cultures and historical periods, differences of race and gender, differences between those who have power or wealth and those who do not. Indeed, it might be said that the experience of such differences is as much part of what it is to be a human being, as experience of those capacities (such as the ability to recognize the expressive atmosphere of a Constable or a Monet) which we – or some of us – may share.

In 'Depiction and the Golden Calf,' Michael Podro explores an issue which seems extremely close to Wollheim's 'twofoldness' – the 'dual aspect' that representations have, of depicting a scene and at the same time existing as marks on a surface. Both philosophers are concerned with the way that the two sides of this 'dual aspect' are inseparable and simultaneous: in their view it is wrong to say that a spectator recognizes the content of a depiction and *then* attends to the marks on the pictorial surface, or that viewing alternates between these poles. Rather, awareness of the medium and awareness of the depicted scene arise together, in a single phenomeno-logical experience (with two aspects). Although Podro and Wollheim share this concern with the unity of the experience of viewing, Podro's develop-ment of the concept of 'twofoldness' takes it in a direction that is subtly yet distinctly different from Wollheim. The reader may judge the extent to which their views are finally compatible.

For Podro, the singleness of the experience of seeing *what* a painting depicts, and *how* it does the depicting (through the handling of the medium, facture, and artistic 'procedure' in general) enjoins the viewer to attend to the *interaction* of content and medium. When we follow the lines of a Raphael drawing of the Madonna, we can observe the way that the spiralling rhythm of the line 'registers and connects the complex forms of the Virgin's

turning body, her foreshortened arm, the articulation of her wrist, and the torsion of the reaching child,' and we can see that the line's rhythm 'does all this without loss of its own graphic impulse.' It is wrong to imagine that Raphael first conceives of the drawing, fully arranged in his mind in all its details, and then transfers that completed image on to the surface. Rather, we are aware that, as he draws, a continuous self-monitoring or feedback of the drawing process upon itself produces complex adjustments of the image as it unfolds. The medium, and the artist's thought within the medium, are mutually involved and implicated to such a degree that the word 'medium' itself, with its suggestion of neutral means to an end, seems crude and inapposite. But the field of quickened attention revealed in the 'process' aspect of the drawing also includes the content or subject of the image – in this case, the Virgin. It is not that there is some independent iconographic formula for the Virgin which is then transferred intact on to the surface; rather, the image of the Virgin emerges in a field of mutual accommodations and interactions between the subject, the medium, and the artist's awareness as he draws. If Wollheim's focus is on the twofoldness of the act of viewing, Podro's is on the twofoldness of the art of making the image – twofold, because the subject (the Virgin) and the medium (graphic line) mutually bring each other into being. This kind of organic interaction between subject and medium is what Podro indicates by the term *disegno*.

The *disegno* thesis implies that the interaction between the 'what' and the 'how' of depiction produces something new in the world – something irreducible to the kinds of recognition that obtain in ordinary viewing. We might, in ordinary life, see figures who resemble the Virgin by Raphael; but what we recognize in the Raphael is something new, the Virgin-in-the-drawing, and this new figure belongs to another world. Where Wollheim argues that in order to recognize a depicted scene we need mobilize only our basic perceptual equipment (which we share with tribesmen in south-west Africa, prehistoric hunters, etc.), Podro maintains that in recognizing a Raphael Madonna we use more specialized perceptual equipment, that enables us to see not only what is depicted but the agency of the medium in building the depiction. The *disegno* thesis, in other words, posits an aesthetic domain that is separate from mundane experience, which it transforms and, in some sense, transfigures.

How separate is this higher world of *disegno* from the ordinary world of mundane viewing? The question is important, because if the new objects made by the processes of art are felt to inhabit a quite separate, perhaps more exalted aesthetic universe, then it may seem inappropriate to bring to bear on them concerns that press upon us in our lower, non-aesthetic world. If the operations of *disegno* truly establish an aesthetic world apart, then it may seem that there is little that viewing can do, except admire the *disegno* that creates this separate, and beautiful, realm. And for some viewers, the

visual delight supplied by the Raphael drawing is where discussion may finally end. Yet there is another way of considering the *disegno* thesis, as part of the whole problematic of aesthetic 'distance' and 'transfiguration.' To a viewer of the Reformation, the Roman Virgin may appear, not as sublimely beautiful, but as part of a religious cult resolutely to be opposed; to a modern feminist viewer, the cult of the Virgin Mother may have thoroughly negative overtones. The *disegno* thesis certainly provides a way of describing and demarcating an aesthetic realm, but of itself it does not ask, in whose interests is this aesthetic realm established? And it makes it more difficult to think through the ways in which issues that trouble and disturb us in the non-aesthetic world actually persist in the aesthetic domain which the *disegno* thesis presents as distinct from non-aesthetic concerns.

Although the essays by Wollheim and Podro point in different directions, both align the discussion of art towards questions of perceptual psychology – of what it is to perceive marks on a surface as representing some particular thing. Both are opposed to the semiological view of art, which sees the art work as part of a system of signs and representations in complex interaction with other systems of signs and representations in the social formation. The difference between such a view, and the approach to art via the psychology of perception, is clear in their divergent uses of the idea of 'recognition.' For Podro and Wollheim, recognition is primarily *identification*: when we spot the resemblance between Charles Laughton and Henry VIII, or see a cumulus cloud as a gigantic torso, or interpret dull yellow strokes of paint as signifying gold, we are performing the acts of recognition in which perceptual psychology is interested. For those critical of the attempt to account for art in terms of perceptual psychology, this kind of recognition is unduly restricted. The semiological approach to art, for example, starts from the observation that, as complex social creatures who live in a world of elaborate and nuanced social meanings, our visual experience is far more complicated than models of simple visual identification suggest. Perceptual psychology is concerned with primary visual identifications whereby we are able to perform such feats as recognizing a face in a Rorschach test card, or interpret convergent lines as indicating depth, or retrieving the rabbits and fish in a puzzle picture (all examples used by Wollheim). Although Podro's essay makes more concessions to aesthetic complexity than does Wollheim's, the emphasis is still on the remarkable human capacity to recognize that something is being represented (the Virgin) and yet to be aware of the medium of representation (the line).

Without losing our sense of wonder at such perceptual accomplishments, we may want to ask whether this kind of recognition is able convincingly to typify or sum up the enormous range of visual experiences, either of the world we ordinarily inhabit, or of the highly coded artefacts with which art history is concerned. If one's account of human perception is sufficiently

minimal or reduced, if it attends exclusively to the elementary kinds of recognition that all human beings are able to perform in all cultures and eras, it will indeed appear that the perception which art engages is trans-historical and universal. And other consequences follow: if the art chosen to illustrate these trans-cultural processes is nevertheless predominantly European and post-Renaissance, then it will seem that specifically European culture is in fact universal; and if the visual processes are presented as unaffected by historical determination, then the art which embodies them will seem to exist outside history, in a timeless realm of aesthetic contemplation. Yet many might wish to question this 'universaliz-ing' line of thought.

In 'Description and the Phenomenology of Perception,' Arthur Danto is interested in the ways in which physical knowledge can be regarded as penetrating perception phenomenologically, yet the direction he takes is one of speculating about the relevance of recent experiments in animal psychology for the understanding of what makes art art. He surveys two models of attack: the 'externalists' claim that though our descriptions of what we see may differ historically, socially, or perhaps even across species, we are still originally perceiving the same fundamental objects and events in the world. The 'internalists,' on the other hand, assert that there is no one way the world is, no possibility of an observation that itself is not always already a theory. In his words, 'Do we see different things, or the same thing under different descriptions – but the descriptions themselves are as it were external to what I see?' (p. 206) The critical issue is the extent to which per-ception and description are divisible processes, or rather, as Danto is at one point inclined to argue, they co-penetrate at every stage of observation. The nagging question of whether visual representation indeed has anything to do with the perception of objects in the natural world remains unanswered.

Although he scrupulously balances the externalist/internalist accounts, it is clear that in the first part of his essay Danto is nothing but sympathetic to the later Wittgensteinian position that all seeing is seeing-as, and that language at every moment penetrates perception. The inevitable extension of such a view, however, would lead him to speak of historical or social or gender differences in the perception of art, and this is something the author is clearly reluctant to do, for it would call into question the rarefied status of art itself. Consequently, in an almost whimsical move, pigeon perception is invoked as a substantiation for the trans-historical definition of art.

The argument proceeds like this. Referring to Fodor's experiments with pigeons, Danto advances the [externalist] 'hard-wiring' thesis – the hypothesis that certain perceptions are rooted in innate ('architectural' he calls it) features of the cognitive apparatus, which is to say that 'the grounds of connoisseurship are wired in.' (p. 210) Although some creatures may be astute connoisseurs of pictures of things as well as the things themselves for

sound adaptational reasons (detecting subtle photographic changes in light-ing or slight variations in costumes, for example), Danto is quick to claim that perception of a work of art is of another order altogether. A pigeon may be trained to recognize a Brillo box, or a painting of a Brillo box, but the genius of Warhol eludes the beast. In other words, there is far more to a work of visual art than perception can account for; and the human spectator, attuned to iconographic subtleties or formal innovation, for example, is far better equipped perceptually to identify and empathize with the descriptive or propositional brilliance of great works of art than is a bird.

Art always, in all times, in all places, necessitates acknowledgement as art – as that ineffable something that exists on the other side of our perceptual horizon and beyond our capacity to interpret it historically. Artists and spectators have more in common with philosophers than pigeons, and art is itself accorded the status of analytic philosophy.

> Paul Klee said beautifully and movingly, that art does not render the visible but renders visible, which means that we see by means of art something not to be seen in other ways, something in effect that must be made visible ... art has the power of thought, and what makes something a work of art rather than a mere thing is that it gives embodiment in a sensuous idiom to a thought, the grasping of which is like understanding a proposition. (p. 211)

In 'Real Metaphor' David Summers approaches the question of visual representation by examining the problem posed by conceptual images for traditional theories of resemblance. If visual representation is somehow related to the world of appearances, that is, if the act of representation always involves reference to nature, then how can we account for the vast quantity of art that is non-mimetic? While Summers believes that the distinction between perceptual and conceptual images should be preserved, he admits that conceptual images cannot be understood in terms of the resemblance theory. In seeking an alternative theory to account for them, he turns to ideas first developed by Gombrich in *Meditations on a Hobby Horse*. In Gombrich's essay, Summers finds the notion that substitution may play an important role in representation. According to Gombrich, one of the functions of art is to stand for something else, in the way say that a child's hobby horse can stand for a real horse.

Summers finds an analogy to Gombrich's theory in Freud's essay, *Beyond the Pleasure Principle*, which provides an account of the way in which an eighteen-month-old child coped with the repeated absence of its mother by developing a game that depended on the symbolic substitution of both words and objects. That is, the child threw a reel from its cot while uttering the German word 'fort' (away), and drew it back on a string, while saying 'da'

(there). Summers uses Freud's narrative to suggest that the act of substitution involved in the creation of visual art is a deep-seated psychological drive – i.e., an expression of desire. However, he also wants to say that the apparent parallel that exists between the child's use of words and the tossing of the reel is misleading. He argues that despite the seemingly arbitrary quality of the toys flung from the child's crib before it settled on the reel, they actually suited or fit the purpose of the game. 'It implies a scalar relation, a relation of fit, one in which the size of the child's acts and strengths, the actual size of his capacity to grasp, lift and toss, become congruent in a geometric sense to the space of the game itself, which is similar to the space of the child's control, and thus the basis of the actual magical value of both the substitution and the game. This very manageability, it may be noted, is itself significant and implies a foundation for the meaning of objects that are possessable and manipulable.' (p. 244) By means of this argument Summers attempts to 'naturalize' the seemingly arbitrary notion of substitution. Not just anything can be substituted for anything else; it must be something 'manageable' and 'congruent' – something above all which corresponds to the space in which the substitution takes place. By naturalizing the notion of substitution, Summers suggests that while conceptual art cannot be defined in terms of perception, it must still be defined in terms of the human body. Referring to the hobby horse, Summers writes, 'However widely the appearance of substitutes for the same thing may vary, they are not therefore utterly arbitrary because they must be suited to human use before they are "like" a horse or before they can "stand for" a horse.' (p. 245)

In attempting to define the sense in which the type of substitution that is characteristic of conceptual art is not arbitrary, Summers introduces the terms *real metaphor* and *subjunctive space*. By real metaphor, he means something that is not a metaphor but the analogy that lies behind the metaphor. By subjunctive space, he means the space that is implied by an object in becoming a substitute. It is important to note that these concepts both make reference to a posited ground in which language operates. It invokes a phenomenological reality that precedes, underlies, and justifies the operations of language.

The consequence of Summers' argument is to place conceptual images alongside perceptual images, as images defined by basic human characteristics. In basing his definition of conceptual art on this ground, Summers effectively eliminates the importance of the historical and cultural circumstances in which such art was produced. If the most important quality of such art is the way in which it manifests the potentials and limitations of the human body, then what we know of its history and geographical origin becomes incidental. Unlike Summers, a semiotic theorist, for example, would take Freud's narrative at face value as positing a genuine parallel

between words and objects in order to read objects in ways that are analogous to the interpretation of texts and other signifying systems operant in particular cultures at specific historical moments. Such a view, however, is dismissed by Summers as a manifestation of 'linguistic imperialism.' (p. 255) The semiotic approach, one which would regard the child's substitution of words and objects as equally arbitrary, is faulted for failing to do justice to the way in which objects cannot be equated with words. The two systems, i.e., language and art, are regarded as operating in different 'spaces.' Language, it is implied, is free of 'subjunctive space,' whereas works of art are not. Whether it is fair to define language as free of spatial implications will be up to the reader to decide. It could be argued, for example, that language is saturated with the social space in which it takes place, and that it draws its meaning from the historical and cultural context in which it is located.

<div style="text-align: right">

Norman Bryson
Michael Ann Holly
Keith Moxey

</div>

1

WOMEN, ART, AND POWER

LINDA NOCHLIN

I N this essay, I shall be investigating the relationships existing among women, art, and power in a group of visual images from the late eighteenth through the twentieth centuries. These visual images have been chosen for the most part because they represent women in situations involving power – most usually its lack. It is obvious that the story or content or narratives of these images – what art historians call their 'iconography'. – will be an important element for analysis in this project: the story of the Horatii represented by David; that of the death of Sardanapalus depicted by Delacroix; or the sad, exemplary tale of domestic downfall and punishment bodied forth by the English painter, Augustus Egg, in his pictorial trilogy known as *Past and Present*.[1]

Yet what I am really interested in are the operations of power on the level of ideology, operations which manifest themselves in a much more diffuse, more absolute, yet paradoxically, more elusive sense, in what might be called the discourses of gender difference. I refer, of course, to the ways in which representations of women in art are founded upon and serve to reproduce indisputably accepted assumptions held by society in general, artists in particular, and some artists more than others, about men's power over, superiority to, difference from, and necessary control of women, assumptions which are manifested in the visual structures as well as the thematic choices of the pictures in question. Ideology manifests itself as much by what is unspoken – unthinkable, unrepresentable – as by what is articulated in a work of art. In so far as many of the assumptions about women presented themselves as a complex of common-sense views about the world, and were therefore assumed to be self-evident, they were relatively invisible to most contemporary viewers, as well as to the creators of the paintings. Assumptions about woman's weakness and passivity; her sexual availability for men's needs; her defining domestic and nurturing function; her identity with the realm of nature; her existence as object rather than creator of art; the patent ridiculousness of her attempts to insert herself

actively into the realm of history by means of work or engagement in political struggle – all of these notions, themselves premised on an even more general, more all-pervasive certainty about gender difference itself – all of these notions were shared, if not uncontestedly, to a greater or lesser degree by most people of our period, and as such constitute an ongoing subtext underlying almost all individual images involving women. Yet perhaps the term 'subtext' is misleading in view of my intentions. It is not a *deep* reading I am after; this is not going to be an attempt to move *behind* the images into some realm of more profound truth lurking beneath the surface of the various pictorial texts. My attempt to investigate the triad woman–art–power should rather be thought of as an effort to disentangle various discourses about power related to gender difference existing simultaneously with – as much surface as substratum – the master discourse of the iconography or narrative.

It is important to keep in mind that one of the most important functions of ideology is to veil the overt power relations obtaining in society at a particular moment in history by making them appear to be part of the natural, eternal order of things. It is also important to remember that symbolic power is invisible and can be exercised only with the complicity of those who fail to recognize either that they submit to it or that they exercise it. Women artists are often no more immune to the blandishments of ideological discourses than their male contemporaries; nor should dominant males be envisioned as conspiratorially, or even consciously, forcing their notions upon women. Michael Foucault has reflected that power is tolerable 'only on the condition that it mask a considerable part of itself'.[2] The patriarchal discourse of power over women masks itself in the veil of the natural – indeed, of the logical.

Strength and weakness are understood to be the natural corollaries of gender difference. Yet it is more accurate to say, in a work like David's *Oath of the Horatii* (see plate 1) that it is the representation of gender differences – male versus female – that immediately establishes that opposition between strength and weakness which is the point of the picture.

In the *Horatii*, the notion of woman's passivity – and her propensity to give in to personal feeling – would appear to have existed for the artist as an available element of a visual *langue* upon which the high intelligibility of this specific pictorial *parole* depends. It is important to realize that the particular narrative incident represented here – the moment when the three brothers, the Horatii, take a patriotic oath of allegiance to Rome on swords held before them by their father in the presence of the women and children of the family – is not to be found in Classical or post-Classical texts, but is in essence a Davidian invention, arrived at after many other explorations of potential subjects from the story.[3] It is an invention which owes its revolutionary clarity precisely to the clear-cut opposition between mascu-

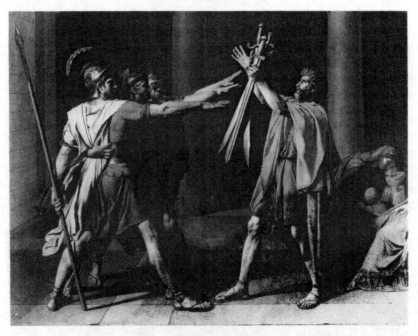

Plate 1 Jacques-Louis David. *The Oath of the Horatii*

line strength and feminine weakness offered by the ideological discourse of the period. The striking effectiveness of the visual communication here depends in the most graphic way possible upon a universal assumption: it is not something that needs to be thought about. The binary division here between male energy, tension and concentration as opposed to female resignation, flaccidity and relaxation is as clear as any Lévi-Straussian diagram of a native village. It is carried out in every detail of pictorial structure and treatment, inscribed on the bodies of the protagonists in their poses and anatomy and is even evident in the way that the male figures are allotted the lion's share of the architectural setting, expanding to fill it, whereas the women, collapsed in upon themselves, must make do with a mere corner. So successful is the binary division of male versus female in conveying David's message about the superior claims of duty to the state over personal feeling that we tend to consider a later version of the *Oath of the Horatii*, like that by Armand Caraffe,[4] to be weak and confusing, at least in part, because it fails to rely on the clear-cut 'natural' opposition which is the basis of David's clarity.

In the middle of the nineteenth century, in Victorian England, woman's passivity, her defining inability to defend herself against physical violence, would appear to have been such an accepted article of faith that the poses

which had signified weakness – the very opposite of heroism in David's *Horatii* – could now, with a bit of neck straightening and chin stiffening in the case of British ladies, be read as heroism itself. Indeed, Sir Joseph Noel Paton, the author of such a work, which appeared in the 1858 Royal Academy show under the title *In Memoriam* (see plate 2) (the original has disappeared), dedicated it 'to Commemorate the Christian Heroism of the British Ladies in India during the Mutiny of 1857.' It must be added parenthetically that the figures entering so energetically from the rear were

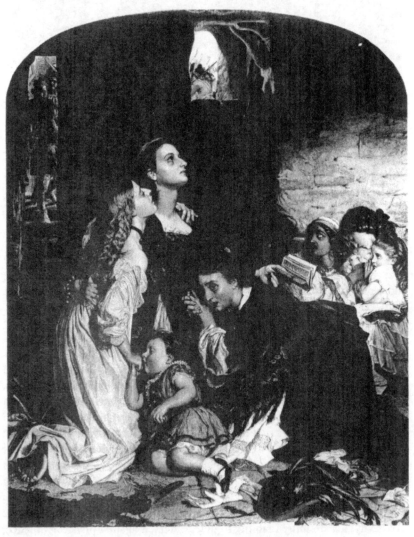

Plate 2 Sir Joseph Noel Paton. *In Memoriam*

originally not the Scottish rescuers we see in this engraving after the painting, but those of bloodthirsty Sepoys, the Indian rebels, which were altered because the artist felt their presence created 'too painful an impression.'[5] The heroism of British ladies would seem to have consisted of kneeling down and allowing themselves and their children to be atrociously raped and murdered, dressed in the most unsuitably fashionable but flattering clothes possible, without lifting a finger to defend themselves. Yet to admiring spectators of the time, tranquility and the Bible, rather than vigorous self-defense, were precisely what constituted heroism for a lady. Said the reviewer in the *Art Journal* of the time: 'The spectator is fascinated by the sublimely calm expression of the principal head – hers is more than Roman virtue; her lips are parted in prayer; she holds the Bible in her hand, and that is her strength.'[6] There are at least two discourses articulated in this image. One is the overt story of heroic British ladies and their children during the Sepoy mutiny, fortifying themselves with prayer as they are about to be assaulted by savage, and presumably lustful, natives. The other discourse, less obvious, is the patriarchal and class-defined one, which stipulates the appropriate behavior for the lady, and it implies that no lady will ever unsex herself by going so far as to raise a hand in physical violence, even in defense of her children. Such a notion about ladylike or 'womanly' behavior had of course some but not necessarily a great deal of relationship to how women, British ladies during the Sepoy mutiny included, have actually acted under similar circumstances.[7] Goya's women, in the etching *And They are Like Wild Beasts* (plate 3) from the 'Disasters of War' series, though obviously not ladies, are shown behaving quite differently from those in *In Memoriam*, although the very fact that these peasant women resort to violence itself functions as a sign of the extremity of the situation. The Spanish mothers who fight so desperately to defend their children, it is implied, are something other than women: they 'are like wild beasts.'[8]

The suffragists, at the beginning of the twentieth century, attempted, as Plate 4 reveals,[9] to create a convincing image of women combining ladylike decorum *and* overt physical power. The results – a properly dressed young woman toppling a startled policeman with a jujitsu throw – hover between the invigorating and the ludicrous. The discourse of power and the code of ladylike behavior can maintain only an unstable relationship: the two cannot mix.

The success of a discourse in confirming an ideological position rests not in its reliance upon evidence but rather in the way it exercises successful control through the 'obviousness' of its assumptions. Force, to borrow the words of Talcott Parsons, rather than being the *characteristic* feature, is, in fact, a special limiting case of the deployment of power;[10] coercion represents the regression of power to a lower domain of generalization; a 'show of force' is the emblematic sign of the failure of power's *symbolic* currency.[11]

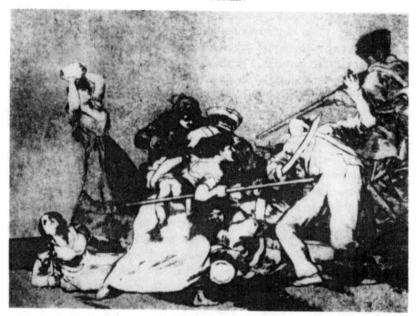

Plate 3 Francisco Goya y Lucientes. *And They Are Like Wild Beasts.* Etching and
aquatint

Nevertheless, Victorian assumptions about ladylike behavior are premised
on the kinds of threats that, although rarely mentioned, lie in store for those
who call them into question: the woman who goes so far as to rely on
physical force or independent action is no longer to be considered a lady. It
then follows that because women are so naturally defenseless and men so
naturally aggressive – real ladies must depend not on themselves, but on
male defenders – as *In Memoriam*, the Scottish troops – to protect them from
(similarly male) attackers – the (overpainted) Sepoy mutineers.

 That these views were held to be self-evident by both men and women at
the time goes without saying: ideology is successful precisely to the degree
that its views are shared by those who exercise power and those who submit
to it. But there is a corollary to the assumptions underlying the visual text
here which would have been more available to men than to women; what
one might call its fantasy potential – a discourse of desire – the imaginative
construction of a sequel to *In Memoriam*: something like *The Rape and Murder
of the British Women during the Indian Mutiny* – a subject current in the popular
press of the period. It is this aspect of the painting, its hint of 'unspeakable
things to come,' delicately referred to in the contemporary review as 'those
fiendish atrocities [which] cannot be borne without a shudder,'[12] which
must have in part accounted for its popularity with the public.

 This sort of sequel does, of course, exist, although it pre-dates *In*

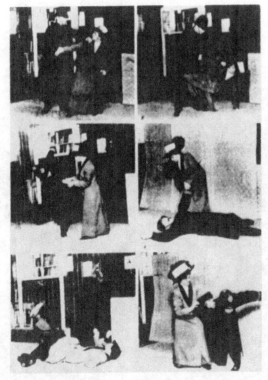

Plate 4 *Woman Toppling Policeman with Jujitsu Throw*. Photograph

Memoriam and was painted in France rather than in England: Delacroix's *Death of Sardanapalus* (see plate 5). 'In dreams begin responsibilities,' a poet once said.[13] Perhaps. Certainly, one is on surer footing asserting that in power dreams begin . . . dreams of still greater power – in this case, fantasies of men's limitless power to enjoy, by destroying them, the bodies of women. Delacroix's painting cannot, of course, be reduced to a mere pictorial projection of the artist's sadistic fantasies under the guise of exoticism. Yet one must keep in mind that subtending the vivid turbulence of the text of Delacroix's story – the story of the ancient Assyrian ruler, Sardanapalus, who, upon hearing of his incipient defeat, had all his precious possessions, including his women, destroyed, and then went up in flames with them in his palace – lies the more mundane assumption, shared by men of Delacroix's class, that they were naturally 'entitled' to desire, to possess, and to control the bodies of women. If the men were artists, it was assumed that they had more or less unlimited access to the bodies of the women who worked for them as models. In other words, Delacroix's private fantasy exists not in a vacuum but in a particular social context, granting permission

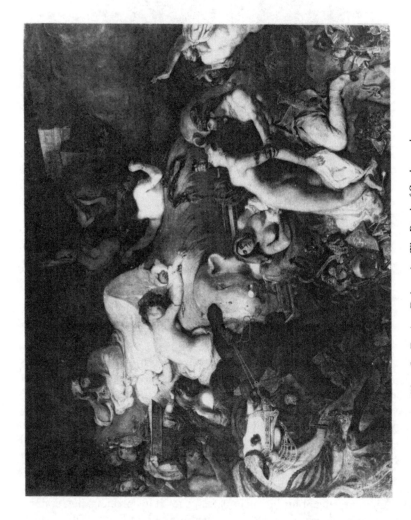

Plate 5 Eugène Delacroix. *The Death of Sardanapalus*

as well as establishing boundaries for certain kinds of behavior. It is almost impossible to imagine a *Death of Cleopatra*, say, with nude male slaves being put to death by women servants, painted by a *woman* artist of this period. In the sexual power system of patriarchy, transgression is not merely that which violates understood codes of thought and behavior: it is, even more urgently, that which marks their farthest boundaries. Sexual transgression may be understood as a *threshold* of permissible behavior – actual, imaginary – rather than as its opposite. The true site of opposition is marked by gender difference.

Delacroix attempted to defuse and distance his overt expression of man's total domination of women in a variety of ways, at the same time that he emphasized the sexually provocative aspects of his theme. He engaged in the carnage by placing at the blood-red heart of the picture a surrogate self – the recumbent Sardanapalus on his bed – but a self who holds himself aloof from the sensual tumult which surrounds him, an artist–destroyer who is ultimately to be consumed in the flames of his own creation–destruction.

Despite the brilliant feat of artistic semi-sublimation pulled off here, the public and critics were apparently appalled by the work when it first appeared, in the Salon of 1828.[14] The aloofness of the hero of the piece fooled no one, really. Although criticism was generally directly more against the painting's formal failings, it is obvious that by depicting such a subject with such obvious sensual relish, such erotic *panache* and such openness, Delacroix had come too close to an overt statement of the most explosive, hence the most carefully repressed, fantasy of the patriarchal discourse of desire: the Sadean identification of murder and sexual possession as an assertion of absolute *jouissance*.

The fantasy of absolute possession of women's naked bodies, a fantasy which for the nineteenth-century artist was at least in part a reality in terms of specific practice – the constant availability of studio models for sexual as well as professional needs – lies at the heart of less inspired pictorial representations of Near Eastern or Classical themes, such as Jean-Léon Gérôme's *Oriental Slave Market* (plate 6). In this case, of course, an icono-graphical representation of power relations coincides with, although it is not identical to, assumptions about male authority. Although ostensibly realistic representations of the customs of picturesque Orientals,[15] Gérôme's paintings are also suitably veiled affirmations of the fact that women are actually for sale to men for the latter's sexual satisfaction – in Paris just as in the Near East. Sexual practice is more successfully ideologized in this case than in Delacroix's painting, and works like these appeared frequently in the Salons of the period, and were much admired. Why was this the case? First of all, on the level of formal structure, they were more acceptable because Gérôme has substituted a chilly and remote pseudo-scientific naturalism – small, self-effacing brushstrokes, 'rational' and convincing

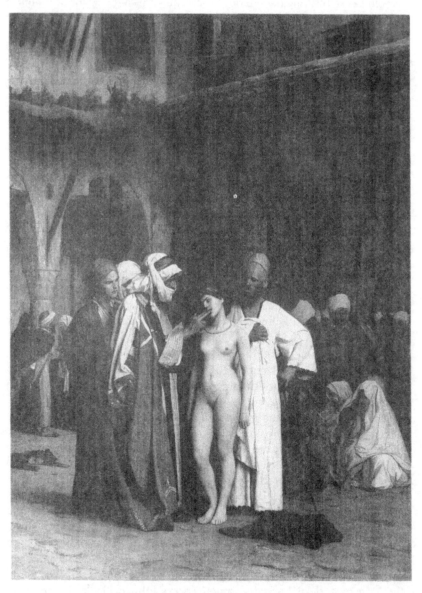

Plate 6 Jean-Léon Gérôme. *Oriental Slave Market*

spatial effects (an apparently dispassionate empiricism) – for Delacroix's tempestuous self-involvement, the impassioned brio of his paint surfaces. Gérôme's style justifies his subject (if not to us, who are cannier readers, certainly to most of the spectators of his time), by guaranteeing through sober 'objectivity' the unassailable Otherness of the characters enacting his narrative. He is saying in effect: 'Don't think that I, or any other right-thinking Frenchman, would ever be involved in this sort of thing. I am merely taking careful note of the fact that less enlightened races indulge in the trade in naked women – but isn't it arousing!' Gérôme is, like many other artists of his time, managing to body forth a double message here: one about men's power over women and the other about white man's superiority to, hence justifiable control over, darker races – precisely those who indulge in this sort of lascivious trade. Or one might say that something more complex is involved in Gérôme's strategies here *vis-à-vis* the *homme moyen sensuel*: the latter was invited sexually to identify with yet at the same time morally to distance himself from his Oriental counterparts within the objectively inviting yet racially distancing space of the painting.

Edouard Manet's *Ball at the Opera* of 1873 (plate 7) may, for the purposes of my argument, be read as a combative response to and subversion of both the manifest and latent content of Gérôme's slave markets.[16] Like Gérôme's painting, Manet's, in the words of Julius Meier-Graefe, represents a 'fleshmarket.'[17] Unlike Gérôme, however, Manet represented the marketing of attractive women not in a suitably distanced Near Eastern locale, but behind the galleries of the Opera House on the *rue* Lepeltier; and the buyers of female flesh were not Oriental louts but, rather, civilized and recognized Parisian men-about-town, Manet's friends, and in some cases, fellow artists whom he had asked to pose for him. Unlike Gérôme's painting, which had been accepted for the Salon of 1867, Manet's was rejected for that of 1874. I should like to suggest that the reason for Manet's rejection was not merely the daring close-to-homeness of his representation of feminine sexual availability and male consumption of it, nor merely, as his friend and defender at the time, Stéphane Mallarmé suggested, its formal daring – its deliberate yet casual looking cut-off view of the spectacle[18] – but rather the way these two kinds of subversive impulses interact.

It is precisely Manet's anti-narrative strategies in the construction of the painting, his refusal of transparency, that renders the ideological assump-tions of his times unstable. By rejecting traditional modes of pictorial storytelling, by interrupting the flow of narrative with cut-off legs and torso at the top of the painting and a cut-off male figure to the left, Manet's painting reveals the assumptions on which such narratives are premised. The detached parts of female bodies constitute a witty rhetorical reference, a substitution of part for whole, to the sexual availability of lower-class and marginal women for the pleasure of upper-class men. By means of a brilliant

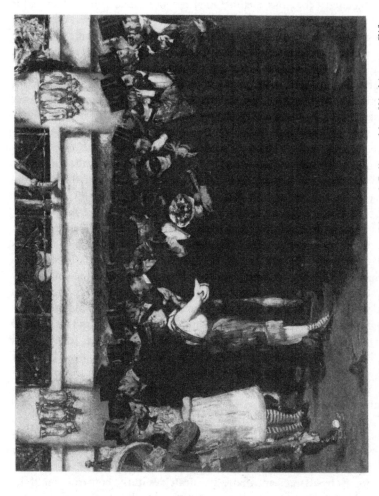

Plate 7 Edouard Manet. *The Ball at the Opera* (National Gallery of Art, Washington; Gift of Mrs Horace Havemeyer in memory of her mother-in-law, Louisine W. Havemeyer – dated 1873; oil on canvas, 0.590 × 0.725 (23¼ × 28½ ins)

realist strategy, Manet has at once made us aware of the artifice of art, as opposed to Gérôme's pseudo-scientific denial of it with his illusionistic naturalism, and, at the same time, through the apparently accidentally amputated legs, of the nature of the power relations controlling the worldly goings-on here. Later, in *The Bar at the Folies-Bérgère* of 1881, the device of the cut-off legs appears again in Manet's representation of a working woman, the bar maid, to remind us of the nature of the discreet negotiations going on between the foreground figure and the shadowy men reflected in the mirror, and at the same time to call attention to the arbitrariness of the boundaries of the frame. The image of the cut-off leg offers an easily grasped, nontransferable synecdoche of sexual power relations. When the image is feminine, as it is in André Kertesz's well-known photograph of a dancer's legs of 1939 (see plate 8), it inevitably refers to the implied sexual attractiveness of the invisible model, presented as a passive object for the male gaze. This is never the implication of similarly fragmented masculine legs, whether they be those of the ascending Christ in a medieval manuscript or those of the avenging hero in a modern comic strip.[19] If the fragmented

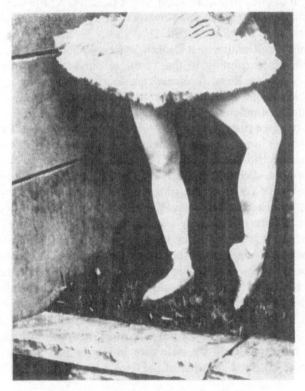

Plate 8 André Kertesz. *Dancer's Legs*

legs are masculine, they consistently function as signifiers of energy and power.

Within the implicit context of passivity, sexual availability, and helplessness, how might a respectable woman artist in England in the middle of the nineteenth century create a convincing image of her professional situation? Not very easily or very convincingly. Indeed, it has been hard for viewers to tell that Emily Mary Osborn's painting, *Nameless and Friendless* (plate 9), is in fact a representation of a woman artist. The subject has been defined as 'A Gentlewoman reduced to dependence upon her brother's art' in the 1970 edition of *The History and Philosophy of Art Education*.[20] Yet the documentary evidence as well as a careful reading of the pictorial text points to the fact that Osborn intended this as the representation of a young, orphaned woman artist offering her work with considerable anxiety to a skeptical picture dealer.[21] It is then, to some extent a self-image of the woman artist who painted it, clothed in the language of British genre painting. Even the briefest inspection of the accepted codes for the representation of artists and the accepted codes for the representation of respectable young ladies at the time reveal at once why a spectator might misinterpret the work and why Osborn might have chosen this somewhat ambiguous iconography for her representation of the woman artist.

One might well assume that Osborn, as a canny and popular purveyor of acceptable genre painting to the Victorian public, shared the 'natural' assumptions of the Royal Academy's public: that the proper setting for a respectable young woman was that of home and family. She also, no doubt, shared the assumptions controlling the first canvas of Augustus Leopold Egg's trilogy (see plate 10) about a respectable married woman's fall and expulsion from home. An independent life, a life outside the home, was all too often, for the gentlewoman, above all, related to potential sexual availability and, of course, understood to be the punishment for sexual lapse in the narrative codes of the time. Indeed, there is more than a hint, conveyed by the ogling loungers to the left of Osborn's picture, who lift their eyes from a print of a scantily clad dancing girl to scrutinize the young woman artist, that merely being out in the world at all rather than safely home opens a young, unprotected woman to suspicion. It becomes clearer why Osborn has chosen to define the situation of the woman artist as one of plight rather than of power. Only dire necessity would, she implies, force a young woman out into the dangerous public arena of professionalism. The narrative of the woman artist is here cautiously founded on a pictorial discourse of vulnerability – of powerlessness, in short. Osborn's woman artist, in her exposure to the male gaze within the painting, is positioned more in the expected situation of the female *model* than that of the male artist.

By no stretch of the imagination can one envisage a woman artist of the

Plate 9 Emily Mary Osborn. *Nameless and Friendless*

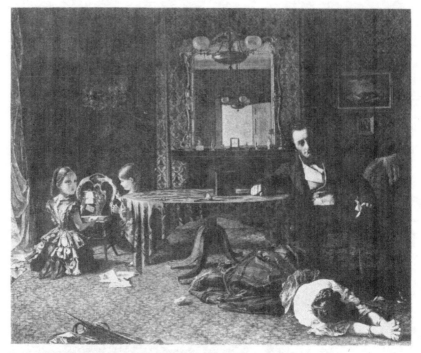

Plate 10 Augustus Leopold Egg. *Past and Present*. Number one from the trilogy

nineteenth century interpreting her role, as did her male counterparts quite freely and naturally, in terms of free access to the naked bodies of the opposite sex. Gérôme, on the contrary, in his self-portrait, *The Artist and his Model* (plate 11), has simply depicted himself in one of the most conventionally acceptable, and indeed, self-explanatory narrative structures for the self-representation of the artist. The topos of the artist in his studio assumes that being an artist has to do with man's free access to naked women. Art-making, the very creation of beauty itself, was equated with the representation of the female nude. Here, the very notion of the originary power of the artist, his status as creator of unique and valuable objects, is founded on a discourse of gender difference as power.

This assumption is presented quite overtly, although with a certain amount of tactful, naturalistic hedging, in *The Artist and his Model*. The artist does not represent himself touching the *living woman* on her thigh, but only her plaster representation, with gloved hands; and the artist himself is (conveniently for the purposes of the painting) white-haired and venerable rather than young and lusty. He may remind us more of a doctor than an artist, and he keeps his eyes modestly lowered on his work, rather than raising them to confront the naked woman. The overt iconography here is

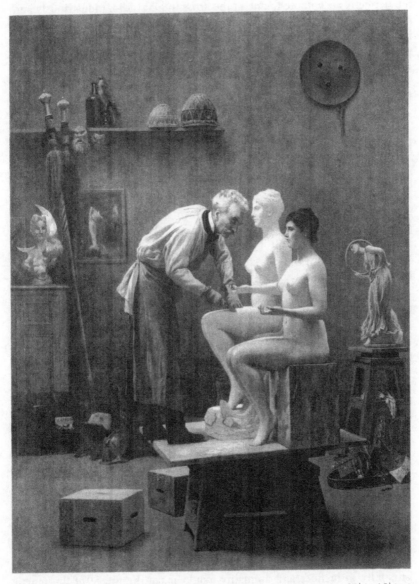

Plate 11 Jean-Léon Gérôme. *The Artist and his Model*. oil on canvas (20¼ × 15¼ ins)

the perfectly acceptable theme of the artist in his studio, industriously and singlemindedly engaging in creative activity, surrounded by testimonials to his previous achievements. Assumptions about masculine power are perfectly and disarmingly justified by the noble purposes which this power serves: although the naked model may indeed serve the purposes of the artist, he in turn is merely the humble servant of a higher cause, that of Beauty itself. This complex of beliefs involving male power, naked models and the creation of art receives its most perfect rationalization in the ever-popular nineteenth-century representation of the Pygmalion legend: stone beauty made flesh by the warming glow of masculine desire.

Nowhere is the work of ideology more evident than when issues of class join with issues of gender in the production of female imagery. In the case of the peasant woman, the association of the rural female with a timeless, nurturing, aesthetically distancing realm of nature served to defuse her potentiality – indeed, her actuality, in France, where the memory of women armed with pitchforks still hovered like a nightmare – as a political threat. The assimilation of the peasant woman to the realm of nature helped to rationalize rural poverty and the farm woman's continual grinding labor, as well as to justify her subjugation to a tradition of male tyranny within peasant culture itself.

Works like Giovanni Segantini's *The Two Mothers* with its overt connection between the nurturing functions of cow and woman, make clear the presuppositions of an ideology which supports motherhood as woman's 'naturally' ordained work, and demonstrates, at the same time, that the *peasant* woman, as an elemental, untutored – hence eminently 'natural' – female, is the ideal signifier for the notion of beneficent maternity, replete with historical overtones of the Christian Madonna and Child.

The peasant woman also served as the natural vehicle for uplifting notions about religious faith. In works like Alphonse LeGros's *The Ex-Voto*, or Wilhelm Leibl's *Peasant Women in the Church*, piety is viewed as a natural concomitant of edifying fatalism, as is the peasant woman's conservative instinct to perpetuate unquestioningly traditional religious practices from generation to generation.

Yet contradictorily – ideology of course, functioning to absorb and rationalize contradiction – at the same time that the peasant woman is represented as naturally nurturing and pious, her very naturalness, per proximity to instinct and animality, could make the image of the female peasant serve as the very embodiment of untrammeled, unartificed sexuality. Sometimes this sexual force may be veiled in idealization, as in the work of Jules Breton, who specialized in glamorizing and classicizing the erotic charms of the peasant girl for the annual Salon and the delectation of Middle Western *nouveau riche* collectors (see plate 12); sometimes it is served up more crudely and overtly, but the peasant woman's 'natural' role

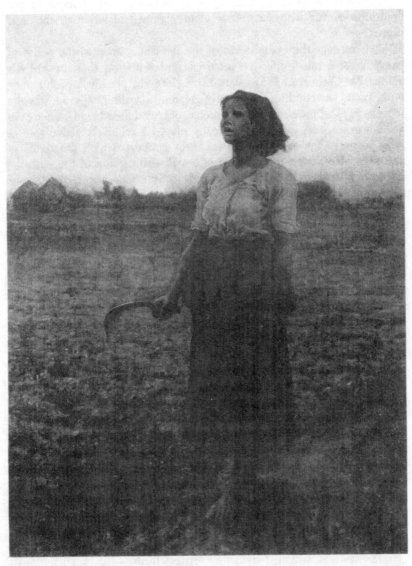

Plate 12 Jules Breton. *The Song of the Lark*. 1884, oil on canvas, 110.6 × 85.8 cms, Henry Field Memorial Collection, 1894.1033

as a signifier of earthy sensuality is as important an element in the nineteenth-century construction of gender as her nurturant or religious roles.

Nowhere does the assimilation of the peasant woman to the realm of nature receive more effective pictorial representation than in Millet's famous *The Gleaners* of 1857 (plate 13).[22] Here, the genuinely problematic implications surrounding the issue of gleaning – traditionally the way the poorest, weakest members of rural society obtained their bread – an area in which women had, in fact, historically played a relatively active role as participants in the recurrent disturbances connected with the rights of *glanage*[23] – have been transformed into a Realist version of the pastoral. Although overwrought conservative critics of the time may have seen the specter of revolution hovering behind the three bent figures, a cooler reading of the pictorial text reveals that Millet was, on the contrary, unwilling to emphasize the potentiality for an expression of genuine social conflict implied by the contrast between the richness of the harvest of the wealthy landowner in the background as opposed to the poverty of the gleaning figures in the foreground.[24] Rather, Millet chose by ennobling the poses and assimilating the figures to Biblical and Classical prototypes, to remove them from the politically charged context of contemporary history and to place them in the suprahistoric context of High Art. At the same time, through the strategies of his composition, Millet makes it clear that this particularly unrewarding labor must be read as ordained by nature itself rather than brought about by specific conditions of historical injustice. Indeed, the very fact that the workers in question are *glaneuses* rather than *glaneurs* makes their situation more acceptable; as women, they slide more easily into a position of identity with the natural order. Millet emphasizes this woman–nature connection in a specific aspect of his composition: the bodies of the bending women are quite literally encompassed and limited by the boundaries of the earth itself:[25] it is as though the earth imprisons them, rather than feudalism or capitalism.

As a visual affirmation of feminine self-assertiveness and power, Käthe Kollwitz's *Losbruch* (see plate 14) – *Outbreak* or *Revolt* – offers the most startling contrast to Millet's *Gleaners*. An etching of 1903 from the artist's 'Peasants' War' series, the image can be seen as a kind of 'anti-*glaneuses*,' a counter-pastoral, with the dynamic, vertical thrust of its angular female protagonist, who galvanizes the crowd behind her, serving to subvert the message of passive acquiescence to the 'natural' order created by Millet's composition. One might say that what Millet scrupulously avoided by resorting to the peasant woman in his representation, Kollwitz openly asserts through her: rage, energy, action.

Kollwitz turned for historical as well as pictorial inspiration for her dominating figure of Black Anna, a leader of the sixteenth-century peasant

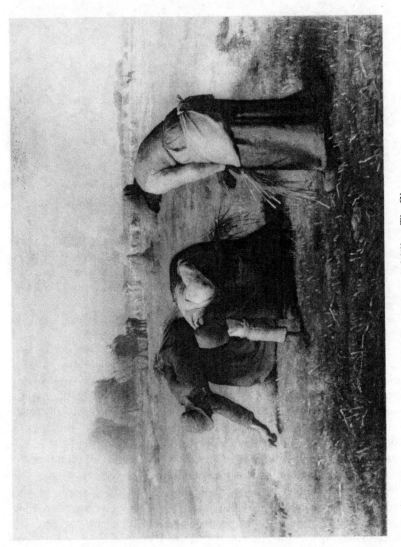

Plate 13 Jean-François Millet. *The Gleaners*

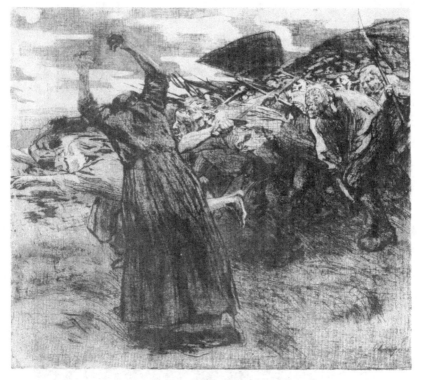

Plate 14 Käthe Kollwitz. *Losbruch (Outbreak)*

uprising, to Wilhelm Zimmermann's classical account, *The Great German Peasants' War*, which described this powerful woman and provided a popular woodcut illustration of her as well.[26] No doubt Delacroix's classical revolutionary image, *Liberty at the Barricades*, lingered in the back of Kollwitz's mind when she created her print. But the difference is, of course, that Delacroix's powerful figure of Liberty is, like almost all such feminine embodiments of human virtue – Justice, Truth, Temperance, Victory – an allegory rather than a concrete historical woman, an example of what Simone de Beauvoir has called Woman-as-Other. The figure of Black Anna, on the contrary, is historically specific and meant to serve as a concrete locus of identification for the viewer. By introducing the back-view figure of a powerful woman-of-the-people into the foreground of the scene, the artist attempts to persuade the viewer to identify with the event as she herself does.[27] Kollwitz, who sympathized with both feminism and socialism at this time and was particularly impressed by August Bebel's pioneering document of feminism, *Woman Under Socialism*, specifically identified herself with Black Anna. She told her biographer that 'she had portrayed

herself in this woman. She wanted the signal to attack to come from her.'[28] In *Outbreak*, perhaps for the first time, a woman artist has attempted to challenge the assumptions of gender ideology, piercing through the structure of symbolic domination with conscious, politically informed awareness.

It is also significant that Kollwitz selected a narrative of outright social disorder for the representation of a powerful, energetic female figure, directing rather than submitting to the action of her fellows. The topos of woman on top, to borrow the title of Natalie Zemon Davis's provocative study of sex-role reversal in pre-industrial Europe, has always been a potent, if often humorous, image of unthinkable disorder.[29] Generally during our period, gestures of power and self-affirmation, especially of political activism, on the part of women were treated with special visual viciousness. Daumier, in a lithograph subtitled 'V'la une femme qui à l'heure solonelle où nous sommes, s'occupe bêtement avec ses enfants', created in 1848, the very year of the democratic revolution fought in the name of greater equality, treated the two feminists to the left of the print (recognizable caricatures of two prominent activists of the time) as denatured hags, saggy, scrawny, uncorseted creatures, whose dissatisfied gracelessness contrasted vividly with the unselfconscious charm of the little mother to the right, who continued to care for her child heedless of the tumult of history.[30] The working-class women activists of the Commune, the so-called *pétroleuses* (see plate 15), were mercilessly caricatured by the Government of Order as frightening, subhuman, witchlike creatures, demons of destruction intent on literally destroying the very fabric of the social order by burning down buildings.[31]

In the sixteenth century, Pieter Brueghel had used the figure of a powerful, active woman, Dulle Griet or Mad Meg, to signify contemporary spiritual and political disorder. Indeed, it is possible that Kollwitz herself may have turned to this, one of the most potent images of the menace of the unleashed power of women, for her conception of Black Anna in the 'Peasants' War' series, an image more or less contemporary with her subject: Mad Meg, who with her band of ferocious female followers served as the very emblem of fiery destruction and disorder, a visual summary of the reversal of the proper power relations and the natural hierarchy of a well-ordered world, to borrow the words of Natalie Zemon Davis.[32] For the sixteenth century, as for the nineteenth, the most potent natural signifier possible for folly and chaos was woman unleashed, self-determined, definitely on top: this was the only image sufficiently destructive of 'normal' power relations, rich enough in negative significations, to indicate the destruction of value itself.

In the figure of Black Anna, Kollwitz has transvaluated the values of Mad Meg, so to speak, and made them into positive if frightening visual

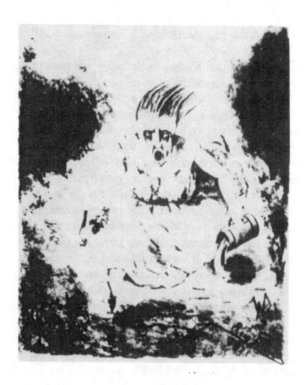

Plate 15 *'La Femme émancipée répandant la lumière sur le monde' (La Pétroleuse)*

signifiers.[33] The dark, chthonic force associated with the peasant woman, those malevolent, sometimes supernatural powers associated with the unleashing of feminine, popular energies and not totally foreign to the most menacing of all female figures – the witch – here assumes a positive social and psychological value: the force of darkness, in the context of historic consciousness, is transformed into a harbinger of light.

On 10 March 1914, approximately ten years after Kollwitz had created her image of woman's power, a militant suffragette, Mary Richardson, alias Polly Dick, took an axe to Velázquez's *Rokeby Venus* (see plate 16) in the National Gallery in London. It was an act of aesthetic destruction comparable in the strength of its symbolic significance to Courbet's supposed destruction of the Vendôme Column during the Commune, and was greeted with a similar sort of public outrage. Mary Richardson declared that she had tried to destroy the picture of the most beautiful woman in mythological history as a protest against the Government for destroying Mrs

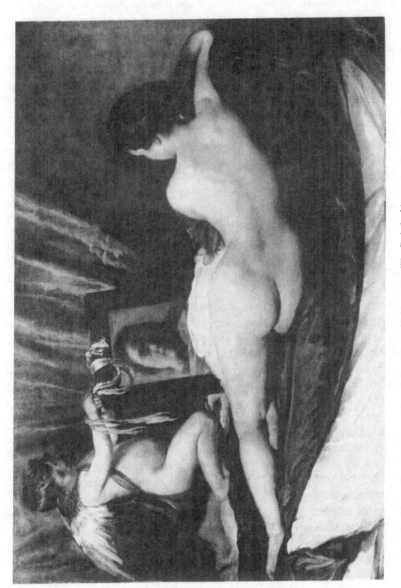

Plate 16 Diego Velázquez. *The Rokeby Venus*

Pankhurst, who was the most beautiful character in modern history. The fact that she disliked the painting had made it easier for her to carry out her daring act.[34] Richardson's vandalism quite naturally created a public furore at the time: she had dared to destroy public property, ruined a priceless masterpiece, wielded a dangerous weapon in an art gallery. Even today, the right-thinking art lover must shudder at the thought of the blade hacking through Velázquez's image, through no mere accident the very image of Beauty itself. We may find Mary Richardson admirable for acting courageously, engaging in a punishable act for a political cause she deemed worth fighting for and attempting to destroy a work she believed stood for everything she, as a militant suffragette, detested: yet it is clear that she was also wrong. Wrong because her act was judged to be that of a vicious madwoman and did the suffrage cause little or no good; but more than that, wrong in that her gesture assumes that if the cause of women's rights is right, then Velázquez's *Venus* is wrong. Yet it also may be said, as Jacqueline Rose has in her article, 'Sexuality in the Field of Vision,' that 'if the visual image, in its aesthetically acclaimed form serves to maintain a particular and oppressive mode of sexual recognition, it nevertheless does so only partially.'[35] Is it then possible to respond differentially to the image of Venus?

Apart from our specialized reactions to *The Rokeby Venus*'s unique qualities of shape, texture, and color, and yet because of these qualities, we may respond to a variety of other kinds of discourse suggested by the painting: suggestions of human loveliness, physical tenderness, and the pleasures both sexes take in sexual discovery and self-discovery; we may also, if we are past youth and well-versed in our iconography, be reminded of the swift passage of beauty and pleasure and the vanity of all such delights, visual and otherwise, suggested in the painting by the *topos* of the woman with a mirror: *vanitas*. Here, the mirror brings us not only an adumbration of mysterious beauty, but, at the same time, intimations of its inevitable destruction. Such readings are possible either if we are totally unaware of the power relations obtaining between men and women inscribed in visual representation; or, if we have become aware of them, we choose to ignore them while we enjoy or otherwise respond positively to the image in question; or, if we cannot ignore them, feeling that we are in no way affected by them.

The question whether it is possible at this point in history for women simply to 'appreciate' the female nude in some simple and unproblematic way leads us to ask the question of whether any positive visual representation of woman is possible at all. A photo-collage, *Pretty Girl* (*Das schöne Mädchen*) (plate 17), of 1920 by Hannah Höch, a member of Berlin Dada, suggests 'in Utopia, yes; under patriarchy, in a consumer society, no.' Höch's photo-collage reminds us of another kind of cutting practice in art besides the destructive one of Polly Dick: deconstructive and instructive.

Plate 17 Hannah Höch. *Pretty Girl*

Obviously Höch's cut-ups offer an alternative to the slicing up of
Velázquez's nude, another way of refusing the image of woman as a
transcendent object of art and the male gaze, generator of a string of
similarly depoliticized art objects. This deconstructive practice of art – or
anti-art – reveals that any representation of woman as sexual object, far from
being natural or simply 'given,' is itself a construction. If traditional
representation has insisted upon maintaining the spectator within 'an
illusorily unfissured narrative space,'[36] then it hardly seems an accident that
the material practice of photo-collage, that free and aggressive combination
of words and ready-made images characteristic of Berlin Dada in the 1920s,
manifests its subversive politics in an art of cutting down and reconstruct-
ing, in which the original deconstructive impulse remains assertively
revealed in the deliberate crudeness, discontinuity, and lack of logical
coherence of the structure of the work. A photo-collage like Hannah Höch's
Pretty Girl, made out of ready-made materials, denies the 'originality' or
'creativity' of the masterful male artist *vis-à-vis* his female subject. It denies

the beauty of the beautiful woman as object of the gaze and at the same time insists on the finished work as the result of a process of production – cutting and pasting – rather than inspiration. *Pretty Girl* is in part a savagely funny attack on mass-produced standards of beauty, the narcissism stimulated by the media to keep women unproblematically self-focused. At the same time, the collage allegorizes the arbitrarily constructed quality of *all* representations of beauty: the 'pretty girl' of the title is clearly a product assembled from products – it is the opposite of the *belle peinture* of the *belle créature*. Hannah Höch, previously considered 'marginal' within the context of Berlin Dada, now assumes a more central position in light of the work of contemporary women image-makers concerned with the problematics of gendered representation. Barbara Kruger, Cindy Sherman, Mary Kelly and many others are again cutting into the fabric of representation by refusing any kind of simple 'mirroring' of female subjects; they turn to collage, photomontage, self-indexical photography, combinations of texts, images and objects as ways of calling attention to the production of gender itself – its inscription in the unconscious – as a social construction rather than a natural phenomenon.

What of women as spectators or consumers of art? The acceptance of woman as object of the desiring male gaze in the visual arts is so universal that for a woman to question, or to draw attention to this fact is to invite derision, to reveal herself as one who does not understand the sophisticated strategies of high culture and takes art 'too literally,' and is therefore unable to respond to aesthetic discourses. This is of course maintained within a world – and a cultural and academic world – which is dominated by male power and, often unconscious, patriarchal attitudes. In Utopia, that is to say, in a world in which the power structure was such that both men and women equally could be represented clothed or unclothed in a variety of poses and positions without any implications of domination or submission – in a world of total and so to speak, unconscious equality – the female nude would not be problematic. In our world, it is. As Laura Mulvey has pointed out in her often-cited article, 'Visual Pleasure and Narrative Cinema,' there are two choices open to the woman spectator: either to take the place of the male or to accept the position of male-created seductive passivity and the questionable pleasure of masochism – lack of power to the nth degree.[37] This positioning, of course, offers an analogue to the actual status of women in the power structure of the art world – with the exception of the privileged few. To turn from the world of theory to that of mundane experience: I was participating as a guest in a college class on contemporary realism, when my host flashed on the screen the close-up image of a woman's buttocks in a striped bikini, as a presumed illustration of the substitution of part for whole in realist imagery, or perhaps it was the decorative impulse in realism. I commented on the overtly sexual – and sexist – implications of the image

and the way it was treated. My host maintained that he 'hadn't thought of that' and that he 'had simply not been aware of the subject.' It was impossible for any woman in the class 'not to think of that' or for any man in the class to miss its crudely degrading implications. In a university art class, one is not supposed to speak of such things; women, like men, are presumably to take crudely fetishized motifs as signifiers of a refreshing liberatedness about sexual – and artistic – matters. My host insisted on the purely decorative, almost abstract, as he termed it, implications of the theme. But such abstraction is by no means a neutral strategy, as Daumier discovered when he transformed the recognizable head of Louis Philippe into a neutral still life object in his 'La Poire' series. For women, the sexual positioning of the female in visual representation obtrudes through the apparently neutral or aesthetic fabric of the art work. Yet how little women protest, and with good reason, for, on the whole, they are in similarly powerless or marginalized positions within the operational structure of the art world itself: patient catalogers rather than directors of museums; graduate students or junior faculty members rather than tenured professors and heads of departments; passive consumers rather than active creators of the art that is shown at major exhibitions.

A striking case in point was the dilemma of the female spectator at the Balthus exhibition which took place at the Metropolitan Museum of Art in New York in 1984 (plate 18).[38] A barrage of discourse was directed at her to convince her that this was indeed Great Art; that to take too much notice of the perversity of the subject matter was not to 'respond' to these master-pieces with the aesthetic distance they deserved; and that to protest on the grounds that these representations of young women were disturbing was simply to respond to a major element in the grandeur of the artist's conception: after all, they were 'supposed to be' disturbing. To believe that being disturbed by the representation of young women in sexually perverse and provocative situations is a suitable object for questioning, much less for a negative critique, is considered the equivalent of disapproval of the erotic itself. But, of course, women are entitled to ask: 'For whom, precisely, does this constitute an erotic discourse? Why must I submit to a male-controlled discourse of the erotic? In what sense is the gaze of the male fetishist equivalent to and identical with an erotic discourse? Why must I accept a discourse that consistently mystifies my sexuality by constituting the image of the vulnerable and seductive adolescent as a universally erotic one?' And to those who hold up Balthus's canvases as more general, radical images of transgression, one might well point out that in terms of their language, they are scarcely transgressive at all, extremely conservative, in fact, in the way they cling to an outmoded but modish language of visual repleteness, refusing to question the means of art except as the occasion of an added *frisson*. For the daring deconstruction and questioning of patriarchal

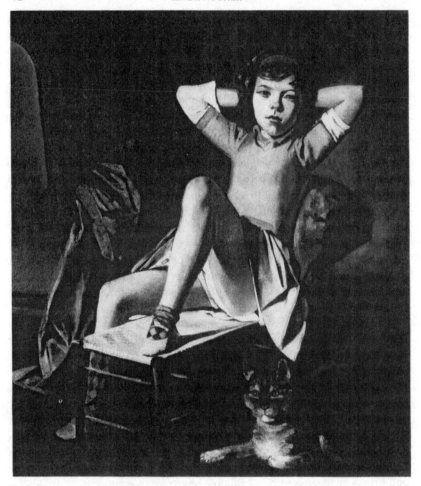

Plate 18 Balthus. *Girl with Cat* (*Thérèse Blanchard*)

authority central to Dada and to some aspects of Surrealism, Balthus's paintings substitute an unproblematically naturalistic replication of that order; Balthus's *œuvre* is, in fact, a prime exemplar of the *retour à l'ordre* itself.

There is an analogue between women's compromised ability – her lack of self-determining power – in the realm of the social order and her lack of power to articulate a negative critique in the realm of pictorial representation. In both cases, her rejection of patriarchal authority is weakened by accusations of prudery or naiveté. Sophistication, liberation, belonging are equated with acquiescence to male demands; women's initial perceptions of oppression, of outrage, of negativity are undermined by authorized doubts,

by the need to please, to be learned, sophisticated, aesthetically astute – in male-defined terms, of course. And the need to comply, to be inwardly at one with the patriarchal order and its discourses is compelling, inscribing itself in the deepest level of the unconscious, marking the very definitions of the self-as-woman in our society – and almost all others that we know of. I say this despite – indeed, because of – the obvious manifestations of change in the realm of women's power, position, and political consciousness, brought about by the women's movements and more specifically by feminist criticism and art production over the past fifteen years. It is only by breaking the circuits, splitting apart those processes of harmonizing coherence that, to borrow the words of Lisa Tickner, 'help secure the subject to and in ideology,'[39] by fishing in those invisible streams of power and working to demystify the discourses of visual imagery – in other words, through a politics of representation and its institutional structures – that change can take place.

Notes

1 For the most recent information about the three paintings usually referred to as *Past and Present*, see Lynda Nead, *Myths of Sexuality: Representations of Women in Victorian Britain*, Oxford, Basil Blackwell, 1988, pp. 71–86.

2 Michel Foucault, *The History of Sexuality. Volume I: An Introduction*, New York, Pantheon, 1978, p. 86.

3 Robert Rosenblum has pointed out that David's theme may well have been the artist's own invention. See his *Transformations in Late Eighteenth Century Art*, Princeton, Princeton University Press, 1967, p. 68.

4 For a reproduction of Caraffe's *Oath of the Horatii* of 1791 (Arkangelski Castle), see the exhibition catalogue, *French Painting 1774–1830: The Age of Revolution*, Grand Palais, Paris, 1974–5; Detroit Institute of Arts, 1975; The Metropolitan Museum of Art, New York, 1975, no. 18, p. 125.

5 For information about the change, see M. H. Noel-Patton, *Tales of a Granddaughter* (Elgin, Moray, Scotland: Moravian Press, 1970), p. 22.

6 See the *Art Journal*, New Series, Vol. IV, 1858, p. 169 for a review of *In Memoriam*. The painting was no. 471 in the Royal Academy Catalogue of that year.

7 For a full account of the daily life of British women in India in the nineteenth century, including their behavior during the Indian mutiny, see Pat Barr, *The Memsahibs: The Women of Victorian India*, London, Secker and Warburg, 1976.

8 The Spanish title of Goya's print is 'Y son fieras'.

9 The photograph is taken from Midge Mackenzie, ed., *Shoulder to Shoulder: A Documentary* (New York: Knopf, 1st American edn, 1975), p. 255. It represents Mrs Barrud, a well-known suffragette, demonstrating the methods of jujitsu.

10 Talcott Parsons, *Politics and Social Structure*, New York, The Free Press, 1969, pp. 365–6. Parsons has observed that 'The threat of coercive measures, or of compulsion, without legitimation or justification, should not properly be called the use of power at all, but is the limiting case where power, losing its symbolic

character, merges into an intrinsic instrumentality of securing wishes, rather than obligations.' From 'On the Concept of Political Power,' in *Sociological Theory and Modern Society*, New York, The Free Press, 1967, p. 331. Parsons' whole chapter, originally published in 1963, is relevant to a discussion of women and power, as is the preceding chapter in the same book, 'Reflections on the Place of Force in Social Process,' pp. 264–96. See for instance, Parsons' distinction between force and power: 'In the context of deterrence, we conceive force to be a residual means that in a showdown, is more effective than any alternative. Power, on the other hand we conceive to be a *generalized medium* for controlling action – one among others – the effectiveness of which is dependent on a variety of factors of which control of force is only one, although a strategic one in *certain* contexts', pp. 272–3.

11 This summary of Parsons' position is to be found in Arthur Kroker and David Cook, 'Parsons' Foucault', in *The Postmodern Scene: Excremental Culture and Hyper-Aesthetics*, New York, St Martin's Press, 1986, p. 228.

12 *Art Journal*, New Series, vol. IV, 1858, p. 169.

13 'In Dreams Begin Responsibilities' is the title story of a book by the American poet, Delmore Schwartz, published in 1938. Schwartz indicated that the title derived from an epigraph, 'In dreams begins responsibility,' which William Butler Yeats placed before his own collection, *Responsibilities: Poems and a Play*, Churchtown, Dundrom, The Coake Press, 1914, and attributed to an 'old play.' Richard McDougall, *Delmore Schwartz*, New York, Twayne Publishers, Inc., 1974, pp. 46–7.

14 For the almost universally negative reception of Delacroix's painting, see Jack Spector, *Delacroix: The Death of Sardanapalus (Art in Context)*, New York, The Viking Press, 1974, pp. 80–3.

15 Edward Said's *Orientalism*, New York, Pantheon Books, 1978, is the basic text on the subject of the representation of the Near East. Also see my article, 'The Imaginary Orient,' *Art in America*, 71 (May 1983), pp. 118–31, upon which much of my analysis of Gérôme is based.

16 For a more detailed examination of the issues surrounding *The Ball at the Opéra*, see my 'A Throroughly Modern Masked Ball,' *Art in America*, 71 (November 1983), pp. 188–201.

17 Julius Meier-Graefe, *Edouard Manet*, Munich, 1912, p. 216. It must be understood that *The Ball at the Opéra*, like so many Impressionist representations of so-called scenes of 'leisure' or 'entertainment,' may actually be read as a kind of work scene: a representation of women in the entertainment or urban service industries. Bourgeois men's leisure was, and often still is, maintained or sustained by women's work, often work related to the marketing of their own bodies. *The Ball at the Opéra*, like a Degas ballet scene or Manet's representations of café waitresses or prostitutes is a representation of women's labor just as much as Millet's imagery of the female farmworker or domestic laborer. For some of the ambiguities surrounding the notion of prostitution as 'work' in the nine-teenth century, see T. J. Clark, *The Painting of Modern Life: Paris in the Art of Manet and his Followers*, New York, Alfred A. Knopf, 1985, pp. 101–8; Hollis Clayson, 'Avant-Garde and *Pompier* Images of 19th-Century French Prostitution: The Matter of Modernism, Modernity and Social Ideology', in Benjamin H. D. Buchloh, Serge Guilbaut, and David Solkin (eds), *Modernism and Modernity: The*

Vancouver Conference Papers, Nova Scotia, Nova Scotia College of Art and Design, 1983, pp. 43–64; and Lynda Nead, *Myths of Sexuality*. For a variety of reasons, women's work both in the home and in the 'entertainment' or 'prostitution' trades escaped the Marxist analysis of production in the nineteenth century. See Linda Nicholson, 'Feminism and Marx: Integrating Kinship with the Economic,' in *Feminism as Critique: On the Politics of Gender In Late Capitalist Societies*, ed. S. Denhabib and D. Cornell, Minneapolis, University of Minnesota Press, 1987, pp. 16–30.

18 For Mallarmé's view of the *Ball*, see his 'Le Jury de peinture pour 1874 et M. Manet,' in *Œuvres complètes*, ed. H. Mondor and G. Jean-Aubry, Paris, Gallimard, 1945, p. 695. The article originally appeared in *La Renaissance artistique et littéraire* in 1874. For Mallarmé's comments on Manet's formal innovations see 'The Impressionists and Edouard Manet,' an article which originally appeared in the 30 September 1876 issue of *The Art Monthly Review and Photographic Portfolio* in London, and was recently republished in the exhibition catalogue, *The New Painting: Impressionism 1874–1866*, The Fine Arts Museums of San Francisco and the National Gallery of Art, Washington, DC, 1986, p. 31.

19 The trope of the fragmented legs in the medieval imagery of the ascending Christ is discussed by Meyer Schapiro in 'The Image of the Disappearing Christ: The Ascension in English Art Around the Year 1000,' *Gazette des Beaux-Arts*, March 1943, pp. 135–52.

20 Stuart MacDonald, *The History and Philosophy of Art Education*, London, University of London Press, 1970, title to fig. 9, p. 96. For the most recent information on Emily Mary Osborn, see Charlotte Yeldham, *Women Artists in Nineteenth-Century France and England*, New York and London, Garland Publishing, 1984, vol. I, p. 167 and pp. 309–11.

21 This is the interpretation of the painting given in the *Art Journal of 1857*, the year when *Nameless and Friendless* was exhibited as no. 299 at the Royal Academy Exhibition: 'A poor girl has painted a picture, which she offers for sale to a dealer, who, from the speaking expression of his features, is disposed to depreciate the work. It is a wet, dismal day, and she has walked far to dispose of it; and now awaits in trembling the decision of a man who is become rich by the labours of others,' *Art Journal*, New Series, vol. III (1857), p. 170.

22 For a lengthy analysis of the representation of the peasant woman in nineteenth-century, mostly French, art, see Linda Nochlin, 'The *Cribleuses de blé*: Courbet, Millet, Breton, Kollwitz and the Image of the Working Woman,' in *Malerei und theorie: Das Courbet-Colloquium in 1979*, ed. Klaus Gallwitz and Klaus Herding, Frankfurt am Main, Stadtische Galerie im Stadelschen Kustinstitut, 1980, pp. 49–74.

23 See Paul de Grully, 'Le Droit de Glanage: Patrimonie des pauvres.' Ph.D., Law Faculty, University of Montpellier, 1912 for a complete historical examination of the issue of gleaning.

24 For the most penetrating examination of the social contradictions embodied in Millet's *Gleaners*, see Jean-Claude Chamboredon, 'Peintures des rapports sociaux et invention de l'eternel paysan: les deux manières de Jean-François Millet,' *Actes de la recherche et sciences sociales*, nos 17–18, November 1977, pp. 6–28.

25 I owe this observation to Robert Herbert.

26 See the exhibition catalogue *Käthe Kollwitz*, Frankfurter Kunstverein, 2nd edn, Frankfurt, 1973, fig. 17.

27 Françoise Forster-Hahn, *Kaethe Kollwitz, 1867–1945: Prints, Drawings, Sculpture*, exhibition catalogue, Riverside, California, University Art Galleries, 1978, p. 6.

28 Otto Nagel, *Kaethe Kollwitz*, trans S. Humphries, Greenwich, Conn., New York Graphic Society, 1971, p. 35.

29 Natalie Zemon Davis, 'Woman on Top', in *Society and Culture in Early Modern France*, Stanford, California, Stanford University Press, 1975, pp. 124-51 and especially p. 129.

30 'V'la une femme . . .' is part of the series 'Les Divorceuses' and appeared in *Le Charivari* on 12 August 1848. The feminist to the left is meant to represent Eugénie Niboyet, who started the 'Club des femmes' and the journal *La Voix des Femmes*, which she holds with the title partly hidden behind her back. The figure to the right is probably meant to refer to Jeanne Deroin, a feminist activist who was frequently the butt of Daumier's scathing satire in his anti-feminist series 'Les Femmes Socialistes' which appeared in *Le Charivari* from April to June 1849. See Jan Rie Kist, *Honoré Daumier 1808–1879* (exhibition catalogue), National Gallery of Art, Washington DC, 1979, no. 58, p. 59; and Françoise Parturier, *Intellectuelles (Bas Bleus et Femmes Socialistes)*, Paris, Editions Vilo-Paris, 1974. For a study of Daumier's anti-feminist caricatures, see Caecillia Rentmeister, 'Daumier und das hässliche Geschlecht,' in the exhibition catalogue, *Daumier und die ungelösten Probleme der bürgerlichen Gesellschaft*, Berlin, Schloss Charlottenburg, 1974, pp. 57–79.

31 For a discussion of caricatures of women of the Commune, see James A. Leith, *Images of the Commune*, Montreal and London, McGill–Queen's University Press, 1978, pp. 135–8; and Adrian Rifkin, 'No Particular Thing to Mean,' *Block*, 8 (1983), pp. 36–45.

32 Zemon Davis, *Society and Culture*, p. 129.

33 This frightening aspect of Black Anna is manifested particularly in the print from the series entitled 'Whetting the Scythe', a soft-ground etching, in which the figure looms out at the spectator from a shadowy background, her weapon clutched to her body, her expression a kind of brooding malevolence.

34 Mackenzie (ed.), *Shoulder to Shoulder*, pp. 258–61.

35 Jacqueline Rose, 'Sexuality in the Field of Vision,' in *Sexuality in the Field of Vision*, London, Verso, 1985, p. 232.

36 Peter Wollen, 'Counter-Cinema and Sexual Difference,' in *Difference: On Representation and Sexuality*, exhibition catalogue, New York, The New Museum of Contemporary Art, 1985, p. 37.

37 Laura Mulvey, 'Visual Pleasure and Narrative Cinema,' *Screen*, 16, no. 3 (Autumn 1975), pp. 6–18. As Mulvey herself has later pointed out, this is perhaps too simple a conception of the possibilities involved. Nevertheless, it still seems to offer a good working conception for beginning to think about the position of the female spectator of the visual arts.

38 See the exhibition catalogue *Balthus*, by Sabine Rewald, New York, Metropolitan Museum of Art, Harry Abrams, 1984.

39 Lisa Tickner, 'Sexuality and/in Representation: Five British Artists,' in exhibition catalogue *Difference: On Representation and Sexuality*, p. 20.

Will (S)he Stoop to Conquer? Preliminaries Toward a Reading of Edward Hopper's Office at Night

Ellen Wiley Todd

Linda Nochlin's 'Women, Art, and Power' can be thought of as a general blueprint for examining the different ways in which 'discourses of gender difference' – specifically power and its lack for women – are embodied in both the narrative and visual structures of works of art over an extended chronological period. She poses questions, offers framing concepts, and provides us with a set of strategies for a surface reading of these discourses about power related to gender difference. What happens when we appropriate her strategies for a reading of a single painting? How do we locate the work within particular discourses on gender difference at a given historical moment? Should Nochlin's terms be considered a method or a feminist tactic within the iconographic method? Using Nochlin's idea that representations of women 'serve to reproduce' society's and artists' shared assumptions about 'men's power over, superiority to, difference from and necessary control of women,' I propose to read Edward Hopper's *Office at Night* (1940) (see plate 19) as a 'narrative' of ambiguous and unresolved power/gender relations.[1] Hopper's painting may be considered as one of many 'texts' embodying deeply held notions of gender difference that were part of the discourse on female office workers in the inter-war decades.

In *Office at Night*, the boss and his private secretary stay late to wind up the day's work. He – young, handsome and fair-haired – sits upright behind his desk, fully absorbed in the document he holds securely with both hands. She – young, attractive, and dark haired, with ruby lips and heavily shadowed eyes – stands in front of a tall filing cabinet. Her right hand rests idly on the open file drawer, her invisible left arm disappears into the drawer, reserving a slot for the document he will momentarily pass over to her. He works, she waits. He initiates, she responds ... or can we reverse this last scenario, depending on our reading of just what is being initiated here?

No one who looks closely at this picture can miss the suppressed narrative with its powerful erotic charge. Gail Levin locates a 'psychic

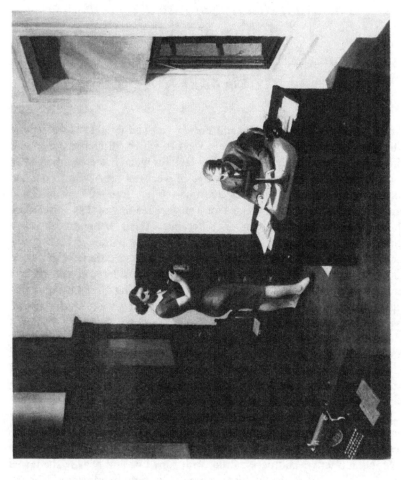

Plate 19 Edward Hopper. *Office at Night*, 1940. Gift of T. B. Walker Foundation, Gilbert M. Walker Fund, 1948

tension' between the 'curvaceous woman' and the man who ignores her, in both the nighttime setting and in a pictorial structure the unusual trapezoidal shape of which suspends the viewer in mid-air above a tense and intimate space.[2] Linda Nochlin, ever alert to pictorial cues embodying gender difference, contrasts the erotic curve of the woman's buttock with the [man's] rigid vertical desk lamp. She finds the narrative thread in 'the unasked and unanswerable question of whether the woman will stoop over to pick up the piece of paper half-hidden behind the desk' – a gesture of servitude that would however, initiate contact between the figures.[3] And then there is the woman's impossible pose,[4] a temptress' serpentine twist, spotlit to display equally her substantial breasts and buttocks. The latter strain against a clinging dress and appear even more pronounced in relation to the curving chair arm that insinuatingly penetrates the space beneath her buttocks, grazing her thigh and her hemline. Within the kind of cinematic setting that was so much a part of Hopper's aesthetic, the secretary is a mute attendant offering, set up as an object of desire for the viewer, and, should her own gaze be returned, for the man behind the desk.

Three preliminary studies for the work show that Hopper's narrative actually began with more co-operation and exchange between the figures. In both drawings, an older bald man acts the part of boss, making the eerily lit scenario of late night overtime somewhat more benign. In the first of these drawings, even though the man looks down at a document, he and the secretary face one another, the identical profile poses of their heads creating an equality of interchange across the gap between filing cabinet and desk. Furthermore, the secretary's back faces the viewer in a naturally relaxed stance that de-emphasizes her figure. In the last study, both boss and secretary take their final poses. But Hopper has yet to darken and extend the wave of hair, or to exaggerate the eyes and lips of the secretary, marks that transform her into the potent siren-style temptress of the final work. Though her dress fits snugly in this final sketch, without the other attributes, she appears more girlish and deferential.

In the final painting, these more overt narratives of co-operation have been replaced by a diffused (but arguably present) erotic subtext that hinders communication. In his reading of the piece, post-modernist critic and photographer Victor Burgin argues that the picture confronts the *particular* problem of 'the organization of sexuality within ... and *for* capitalism.'[5] In patriarchal society, authoritative men assign women to supporting roles at home and within the workplace. The idea of 'coupling' to reproduce subjects for the workplace contains a sexual imperative that the family functions to restrain, but the erotic element spills over into the workplace – here represented by the fictional couple – and 'threatens to subvert' the orders of rationalized production. For Burgin, Hopper's formal system of interlocking rectangles, combined with the refusal of the male to

return his secretary's gaze, stabilizes the erotic threat from the woman by providing 'a moral solution' that is patriarchal.[6] The male viewer can initially achieve erotic titillation by enjoying the woman's fully displayed figure, but then in identifying with the seated boss he can look without blame, deny his own voyeurism, and participate fully in keeping the workplace and the capitalist order intact.

While I agree with the general outlines of Burgin's interpretation, Hopper's pictorial narrative is more ambiguous in granting the woman a superficial power that masks her own otherwise subordinate status. By situating Hopper's pictorial text[s] within a larger discourse on office work in the 1930s – located in a widely read literature on clerical work that ranged from statistical studies and descriptive feature articles to popular fiction and advice manuals – we may broaden the account in two ways. First, the painting's narrative may stop just short of the 'patriarchal moral solution' by leaving the outcome in suspense. And secondly, the work thematizes some of the conflicted power and gender relations that were part of mainstream American society in the 1930s.

While 1940s viewers of Hopper's *Office at Night* undoubtedly understood the sexual undercurrent of the pictorial narrative, they also would have seen a glamorous and highly successful private secretary in an exalted position that gave her a level of status available to only a few working women; the mechanization of office work in the 1930s placed most clerical workers into vast stenographic pools, diminishing the degree of upward mobility. The secretary gained her position by negotiating carefully prescribed standards of behavior and dress. In an increasingly competitive job market, job counselors and employers began to place as much emphasis on appearance as on skills in hiring women clerical workers. They sought women who would enhance the office decor while typing well, and went so far as to equate good looks with high quality work: 'The kind of girl who takes pains to make the most of herself in every small detail of her appearance will also be orderly and painstaking in her work.'[7] At the same time, however, good appearance featured a restricted dress of tailored clothes, small jewelry and tasteful makeup. As a general rule, the higher a woman moved up the occupational scale, the more simple her dress; the kind of plain frock with geometric trim worn by Hopper's female figure constituted appropriate private secretarial attire. Glamor and sex appeal, though acceptable in moderate amounts – designated by the polyvalent word 'charm' – were to be downplayed in favor of a deferential, yet none the less efficient manner. One author characterized this as 'the right attitude ... a combination of friendliness and reticence, of assurance and modesty, of ambition and willingness to do anything'[8] anything especially for the male boss. Through such polarized terms, advice book writers counseled secretaries to dust the boss' desk, run his wife's errands – and a host of other domestic tasks, no

matter what the cost in overtime, or the personal sacrifice – in order to 'get ahead.' Counselors perpetuated both the hope and the myth of occupational and social advancement. One moved up the clerical ladder to secretary and then into a higher social position by meeting and marrying a better sort of man.[9]

A woman's 'power' in the workplace came from her ability to behave in a deferential 'womanly' manner, according to an ideology of woman's proper place that valued her subordination to the demands of her male superiors. Since office work depended upon the extension of a woman's reputedly natural domestic skills into the public sphere – making the work environment more pleasant and inviting, managing the office efficiently – it was argued that her achievement occurred because clerical occupations required womanly skills with which men could not compete. The private secretary's status came from her indispensable role as the daytime wife of the boss; but as one author claimed in 1935, 'it was a triumph for [her] womanhood and not for [her] ambition.'[10] Even as she triumphed in a 'new role' the old assumptions, held by men and women alike, remained fully intact – new role, same old, 'natural,' necessary status.

Through the pictorial structure and narrative of *Office at Night*, Hopper recognizes the kinds of irreconcilable polarities found in popular advice literature, and gives visual form to the ambiguous power/gender relations embodied in the boss/private secretary or male/female relationship.[11] On one hand, the secretary has power. A fully realized figure, she towers above her boss, and controls not only the access to and organization of office information (the filing cabinet), but also office 'production.' In the final painting, Hopper gives greater emphasis to the secretary's desk and typewriter. They protrude into the lower lefthand corner of the painting, and along with the filing cabinet and the boss' desk they become an important third term in the painting's triangular configuration of work. At the same time, her power is subverted by a series of intricate, even subtle strategies. She 'controls' the office decor with her beauty and her obviously correct attire. Yet her dress is so tight, her makeup so heavy, she oversteps the category 'charm' to the overtly sexual and therefore questionable behavior which the male counteracts by denying her gaze. Ironically, her eyes are so shaded by heavy makeup that her mysterious gaze can be (as Burgin points out) either directed and predatory (hence filled with power) or downcast and modest (hence deferential). Although she appears to be able to move freely throughout the office, managing its appearance and work structure, everything blocks her access to the seat of power behind the man's desk; the two shapes of filing cabinet and desk intersect to create an unbridgeable gap. Another exists between her desk and his. She never generates an activity but must wait for instructions.

In *Office at Night* Hopper leaves such contradictions unresolved by

including and striking a tense balance between what viewers understand as the 'correct' and 'unacceptable' boundaries of male/female behavior in the workplace. Furthermore, when viewed in conjunction with its less sexually charged preliminary sketches, the painting's exaggerated eroticism also problematizes the nature of Hopper's American Scene realism. Specifically, one wants to ask whether the final version makes a leap from Hopper's late night observations of New York offices from the 'L' train to his own and/or his male subject's fantasy.[12] No matter what the answer to this particular question, with the degree or kind of power – sexual, productive, managerial – the painting inscribes for the secretary, both Hopper, the male artist in control through appropriation of the female image from other contemporary texts/images, and the socio-economic structure that figured her, shared assumptions that her subordinate role as woman worker derived from an ultimately superior male.

Notes

1 In spite of what many have seen as the 'alienated' and abstract qualities of Hopper's work, the artist's background as an illustrator, his borrowings of formal and thematic devices from cinema, and his working out or progressive elimination of story line from preliminary sketch to final work (see below) justifies the narrative reading here. Hopper himself teased the viewer by captioning one sketch for the work 'Confidentially Yours, Room 1005' and naming the subject Shirley. He ended the description with a cautionary note: 'Any more than this the picture will have to tell, but I hope it will not tell any obvious anecdote, for none is intended.'

2 Gail Levin, 'Edward Hopper's *Office at Night*,' *Arts magazine* (January 1978), pp. 135 and 137.

3 Linda Nochlin, 'Edward Hopper and the Imagery of Alienation,' *Art Journal*, 41 (Summer 1981), p. 138.

4 Victor Burgin, *Between*, Oxford, Basil Blackwell, in association with the Institute of Contemporary Arts, 1986, p. 184.

5 Ibid., p. 183.

6 Ibid. Nochlin might situate Hopper's morality in what she sees as a 'coy puritan stiffness of contour' that is particularly American, 'Hopper and Alienation,' p. 138.

7 Elizabeth MacGibbon, *Manners in Business*, New York, The Macmillan Company, 1936, pp. 16–17.

8 Hazel Rawson Cades, *Jobs for Girls*, New York, Harcourt, Brace and Company, 1928, p. 16.

9 As with any topic, the relation between myth and historical 'fact' is hard to determine. Even as they sang the praises of the hard-working stenographer, job counselors encouraged women to keep an eye out for a good marriage without aiming too high. The rising executive often looked outside the office to the

society girl or 'junior leaguer.' The stigma against the working girl remained intact even though the well-trained office worker was billed as a 'good wife.' It would be useful to speculate about the issues of class as well as gender that might be in evidence here, as well as in other works by Hopper.

10 'Women in Business: II,' *Fortune*, 12 (August 1935), p. 86.

11 The visible manifestations of these unresolved gender/power conflicts may also be understood as part of Hopper's own personal situation. Biographers have often contrasted Hopper's reticent and withdrawn personality with his wife Jo's effervescent one. At the expense of her own artistic career, she took over the secretarial management of his enterprise, working as his archivist and only model – giving Hopper ultimate control over her image – and she advised him during the interviews.

12 Levin, 'Edward Hopper's *Office at Night*,' p. 134.

Linda Nochlin's Lecture 'Women, Art, and Power'

Ludmilla Jordanova

To bring together women, art and power is to associate three complex and emotive terms, all of which have abstract qualities, at the same time as they evoke the quite palpable, concrete, material world. Let us examine each concept in turn, for none of them is without its difficulties.

Nochlin discusses women in a number of different senses – woman as the object of the male gaze; women as artists; women as viewers; the metaphorical associations customarily given to women; women as activists and their representation; women as studio models/objects of desire; woman as the subject matter of a number of distinct visual genres. A number of different issues are embedded in this list. Most important, I believe, is the question of the relationships between woman-as-represented and woman-as-lived. These are analytically distinct phenomena, although it is generally assumed, as Nochlin does, that they are related. Unfortunately, the relationship between the woman in the studio (woman-as-lived) and the woman who appears on the canvas (woman-as-represented) is not straightforward, so we need to address directly the problem of how such a relationship could be conceptualized. Nochlin is also interested in the woman-as-viewer, in how we, as persons in whom gender difference is internalized, see pictures of our own sex. This too is a tricky area, because we as yet know very little about the exact ways in which gender informs manners of looking. However, Nochlin signals to us the importance of these three aspects of women/ woman in relation to art and it is crucial to clarify the relationships between them.

Having identified these three aspects of women, the complexities grow. Two issues that arise out of the woman/gender theme have to be faced at this point. First, there is a tension between a concern with the female and an assertion that gender is the guiding term. It is possible to effect a reconciliation by saying that awareness of sexual difference has generally been registered through special attention being given to the feminine side of the equation. Woman is seen as other and as relative to man. Where the male is

the norm, the female constitutes the deviation. There is a good deal in such assertions, which can readily be backed up with examples drawn from Western philosophy of virtually any period beginning with the classical era. But there is also a partial truth here. The nature of masculinity has *never* been taken to be unproblematic in European culture; it, too, is subject to contest, debate and strife. After all, myths abound in which what men do is presented as questionable, of which Prometheus, a key figure in the Western imagination, is a prime example. Similarly, male authority has been relentlessly scrutinized, particularly in the period covered by Nochlin's paper, which includes the French Revolution, with its 'parricide', liberal divorce legislation and extensive female political activism. The Reformation had already raised these matters in a dramatic form with its disdain for the Pope and the priest, and its enthusiasm for new approaches to family and marriage. Furthermore, the literature of the Enlightenment relentlessly called into question the role of fathers, husbands, kings, judges, nobles and priests. I am not making any assertions here about 'how well off' women were under these regimes. Rather, I am suggesting that if we start with a strong commitment to 'gender' rather than 'women' as the key analytical term, we find that not only should both men *and* women, their experience, representation and their visual culture be considered, but also that masculinity is a contested term, in ways that are inevitably entangled with the ways in which femininity is contested.

The second issue relating to gender concerns the nature of historical change. I assume that as a discipline, art history is a branch of that larger field we call history, that it must therefore consider the fluctuating forces of continuity and change, and use the highest standards of historical scholarship currently available. Historians in general are perhaps overly committed to specificity, to always seeking out differences of all kinds, chronological, geographical, structural and so on. This search can in fact be disabling if it blinds us to perennial themes – themes that are especially important to feminist scholars trying to uncover the depth and persistence of sexual inequality. Indeed, stressing continuity is helpful, especially in highly reflexive fields like art, literature and philosophy, since they are constantly looking back and reworking, even reappropriating earlier work – processes we often feebly discuss through the ideas of 'influence' and 'borrowing'. The idea of continuity is also compelling because it seems that no societies function without a lively sense of gender, and because we further notice that there are a number of persistent motifs through which this sense of difference is expressed. Nochlin refers to one of these in her paper, namely the identification of women with nature, which has become a commonplace of modern scholarship. We can in fact use this example to illustrate the points already made about women/gender and the point I am in the process of making about history. It is the case that many societies associate women

in some way or other with nature. But, and it is a very big but, such a statement cannot stand on its own. Next to it needs to be set the fact that women are also commonly associated with civilization, refinement, culture, high sentiments, principles and feelings – terms which customarily stand in opposition to nature. It is also a fact that nature itself has no stable meaning; not only has the term changed markedly over time, but any one society or social group can simultaneously hold diverse and contradictory views of nature. It may then be true that there is a long-standing pre-occupation with sexual duality, but it is equally true that male and female are mutually defining, inherently labile, and capable of holding, simultaneously, multiple meanings in tension with each other. The same holds for nature, whether we take it as a single term or as one side of a dichotomy paired, for example, with culture. This situation implies that we must learn to be very scrupulous indeed when it comes to the historical context of both gender and of ideas of nature, and to be sceptical of claims to universality.

About 'art' in the context of Nochlin's paper I shall say less. Like all abstractions it has its pitfalls. I have two reflections on it here. First, 'art' is, of course, a composite; it comprises art practices, the objects produced, the market and education and the social groups that consume and produce it. It seems quite possible that in each of these cases gender enters in a distinctive manner. It would be particularly helpful if there were more work that traced systematically the relationships between art and gender for a specific historical case. My second reflection concerns the diversity of visual genres. In the course of her paper, Nochlin refers to nudes, history paintings, genre paintings, collages and prints, as well as a number of images that do not sit easily in established categories. Furthermore these images were produced in a number of countries over several hundreds of years. It seems possible that we will want to analyse the ways in which the subtle blend of historical and visual elements that make up distinctive types of images articulate with changing gender and power relations. In other words this is to ask about the linkages between art and power in specified settings, and it is therefore to the question of power that we must now turn.

But what is power? How can we perceive its operations, describe its effects? These have been questions pre-occupying scholars from many disciplines throughout the 1970s and 1980s, yet we are still dogged by the high abstraction and the slipperiness of the term 'power' itself. A commitment to a historical mode of enquiry entails specifying more closely both the differences between various sorts of power in a given situation, and the necessary evidential basis for understanding them and their effects. In addition it is imperative to recognize that power is never, or almost never, absolute – even under absolutist monarchies, for example, the king's power was hedged in, negotiated, conditional and contested, by elites, by other states, by financial and military considerations, by the material conditions of

life. The same holds true of gender power. Nochlin, by contrast, takes a more 'absolute' view: 'representations of women in art are founded upon and serve to reinforce indisputably accepted assumptions held by society in general . . . about men's power over, superiority to, difference from and necessary control of women' (p. 13). Such a statement forecloses complexity, by defining, rather narrowly, the nature of men's power over women. It treats such power as self-evident and undisputed. It therefore follows from her statement that certain forms of gender power are intrinsic to a society and, by the same token, to its representational practices. Furthermore, when the word 'necessary' is used, we are drawn to ideas of logical entailment. How can this be? And, what does it mean to claim that male control of females is logically necessary? Whose logic is this and what are its characteristics?

It may be helpful at this point to return to the question of history. Contingency is central to historical analysis; each moment in time is composed of disparate forces and conditions, united in part fortuitously by circumstances which can never be fully reconstructed through historical scholarship. Historians therefore pick out a few threads, and seek to unravel them, and in so doing they cultivate a vivid sense of the particularities of each situation. There is no reason why these procedures should not be applied to the study of 'power'. Some may resist this suggestion because the very word 'power' is spell-binding, serving as a magical link between vastly different phenomena. At the same time, however, historians understand each moment as issuing from a prior state of affairs. Sometimes there is indeed a logical relationship here – a fiscally weak state entering a war, with no new resources to exploit, will indeed, by inexorable logic, move towards a deep crisis, the exact nature of which appears in hindsight as an inevitable consequence of prior conditions. Viewed from the perspective of the time, on the other hand, there was a series of choices to be made, these were indeed limited, and probably none could have circumvented crisis. Any one of these avenues, in retrospect, would have seemed a logical outcome. There are numerous examples like this in the historical record, and an equal number illustrating the point about contingency. We can therefore only argue for 'men's . . . necessary control of women' if we can show that the history of gender relations is grounded in some special way in a logical relationship that differs from other historical relationships.

The *language* of power is also at issue here. In the section quoted above, Nochlin links power, superiority, difference and control. Elsewhere she speaks of mastery, strength, force, and coercion. These are indeed power-words, but they are not the whole of that vocabulary. Power also comprises fear, reverence, mystery and delight; idealization as well as degradation, blending and separation; nurturing, creation and cultivation alongside control. Power, like gender, like nature, is never univalent, never single,

always multiple, always dynamic. It follows from this that, to take a specific example, 'the clearcut opposition between masculine strength and feminine weakness' cannot be treated as a 'universal assumption' (pp. 14–15). Indeed, at the very time that David was painting, medical writers were considering women's greater longevity and their superior pain-bearing capacities, and, these very same writers also entered the universe of the *Oath of the Horatii* by claiming that women were, in a variety of ways, 'weaker' than men. This reveals, not a universal assumption, but a degree of common ground in the representational practices in the period *and* the diversity of those practices even within a single text. Of course, this same society also assumed that working women were capable of extreme physical labour, and it actually contained extensive physical abuse between men and women, although women's violence against men was not necessarily of the same kind as that of men against women. This point bears directly on our analysis of languages of power.

Let us be explicit about the centrality of language here. Nochlin talks about 'disentangling various discourses about power' (p. 14) and she further makes it clear that metaphorical extensions of ideas of power are central to the effectiveness of images like David's. She also implies that these discourses are linked to women's experiences, as artists and models, for example. Although such discourses cannot be read in *any* way, they are excessively fertile in the meanings that they can hold. It should be taken as read that metaphors are central to power as it is actually deployed – consider for example the panoply of symbolism employed by absolute rulers as both a source of metaphors to buttress their position and as a real justification of their power. No social group has ever successfully contained, predetermined or fully controlled such language, however. While, according to Nochlin, it may be in men's interests for David to represent women as flaccid, relaxed and resigned, where men are energetic, tense and con-centrated, this does not prevent his contemporaries also representing them as resilient and tenacious, or as uncontrollable and wild, or as the source of social stability, or as soft, or as imaginative, or as intellectually limited, as duplicitous and so on. Languages, and societies, just work like that. We can find women represented in all the above ways in images and writings of David's period. I conclude from this first of all that we must give up claims about universality, and also that global terms like 'patriarchy' have limited analytical value. I further conclude that we will never perceive the patterns in the diverse ways of representing gender until we routinely examine the representation of men as closely as that of women, until we put gender in the context of age, class and race, since these inter-relate in formidably complex ways, until we root all these issues in specific historical locations. Let me give a specific example.

Nochlin contrasts Black Anna, as represented by Kollwitz, with Liberty

as represented by Delacroix. Of course, this is to compare two very distinct types of image, but more important for our present purpose are two remarks Nochlin makes in the subsequent discussion. First: 'For the sixteenth century, as for the nineteenth, the most potent natural signifier possible for folly and chaos was woman unleashed, self-determined, definitely on top: this was the only image sufficiently destructive of "normal" power relations, rich enough in negative significations, to indicate the destruction of value itself' (p. 35). Folly and chaos are quite distinct, since folly can be the privileged state of insight and wisdom, the indicator of special genius as it was commonly in the sixteenth, seventeenth and eighteenth centuries. We cannot assume that 'folly' means the same in different historical periods, nor that its gender associations remained stable. By the nineteenth century, madness had been classified and institutionalized; producing very different and quite specific gender associations from those of the sixteenth century. 'Women on top' are quite another matter, since this phrase refers to ritual reversals of a hierarchy that stayed firmly in place and hence was not threatened. If we want to look for anarchy in the nineteenth century, we find it in the mob, the crowd, the political collectivity, which are far from being understood in exclusively feminine terms. Fear of chaos often takes on highly specific forms as the nature of popular protest and reactions to it amply testify. Images of chaos derive from the social dynamics of the time, not directly, but through the salient features of disequilibrium that elite groups react to, often those traits which touch them most deeply. These are naturally linked to what is found most threatening at that moment, and, in nineteenth-century Europe and America at least, this is likely to be an amalgam of gender, race and class. Similarly, the representation of folly/madness has its own historical dynamic.

Secondly, and also in connection with Kollwitz, Nochlin states: 'The dark, chthonic force associated with the peasant woman, those malevolent, sometimes supernatural powers associated with the unleashing of feminine, popular energies and not totally foreign to those most menacing of all female figures – the witch – here assumes a positive social and psychological value' (pp. 35–6). The peasant woman was indeed for some nineteenth-century writers and artists a figure to be feared, but for others she was to be revered, as the mainstay of a valued rural community, as 'the salt of the earth'. It was rarely peasant women, however, who unleashed popular energies; these were much more to be feared from urban artisans and factory workers. It was common to praise the peasant woman for her productive powers and for her simple virtue. The case of the witch is altogether different. During the principal period of concern about witches (sixteenth and seventeenth centuries), many different images of witches existed, reflecting the diversity of people prosecuted. It seems that on average about eighty per cent of those prosecuted were women, usually older ones, and that in addition to a

sizeable number of men, there were also considerable numbers of children involved. The idea of the woman as witch/seductress, although clearly in place in the early modern period, does not seem to have been linked to witches themselves. By contrast, in nineteenth-century Europe considerable literary and artistic attention was paid to the witch, who, not surprisingly, has taken on many new attributes – young, erotic, naked. This was particularly true in Germany, where there was a veritable explosion of artistic interest in witchcraft. We could locate Kollwitz in this context, of her own society's pre-occupation with femininity and witchcraft, since there is no enduring figure of 'the witch' but several different ones, which served quite distinct purposes. It will, I think, greatly enhance our understanding of gender relations and their associated representational practices if we can chart the variety of uses to which 'the witch' has been put, by woman as much as by men.

I am not denying the importance of the project Nochlin has so persuasively laid out, both here and in her other work. To link gender, art and power and to explain the force of the association are surely among the most important tasks historians in general and art historians in particular can undertake. The results will be more exciting and important if this is a fully historical enterprise. That it must be a feminist enterprise goes without saying. Yet, it remains unclear what route feminist scholarship should take here. The lack of settled answers is one reason why feminism has brought not only to art history but all the humanities and social sciences disciplines a new impetus that is both theoretical and empirical. A challenge of such magnitude will be met only slowly and gradually, by constantly refining terms of analysis and broadening terms of reference. Much still depends on our initial assumptions about the nature of gender, and it is always necessary to be quite open about these. I have tried here to comment on Nochlin's paper in such a way as to bring out some of the different assumptions we can deploy, and, in so far as this is possible, to be honest about my own.

2

SEMIOLOGY AND VISUAL INTERPRETATION

NORMAN BRYSON

IN this essay I want to sketch the outlines of a semiological approach to painting. Semiology approaches painting as a system of signs. The emphasis on *sign* may seem odd, but what this term in the first instance displaces is the term *perception*. The idea of painting as the record of a perception may be historically recent. Reynolds in the *Discourses*, for example, urges painters to rise *above* mere perception, and by abstraction to derive from perception its central forms, and to paint those. The hierarchy of genres gives pride of place to painting that sheds the particularity of perception in favour of the ideality of averaged or abstracted forms (in 'the grand manner'): the discarding or 'scraping away' of perception is regarded as the precondition of high art. But in Ruskin's *Modern Painters* painting is consistently approached *from* perception. Turner's paintings are said by Ruskin to record how Turner perceives what is there: some paintings by Turner may look 'visionary' – deviating from what is there – but, Ruskin argues, they are actually grounded in a perceiving consciousness 'on the heights' (yet perceiving clearly from those heights). Ruskin's commitment to this principle gets him into some famous knots. He notices, for example, that Turner often uses the same device for depicting a particular motif, say, a bridge. Ruskin argues that each new bridge Turner sees and paints reminds Turner of previous bridges he has seen, and that Turner's new perception of a bridge brings with it the train of all the bridges Turner has previously perceived: what is painted, Ruskin alleges, is the entire chain of associated perceptual memories in articulation with the new perception.[1] *That* is why Turner's bridges tend to look alike: because of their concatenation of perceptions; not because – as one might far more economically say – this is just Turner's way of painting bridges. Old concepts such as 'invention', 'manner' or 'central form' are transposed and re-expressed as the consequences of perception. This seems to be the dominant strategy of *Modern Painters*, a work which indicates how fully fledged a 'Perceptualist' account of art could be, in 1843.

To place the forms of painting in relation to a psychology of perception is a familiar move among 'the Critical Historians of Art'. Michael Podro has described for us the way that Hildebrand's *Das Problem der Form in der bildenen Kunst* (1893) accounts for artistic form as the structuring of (formless?) *experience*, analysed in terms of sensorium (optical and tactile registers in interplay). 'Optical' and 'tactile' have important work to do in Wölfflin's *Grundbegriffe* (1915), and Riegl's *Spätromische Kunstindustrie* (1901). Panofsky's third, iconological level of meaning – though for us it may throw the gates open to 'context' when we consider works of art – seems in the argument to reduce whatever may lie beyond the second, iconographic level to the psychology of an epoch.[2]

This tradition is still vigorous, notably at the point where German and English aesthetics meet, namely in Gombrich. *Art and Illusion* (1960) has had, in its own time, a centrality and inevitability comparable to Reynolds' *Discourses* in the late eighteenth century.[3] Gombrich's approach to art by way of a psychology of perception is fortified by twentieth-century cognitive psychology, as well as the 'making and matching' model taken from Popper. In a sense this work is the climax of the 'Perceptualist' tradition. Painting is viewed *principally* as the mimesis of perception, modified by a schema. The semiological perceptive questions this mimetic model by giving emphasis to the term *sign* rather than to *perception*; from this move follow a number of consequences.

It is still almost natural for us to think of painting as in some sense, if not completely, the record of perception, perception which – if we follow Gombrich on this point – is variously conditioned by the previous representations of perceptions that come to the artist from his or her tradition. Our ordinary assumptions here owe much to Gombrich, and it is not out of place to clarify some of the thinking we almost take for granted when we picture to ourselves what is involved when the representational painter sets out to create a painting. The thinking, as Gombrich is the first to point out, models itself on a certain understanding of observation in science. First there is an initial problem, which science intends to explore. A trial solution is proposed, in the form of the hypothesis most appropriate to the problem and the one likeliest to lead to the problem's solution. An experimental situation is devised in which the strengths and weaknesses of the hypothesis can be submitted to falsification. The resulting situation reveals new problems the existence or importance of which were not apparent at the commencement of the process. And so scientific observation continues, constantly testing its hypotheses against the observed world, and re-testing its scheme of things against perceptual disclosure.

In *Art and Illusion* Gombrich characterizes the work of art along just these lines: as a continuous development consisting in what he calls the 'gradual modification of the traditional schematic conventions of image-making

under the pressure of novel demands'. The pattern for art is the same as that for science. First there is the initial problem: Giotto, for example, sets out to record the appearance of the human face. Tradition suggests a particular formula or schema for its transcription onto canvas; let us imagine that it is an early Giotto where the influence of Cimabue is strongly felt. Giotto tests the schema against observation of the face. Observation reveals that here and there the Cimabue-schema is inadequate to the perceptual findings, and that the schema must be modified in accordance with the discrepant data. The modified schema in turn enters the repertoire of schemata and will in due course be subjected to similar tests and elaborations as its predecessor.

This conception of image-making, with its key terms of *schema*, *observation* and *testing*, can be called the Perceptualist account, because the essential transaction concerns the eye, and the accommodations the schema must make to new observations coming into the eye. The viewer, for his or her part, is defined by this Perceptualist account as performing an activity where those terms re-appear in more passive guise: the viewer confronting a new image mobilizes the stock of perceptual memories, brings them to the new work for testing, and the visual schemata are in turn modified by the encounter between the new image and the viewer's gaze. And if we stand back a little and begin to ask questions of the Perceptualist account we will find that, crucially, it leaves no room for the question of the relationship between the image and power.

The account exhausts itself in a description of image-making that omits or brackets the social formation, for in the Perceptualist account the painter's task is to transcribe perceptions as accurately as he can, just as it is the viewer's task to receive those relayed perceptions as sensitively as possible, and with minimal interference or 'noise'. The painter perceives and the viewer re-perceives, and the form which unites them is a line of communication from one pole, replete with perception, the painter's vision, to the other pole, the viewer's gaze, eager for perception. The image is thought of as a channel, or stream of transmission, from a site dense in perception to another site, avid for perception. And if social power features anywhere, in this picture of things, it is as something which intervenes between the two sites or poles, which interposes itself and makes demands of another kind.

Power, social and political power, may utilize this channel and its object of perceptual transmission, the image, in various ways and according to its own ends. Its intervention may be construed as a positive and supportive nature, as when for example an individual or an institution – the patron, the Church – economically enables the painter to carry out his work. Or the intervention by social and political power may be of a negative and subtractive nature, appropriating the image to a particular ideology, of the

Church, the State, the patron class. But either way the place of power is on the outside of this inward perceptual activity of painting and viewing. Power seizes, catches hold of, expropriates and deflects the channel of perception that runs from painter to viewer; perhaps it enables, supports, maintains, finances that channel; but however we view it, power is theorized by the Perceptualist account as always outside this relay of the visual image. Power is an external that moves in, and the forcefulness of power is measured by the degree to which it penetrates and overtakes the private transmission of percepts, where the essence of power manifests exactly in its exteriority.

Built into the Perceptualist account, whose fullest statement is Gombrich's *Art and Illusion*, is the idea of power as alien to the making of images, and accordingly a direction of enquiries into the relation of power to the image, *away* from the canvas and into institutions *outside* painting. Yet the connections between the image and power become instantly mysterious, for one is by definition outside the other: both are positioned in a mutual exteriority. A mystic simultaneity arises in which it can become acceptable practice to draw up two separate but nevertheless darkly inter-related columns, one of social events, and one of paintings painted. Clearly this 'two-column' approach is inadequate, so let us go back to the fundamentals of image-making and this time examine it from the other side – from the viewer's gaze.

It may indeed be the case when I look at a particularly life-like representation, I, the viewer, re-experience at one remove the original vision, retinal or imaginary, of its creator, the artist. There *might* be absolute congruence between the two mental fields of artist and spectator. Yet the recognition of a painting can hardly involve such congruence as a necessary criterion. While it might be possible for the painter to know that the image corresponds to his or her original vision or intention, no such knowlege is available to the viewer. Recognition, here, is not at all an act of cross-comparison between two mental fields, or cross-referral of perceptions from one end of the channel to another. It might well be true that when I look at a particular canvas I obtain a set of perceptions I can obtain from *this* canvas and no other, but the set of perceptions in the viewing gaze cannot of itself provide criteria of recognition. This is clear enough if we think of sign-systems other than painting. With mathematics, for example, I may have a vivid picture in my mind of a certain formula, but the criterion of my knowing that the picture was a *formula*, and not simply a tangle of numbers, would be my awareness of its mathematical application. The test of whether or not I had understood the formula would not consist in the examination of my private mental field, or even the comparison between my mental field and its counterpart in the mind of whoever produced the formula, but in seeing if I could place the formula in the general context of my knowledge of

mathematical techniques, in my ability to carry out related calculations, and so forth: in short, in my executive *use* of the formula.

Again, in the case of a child learning to read, it is hard to determine the sense of the question, 'Which was the first word the child *read?*' The question seems to appeal to an inward accompaniment to the physical progress of the eye through the chain of characters, an accompaniment which at a particular point takes the form of a 'Now I can read!' sensation. Yet the criterion for right readings cannot be this. The child might indeed have such a sensation, yet be quite unable to read correctly; where reading, like the activity of mathematics, and like the recognition of an image, can be said to take place only when the individual is able to 'go on'; not to reveal to the world a secret event of the interior but to meet the executive demands placed upon the individual by his or her world.[4]

I hope the implications are becoming clear. Perceptualism, the doctrine whose most eloquent spokesman is undoubtedly Gombrich, describes image-making entirely in terms of these secret and private events, perceptions and sensations occurring in invisible recesses of the painter's and the viewer's mind. It is as though understanding in mathematics had been reduced to the occurrence of 'Now I see it!' experiences, or the test of whether or not someone read aright were whether he or she experienced a 'Now I can read!' sensation. The point is that mathematics and reading are activities of the sign, and that painting is, also. My ability to recognize an image neither involves, *nor makes necessary inference towards*, the isolated perceptual field of the image's creator. It is, rather, an ability which presupposes competence within social, that is, socially constructed, codes of recognition. And the crucial difference between the term 'perception' and the term 'recognition' is that the latter is *social*. It takes one person to experience a sensation, it takes (at least) two to recognize a sign. And when people look at representational painting and recognize what they see, their recognition does not unfold in the solitary recesses of the sensorium but through their activation of codes of recognition that are learnt by interaction with others, in the acquisition of human culture. One might put this another way and say that whereas in the Perceptualist account the image is said to span an arc that runs from the brush to the retina, an arc of inner vision or perception, the recognition of painting as sign spans an arc that extends from person to person and across *inter-individual space*.

A changeover from the account of painting in terms of perception to an account of painting as sign is nothing less than the relocation of painting within the field of power from which it had been excluded. In place of the transcendental comparison between the image and perceptual private worlds, stand the socially generated codes of recognition; and in place of the link, magical and illogical, that is alleged to extend from an outer world of things into recesses of inwardness and subjectivity, stands the link

extending from individual to individual as consensual activity, in the *forum* of recognition. The social formation isn't, then, something which supervenes or appropriates or utilizes the image so to speak *after* it has been made: rather painting, as an activity of the sign, unfolds within the social formation from the beginning. And from the inside – the social formation is inherently and immanently present in the image and not a fate or an external which clamps down on an image that might prefer to be left alone.

So far I have been addressing Perceptualism, the notion that artistic process can be described exclusively in terms of cognition, perception, and optical truth. What Perceptualism leads to is a picture of art in isolation from the rest of society's concerns, since essentially the artist is alone, watching the world as an ocular spectacle but never reacting to the world's meanings, basking in and recording his perceptions but apparently doing so in some extraterritorial zone, off the social map. Perceptualism always renders art banal, since its view never lifts above ocular accuracy, and always renders art trivial, since the making of images seems to go on, according to Perceptualism, out of society, at the margins of social concerns, in some eddy away from the flow of power. But one need not think this way: if we consider painting as an art of the sign, which is to say an art of discourse, then painting is coextensive with the flow of signs through both itself and the rest of the social formation. There is no marginalization: painting is bathed in the same circulation of signs which permeates or ventilates the rest of the social structure.

This said, I think it equally important to address what might appear to be the opposite extreme, the position which says that art is to be approached in terms of social history, that art belongs to the superstructure and that the superstructure cannot be understood without analysis of the social, and in particular the economic, base. You might perhaps have supposed that in the claim for the immanently social character of the sign, a social history of art was necessarily being advocated, but that doesn't follow in any simple sense, and the reason it doesn't is once again that a strict economism is no better placed than Perceptualism to follow through the implications of what it means when we begin to think of paintings as signs.

The essential model here is inevitably that of *base* and *superstructure*. Taking the base-structure as consisting of the ultimately determinant economic apparatus of the society, and assuming the unified action of productive forces and relations of production, then 'art', alongside legal and political institutions and their ideological formations, is assigned firmly to the superstructure. If we want to understand painting, then first we must look to the base, to the questions of who owns the means of production and distribution of wealth, to what constitutes the dominant class, to the

ideology this class uses to justify its power; and then to the arts, and to painting, as aspects of that legitimation and that monopoly.

The problem here is in interesting ways the same problem as that created by Perceptualism, because the question that needs most urgently to be addressed to the base–superstructure model is: In which tier of the model should we place the *sign*? Social history, in this view, is the expression in the superstructure of real, determinant events occurring in the economic base; legal institutions, political institutions, ideological formations, and among these the arts – and painting – are said to be secondary manifestations or epiphenomena of base action. Very well. But where shall one allocate the sign? Does the sign belong above, along with ideology, law, and other derivations? Or is it primary, down there next to the technology, the plant, the hard productive base?

It is indeed a crucial question. In the extreme statements of base–superstructure thinking, signs are no more than the *impress* of base on superstructure. The sign follows the base without deviation, which is also to say that the base *determines* discourse, that discourse takes its patterns from power and repeats them in another key, the key of ideologies. Signs, and discourse, are assumed to accept the impact of the material base as wax accepts the impress of a seal. The sign, and discourse, and painting as a discursive art, are the *expression* of the given reality, and, so to speak, its negative profile. First there is the original matrix of economic reality, then out of that matrix there appears the *inscription*, the writing into art of what is happening in the base. But as soon as this picture is fully drawn in we can see how difficult it is to understand how the model is to work in practice. The base–superstructure conception posits a material base that of *itself* engenders the sign, at its every point of change. The picture proposes a mystery of spontaneous generation of signs directly out of material substance. Yet it is clear that the economic or material base never *has* produced meanings in this uncanny sense; the world does not bear upon its surface signs which are then simply *read* there. And while the base–superstructure model may *seem* to lead to a social history of art, and to concede the social character of the sign on which I was earlier laying stress, in fact the iron-clad pronouncement that the sign belongs to the superstructure omits its social history. It is in matter – in the prior contour of material reality – that the sign is said to arise, as its negative relief, or stencilled echo. Yet the sign's *own* materiality, its status as material practice, is sublimed or vaporized just as drastically as in the Perceptualist account. The global body of signs – discourse – is said to be part of the cloud of ideas and ideologies hovering over and obscuring the real material base, as though discourse were the transcendental accompaniment, floating and hazy, to a real material world. What the economist position is forced to deny is that the sign, that discourse, is material *also*, and as

much entails material work and elaboration as the activities of the alleged base.

In the case of painting, the material character of the sign is far more evident than it is in the case of language, and it is therefore perhaps easier to think of the image in non-idealist terms, than it is to think of the word in non-idealist terms. The problem here is that although the material character of painting cannot be ignored, that materiality tends to be equated with substance, pigment, with the brush and the canvas. And if one sets side by side the picture of a factory turning out machines, and a studio turning out paintings, then it will seem as though all the power is in the factory and none in the studio, and that the social history of art must first describe the hard reality of production, ownership, capital, and dominant and dominated classes, and then trace the repercussions of this hard reality in the *atelier*. Once again, painting is off the map, or at least relegated to the margin, just as it was in Gombrich. But figurative painting isn't just the material work of brush and pigment on canvas. Non-figurative painting may tend in that direction, but for as long as the images one is dealing with involve recognition, for as long as they are *representations*, then they are material signs, and not simply material shapes. And as signs, as complex statements in signs and as material transformations of the sign, paintings are part of a flow of discourse traversing both the studio and the factory.

Discourse doesn't appear spontaneously out of matter: it is the product of human work and human labour. It is an institution that can't be simply derived from the alleged economic base. Like economic activity, discursive activity is nothing less than the transformation of matter through work, and though the economic sphere and the discursive sphere may interact, and in fact can hardly be conceived outside their interaction, to think of discourse as a floating, hazy, transcendental cloud hovering above the machinery amounts to a mystification of the material operation of ideology. To put this another way: to theorize the image as a nebulous superstructural accompaniment to a hard and necessary base is to deny the institution of discourse as a cultural form which interacts with the other, legal, political, economic forms in the social world.

The crucial reformulation here involves breaking the barrier between base and superstructure which in effect places the sign in exteriority to the social formation – an exteriority that merely repeats, in a different register, the Perceptualist separation of the image from social process. What is needed, then, is a form of analysis sufficiently global to include within the same framework *both* the economic practices which Historical Materialism assigns to the base, *and* the signifying practices which are marginalized as superstructural imprint. And the topology must be clear. The base–superstructure model can't easily cope with the question of the sign, and the problems that arise as soon as one tries to work out which tier of the model

the sign is supposed to fit into are enormous. The difficulties make clear the need for a form of analysis in art history dialectical enough, and subtle enough, to comprehend as *interaction* the relationship between discursive, economic and political practices.

In discussing the visual arts at the moment the need is, I think, an urgent one. In one vigorous theorization of painting – Perceptualism – the social formation has little part to play except as intervention or utilization. The inherently social character of the painterly sign is eclipsed by the picture of the artist alone in the studio, immersed in the privacy of perceptions, the only link with the outer world consisting of optical contact with the surface of things, and the only major difficulty being the accommodation of the schema to the influx of new sensations. In Historical Materialism the same sequestration of art from the public domain is reinstated, for although the social history of art wants the *atelier* to come into contact with the rest of society, the contact can now be seen as *narrowly* economic. Out there, in the social base, an economic apparatus is generating dominant and dominated classes, is organizing the means of production and distribution of wealth, and is forging the determinants over the superstructure. In here, in the hush of the studio, the painter passively transcribes on to canvas the visual echo of those far-off events. Or let us say that economic determination is less ambitious, and that it examines instead the more local relation that exists between the painter and his patron or patron-class. This is certainly an improvement on Perceptualism's relegation of the painter into social limbo, and hardly less of an improvement on the attempt by a dogmatic Historical Materialism to transform the painter into an echo of the distant rumble of history. The lines of capital that link the painter to his patron or patron-class are real and of enormous importance. But they are not the only lines that link the painter to the rest of the social world, for there is another flow that traverses the painter, and the patron class, and all those who participate in the codes of recognition: the flow of signs, of discourse, of discursive power.

It is a flow in two directions, for the painter can work on the discursive material, can elaborate it, transform it through labour, and return it to the social domain as an alteration or revision of the society's discursive field. I stress this because neither Perceptualism nor the economism underlying the 'two column' social history of art has much to say about creativity, or innovation, or more simply (and perhaps more accurately) the *work* of the sign. If the task of the artist is, in Gombrich's words, the 'modification of the schema under the pressure of novel [visual] demands', then the effort of image-making consists in making and matching against what is already and pre-existently there. The problem for the image becomes a matter of catching up with reality, of discarding those elements within the schema that occlude the limpid registration of the world. The image doesn't have

the power to inaugurate, to commence, to molest the given structures. And again with a strict economism in its full, base–superstructure expression, the image can only at best repeat the larger and truer events of history. Capital flows into the *atelier*, power flows in, but the flow is in one direction, and it becomes difficult, if not impossible, to conceive of the reverse of this process, in which the image could be seen as self-empowered and out-flowing, or as an independent intervention within the social fabric.

A virtue of considering the visual image as sign is that having relocated painting within the social domain, inherently and not only as a result of its instrumental placing there by some other agency, it becomes possible to think of the image as discursive work which returns into the society. The painter assumes the society's codes of recognition, and performs his or her activity within their constraints, but the codes permit the elaboration of new combinations of the sign, further evolution in the discursive formation. The result of painting's signifying *work*, these are then recirculated into society as fresh and renewing currents of discourse. The configuration of signs which constitutes a particular image may or may not correspond to configurations in the economic and political spheres, but it need not have first been read there, or match events which only by an act of arbitrary election are privileged as the truth of social history.

It is usually at this point that one encounters the objection that the power of the image to intervene in the social fabric is severely limited, that the image possesses in-built strategic inadequacies, and that unless images articulate their local acts of innovation with the stronger, the major movements and activities within the social formation, they are insignificant (where that word operates as a term of quantity, a measure of instrumental efficacy). No one is so misguided or so out of touch as to claim otherwise. If we think of even revolutionary moments in painting, the impact of the image on its surrounding world may seem hopelessly curtailed. Géricault's portraits of the mad did nothing to modify the juridical status or treatment of the insane; nor did the appearance of *Olympia* at the Salon of 1865 do much, so far as we can tell, to change the interesting nocturnal economy of Paris. Yet this is only a truth of logistics, of *administration* of the image. The danger is that this obvious truth of instrumental inadequacy conceals, makes it difficult to think through, a subtle and more important truth, of topology.

Instrumentally, an *Olympia* at the Salon of 1865 may do little to affect the status of prostitution; but the essential point is that its juxtaposition of Odalisque and Prostitute, or Géricault's elision of the social fixity of the portrait with the social placelessness of the insane, these collisions of discursive forms occur *within* the social formation: not as echoes or duplicates of prior events in the social base that are then expressed, limpidly, without distortion, on the surface of the canvas; but as signifying *work*, the effortful and unprecedented pulling away of discursive forms,

away from their normal locations and into *this* painting, *this* image. To look for a result in the form of a change in the base, or in the political sphere, is once again to assume that it is only there, in those arbitrarily privileged zones, that 'real' change happens. If your politics are such that the only changes you recognize are those which take place in the economic sphere, and all the rest are mere swirlings in the cloud of superstructure, then you will not find a painting a particularly interesting or forceful instrument. And this will be because power is located exclusively in agencies other than discourse: in capital, in the factory, in the production and distribution of wealth. The only revolution and indeed the only change that will then be recognized is in those limited spheres privileged by the analysis. Either too narrow or too ambitious in its sense of social change, a dogmatic Historical Materialism will miss where the power *is* in discourse, and in painting. In fact it will be found in every act of looking, where the discursive form of the image meets the discourses brought to bear upon the image by the viewer, and effects a change; where in order to recognize the new discursive form that is the image, the existing boundaries of discourse, the categories and codes of recognition, must be moved, turned and overturned in order to recognize what this image is, that is at once Odalisque and Prostitute, socially fixed by the portrait and socially displaced as insanity. If power is thought of as vast, centralized, as a juggernaut, as panoply, then it will not be seen that power can also be microscopic and discrete, a matter of local moments of change, and that such change may take place whenever an image meets the existing discourses, and moves them over; or finds its viewer, and changes him or her. The power of painting is there, in the thousands of gazes caught by its surface, and the resultant turning, and the shifting, the redirecting of the discursive flow. Power not as a monolith, but as a swarm of points traversing social stratifications and individual persons.

These remarks on the 'swarm of points' lead to the last semiological position in this paper, which concern the sign as *project*.

One might usefully draw a distinction between *classical* and *projective* models of sign activity. A 'classical' conception (e.g. Port Royal, Saussure) of the sign gives it two halves: a meaning, and the thing which carries the meaning. The meaning of a word may be, for example, the idea I have in my mind when I use that particular word. The idea exists in some degree of separation from the word itself; the idea is anterior to its expression. But it is a characteristic of signs that are given some permanent or notational form (a text, a painting, etc.) that the signs are able to travel away from the context of their making both in space and in time, without ceasing to be signs. Such objects as texts or paintings are structures governed by 'dissemination'. They enter contexts other than the context of their emergence. But even in that first context (for example, the Salon of 1865), the sign acquires its meaning from an interpreter. That is, its meaning comes *to* the sign *from* the

place it projects itself forward to, or 'lands' in. Until it completes this projection, so the argument runs, it is not *yet* a sign, not even 'half' a sign. Which gives to writing about art a double mandate: it is both archival and hermeneutic.

The first of these is the mandate which governs most art history at the present time: to trace the painting back to its original context of production. Yet the context may now have to be defined in a new way. It cannot be thought of simply as the circumstances of patronage or commission (important though such factors most certainly are) nor as the conditions of original perception and its notation. Original context must be considered to be a much more global affair, consisting of the complex interaction among all the practices which make up the sphere of culture: the scientific, military, medical, intellectual and religious practices, the legal and political structures, the structures of class, sexuality and economic life, in the given society. It is here, in the interactive sphere, that one would locate the theoretical position of, for example, Mukarovsky, or the work of Svetlana Alpers and Michael Baxandall, among others.[5]

The second, hermeneutic mandate arises from the fact that the sign projects itself historically: it throws itself forward in space and time. Let us say that it survives into a much later period. Its interpretation will now be governed by two historical 'horizons', 'then' and 'now'; but the 'then' is only known as it arises within the 'now', and one must accept this fact – which is simply the fact of living in history. Signs are subject to historical process; their meaning can never escape historical determinations. This gives to thinking and writing about signs a necessary mandate to *go on* interpreting works of art beyond the context of their making. To insist that interpretation attempts exclusively to reconstruct a 'period' response amounts here to a negation of the sign's projective character. As Keith Moxey has put it,

> The focus of the 'intention' of the work of art assigns it a 'terminal' role in the life of culture, a location representing a synthesis of ideas current in the culture of the patron or patrons who commissioned it. It ignores the life of the work of art after it has entered a social context. By concentrating on the way in which the work of art 'reflects' the life of its times, the pre-occupation with 'intention' fails to recognise the function of the work of art in the development of cultural attitudes and therefore as an agent of social change.[6]

But if we open the work of art fully to the present, does this mean *anarchy* of interpretation? The question may be newer to art historians than it is to literary critics, who have faced the 'anarchy' issue several times (Wimsatt and Beardsley on 'intention'; Barthes, *Critique et vérité*; Derrida, *Of Grammatology*).[7] There seem to be about three positions: to separate 'original

meaning' from 'subsequent interpretation', usually in order to privilege the former; to assume the position that 'dissemination' *is* anarchic (arguably Derrida's viewpoint); and to claim that anarchy of interpretation cannot arise, because interpretation is always bounded by a specific historical horizon, forms of life, and institutions of interpretation. However, the semiological approach is at this point not so much prescriptive as descriptive. It accounts for what we are already doing, rather than what we should be doing, when we interpret. If one chooses to separate 'original meaning' from 'subsequent interpretation', this is because one's historical horizon, forms of life, and institutions of interpretation enjoin one to do so; if we choose to dissolve the distinction between 'original meaning' and 'subsequent interpretation', it will be for the same reason. What we do and will do when we interpret is a matter, in other words, entirely in the domain of *pragmatics*.

Notes

1 John Ruskin, *Modern Painters*, London, 1856, vol. 4, pp. 26–31.

2 Adolf Hildebrand, *Das Problem der Form in der bildenen Kunst* (1893), 3rd edn, Strasbourg, 1901; Heinrich Wölfflin, *Kunstgeschlichtliche Grundbegriffe: Das Problem der Stilentwicklung in der neueren Kunst*, Munich, 1915; Alois Riegl, *Spätromiche Kunstindustrie* (1901), Vienna, 1927; Erwin Panofsky, Introductory chapter to *Studies in Iconology: Humanistic Themes in the Art of the Renaissance* (1939), reprinted New York, Harper and Row, 1962.

3 E. H. Gombrich, *Art and Illusion: A Study in the Psychology of Pictorial Representation*, 2nd edn, Princeton, Princeton University Press, 1961.

4 On the examples of understanding a mathematical formula and learning to read, see Ludwig Wittgenstein, *Philosophical Investigations*, 3rd edn, trans. G. E. M. Anscombe, New York, Macmillan, 1953, esp. paragraphs 186–90, 156–71.

5 Jan Mukarovsky, 'Art as Semiological Fact,' in *Calligram: Essays in New Art History from France*, ed. N. Bryson, Cambridge, Cambridge University Press, 1988; Svetlana Alpers, *The Art of Describing: Dutch Art in the Seventeenth Century*, Chicago, University of Chicago Press, 1983; Michael Baxandall, *Painting and Experience in Fifteenth Century Italy*, Oxford, Clarendon Press, 1972.

6 Keith Moxey, 'Panofsky's Concept of "Iconology" and the Problem of Interpretation in the History of Art,' *New Literary History*, 17 (Winter 1986), p. 271.

7 W. K. Wimsatt and Monroe Beardsley, 'The Intentional Fallacy,' in *Literary Intention*, ed. David Newton-De Molina, Edinburgh, Edinburgh University Press, 1976, pp. 1–13; Roland Barthes, *Critique et vérité*, Paris, Seuil, 1966; Jacques Derrida, *Of Grammatology*, trans. Gayatri Spivak, Baltimore, The Johns Hopkins University Press, 1976.

Reflections on Bryson

Stephen Melville

Over the past several years, Norman Bryson has emerged as one of the most distinctive and powerful voices urging a more active interplay between literary theory and art history, and his essay, 'Semiology and Visual Interpretation,' offers a certain programmatic emplotment of that interplay. In this essay I would like to address both the particular program Bryson lays out and the more general question of the pressures, promises, and risks arising at the interface of literary theory and art history.

Recent work in art history by figures as diverse as Bryson, Alpers, Baxandall, Clark, Fried, and Krauss testifies amply to the real interest literary theory can have for art history, and it is clear that the project of the Institute arose in considerable part from an awareness of this interest and with a desire to explore it more fully and systematically. At the same time, it seems to me an important fact about the Institute's exploration that it did not constitute itself first of all as a methodological investigation predicated on primary reading in the texts of theory: we did not see ourselves as inquiring into the prospects of a Lacanian or Derridean or Foucauldian or semiotic art history. Instead, we were organized to a high degree as an inquiry into the existing foundations of the discipline, and our excursions into explicit theory were ordered by their pertinence to such an inquiry – a proceeding with which, it should be noted, the participants were not always entirely happy.

This proceeding did have at least one great strength, and that was to emphasize the very 'foundedness' of art history. This can unfold into a further awareness of the degree to which the study of literature and the study of the visual arts as both have emerged in the United States are not symmetrical activities. This dissymmetry is perhaps marked already in the relative distance between the literary work and most discussions in aesthetics, as well as in our ordinary tendency to take the phrase 'work of art' as referring in the first instance to works of visual art,[1] but the feature that most interests me here is the contrast between a field of study that has been

more or less able to develop within an assumption of the non-problematic and permanent availability of its objects and a field that comes into existence only through an explicit work of argument and reflection that produces both an object and an account of its availability.[2] Although recent years have seen a considerable focus within literary studies on a critique of the constitution of the field itself, this critique has been, by and large, confined to institutional analyses and has not been able to cast itself at the level of, for example, Michael Podro's *The Critical Historians of Art*.[3]

If we take a somewhat nearer and more concrete view, we may be struck by the difference between the 'new critical' efforts to secure the study of literature and the struggles that went into the founding of art history. I. A. Richards and others could take for granted that there was literature, that the specification of it as 'English' posed no special problems, and that the historical availability of literature for study was simply a fact; what needed showing was that there was a form of language use deserving of serious study in the face of strong positivist and scientizing claims to the contrary. A certain image of science played a crucial role in shaping modern literary criticism and history, and this image seems in some ways still at work within the field's aspiration to 'theory.' Art history is hardly immune to such aspirations – no field of study now can be – but its founding terms owe much more to struggles with a very different philosophic past, a past it interestingly shares to a high degree with at least certain of the continental tendencies that have fueled the emergence of literary theory.[4]

I begin with these general claims because I think the encounter between literary theory and art history poses questions not simply about the pertinence of one or another body of materials to the two fields but also about the shape of the fields themselves. Moving too quickly to apply the apparent achievements of literary theory to art history may result in covering over more important questions about the structure of inquiry itself; more particularly, the move to absorb art history into semiology may pull the field away from a developed sense of objectivity that is one of its central strengths and which may have within itself the resources to mount a serious and valuable critique of certain tendencies in literary studies.[5]

Bryson's lecture follows a pattern that runs through his published work and in which the appeal to literary-theoretical models is motivated by a considered unhappiness with Gombrichian 'Perceptualism.' The power of the semiological model is taken to lie in its ability to question, radically, a mimetic model of art, painting above all (Bryson usually takes off from the notion of the image as an 'Essential Copy'). What interests me here is neither the accuracy of the critique nor the power of the consequences Bryson draws (both of which are considerable), but the choice itself of such a starting point. Certainly, if one approaches the question of art history from either a concern with modernism[6] or from a reading of the founders of the

discipline, the perceptualist thesis is not likely to seem an object of central contention: at either of these limits mimesis is not going to seem anywhere near as important as the delimitation of vision and the visual itself – but this issue is eclipsed in the apparent choice between perception and signification.

The choice of Perceptualism as the object of enabling critique does, however, chime with central motifs in contemporary literary study and film theory where we are regularly held to be the dupes of Realism and in need of delivery from the invisible grip of second-nature. I am not sure why Realism has such a central place in so many literary theoretical discussions (even if it is true that most of us are most of the time quite comfortable talking about Jane Austen's Emma Woodhouse as if she existed, I doubt that we are doing so because we have been taken in on this matter). My as yet unjustifiable suspicion is that it has a great deal to do with an inability within the field to think well about modernism or to pose with any sharpness questions about medium, such that we are forced to refight old battles because we don't yet know where the real ones are. Which is to say that just here may be a point at which literary study may have something to learn from art history rather than vice versa.[7]

But in saying this, I am drawing on views of modernism that may themselves not be standard to art history and that are in their own ways deeply informed by literary theory, views associated primarily with Michael Fried and Rosalind Krauss. What I take to hold these two, sometimes quite opposed, positions together is a common (although very differently resolved) concern with issues of medium and medium-specificity and a commitment to criticism – the particular encounter with particular works – in advance of and as a check upon the commitment to theory.

For both Fried and Krauss, the on-going commitment to the specificity of their objects obliges them to a recognition of their role as writers within a history or even a play of histories. The field deployed before them is composed not of objects disposed before their theoretical gaze, but of objects constituted by their historical standing within or without one another's gaze; the critic/historian's beholding of them does not take place except in this field of inter-vision. It seems to me that this kind of position is richly resonant with the issues engaged at the foundations of art history – as indeed the elements of literary theory on which Fried and Krauss draw (primarily the work of Jacques Lacan and Jacques Derrida) in many ways continues the philosophic tradition that informs also the emergence of art history.[8]

Such a position is *ab origine* interpretive not in the sense that one is free to interpret as one wishes but in the harder senses that nothing other than interpretation is imposed upon one, and that one's interpretations cannot claim to stand free of their engagement with particular objects and

audiences and acts. The gap between prescriptive and descriptive within which Bryson would install a semiological science apart from the domain of pragmatics is not open to them.[9] This position is fully and literally anarchic – but anarchy here names the shape of history and society not an imagined radical freedom of the individual.[10]

Here I may appear to be rejoining Bryson's conclusions, but it is important to see the difference between imagining a blank juxtaposition of the realms of semiological freedom and pragmatic necessity,[11] on the one hand, and an effort to imagine or reimagine the dimensions of human action on the other.

More generally, I have been concerned here not with the particular theses Bryson advances but with the space in which they are put forward. Some of these theses will survive the shift from theory to discipline, semiology to hermeneutics or deconstruction; others will not. It seems to me that the real questions facing art history as it looks to literary theory lie not in particular methodological stances or theoretical propositions but making out the general shape of the objectivity of art history. If Gombrich has a certain insistent appeal for Bryson, this is, I suggest, in part because they share a general vision of the nature of art historical inquiry and the place of theory within it; for my part, I want to refuse Gombrich a central role in rethinking art history just because the terrain on which that battle would be fought is already not the ground on which I want to work and move – that ground belongs much more nearly to Riegl, Wölfflin, and perhaps Panofsky.

Notes

1 In this light, and for future reference, it should be remarked that one feature of Martin Heidegger's essay 'The Origin of the Work of Art' is that it urges the promotion of poetry to the center of our thinking about art; in *Poetry, Language, Thought*, trans. Albert Hofstadter, New York, Harper and Row, 1971, pp. 17–87.

2 In referring to the 'foundedness' of art history I have in mind in the first instance the work of Wölfflin, Riegl, and others. While this should not be taken to amount to a claim that there is no 'art history' prior to their efforts, it does suggest that their relation to the presumed past of their discipline, whether Burckhardt or Alberti, is different in kind from that found in the field of literary criticism and history.

3 Two qualifications: (1) Many of those engaging in institutional critique would, of course, not accept this distinction of levels; however even if this distinction is not accepted, the general dissymmetry I am pointing to would still need to play some role within the resulting institutional critique. (2) Still largely unreceived in Anglo-American circles, Phillipe Lacoue-Labarthe and Jean-Luc Nancy's *The Literary Absolute* (Albany State University of New York Press, 1988) does engage a reflection on the emergence of the literary object as such.

4 I have tried to explore some of these questions more fully in a paper for the 1988 meeting of the College Art Association.

5 Given that an inevitable consequence of the emergence of theory will be a transformation both of the individual disciplines it touches and the relations among them, a central question will be whether one characterizes this transformation as a 'de-disciplining' of knowledge or as the emergence of a 'trans-disciplinary' object or as a radical revision of the notion of 'inter-disciplinarity.' I am arguing, here and elsewhere, for the third of these alternatives.

6 On this account, it is a feature of Bryson's work that it must repeatedly cut modernism out of its field of view; what he seems to address as painting in general must be repeatedly qualified as either 'representational' or 'figurative.' One might note, for example, the paragraph on p. 62 above beginning 'It is still almost natural for us to think of painting as in some sense, if not completely, the record of perception . . .' and moving on to suggest that 'it is not out of place to clarify some of the thinking we almost take for granted when we picture to ourselves what is involved when the representational painter sets out to create a painting.' I find I want to ask about the coherence of this act of imagination: am I being asked to imagine a representationalist setting out to create a representation or a painter setting out to create a painting? That is, I feel maneuvered into a false position by the question – I am tempted to say that a certain experience of modernism renders this imagination of intention impossible or incoherent.

7 It is perhaps interesting to note here that one of the most successful of the recent wave of primers in literary theory, Catherine Belsey's *Critical Practice* (London, Methuen, 1980) moves early to establish Realism as the central object of attack and then produces as its first example Ruskin on Turner. Something funny is going on in this chiasmus – something funny that seems to go on with some regularity between criticism, literature, and painting, and something the diagnosis of which might powerfully inform our thinking about the extension of literary theory into the visual domain.

8 The underlying claim here is that a commitment to disciplinary, rather than 'scientific' or 'theoretical,' objectivity and a commitment to medium-specificity in criticism go hand-in-hand, and that this continues to be the case even where those commitments turn against themselves in the form of radical disciplinary or artistic autocritique.

9 To put it somewhat differently, the 'hermeneutic mandate' taken up by Bryson on p. 72 cannot be considered secondary to or separable from an otherwise imaginable 'archival mandate' – which is of course not to say that Baxandall and Alpers cannot do what they do but just that the overarching condition of that work remains hermeneutic.

10 And here, of course, we come up against issues that run far beyond the scope of art history but which may nonetheless be crucial to our feelings about why art history might matter – issues about our imagination of human freedom and activity ('When we imagine a representational painter setting out to create a painting . . .,' what do we imagine, what can we imagine?)

11 It should be perhaps explicitly noted that Bryson's semiological theory here appears to deliver itself utterly to Stanley Fish and the argument 'against theory.'

3

USING LANGUAGE TO DO BUSINESS
AS USUAL

ROSALIND KRAUSS

I N June 1986 the French weekly *Le Nouvel Observateur* came out with a cover story devoted to what it called 'La Grande Lessive,' a term that would roughly translate as 'the great house-cleaning,' or 'the big wash-up' or even 'the great purge.' And, lest anyone miss the point about who or what was being cleared away, the cover carried the picture of a sort of all-purpose intellectual, his glasses horn-rimmed, his hair a little long and a bit rumpled, his jacket tweed, his tie askew. Only *this* intellectual had great bubbles frothing from his astonished, open mouth, which as anyone could see had just been washed out with soap.

The clean-up that 'La Grande Lessive' was thus recognizing was not simply the current realignment of power as a result of a major shift in French intellectual life, one that had already started in the 1970s with the 'nouveaux philosophes', but had by now become pervasive among the academic elite. The overtones of 'La Grande Lessive' extended beyond this, to imply that what the old guard, now being scattered by its new adversaries, had stood for was somehow just a little bit 'dirty.' The clean-out we were being told was also a clean-up, a necessary remedy against the intellectually obscene.

And indeed in the eyes of most humanists what this old guard of French intellectual life – in whose ranks would have to be numbered Lévi-Strauss, Althusser, Benveniste, Lacan, Foucault, Barthes, Derrida – stood for or stand for, in the radical decentering of the human subject that results from their work, is deeply troubling. For one thing, it consisted of an under-standing that the very discipline within which the human subject was to be considered would no longer be the old humanist domain of the 'sciences morales' but a new territory mapped onto the social sciences which would operate as the 'sciences humaines.' For another, there was, as the basis for this massive disciplinary shift, the decision that the unit of social meaning – the sign – would henceforth be the object of study, the goal of which would be to understand the operations of the sign both within the larger structures

that generate the rules through which meaning is constructed, and, at a micro-level of analysis, within the system of the sign's production through the material logic of the relation between signifiers. Structural linguistics had been put into place, then, as the model of a scientifically analysable social universe to be explored by anthropologists, historians, philosophers, psychoanalysts, or critics of literature, film, art. And within this enterprise the human subject was consistently to be viewed as a function rather than an initiator of the signs he uses: for the only way for the human subject to enter the social system was seen to be as a meaning that is articulated by a structure that utterly exceeds him.

It is this structuralism and its radicalization as post-structuralism that 'La Grande Lessive' was portraying the academy as busily washing out of its hair, so that that academy could return to the very condition of the 'sciences morales,' to their basis in the idea of an autonomous subject, an agent who is in control of his meanings, his intentions, his representations, his desires; a moral subject, a voluntaristic subject, a subject inaugurated in relation to his desire for freedom. In short, so that, after more than a quarter of a century of structuralism's dominance, it can return to business as usual: humanistic and pre-structuralist.

The title of this essay, 'Using Language to do Business as Usual,' intends by its first phrase, 'using language,' to point to the fact that the linguistic mode – even as it is being subjected to a 1980s backlash in Europe – is exercising an increasing power of seduction on those areas of American scholarship that had heretofore been somewhat resistant to the very idea of structuralism, among them, of course, art history. But as can probably be gathered from the point introduced by the *grande lessive* story, this newly awakened interest involves something of a perverse twist, something that implies the use of the linguistic model against its own grain. And thus the second half of my title, where 'business as usual' is meant to indicate a re-entrenchment in or rededication to, or even merely a continuation of those same humanist concepts in whose name the proponents of the *grande lessive* assume they are speaking. So that what we are facing on *this* side of the Atlantic is a very special co-optation of linguistics with all its intellectual glamour and prestige in order to put whatever power, or rigour, or trenchance it might have to work in the service of the old humanist subject, with all his meanings and intentions carefully intact.

I want to make my point by using two rather long anecdotes about arguments that recently occurred over the import of the linguistic model, arguments that erupted during two different public discussions in which I happened to take part. The reason I am resorting to these anecdotes is that they surround what might otherwise be a technical debate over the meaning of this or that semiological concept or term, with what we could see as a context of intellectual urgency; that is, they provide the back-

ground from within which the stakes of the discussion are allowed to become apparent.

The first of these took place at the Museum of Modern Art in the Fall of 1984 at the time of the 'Primitivism' in 20th Century Art exhibition. Kirk Varnedoe, one of the show's organizers, and I had put together a day-long symposium, intending to open for debate the possible difference the exhibition had made to the 'received history of modernism.' We had scheduled ourselves as the opening pair of debaters. Varnedoe went first and his argument was, among other things, pitched against what he knew was going to be my position, which was that by the 1930s a surrealizing kind of primitivism had joined with revivals of Nietzsche and of Sade, with developments in French sociology and psychoanalysis, to posit the productiveness of the violent and the sacrificial, and to find in the hetero-logical and the 'irrational' a way of getting behind the ideological facade of Western rationalism in order to found a new critique.[1] Varnedoe, in opposition to this, was intent on describing a rationalist primitivism.[2]

With great persuasiveness he began to dismantle the kind of art historical folklore that, for example, took Gauguin at his word when he insisted that it was wrong to deprive him of his claim to savagery. 'For it is true,' Gauguin wrote, 'I am a savage. And civilized people suspect this, for in my works there is nothing so surprising and baffling as this "savage-in-spite-of-myself" aspect.'[3] Yet despite this insistence, Varnedoe argued, Gauguin was shaped by a late nineteenth-century attitude in the social sciences that was far from conceiving of primitive peoples as 'savage.' These cultures were instead thought of as making possible access to the onset of those innate, constructive, mental operations on which all social organization depends and through which it originated. They would provide the psychologist or the linguist with 'privileged keys to the basic structures of mental processes.' Varnedoe went on:

> As the new century approached it was more and more broadly recognized that the ways human intelligence, society, and history worked were fundamentally un-'natural' – that is, operating under laws that had little to do with the way plants grew or reflexes twitched ... The mind was newly portrayed not as the passive receptacle of received impressions from nature, but instead as an active, organizing agent that from the beginning imposed its order on the chaos of sensations. Representation was thus seen more as an act than a response. Correspondingly the origins of culture – language, religion, and art – were held to lie not in mimicry but in invention: in the primordial mind's expressive projection of sounds and forms that it then ordered into the elements of communication. In this fashion, the

shift away from naturalist thinking opened the way to a new concept of the primitive: not as the embodiment of man's former inadequacies and his bondage to nature, but as the bearer of his best potential, the essential spark of mind that definitely liberated him from the domain of beasts and plants.[4]

Linking Gauguin's *primitif* to that of contemporary social science. Varnedoe described the artist as looking for the 'basic structures of thought underlying representation,'[5] and he pictured Gauguin's search as particularly fascinated with what could be thought of as early forms of language – like the pictograms copied from Easter Island Rongorongo writing that one finds in his portrait of Tehamana, and again in his elaborate carving *Wood Cylinder with Christ on the Cross*. Varnedoe's point about this fascination was that in coming into contact with the evidence proffered by what he took to be the mysterious markings of an originary linguistic event – the trace of an ur-language – Gauguin was, first, conducting 'an inquiry into the basic nature of signs,'[6] and second, in so doing, he was anticipating the specific revolution of modern linguistics.

Consistently tying this investigation into the operations of an ur- or rudimentary language to the thought of Ferdinand de Saussure, Varnedoe was simultaneously, of course, tying Saussure to his own view of rationalism, which seemed to involve the idea of a constituting consciousness that gradually builds up complicated structures from simple ones: elaborated languages from ur-speech. At one point Varnedoe showed a drawing by Picasso from the moment just following the *Demoiselles d'Avignon*, to illustrate this conception of the birth of the sign as an ur-form, carefully balanced on the boundary line between the icon and the symbol, between resemblance and convention.[7] The ur-sign, according to this conception, is seen as evolving from an origin in nature.

Now from the other members of the panel there were two very vigorous objections to Varnedoe's application of the linguistic model. One of these was quite specific to Saussure, the other addressed the use of linguistics to support the argument for the rationalist subject.

The first objection came from Yve-Alain Bois, both after Varnedoe's presentation and in the course of his own contribution.[8] For Bois did indeed think that Saussure offered a useful model for understanding the difference that a certain view of African sculpture had made in the development of modern art, or, specifically, of cubism. But importantly, that view entailed a break precisely with the idea of the phylogenesis, so to speak, of the sign, or with anything to do with pictographs or ur-languages. To the contrary, that view was one that received African art as a demonstration of what it meant, *structurally* speaking, for the sign to be constituted as wholly arbitrary.

Saussure, as we know, had decisively broken with the idea of linguistics as

an historical discipline, one that involved a diachronic account of the evolution of languages. For him, the very condition of language was that it was – at any given time of its functioning – a synchronous event, a structure whose condition was a function of the complete system of interdependence of its parts. The reason for this interdependence had to do with what Saussure saw as the total arbitrariness of the unit of language's signification, which is to say, the sign. This was not just the arbitrariness that late nineteenth-century conventionalist linguistics imputed to the sign's relationship to its referent – with for example *dog* operating in English and *chien* in French and *Hund* in German. This had to do with the arbitrariness inside the sign itself, as a given phonic substance – the signifier – sliced from the range of the sound possibilities of speech, simultaneously articulating a conceptual cut, setting up a signified, or ideational unit. Neither of these two faces of the sign, neither signifier nor signified, pre-exists the other nor has any meaning outside their relation in the sign. And nothing in nature decrees that a certain signifier should articulate a certain signified. Thus it is at the heart of the sign that arbitrariness reigns, an arbitrariness that dictates that the operation of the sign is dependent on its total independence from the object world for the establishment of its meaning. English has decreed that the difference in the object world between a sheep in the field and one on the table will be spoken through the opposition of *sheep* and *mutton*. The French signifier *mouton* cuts out only a single conceptual unit, one that will function within the structure of French in a different way from that of the two English signs. For signs work to generate meaning from within a whole system of differential oppositions, series of relationships that only exist between signs.

It was this kind of arbitrariness, Bois was arguing, that had been experienced in African sculpture by Carl Einstein in his *Negerplastik* of 1915 and by Vladimir Markov in his 1914 study, *The Art of the Negroes*. One of the striking aspects of the arbitrariness these two writers described is the freedom of the anatomical signifiers of the African sculpture to establish the conceptual units of face or body according to a condensation or proliferation that is utterly free of corporeal reality. Another is the experience, given the arbitrariness of the signifier of the almost limitless possibilities of substitution: cowrie shell for eye, but also nail head, or wooden peg, or drill hole.

If this contemporary conception of African art is central to the debate on cubism, it is because it bears crucially on the interpretation of collage – the fundamental reorientation of the conception of the work of art which Picasso and Braque introduced in 1912. And indeed it was Daniel Henry Kahnweiler, Picasso's dealer and critic (and close friend of Carl Einstein), who maintained that African sculpture began to affect Picasso not in 1907 with the *Demoiselles d'Avignon* or the *Little Dryad* – where the African

influence is nothing but a stylistic tic, a simple variant of Gauguin's vocabulary of primitivized forms – but in 1912 when his purchase of a Grebo mask triggered Picasso's first cut-out construction, the object called *Guitar*. 'The discovery of Grebo art,' Kahnweiler wrote, 'coincided with the end of analytical Cubism. The period of investigation of the external world was over. The Cubist painters now meant to represent things by invented signs which would make them appear as a whole in the consciousness of the spectator, without his being able to identify the details of the sign with details of the objects "read." '[9]

And Kahnweiler was aware that the operation of the sign occurred only from within a system or structure. 'The Grebo masks,' he had said, 'bore testimony to the conception, in all its purity, that art aims at the creation of signs. The human face "seen," or rather "read," does not coincide at all with the details of the sign, whose details, moreover, would have no significance if isolated.'[10] This 'no significance if isolated,' echoes that insistence of Saussure's that the sign functions only within a structure and as such must be seen as 'relative, negative, oppositive.' 'In language,' Saussure had written, 'there are only differences. Even more important: a difference generally implies positive terms between which the difference is set up; but in language there are only differences *without positive terms* . . . The idea or phonic substance that a sign contains is of less importance than the other signs that surround it.'[11]

Thus, if African art had inaugurated collage this was because it opened not only onto the arbitrariness of the sign but also onto its negative character, its quality of being only a marker within a system of differences. And if the *Guitar* that Picasso had fashioned through his experience of the Grebo mask had led to collage and the whole series denoted as synthetic cubism, this was, Bois argued, because 'Picasso realized for the first time that a sign, because it has a value [within a system of differences], can be entirely virtual, or nonsubstantial.'[12]

In part Bois' critique was establishing the deep gulf that separates a Saussurean linguistic model from any notion of ur-languages or from even the possibility that the pictogram could be thought of within a genuine linguistic universe. Because the sign cannot have the kind of substantialist character the pictogram would imply and still function within the fluidity and differentiality of the linguistic structure.

The idea of the ur-language or the pictogram and its conception of the sign's origins in a motivated connection to the object world tends to buttress a notion – utterly un-Saussurean – of the speaker's univocal relationship to the meaning of signs, that is to say, that the system will be contained somehow within the limit of the number of objects there are in the world and that the one-to-one relation between meaning and object will allow the speaker to take charge of meaning, to cut off the possibility of its prolifera-

tion. At least that is what struck me in Varnedoe's confident presentation of *rationalist* primitivism's being underwritten by the linguistic model. And so my own intervention, which was much briefer than Bois', pointed to the following.

The linguistic model has been understood by some semiologists as mapping a circuit of meaning-exchange, constructing a kind of conduit for the transfer of sense, for the ways in which communications occur through the transmission of a message from sender to receiver.[13] This model has been opened to post-structuralist attack on the grounds that it sets up the illusion that there is something that is unified as a 'message' such that its meanings could ever be totalized by its sender, and that he could ever occupy the position implied by this model, that is, the position of an intentional speaker whose meanings are transparent to him, a speaker who says what he means or can mean what he says. Jacques Derrida, who has made this attack, bases it not so much on language's differential structure as on the sign's necessarily iterative nature. As he says:

> The unity of the signifying form only constitutes itself by virtue of its iterability, by the possibility of its being repeated in the absence not only of its 'referent,' which is self-evident, but in the absence of a determinate signified or of the intention of actual signification, as well as of all intention of present communication. This structural possibility of being weaned from the referent or from the signified (hence from communication and from its context) seems to me to make every mark, including those which are oral, a grapheme in general; which is to say . . . the non-present remainder of a differential mark cut off from its putative 'production' or origin.[14]

Thus any code – 'organon of iterability' – as Derrida calls it, any code whether written or spoken, follows the logic of the grapheme's repeatability, and it is this logic of repetition which divides the sender of the message from the totality of his own meanings. 'To write,' Derrida had said,

> is to produce a mark that will constitute a sort of machine which is productive in turn, and which my future disappearance will not, in principle, hinder in its functioning, offering things and itself to be read and to be rewritten. When I say 'my future disappearance,' it is in order to render this proposition more immediately acceptable. I ought to be able to say my disappearance, pure and simple, my non-presence in general, for instance the non-presence of my intention of saying something meaningful, of my wish to communicate, from the emission or production of the mark.[15]

The logic of this structural absence of the speaker from his own meanings, or at least from the totality of his possible meanings, is due, Derrida argues, to the consequences of the sign's repeatability, consequences to which Derrida gives the name 'citational graft' and about which he asks, 'Would a performative utterance be possible if a citational doubling did not come to split and dissociate from itself the pure singularity of the event? This is the possibility on which I want to insist,' he continues,

> the possibility of disengagement and citational graft which belongs to the structure of every mark, spoken or written, and which constitutes every mark in writing before and outside of every horizon of semio-linguistic communication; in writing, which is to say in the possibility of its function being cut off, at a certain point, from its 'original' desire-to-say-what-one-means and from its participation in a saturable and constraining context. Every sign, linguistic or non-linguistic, spoken or written, in a small or large unit, can be *cited*, put between quotation marks; in so doing it can break with every given context, engendering an infinity of new contexts in a manner which is absolutely illimitable. This does not imply that the mark is valid outside of a context, but on the contrary that there are only contexts without any center of absolute anchoring. This citationality, this duplication or duplicity, this iterability of the mark is neither an accident nor an anomaly, it is that (normal/abnormal) without which a mark could not even have a function called 'normal.' What would a mark be that could not be cited? Or one whose origins would not get lost along the way?[16]

Iterability, the condition of possibility of citational graft, throws up a road block within the smooth unrolling of the message from sender to receiver. For the barricade it erects operates within the very heart of the speech act itself, to sever the speaker from what he means-to-say, from the origins of his intention.

In his presentation Varnedoe, in the course of schematizing the modernist relation to primitivism into two distinct camps, had reached for terms to characterize the difference between the two opposing sides. And having found these terms he used them at several different junctures. There was, he said, a good and a bad primitivism, a rational and an irrational kind. The bad, regressive kind was irrational and nonproductive; while the rational kind was, he said, 'good, productive, and profitable.' 'Profitable,' he had said, and it had reverberated to wonderful (if unintentional) effect within the Enlightenment space he was charting and its processing of the rational.

If rationalism operates on the idea that a speaker's meanings are transparent to him and that he, as the sender of a message, can control or totalize his relationship to meaning, we know that both structuralism and post-structuralism challenge this idea. And this challenge is nowhere more forceful than in the argument about the citational graft where the sign's very relation to meaning is shown to contravert the speaker's possibility of mastering his intentions. And there at the Museum the object lesson of the citational graft was before us in that loose cannon of the word 'profitable' rolling around the deck of Varnedoe's presentation and adding itself as a kind of inevitable partner to the couple formed by the terms 'rational' and 'good,' making an abrupt connection between the general economy, through which meanings endlessly circulate, and the altogether different one of the political economy, where profit is the law of reason. It was this meaning, obtruding itself in a somewhat shocking reminder of the ideological, that, I pointed out, seemed to exceed whatever Varnedoe might have thought his own discourse on reason 'intended.' Reason that is to say, does not control and cannot master the linguistic model, for language is not transparent to it.

The second of the examples I wish to present in this context arose within a discussion during February 1987, in the course of a series of panels convened by the Dia Foundation to raise and analyse a variety of art-critical issues.[17] One of these panels was called '1967/1987: Theories of Art after Minimalism and Pop' and on it were Michael Fried, Benjamin Buchloh, and myself. The date selected to open the temporal parenthesis of this topic, 1967, was, given the personnel of this particular panel, far from innocent. For 1967 is the date of Michael Fried's essay 'Art and Objecthood,' a text that had enormous impact at the time of its publication and which continued to structure much of the critical debate about the issues of modernism well into the 1970s.[18]

Briefly, the argument put forward by 'Art and Objecthood' is that the field of modernist art has become split between what must be seen as a true version of itself and a false one, with the false one both deadening our sensitivity to and overwhelming our experience of not only true modernism, but art in general. In order to clarify this distinction, and to deepen its readers' sense of the stakes involved, 'Art and Objecthood' rewrites this opposition in terms of a contrast between the notion of presence and that of presentness – the former (presence) referring to a brute, physical condition; the latter (presentness) describing a situation that transcends the merely physical, one that in a certain mood we might characterize as an opening onto Being (or meaning/being).

That one tendency within modernism was simply to lapse into the sheer physicality of presence was, Fried argued, the result of a peculiarly

reductive understanding of modernism's supposed logic of self-reference. Reading that logic as prescribing the closer and closer approximation of the work of art to the parameters of its physical support, this tendency, culminating in minimalism, produced what Fried characterized as the literalist work of art, the work that, by purging itself of the last vestige of illusion, had become nothing but object. The consequences of this object-hood on the experience of the work were, Fried continued, to create a condition of reciprocity which could not but objectify the work's viewer as well, setting up a situation in which everything around the minimalist work counts as part of its perceptual field – including the body of its beholder. That body, experienced as distanced, hypostatized, alienated, is then – like the object in front of it – submitted to and defined by the flow of material reality, a sort of brute physical plenum without beginning or end, without any inherent drive towards a culmination in meaning, without what could be called 'point.'

Within the series of oppositions that Fried develops in this text it is, of course, art that works in contradistinction to objecthood. And what this means is that art is ineluctably involved in the domain not of the literal but of the virtual: the seeming, the as-if. Within high modernism the major form this virtuality took was to create the illusion that the physical existence of the work of art was entirely a function of the sensory experience to which it was addressed, so that if high modernism's drive was, in Clement Greenberg's words, 'to render substance entirely optical,' that was in order to create 'the illusion of modalities: namely, that matter is incorporeal, weightless, and exists only optically like a mirage.'[19] If 'Art and Objecthood' quotes this passage from Greenberg with approval this is because it organizes the model of virtuality that Fried wants to contrast with literal-ness. And that model is that of the impossible suspension of the work in space as if it were nothing but pure optical glitter, without weight and without density, a condition that establishes the corresponding illusion that its viewer is similarly bodiless, hovering before it as a kind of decorporeal-ized, optical consciousness. And this in turn becomes the dimension within which a further illusion can occur, namely, that there can be an instantane-ously but forever complete experience of knowing, within which this object and this subject can be utterly transparent to one another. This is the opening, or clearing, onto meaning/being that 'Art and Objecthood' takes as the exalted possibility of art: art as it eschews presence and achieves that presentness which as its author says, 'is grace.'[20]

In the context of the Dia panel discussion, each of us delivered a ten-minute paper after which there was a rather general debate. Michael Fried's opening remarks concerned the historical situation within which he wrote 'Art and Objecthood,' while my paper was concerned with a certain kind of critique of the notion of virtuality mounted by this text. I had written:

The goal [of modernist art assumed by 'Art and Objecthood'] is to produce the illusion, in the viewer, that he is not there – an illusion that is set up in reciprocity with the status of the work as mirage: it is not there and so, consequently, he is not there – a reciprocity of absence that the author of 'Art and Objecthood' would go on to call in other contexts, a 'supreme fiction.' But this not being there must clearly be qualified, for we are not talking about total absence: no painting in an empty room. The mirage is there in its insistent condition as anti-matter, as non-physicality, as the fiction of non-presence. So the viewer is there in a mirror condition, abstracted from his bodily presence and reorganized as the noncorporeal vehicle of a single stratum of sensory experience – a visual track that is magically, illusionistically unsupported by a body, a track that is allegorized, moreover, as pure cognition. What we have here is, then, not exactly a situation of non-presence but one of abstract presence, the viewer floating in front of the work as pure optical ray.

Now it can be argued that this very abstract presence, this disembodied viewer as pure desiring subject, as subject whose disembodiment is, moreover, guaranteed by its sense of total mirroring dependency on what is not itself, it can be argued that this is precisely the subject constructed by the field [of what we had always taken to be the opposite and enemy of post-painterly abstraction, that is to say the field of Pop Art] and the world into which it wants to engage, which is to say the world of media and the solicitation of advertising. And this indeed is what I will want to maintain. But it will also be sensed that this very situation, with its disembodiment, its constitution of the subject as a function of the image, its setting the stage for the occlusion of the subject through the mechanisms of identification with the object – that this repeats as well the terms of the Lacanian Imaginary, particularly from the early period of his working out of the concept of the mirror stage. And this reading also is important if we are to explore the deeply dependent and alienated condition of the viewing subject as that is constituted by Pop and all its avatars.[21]

I have gone into this detail in order to set the stage for the exchange that followed our formal presentations. It was here that Fried objected to the way I was characterizing his argument and began to suggest that what he had been proposing in his original article had in fact been in line with the postulates of structural linguistics. He said:

By the time I wrote 'Art and Objecthood' 'opticality' plays a very small role. My attack on minimalism was not made in the name of the

optical versus the literal. I saw minimalism as an attempt to
hypostatize a certain notion of the object – a kind of abstracted object.
That is what I meant by 'literalism,' and its dominant mode of effect
was what I called 'theatrical.' Its counter-term in radical abstraction –
in the truly pictorial or the truly sculptural – was not a notion of
opticality. In the essay I made this explicit in relation to Tony Caro. As
early as 1963, when I wrote an essay for his first major exhibition, what
interested me was the *syntactic* nature of his art. I had first seen a
couple of abstract Caros in his garden in London in 1961 . . . And I
had this instant access of conviction that Caro was a great artist. I was
familiar with David Smith, but there was something else in my
response to Caro. I was already interested in Merleau-Ponty,
philosopher of the body, and Caro's sculptures worked off the body in
a way – very abstract and moving – that was related to phenomeno-
logy. In one of Merleau-Ponty's confused but wonderful essays,
'Indirect Language and the Voices of Silence,' he quotes Saussure on
linguistic value construed as an effect of difference – that the power of
language to signify does not lie in any of its positive terms but in the
difference between its terms. This seemed to me stunningly apposite
to the effect of Caro's sculpture. The sense in which it seemed
fundamentally *not* like an object – this had to do less with any mirage-
like opticality than with its radically differential nature. I made the
point about syntax first in 1963; then Greenberg picked up on it in a
piece in which he talked about relationality, or what he called a
'radical unlikeness to nature'; and then I picked up on that in 'Art and
Objecthood' – what it would mean to think of art syntactically. Thus
the argument was being moved into a realm of signification, ultimately
Saussurian but mediated by Merleau-Ponty.[22]

My reply to this assertion – separated by some discussion between
Michael Fried and Benjamin Buchloh – then went as follows:

I purposely steered clear of the notion of opticality – I don't think I
used it except to quote Greenberg. I did use the term 'mirage,' but
only because it locates work in relationship to the idea of illusion, of
fiction – the aspiration toward an experience of belief, or, let's say, of
the suspension of disbelief. *That*, I think, is what is at issue not only in
'Art and Objecthood' but in all your subsequent work. I know that
opticality is not the term that is contrasted with literalness in your
initial argument. Instead your counterterm is 'presentness,' by which
you were calling for an experience of intense, abstract presence in
relation to the work – an experience which is allegorized as one of
pure cognition, a tremendously powerful moment in which one gets

the point of the work both instantaneously and forever; so that this explosion of 'getting it' is supposed to lift one out of the temporal altogether. Now that model is very hard to reconcile with the Saussurean model of meaning, with its notion of meaning based on difference, on the absence of positive terms. I don't see how you can square that differential model with your notion of instantaneous plenitude. So when you say that Saussure was secretly cooking away in your argument about the experience of art like Caro's – well, I simply don't have a flash of recognition there.[23]

In the context of the original debate, that was the extent of our exchange on this subject. But in the preparation of the transcript for publication, each of us was allowed to add a postscript should we so want. Fried chose to continue this discussion of a proper reading of Saussure. He wrote:

Looking over the transcript I was struck by a remark of Rosalind's that I let go by but want to respond to here – I mean her statement that she doesn't see how I can square a differential model of language derived from Saussure with an emphasis on instantaneously 'getting the point' of Caro's art. But of course there's no contradiction whatsoever: Saussure's model doesn't deny that we experientially grasp the meaning of a word or a sentence in a flash (such a denial would be absurd), but rather that the instantaneous intelligibility that character- izes actual discourse is everywhere underwritten, made possible by a differential structure that *in a certain sense* – that of Derrida's *différance* – implies a notion of temporal deferral. But it's a very special notion of deferral and can't simply be equated with the assertion that under- standing a statement or for that matter a painting or a sculpture takes time. More broadly, the question is what follows from a consideration of these issues from Derrida's radicalization of Saussure; what surely doesn't follow from it, I suggest, is the conclusion that differential structures can only yield *effects* of deferral or indeed lack of plenitude, which seems to be what Rosalind has in mind.[24]

Michael Fried is certainly right to say that differential structures do not 'only yield *effects* of deferral or lack of plenitude.' Indeed, the point of much of linguistic and semiological analysis has been to show that they almost never yield such effects. Language provides a whole set of signs – the syncatagoremes (like the personal pronouns 'I' and 'you,' or the deictics, 'here,' 'today,' 'now') – that allow the speaker to enter the system of the pre- existing signifying structure and to assert *his* or her unique place within it, to claim, that is, his utterances and his meanings as his own. But this system also pre-exists him, exceeds him as well, and the feeling of plenitude it

permits is thus an illusion that it sustains (and that, we could say, it was constructed to sustain). The experience of speaking is never one of standing outside this system, a witness to its play of substitutions, but of being inside it with access to the intelligibility it makes possible, an intelligibility that feels full, not empty.

This fullness, which we could call the 'intelligibility-effect' is of course part of a phenomenological analysis of language: of what it feels like to be inside of it, speaking and hearing, of what Saussure had called *parole* or utterance to separate it, for purposes of his analysis, from *langue* – that structure of the complete language that makes *parole* possible. Saussure made it clear that he had to abandon *parole* if he were to undertake the analysis of the conditions of its very possibility as given through the operations of *langue*.

Langue's relationship to *parole*, from the point of view of the effects of intelligibility it provides, has formed the basis of a great deal of post-structuralist analysis. We have only to think of Roland Barthes's *S/Z*, where the experience of transparency provided by literary realism – the seemingly unmediated accessibility it gives its reader to the object world – is analysed as nothing but a 'reality-effect' (rhyming here with 'intelligibility-effect'). Taking the story *Sarrasine* by Balzac, and enormously dilating it so that phrase-by-phrase he may display the various semiological codes that organize it and speak through it, Barthes reveals the text to be the function of the codes through which culture's systems of 'knowledge' circulate in that chain of linguistic association that we call connotation.

Our innocent view of language, of course, is that connotation follows denotation: an object is named, to which we might have various associations, metaphorical or metonymic; and these associations seem to expand our relation to the object, to ornament the simplicity of its condition as plain fact. But Barthes argues that denotation does not precede connotation; rather, it follows it, is in fact, produced by it. Denotation is the effect of a closure, a limiting of the connotative process, of the productivity of meaning. As Barthes explains,

> Ideologically, this play of connotation has the advantage of affording the classic text a certain innocence . . . denotation is not the first sense, but it pretends to be; under this illusion, it is ultimately only the *last* of connotations (that which seems at once to found and close the reading), the superior myth by which the text pretends to return to the nature of language, to language as nature.[25]

The task that *S/Z* sets itself, then, is to demonstrate the way that realism's 'reality' – its supposed denotation – is only the last of the codes to be put into place.

As a whole, *S/Z* might at first be thought as rather curiously structured, since its highly distended, extravagantly interpolated reading of the story *Sarrasine precedes* the authentic, untampered-with version of Balzac's text, an order that inverts our customary presentation of an object *before* suggesting its interpretation. But that organization of the book mimics Barthes's own analysis, as, encountering the 'real' story as it appears at *S/Z*'s end, we are once more – no matter what the analysis was that preceded this reading – returned to the innocence of the reality-effect, and denotation is indeed the last of the codes to be put into place. Barthes's analysis of *langue* does in fact occur, but then we enter *parole* and we are swamped by immediacy, by meaning as presence.

We cannot analyse the production of illusion at the same time as we are having it. That is why I do indeed see a contradiction between the experience described in 'Art and Objecthood,' an experience of Caro's sculpture, for example, in which the object's physical presence is completely eclipsed by its utter transparency to us as meaning, meaning which is, moreover, characterized as timeless and immutable; I see a contradiction between this – which is *parole* – and something like a Saussurean connection to *langue*.

I hope it will be clear that if I have chosen these two examples as a basis for my discussion, it is linked to my respect for the two scholars involved and my sense that if they, at these two junctures, represent the tendency I have been trying to locate, they do so from a position of eminence and seriousness. None the less it is my own feeling that – contrary to 'La Grande Lessive' – the possibilities that structuralism and the linguistic model offer for deepening our understanding of our social and symbolic systems are too real and too important not to get them right.

Notes

1 This was a direction of my text for the exhibition's catalogue. See my 'Giacometti,' *'Primitivism' in 20th Century Art*, vol. II, New York, The Museum of Modern Art, 1984.

2 Much of his argument followed from his catalogue text, 'Gauguin,' *'Primitivism' in 20th Century Art*, vol. I, The Museum of Modern Art, New York, 1984. Because there is no transcript of the day's meeting, I will be quoting from this essay.

3 Kirk Varnedoe, 'Gaugin' in *'Primitivism'*, vol. I, p. 179.

4 Ibid., p. 183.

5 Ibid., p. 185.

6 Ibid., p. 200.

7 The Picasso is illustrated in the catalogue. Ibid., p. 274.

8 A much expanded version of his contribution has been published. See Yve-Alain Bois, 'Kahnweiler's Lesson,' *Representations*, 18 (Spring 1987).

9 Ibid., p. 53.
10 Ibid., p. 52.
11 Ferdinand de Saussure, *Course in General Linguistics*, trans. Wade Baskin, New York, McGraw-Hill, 1966, p. 120.
12 Bois, 'Kahnweiler's Lesson', p. 53.
13 I was referring to Jakobson's well-known schema of verbal communication. See Roman Jakobson, 'Linguistics and Poetics,' in *Style in Language*, ed. Thomas A. Sebeok, Cambridge, Mass., MIT Press, 1960, p. 353.
14 Jacques Derrida, 'Signature, Event, Context,' *Glyph*, 1 (1977), p. 183.
15 Ibid., p. 180.
16 Ibid., pp. 185–6.
17 The transcript of these panels has been published. See Hal Foster (ed.), *Discussions in Contemporary Culture*, Seattle, Bay Press, 1987.
18 Michael Fried, 'Art and Objecthood,' *Artforum* (June 1967); reprinted in *Minimal Art*, ed. Gregory Battcock, New York, Dutton, 1968.
19 Clement Greenberg, 'The New Sculpture,' *Art and Culture*, Boston, Beacon Press, 1962, p. 145. Cited in 'Art and Objecthood,' p. 137.
20 Greenberg, 'New Sculpture,' p. 147.
21 *Discussions in Contemporary Culture*, pp. 61–2.
22 Ibid., p. 72.
23 Ibid., p. 75.
24 Ibid., p. 87.
25 Roland Barthes, *S/Z*, trans. Richard Miller, New York, Hill and Wang, 1974, p. 9.

The Politics of Arbitrariness

Norman Bryson

In her paper 'Using Language to do Business as Usual', Rosalind Krauss describes two recent discussions in which the figure of Ferdinand de Saussure was invoked in order, she argues, to buttress a wholly un-Saussurean understanding of the cultural work of signs. I would like here to consider her first example, the exchange that took place between Krauss, Kirk Varnedoe and Yve-Alain Bois at the time of *'Primitivism' in 20th Century Art: Affinity of the Tribal and the Modern* exhibition at the Museum of Modern Art in 1984. Immediately at stake was the question of Gauguin's fascination with early forms of language, such as the pictograms he had copied from Easter Island Rongorongo writing, and had incorporated into the portrait of Tehamana, and again into his carving *Cylinder with Christ on the Cross*. Varnedoe argued that Gauguin's interest in such linguistic markings could be seen as 'an inquiry into the basic nature of signs', and more precisely into an ur-language of pictograms; and he made the claim that such an inquiry anticipated, or was in some way similar to, the linguistics of Saussure. Yve-Alain Bois replied that to invoke Saussure in this context was to misunderstand the whole Saussurean project. In the first place, what was decisive in Saussure was his break with phylogenesis – the quest for ur-language which had pre-occupied the old phonological linguistics. In the second place, what Saussure insisted be recognized was the 'arbitrary' character of signs: the way in which words like 'chien' or 'dog' have no natural or intrinsic connection to their referents. Whereas what interested Gauguin (according to Varnedoe) was the category of the pictogram, the mysterious hieroglyphs that seemed to hover between images and words, on the cusp between icon and symbol. Saussure emphasized the wholly conventional, artificial character of linguistic signs; Gauguin was exploring a form of sign halfway between convention and natural resemblance. If Varnedoe *was* arguing that Gauguin's interest in pictograms anticipated, or resembled, Saussure's linguistics, he was misreading Saussure.

I would like, if I may, to run an action replay and freeze-frame it at just this point and to ask, why should Saussure's theory of *linguistics* be taken as relevant to discussion of *images*? Suppose we concede that Varnedoe may have been wrong to invoke Saussure: why would he have wanted, as an art historian, to bring in linguistics at all? And why should Bois and Krauss be interested in claiming that our understanding of paintings and sculptures by Picasso is deepened or enhanced by looking at Saussure's work on language? Isn't this just what David Summers elsewhere in this volume calls 'linguistic imperialism' – the extension of the models of linguistics out beyond their proper bounds into the quite different sphere of visual art? After all, what is true of one kind of sign – speech and writing – may not be true of other kinds, such as painting and sculpture. Words in a language may have no intrinsic or natural resemblance to their referents, but on what grounds should the arbitrariness of language be re-discovered among the works of visual art: isn't it exactly the defining difference between the spheres of verbal and visual representation, that words are joined to their referents by arbitrary conventions, but images are not?

Certainly there have been historical periods when words and images have been felt to be fundamentally different kinds of representation. In the eighteenth century Lessing's *Laokoön*, for example, argued that painting and poetry are domains so far apart that attempts to bring them together produce disaster: poets should not try to do the job of painters, who excel in visual description; painters should not try to do the job of poets, who excel in narration (Lessing was thinking of epic). And from the standpoint of eighteenth-century aesthetics, this view was, doubtless, locally true. Lessing's discussion was keyed to the specific pictorial practices and expectations of the eighteenth century. Medieval or early Renaissance paintings that represented several episodes in a saint's life together in a single panel were beyond the pale of art; there were as yet no cubist collages that inserted letters and words directly into the pictorial space. Lessing's attempt to draw an absolute dividing line between visual and verbal domains reveals itself as local and arbitrary if our historical framework is widened to include types of art that exactly mix verbal and visual elements: the Chinese fusion of calligraphy and figure painting, perhaps, or the art of Magritte or Arakawa. Only by fiat can these kinds of art be declared 'not art'. So one's first observation, on the idea that words and images inhabit different and exclusive domains, is that the evidence suggests otherwise: there are kinds of images in which visual and verbal elements exactly interpenetrate.

However, this observation does not yet deal with the possibility that however much verbal and visual representation may get mixed up, they are none the less distinct in themselves. Neither does it yet tackle the question of whether the arbitrariness which we may all agree characterizes language,

is present in the *non*-verbal components of such verbal/visual mixes as Chinese scrolls, or paintings by Arakawa or Magritte. What if we widen our aesthetic horizon to include African sculptures? Let us suppose that what eventually struck Picasso in the sculpture shown him by Kahnweiler was the arbitrariness of its forms, their disconnection from corporeal reality; that there seemed no basis in natural resemblance to justify the sculptors' formal decisions. By widening our horizon in this way, we might begin to establish *a sliding scale* between resemblance and convention: with African sculpture at the pole of convention, along with verbal signs, and the verbal elements of Magritte or Chinese scrolls; and at the other end the art of *vraisemblance*, the kinds of image the propriety of which Lessing would have recognized and admired, works rooted in the natural likeness between representations and what they refer to. Gauguin's pictograms, or Picasso's *Demoiselles d'Avignon*, we might want to place somewhere in between, straddling the middle. And with the idea of a scale sliding between arbitrariness and illusionism we now move some way beyond talk of *essences* of word and image: we find that in some periods there is overlap, in other periods there is opposition, between verbal and non-verbal elements in representation; and on the issue of the natural resemblance of images we find that some kinds of image work towards resemblance, while others do not. But we would not yet have caught up with the radical emphasis of Krauss' position, which goes beyond the idea of a sliding scale altogether. For the sliding scale still keeps open the possibility that, at the end of the scale marked by 'lifelikeness', images absolutely escape the orbit of arbitrariness. Which is what Krauss denies: in her view, all representation, including what Lessing would have regarded as lifelike, is grounded in the arbitrary.

To understand what is meant by this, we need to remember that the lifelikeness (or otherwise) of an image in no way depends on the actual existence of the object being depicted. There can be lifelike and there can be un-lifelike representations of angels or gods or Homeric heroes; some representations of unicorns are realistic, others are not. The decision that a particular representation is lifelike entails no existential commitment to the reality of unicorns or angels. Rather, the decision depends on the look of the representation, on how persuasively it creates the *effect* of lifelikeness – what has been called 'the effect of the real'. The difference between schematic and lifelike images may be resolved, then, not by going out and testing the representation against something in the world (there may be nothing out there to test it against) but simply by considering the way in which the idea of lifelikeness is produced or not produced from within the representation itself.

This, the radical semiological thesis, has been advanced independently in two very different contexts: by Nelson Goodman, in analytic philosophy;

and by Roland Barthes, in the context of French structuralist and post-structuralist thought. In a moment, I would like to say something of the political implications of the general thesis; but first it is useful to draw a distinction between two of its versions, which I shall call 'formalist' and 'social'.

The 'formalist' version maintains that in order to distinguish lifelike from schematic representations, one need only examine the representation in itself, without reference to the external world: just by looking at the deployment of data within the four sides of the frame, or upon the page, one can see whether the representation can be accorded *vraisemblance*. The sort of representation that counts as lifelike does so because the mode of its notation is quite unlike the mode of notation employed, for instance, in maps, diagrams and charts. A computer that knew nothing of the world, but which could distinguish between such modes of notation, could readily sift the maps from the lifelike drawings. In the same way the computer could tell apart the lyric poems and the realist novels; the latter would possess certain rhetorical features typical to realist fiction (lists, exact schemes of time and place, digressions, gratuitous details, and so forth).

It is not long before this exercise becomes strained. For example: when colour prints are returned from developing, they are sometimes accompanied by colour negatives; like the prints, the negatives are 'dense' and 'replete' (to use Goodman's terms) in their representation of data – their notation is of the type that gets sorted as 'lifelike'. On the basis of these criteria, which are purely internal to the representation, it would be hard to say why we (rather than the computer) would probably want to call the prints lifelike, but not the negatives. And one could try arguing that we call the prints lifelike just because we are so used to that kind of photograph – we have seen a million photographs of this type, but far fewer negatives – and even though the two are identical as far as information goes, familiarity tilts the balance against the negatives. Perhaps one can imagine technicians in the darkroom, surrounded every day of their life by negatives, who see them as no less lifelike than the prints; and surely the prints are far *more* lifelike than, say, mathematical diagrams. Yet this invocation of a further criterion, 'familiar', now to be added to 'dense' and 'replete', moves the discussion beyond consideration of what is internal to the representation, taken within the four sides of the frame and excluding the rest of the world. In the case of the literary text, the earlier work of Barthes similarly emphasized purely internal and formalist features of the text, as responsible for the effect of the real; yet by the time of *S/Z* (1970), Barthes' analyses also stressed cultural familiarity as a force in the rhetoric of persuasion: *vraisemblance* depends on *doxa*, codes of social lore or belief, folded into the text in order to ground it in the prevailing sense of what constitutes the real world.

The semiological thesis – that the scale running from arbitrariness to natural resemblance is conventionally coded throughout its extent – has, then, two rather different elaborations. In the 'formalist' version, the scale is analysed internally: the presence or absence of lifelikeness is estimated in absolute terms, by examining structures internal to the representation (whether this be sculpture, painting, literary text, or film). There is no reference to what constitutes lifelikeness, or its opposite, for a specific social audience. In the 'social' version of the thesis, the issue of lifelikeness is opened to the audience as ultimate arbiters. It is specific viewers and readers, in actual historical milieux, who decide what in a representation is arbitrary, and what is not. The 'social' version of the thesis admits, and insist on, the historically variable character of what, for any given society, constitutes the real. The difference between 'arbitrary' and 'naturally resemblant' is not, then, something given but something culturally produced, and changing.

In the exchange between Varnedoe, Krauss and Bois, one sees this social process in operation. According to Bois and Krauss, Picasso himself fluctuated between different evaluations of the lifelikeness of African sculpture: before 1912, the radically arbitrary nature of this sculpture's forms was not emphasized in his work, but by the time of late cubism Picasso's perceptions had changed and the assimilation of what now seemed to him its arbitrary character moved him to break with the last vestiges of illusionism. According to Varnedoe, on the other hand, Picasso's drawing following the *Demoiselles d'Avignon* was balanced between resemblance and convention, on the same cusp on which Gauguin had placed Rongorongo writing. Even though the social context of the exchange – a symposium at the Museum of Modern Art in New York – is the same on both sides of the discussion, the scale of lifelikeness is used in starkly opposing ways, when interpreting the same visual material. And presumably all three speakers would use the scale differently from Lessing, if we can imagine him transported to Africa, perspiring under his periwig, to view a Benin bronze.

What should emerge from these remarks is that the issue of the arbitrariness of verbal and visual representation cannot be resolved on the plane of essences or ahistorically, as a question of what is intrinsic or not to word and image. Yet it is the historical dimension of this issue that is always repressed by attempts to resolve it in absolute terms, whether by appeal to an essential opposition between word and image (which covers over the constantly changing accounts of their relation over time), or by asserting the conventionality of language as against the natural resemblance of images (which conceals the historically and socially fluctuating character of 'arbitrariness'). When Varnedoe argues that to modernist artists primitivism represented an extended category of universal mind, the appeal to an unchanging human psychology uniting Picasso, Gauguin, and the sculptors

of Africa and Easter Island similarly covers over the enormous historical and cultural differences between these various groups. And in the context of the Museum of Modern Art, it may be possible so drastically to de-contextualize the art of Gauguin, Picasso, Africa and Easter Island, to eliminate the contexts of these very different kinds of art so completely, that they all come to *look* the same. One observes here the confluence of several forces, all interested in rendering invisible the facts of historical and cultural difference: a 'universal psychology', which ends up making us all the same; an art historical formalism that eliminates contextual differences of history and culture in order to produce the homogeneity of all art – and the decontextualizing power of the modernist museum.

The elision of cultural differences involved here may project a picture of human sameness that is entirely consoling and pacific; yet it remains so only if we conveniently disremember the brutal era of European colonialism, which is the unspoken historical background to 'primitivism' itself. The modernist project of taking non-European art away from its context and absorbing it into the mainstream of European art assumes, and is part of, the ideology of colonialism, past and present. And if those who benefit from its operations are content to conceal this by projecting a consoling image of human sameness, by homogenizing European and non-European art in the modernist museum, and by employing a language of universal psychology, the need to remind ourselves of the reality of historical and cultural difference becomes morally and politically urgent. When Rosalind Krauss refers to *la grand lessive* – the attempt to purge French thought of the legacy of Saussure, Barthes, Derrida, and the rest – we would do well to recall the enormous shift in French politics over the twenty years which separate May 1968 from the rise of Le Pen. And in the Anglophone world we have seen a comparable change in climate. If the question whether images are grounded in natural resemblance or in convention can only be answered historically, we should be prepared to look and see what historical processes may be shaping our own discussion of the issue.

4

WHAT THE SPECTATOR SEES

RICHARD WOLLHEIM

1 If we are to understand painting when it is practised as an art – that is, either painting as such or individual paintings – we have to start from the perspective of the artist. However it is crucial to recognize that this does not involve ignoring the point of view of the spectator. It requires only rethinking it. And rethinking it leads us to two conclusions. The first is that to be a spectator is not to be a certain kind of person: it is to fill a certain role. Different roles can be filled by one and the same person. And the second is that, in the case of an artist, multiplicity of roles is a requirement. An artist must fill the role of agent, but he must also fill the role of spectator. Inside each artist is a spectator upon whom the artist, the artist as agent, is dependent. And this dependence is enshrined in what is one of the few constancies in the history of pictorial art: that is, the artist's posture, or that, in the act of painting, he positions himself in front of the support, on the side of it that he is about to mark, facing it, with his eyes open and fixed upon it. Why does the artist adopt this posture?

Confronted by this question, the self-respecting amateur of art, who is unlikely until that moment to have regarded the question as worthy of his attention, will probably give it the wrong answer. He will probably say, In order to see what he has done. According to this answer the artist is like a man dressing in the morning who looks in the mirror to see how he has tied his tie, or like a young ballet dancer at the barre who glances down her body to see where she has placed her feet. As an answer this must be wrong, if only because it implies that the artist might eventually reach a level of accomplishment at which he can dispense with the help of the eyes. But, as I see it, the only circumstance in which this could happen is the very special case, which repels generalization, when a great artist, after years of experience, goes blind and has no eyes left to help him. All he has to help him are the years of experience.

A better answer is that the painter places himself as he does because he paints with – that is, partly with – his eyes.[1] It isn't that he paints first, and

looks afterwards. The eyes are essential to the activity. But the problem is that, if this answer is right, which I believe it is, the same goes for, say, driving a car, and the answer, as we have it, doesn't discriminate.

The truth seems to be this: In driving a car, the driver uses his eyes to keep him on track. (He doesn't drive first and then see whether he is on track.) But if the artist's eyes keep him on track, they also do more. For the track that the driver's eyes are expected to keep him to, which is the road, has been independently laid down, independently, that is, of him: but the track to which the artist's eyes keep him is a track of his eyes' making. Indeed 'keeping the painting on track' is just a phrase, a metaphor, for making the painting acceptable to the eyes: the eyes, it must be appreciated, determining acceptability by very varied criteria. To sum up: Like the driver, the artist does what he does *with* the eyes. Unlike the driver, he also does it *for* the eyes.

Another way of putting what I have just been saying is to say that the artist paints in order to produce a certain experience in the mind of the spectator, and that this is so is not a fact that has been missed by theorists of painting, but they have tended to do justice to it only in one connection: pleasure. Not a negligible connection, but a limited one.

For it goes without saying that, if an artist aims to give pleasure, he paints so as to produce a certain experience. He paints so as to produce a pleasurable experience. But my claim is that, equally, when he aims to produce content or meaning, which is his major aim, he also paints so as to produce a certain experience. He does so because this is how pictorial meaning is conveyed, and this is so because of what pictorial meaning is.

Of course, if an artist is going to make his painting mean something, it is not enough that it should arouse *an* experience in the mind of the spectator. Equally it is not enough if the spectator is to understand what the painting means, that he should have *some* experience or other in front of it. Something more specific is required. So what further can be said about the experience?

In the first place, the experience must be attuned to the intention of the artist where this includes, I have to stress, the desires, thoughts, beliefs, experiences, emotions, commitments that motivate the artist to paint as he does. Intention excludes such mental phenomena in so far as they merely float in the artist's head while he paints, and in no case is it reasonable to think that intention calls for a total preconception in the artist's head of the painting that he intends to make – a kind of inner image of an outer picture which does not as yet exist.

Secondly, the required experience must come about through looking at the picture: it must come about through the way the artist worked. The spectator's experience is irrelevant to the understanding of the picture if it

comes about solely through hearsay, or through having independent knowledge of what the artist intended. Of course, such knowledge can, it very often will, serve as background information in shaping or forming how the spectator sees the painting. But – a point to which I shall return – it oversteps its legitimate role when it leads the spectator to see or think things about the painting that he does not see when he looks at it.

More than this cannot, I believe, be attempted in the abstract. What more there is to be said about the spectator's experience depends on the kind of pictorial meaning sought: as I hope to show in going through the varieties of meaning a picture can have. However let me disavow in advance one general view of how the spectator's experience should relate to what went on in the artist's head. It might be called the Contagion theory, and it holds that, in each and every case, for the spectator to grasp what the artist meant, there must be re-created in his mind when he looks at the painting precisely the mental condition out of which the artist painted it. This view was embraced by Tolstoy in old age,[2] but it has little else to recommend it.

But something general and informative is presupposed by what I have been saying. It is that general account of pictorial meaning which locates pictorial meaning in a triad of factors: the mental state of the artist, the way this causes him to paint, and the experience that a suitably informed and sensitive spectator can be expected to have on looking at the artist's picture. I call this a psychological account, and one consequence of holding to such an account is that it sets me against all those schools of contemporary thinking which propose to explain pictorial meaning in terms like rule, convention, symbol system, or which in effect assimilate pictorial meaning to something very different, which is linguistic meaning. These schools of thought include structuralism, iconography, hermeneutics, and semiotics.

I return to the artist's posture in the act of painting, the better to get at the way in which the artist encapsulates a spectator upon whom he depends.

In the simpler of the two cases in which the artist paints so as to produce a certain experience – that is to say, when he is concerned solely with the production of pleasure – his reliance upon the experience that he himself has in front of the picture is straightforward. He is interested in the experience solely in order to discover whether it is or isn't pleasurable. He has a firm grasp, we must assume, on what a pleasurable experience is like, and he tests the experience he has before the picture to see whether it meets the standard. If it does, then he concludes by analogy that it will produce a pleasurable experience in others, provided only that his pleasure is not conditional upon unique or idiosyncratic factors.

But, when we turn from the simpler to the more complex of the two cases in which the artist paints so as to produce an experience – that is to say, when the experience is designed to carry meaning or to offer understanding

– then his reliance upon the experience that he has as he paints, his dependence upon himself as a spectator, is heavier. Fundamentally his interest in the experience is so as, as I have put it, to keep the picture on track: that is, to ensure that the experience that the picture is calculated to produce in others is attuned to the mental condition, or the intention, out of which he is painting. It is indeed because the experience has, in this role, such an important share in the formation of the picture that it must be wrong to think that the intention is formulated in an inner facsimile of the painting to be. For, if there were this inner facsimile, which the artist has then only to copy, the experience that the artist has of his painting while he is painting it would be left with too small an influence upon the painting itself. Feed-back,[3] which is the primary role of the experience, would be in effect denied.

But feedback is not all there is for the experience to do. There are at least two other roles for it to fill. It can inform the artist on two other issues on which he will always feel that he has a weaker grip than he would wish. For, in the first place, the experience can refine his knowledge of what it is for an experience had in front of a painting to be attuned to the mental condition that motivated it. And, secondly, the experience can enlarge his knowledge of just what mental condition it is that has been motivating him to paint the painting in front of him in the way that he has. And it can do all this without having to do any of it explicitly, or even consciously.

And there is another thing that the artist's posture can do for him.

None of this reflexiveness, none of this pondering what he has done, and to what effect, and how he might go on to do better, is feasible unless the artist in the course of painting can assume certain broad perceptual capacities that the spectator has and will bring to bear upon the completed painting. There are various sources from which the artist can be expected to derive this knowledge. But there is, I believe, no source of information that has for him the same weight, the same authority, the same immediacy, as the posture that history requires of him. The posture draws the knowledge out of him.[4]

There are three fundamental perceptual capacities that the artist relies upon the spectator to have and to use. They are (1) *seeing-in*: (2) *expressive perception*: and (3) the capacity to experience *visual delight*. Upon these perceptual capacities rests the three basic powers that belong to painting, from which other powers derive. The basic powers are (1) the power to *represent* external objects: (2) the power to *express* mental or internal phenomena: and (3) the power to induce a special form of *pleasure*, or the much maligned property of the decorative. In this essay I shall have something to say only about the first.

2 I begin with 'seeing-in'.[5]

Seeing-in is a distinct kind of perception, and it is triggered off by the presence within the field of vision of a differentiated surface. Not all differentiated surfaces will have this effect, but I doubt that anything significant can be said about exactly what a surface must be like for it to have this effect. When the surface is right, then an experience with a certain phenomenology will occur, and it is this phenomenology that is distinctive about seeing-in. Theorists of representation consistently overlook or reduce this phenomenology with the result that they garble representation. The distinctive phenomenological feature I call 'twofoldness',[6] because, when seeing-in occurs, two things happen: I am visually aware of the surface I look at, and I discern something standing out in front of, or (in certain cases) receding behind, something else. So, for instance, I follow the famous advice of Leonardo da Vinci to an aspirant painter and I look at a stained wall,[7] and at one and the same time I am visually aware of the wall, and I recognize a naked boy in front of a darker ground (see plate 20). In virtue of this experience I can be said to see the boy in the wall.

The two things that happen when I look at the stained wall are, it must be stressed, two aspects of a single experience that I have, and the two aspects are distinguishable but also inseparable. They are two aspects of a single experience, they are not two experiences. They are neither two separate simultaneous experiences, which I somehow hold in the mind at once, nor two separate alternating experiences, between which I oscillate – though it is true that each aspect of the single experience is capable of being described as analogous to a separate experience. It can be described as though it were a case of simply looking at a wall or a case of seeing a boy face-to-face. But it is error to think that this is what it is. And we get not so much into error as into confusion if, without equating either aspect of the complex experience with the simple experience after which it can be described, we ask how experientally like or unlike each aspect is to the analogous experience. We get lost once we start comparing the phenomenology of our perception of the boy when we see him in the wall, or the phenomenology of our perception of the wall when we see the boy in it, with that of our perception of boy or wall seen face-to-face. Such a comparison seems easy enough to take on, but it proves impossible to carry out. The particular complexity that one kind of experience has and the other lacks makes their phenomenology incommensurate. None of this is to deny that there is an important causal traffic between seeing-in and seeing face-to-face. Children learn to recognize many familiar and unfamiliar objects through first seeing them in the pages of books.[8]

The twofoldness of seeing-in does not, of course, preclude one aspect of the complex experience being emphasized at the expense of the other. In seeing a boy in a stained wall I may very well concentrate on the stains, and

Plate 20 Aaron Siskind.*Chicago 1948*. Photograph

how they are formed, and the materials and colours they consist of, and how they encrust or obscure the original texture of the wall, and I might in consequence lose all but a shadowy awareness of the boy. Alternatively, I might concentrate on the boy, and on the long ears he seems to be sprouting and the box he is carrying – is it a bomb, or a present for someone? – and thus have only the vaguest sense of how the wall is marked. One aspect of the experience comes to the fore, the other recedes. And sometimes this preference for one aspect of the experience gets carried to the point where the other aspect evaporates. Twofoldness is lost, and then seeing-in succumbs to an altogether different kind of experience. This shift can take place in either direction, so that seeing-in may be succeeded by seeing the wall and its stains face-to-face, or it may give way to visualizing the boy in the mind's eye. But, given that the wall was adequately differentiated so as to permit seeing-in in the first place, it is unlikely that either of these successor experiences will prove stable. Seeing-in will probably reassert itself: such is its pull.

3 Seeing-in, as I have described it, precedes representation: it is prior to it, logically and historically. Seeing-in is prior to representation in that I can see something in surfaces that neither are nor are believed by me to be representations. To the example we have just looked at, others can readily be added. Clouds: I can, for instance, see a great Wagnerian conductor in clouds ranged against the vault of the sky (see plate 21). And seeing-in is prior to representation historically in that surely our remotest ancestors engaged in these exercises long before they thought to decorate their caves with images of the animals they hunted.

But it is not just that seeing-in precedes representation. Representation can be explained in terms of seeing-in, as the following situation reveals: In a community where seeing-in is firmly established, some member of the community – let us call him (prematurely) an artist – sets about marking a surface with the intention of getting others around him to see some definite thing in it: say, a bison. If the artist's intention is successful to the extent that a bison can be seen in the surface as he has marked it, then the community closes ranks in that someone who does indeed see a bison in it is now held to see the surface correctly, and anyone is held to see it incorrectly if he sees, as he might, something else in it, or nothing at all. Now the marked surface represents a bison.

Representation arrives, then, when there is imposed upon the natural capacity of seeing-in something that so far it had been without: a standard of correctness and incorrectness. This standard is set – set for each painting – by the intentions of the artist in so far as they are fulfilled. Holbein's famous portrait, which has come down to us in various versions, is not a portrait of Charles Laughton, though old film buffs can, and I dare say will, see Charles

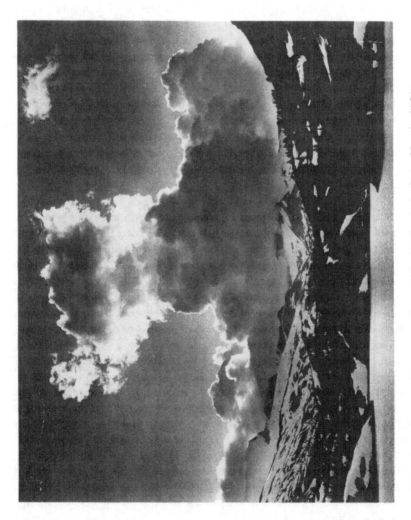

Plate 21 Ansel Adams. *Evening Cloud, Ellery Lake, Sierra Nevada*, 1934.
Photograph

Laughton in it (see plates 22 and 23). It is a portrait of Henry VIII, because Henry VIII too can be seen in it and this is the visual experience that Holbein intended. With damp-stains, with frosted panes of glass, with clouds, there is – as the famous interchange between Hamlet and Polonius makes clear – nothing that is correct to see in them. It is not even correct to see something in them rather than nothing.

What prompts this very last point is that there is a kind of picture that is a half-way house to representation. There are pictures in which it is correct to see something – to see something rather than nothing – but there is nothing – there is no one thing – of which it is true to say that it is correct to see in the picture. A good example is the Rorschach card (see plate 24). The efficacy of these simulated ink-blots as diagnostic tests depends upon the satisfaction of two conditions: that it is possible to see something in them, but that nothing, no one thing, has a stronger claim to be seen there than anything else.

However, even with full-blown representation, where the standard of correctness stipulates specifically what is to be seen in the picture, it is still possible, enjoyable and maybe profitable, to take holidays from this standard and select out of the various things we can see in a painting what we choose to. Proust, for instance, used to do this: he would go to the Louvre and find in the paintings of the Old Masters likenesses of his friends or his acquaintances from the Faubourg. Lucien Daudet tells us that, standing in front of the Ghirlandaio double portrait (see plate 25) he pretended that the figure with the polyp at the end of his nose was the old friend of the Comtesse de Greffuhle, the clubman *pur sang*, the Marquis du Lau, whose features are preserved in a faded photograph (see plate 26).[9] And readers of *Swann's Way* will recall how Swann himself had the same fondness for these tricks of perception, feeling that they somehow enhanced his friends for him. But neither in the person of Swann nor in his own person did Proust claim that these games transformed the representational content of the paintings he played them on. He simply, for the pleasure of the moment, or for some enduring consideration, overruled the intention of the artist.

4 At one time it used to be believed that seeing-in, hence representation, was culturally relative: occurring, that is to say, in some societies but not in others. But the evidence that some anthropologists assembled to make this point actually shows something far more limited and of no general significance.[10] So, for instance, they presented tribesmen of south-west Africa with drawings of the sort I illustrate, and then they ask them, Could the huntsman, standing where he is, hit the stag (see plate 27)? Now in so far as the subjects answered, No, he couldn't, for the hill is in between, what these answers reveal is that it takes experience to grasp paintings that depict comparatively complex spatial relations, and, in doing so, depend upon

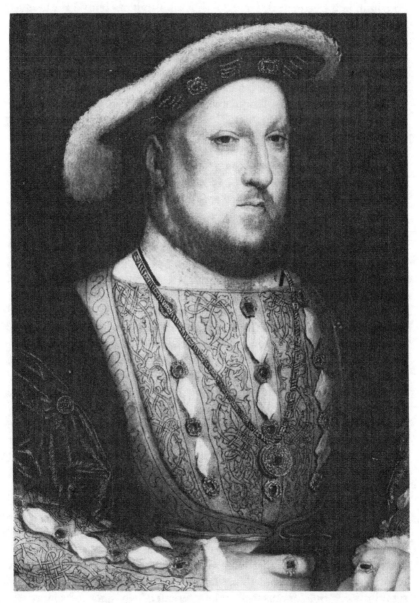

Plate 22 After Hans Holbein the Younger. *Henry VIII*

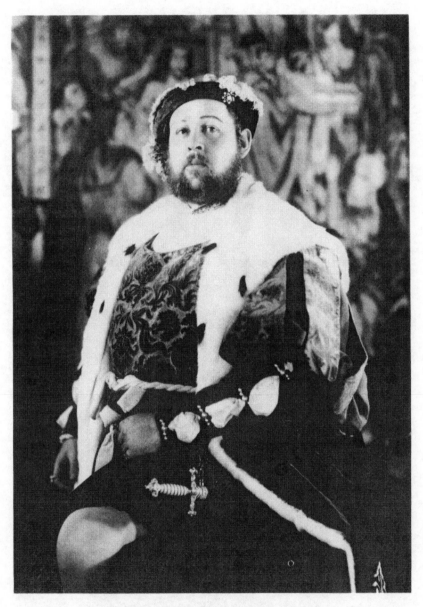

Plate 23 *Charles Laughton as Henry VIII.* Film still from *The Private Life of Henry VIII*

Plate 24 Hermann H. Rorschach. *Test Card, no. II.* From Hermann H. Rorschach, *Psychodiagnostics*, 1942–7

Plate 25 Domenico Ghirlandaio. *Old Man and Boy*

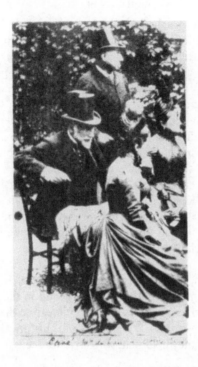

Plate 26 *Marquis du Lau*. Photograph. From *Marcel Proust, Documents Iconographiques*, ed. G. Catlin, Geneva, 1950

Plate 27 *Horizontal Pictorial Space*. Diagram. From W Hudson, *Test Card, fig. 4*

comparatively subtle visual cues. But the fact that the subjects answered the questions at all, or could apply such terms as 'huntsman', 'stag', 'hill', to the picture, showed, surely beyond a doubt, that they had the capacity for seeing-in, even if to a less developed degree than well-primed Europeans.

But a more sweeping, a more momentous, point is that seeing-in appears to be biologically grounded. It is an innate capacity, though, as with all innate capacities, it requires an environment sufficiently congenial and sufficiently stimulating, in which to mature. A baby a few days old will respond to the drawing of a face: fleetingly, of course, but the same goes for all its responses to the external world.[11] I show you a photograph of my daughter, taken when she was twelve months old, hailing a represented companion in the Kunsthistorisches Museum in Vienna (see plate 28). This photograph was taken by a total stranger, who only let us know what he was doing after he had done it. It exemplifies one of the least tainted experiments in psychology.

5 The connection between representation and seeing-in was noted by theorists of representation both in antiquity and in the Renaissance.[12] Yet almost to a person these thinkers got the connection the wrong way round: they treated seeing-in as – logically and historically – posterior to representation. For they held that, whenever we see, say, a horse in a cloud,

Plate 28 Charles Henneghien. *Emilia looking at Titian*. Photograph

or in a stained wall, or in a shadow, this is because there is a representation of a horse already there – a representation made, of course, by no human hand. These representations, which would be the work of the gods or the result of chance, wait for persons of exceptional sensitivity to discern them, and then they deliver themselves up.

This reversal of explanatory direction got into, and created an interesting problem for, representation when Quattrocento artists wished to represent the activity of seeing-in: seeing-in, that is, directed on to natural phenomena. For in order to represent this activity, they had to represent that which, on their account of the matter, this activity presupposes: they had to display nature as an album of well-contrived but also well-concealed representations. A famous example is provided by Andrea Mantegna, *Martyrdom of St Sebastian* (Kunsthistorisches Museum, Vienna), where the artist, in attempting to represent the kind of cloud in which a horseman can be seen, represents the cloud as though it were an antique cameo of a horseman (see plate 29). Weirder examples are two mythological paintings by Piero di Cosimo: *The Misfortunes of Silenus* (see plate 30) and *The Discovery of Honey*. In these paintings wild figures have their images cunningly stamped into the branches and pollarded trunks of the trees.

Of course, even once the traditional account of representation, which reverses the proper explanatory direction, is discarded, it still remains a problem, and it might be thought an insuperable problem, for representational artists to refer in their work to the kind of perception on which, according to my account of the matter, their work depends. It asks for something that is probably inherently beyond their means. Examples of an attempt to solve the problem are provided by drawings by Charles Meryon, the great architectural draughtsman and etcher of nineteenth-century Paris, which set out to represent clouds in which women can be seen (see plate 31). The task, as Meryon saw it, was to represent the clouds but not to represent the women: the women, in other words, are to be seen in the clouds but not in the drawings. The reader may judge the success Meryon had in his Herculean task.

6 That representation is grounded in seeing-in is confirmed by the way seeing-in serves to explain the broad features of representation. For the most general questions about representation become amenable once we start to recognize that representation at once respects and reflects the nature and limits of seeing-in – so long as we also recognize that seeing-in is itself stretched by the experience of looking at representations. I have in mind three general questions. They are, (1) How do we *demarcate representation?*, or, What is, and what is not, a representation?; (2) What can be represented?, or, more particularly, What are the different kinds of thing that can get represented, and what are the *varieties of representation* to which they give

Plate 29 Andrea Mantegna. *Martyrdom of St. Sebastian*

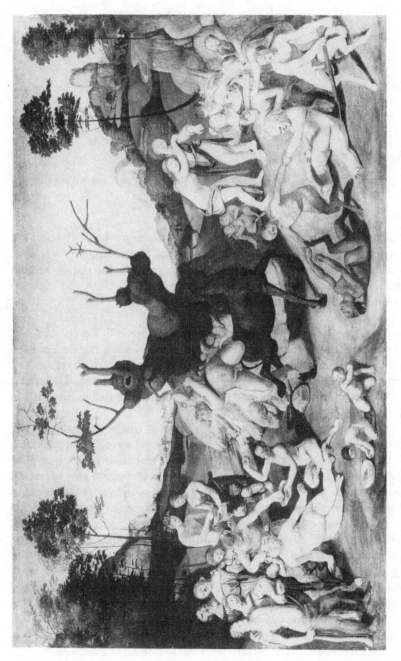

Plate 30 Piero di Cosimo. *Misfortunes of Silenus*, c. 1500. Oil glazes over tempera? on panel 76.2 × 126.3 cms

Plate 31 Charles Meryon. *Anthropomorphic Cloud Studies* (second version)

rise?; and, (3) What is it for a representational painting to be – and now I use these terms interchangeably to refer to the same elusive property – *realistic, naturalistic, lifelike, true?* This last question is one that we can pursue without attaching any particular value to the property itself.

I shall consider these three general questions in turn.

7 First, then, how do we demarcate representations?

Pretheoretically, or before a discussion like this starts, we do not have many strong convictions on this issue, and connecting representation and seeing-in has the advantage of allowing us to organize our thinking about representation in such a way as to preserve and foster those intuitions we do have.

In the first place, then, the connection tells us that representation does not have a very sharp boundary. International road signs, logos, stickmen, the signs on public lavatories – are they representations or not (see plate 32)? Availing ourselves of the connection I propose, we may now recast the question as, Do we, when we look at such things, see whatever they are of in their surface, or do we just see the things as marks, which we then, in virtue of our knowledge of the system to which they belong, recognize to be signs of what they are of? Another way of putting the question is, Do we, in so far as we treat these things as meaningful, have to be aware of depth as well as to pay attention to the marked surface? And I think that in answer to such questions we are likely to say in some of these cases that we probably do, and in other cases that we probably don't: but neither way round are we likely to say this with much conviction. And this suggests that all such cases are on the borderline of representation. That they are, and furthermore that representation exhibits a broad swathe of borderline cases, coincides, I believe, with our pre-existent intuitions such as they are.

Commercial !

Plate 32 *Pure Wool Logo*

Secondly, the connection allows us to exclude from representationality *what?*
signs like maps that are not of whatever it is that they are of because we can
see this in them. We may or we may not be able to see in them what they are
of but, if we can, it is not this fact that secures their meaning. A map of
Holland (see plate 33), is not of Holland for the reason that the land mass of
Holland can be seen in it – even if to a modern traveller a map reminds him
of what he can see, looking down upon the earth, at the flying altitude of a
plane. No: what makes the map be of Holland is what we might summarily
call a convention.

This fact about maps and what they map is confirmed by the way we
extract from them such information as they contain. To do so we do not rely
on a natural perceptual capacity, such as I hold seeing-in to be. We rely on a
skill we learn. It is called, significantly, 'map-reading': 'map-*reading*'.

The difference between representations and maps – the difference
between the two things and between the ways in which we relate to the two
things – is well brought out if we juxtapose representation and map: better
still, if we consider a representation that embeds a representation of a map.
Consider, for instance, Jan Vermeer, *Officer and Laughing Girl* (plate 34),
which represents a man and a woman and a map of Holland. For that which
makes some area of Vermeer's painting be of a woman, and, for that matter,
that which makes some other area of the painting be of a map, is something

Plate 33 *Map of the Netherlands*

quite different from that which makes that map be of Holland. As a consequence, quite different capacities on the part of the spectator, with quite different histories within his life-history, have to be mobilized if he is to learn, on the one hand, what the picture can inform him about the map, and, on the other hand, what the map could inform him about Holland. If he made the grossly inefficient decision to look at the Vermeer in order to find out the facts of Dutch geography, then he would have to mobilize the two capacities serially: first, seeing-in, to tell him that there is a map on the wall

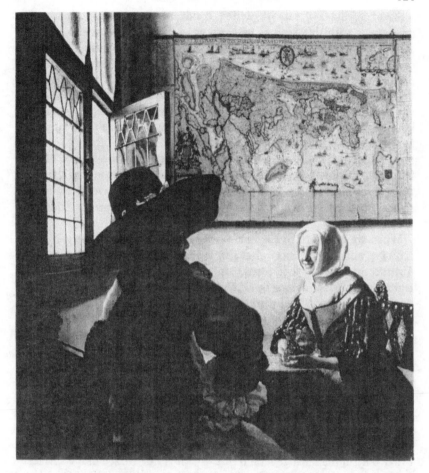

Plate 34　Jan Vermeer. *Officer and Laughing Girl*

and what it looks like, then, map-reading, to tell him what the map, given how it looks, has to say about the land surface of Holland.

Once again, the distinction between representation and maps fits in with our prior intuitions, even if they do not clamour for it.

Thirdly, the connection between representation and seeing-in allows us to reject the contrast, often drawn but quite unwarranted, between representational and abstract painting. To appreciate this point we need to get clear, first, the full scope of seeing-in and, secondly, the nature of abstract painting as we have it or the demands that it characteristically makes upon the spectator. I shall take them in turn.

In one respect the examples I have given of seeing things in natural phenomena could be misleading. I have quoted seeing a boy in a stained

wall; or seeing a great Wagnerian conductor in towering clouds. But continuous with this kind of case are cases in which we see an irregular solid in a sheet of oxidized metal, or a sphere in the bare branches of a tree, or just space in some roughly prepared wall. The two kinds of case differ primarily in the kind of concept under which we bring that which we see in the differentiated surface. In the kind of case I have so far been considering, we use 'boy', 'conductor': we use figurative concepts. In the new kind of case, we use 'irregular solid', 'sphere', 'space': we use non-figurative or abstract concepts. This being so, a natural thing to think is that, while both kinds of case are genuine cases of seeing-in, and as such both pave the way for an art of representation, they differ in that they pave the way for different kinds of representational art. One paves the way for a representational art that is figurative, the other for a representational art that is abstract.

When we now turn to abstract painting as it has in fact emerged in this century, we can see there that this way of thinking is fully borne out. Abstract art, as we have it, tends to be an art that is at once representational and abstract. Most abstract paintings display images: or, to put it another way, the experience that we are required to have in front of them is certainly one that involves attention to the marked surface but it is also one that involves an awareness of depth. In imposing the second demand as well as the first, abstract paintings reveal themselves to be representational, and it is at this point irrelevant that we can seldom put into adequate words just what they represent.

Consideration of a painting like the magnificent Hans Hofmann, *Pompeii* (see plate 35) should clarify the point. For manifestly this painting requires that we see some planes of colour in front of other planes, or that we see something in its surface. And this is true despite the fact that we shall be able to say only in the most general terms what it is that we see in the surface.

I have talked of what most abstract paintings are like. This provokes the question whether there are indeed any abstract paintings that are non-representational or that do not ask for seeing-in. (I have noticed as a strange fact that, once people have had their resistance broken down to the idea that some abstract paintings are representational they become dogmatic that all abstract paintings are representational: they repudiate the very idea of a non-representational abstract painting.) On this point there is cause for circumspection. It is plausible to think that, for instance, some of the vast machines of Barnett Newmann, such as *Vir Heroicus Sublimis* (see plate 36) are non-representational. Arguably correct perception of such a picture, or perception that coheres with the fulfilled intention of the artist, is not characterized by twofoldness.

It is however worth noting that, if there are certain abstract paintings that are non-representational for the reason that they do not call for awareness of

Plate 35 Hans Hofmann. *Pompeii*

depth, there are also paintings that are non-representational for the complementary reason, or because they do not invoke, indeed they repel, attention to the marked surface. *Trompe l'oeil* paintings, like the exquisite series of cabinets executed in gouache by Leroy de Barde (see plate 37), are surely in this category. They incite our awareness of depth, but do so in a way designed to baffle our attention to the marks upon the surface.

8 The second broad question is, What can be represented?, or, on the plausible assumption that what can be represented is sub-divisible in some principled way. What kinds of thing can be represented? What, in other words, are the varieties of representation?

There are, of course, many many ways of classifying representations by what they represent, as many ways indeed as there are of being interested in the things represented, but the most basic way – basic, because it takes us to the core of how representations relate to reality – gives us a cross-classification. Read one way, the classification divides representations into representations of *objects* and representations of *events*. Read the other way, it divides them into representations of *particular* objects-or-events and

Plate 36 Barnett Newman. *Vir Heroicus Sublimis*, 1950–1. Oil on canvas, 7´ 11⅜" × 17´ 9¼" (242.2 × 513.6 cms)

Plate 37 N. Leroy de Barde. *Réunion d'Oiseaux étrangers placés dans différentes caisses*

representations of objects-or-events *that are merely of some particular kind*.[13] Examples will elucidate this classification.

A painting can represent a young woman: then it would represent an object. Or it can represent a battle: then it would represent an event. If it represents a young woman, then it might, like Ingres's portrait, represent Madame Moitessier (see plate 38): then it would represent a particular object. Similarly, it might, if it represents a battle, represent, like Uccello's painting, the *Rout of San Romano* (plate 39): then it would represent a particular event. However, in representing a young woman, a picture might, like Manet, *The Plum* (see plate 40) represent just *a* young woman, or *a* young Frenchwoman, or *a* young Frenchwoman of a particular epoch and class and age and character and occupation and prospects, but still not any young woman in particular: then it would represent something that was merely an object of a particular kind. Similarly, in representing a battle, a picture might represent just a battle, or maybe a cavalry battle, or even a cavalry battle fought between horsemen unevenly matched, some armed with muskets, some with sabres, some with pistols, some with, some without, breastplates, in a terrain that made ambush easy, but still no battle

Plate 38 Jean-Auguste-Dominique Ingres. *Madame Moitessier*. National Gallery of
Art, Washington; Samuel H Kress Collection (dated 1851; canvas;1.467 × 1.003
(57¼ × 39½ ins))

in particular: then it would represent something that was merely an event of
a particular kind (see plate 41).

A way of bringing out this second distinction between pictures that
represent particular objects-or-events versus pictures that represent
objects-or-events that are merely of a particular kind would be this: Told of
a painting that it represents, say, a young woman, we might ask, Which
young woman? Now for some pictures like the Ingres portrait, there *is* an
answer to this question, even if the actual person we ask turns out not to
know it. In such cases the picture represents a particular object. However
for other pictures such as the genre picture by Manet, there is no answer to
the question, and asking the question shows only that we have misunder-
stood what we have been told. In such cases, the painting represents merely
an object or an event of a particular kind.

But the situation has a twist to it.

The exclusive categories are not paintings that represent particular
objects-or-events versus paintings that represent objects-or-events of a

Plate 39 Paolo Uccello. *Rout of San Romano*

Plate 40 Edouard Manet. *The Plum*. National Gallery of Art, Washington; Collection of Mr and Mrs Paul Mellon (*c.* 1877; canvas; 0.736 × 0.502 (29 × 19¾ ins))

Plate 41 Peter Snayers. *Cavalry Skirmish*

particular kind. No: the exclusive categories are paintings that represent particular objects-or-events versus paintings that represent objects-or-events that are *merely* of a particular kind. For every representational painting represents something of a particular kind. And this is not an idle fact about it. For if, additionally, the picture represents something particular, then it represents whatever that something is as belonging to that very kind.[14] So Ingres's portrait of Madame Moitessier representing (as it does) a woman, young, French, born in the early nineteenth century, self-assured, expensive, represents its sitter as just such a person.

And now I must emphasize that the distinction between pictures of particular things and pictures of things merely of a particular kind is a distinction that applies in virtue of the intentions, the fulfilled intentions, of the artist. It has to do with how the artist desired the picture to be taken, and how well he succeeded in making the picture adequate to this desire. The distinction in no way depends upon what we happen to know about who or what the picture is of. So, for instance, a Renaissance portrait of some man, or a Fayum portrait of some princess, whose identity has long been lost and will never be recovered, is now and ever will be what it originally was: it is, like Ingres's portrait of Madame Moitessier, a picture of a particular person, and the fact that probably no one will ever know who does not alter this fact (see plates 42 and 43).

In an essay that set itself a more narrowly theoretical or philosophical aim, much more would be heard of this cross-classification: just because it takes us to the core of how representation relates to the world. In this essay, it is intended to serve only one purpose, which is to confirm and to expand the dependence of representation upon seeing-in – upon seeing-in rather than seeing face-to-face. For what I see in a surface is subject to precisely the same cross-classification as what a painting represents: objects versus events, and particular objects-or-events versus objects-or-events that are merely of a particular kind. And, even if the first part of this classification also applies to what I see face-to-face, it is significant that the second part doesn't. If I claim to see a young woman face-to-face I cannot, when asked, 'Which young woman?, beg off and say that the question doesn't apply and that to ask it only betrays a misunderstanding of what I have said. Of course I can only say that I don't know the answer: but not that there isn't one. It is this fact that argues most conclusively for the view that what can be represented is just what can be seen in a marked surface rather than what can be seen face-to-face.

9 Thirdly, there is that elusive but noteworthy property in terms of which we can sort representations and which we may call, interchangeably I have suggested, naturalism, realism, lifelikeness, truth to nature. I say 'interchangeably' rather than 'synonymously', because I doubt if they are

Plate 42 Antonello da Messina. *Portrait of a Young Man*. National Gallery of Art,
Washington; Andrew W. Mellon Collection (dated *c.*1475; oil on wood; 0.33 ×
0.25 (13 × 9⅜ ins))

synonyms. It seems to me that we use a variety of words, which do not mean
exactly the same, to pick out a property with which we are familiar, and of
which each word catches some aspect. It is the property itself that interests
us, and the property is identified partly by reference to a certain effect that is
brought about in the spectator, and partly by reference to the way in which
the picture brings about this effect. The effect is one that we have all
experienced in front of works like Rogier van der Weyden, *Portrait of a Lady*

Plate 43 Fayum. *Portrait of a Woman*, 2nd century

and George Romney, *Sir Archibald Campbell* (see plates 44 and 45). The effect is however not capturable in words, and therefore the property is best approached, I suggest, through the way in which the effect is brought about. It is on this subject that I shall say something. For the property itself I shall use throughout the term 'naturalism'.

Once again my claim is that, in order to appreciate a crucial aspect of representation – this time, how the naturalistic effect is achieved – the connection between representation and seeing-in provides the essential

Plate 44 Rogier van der Weyden. *Portrait of a Lady*. National Gallery of Art,
Washington; Andrew W. Mellon Collection (*c.* 1460; oil on wood; 0.37 × 0.27 (14½
× 10¾ ins))

materials. Specifically we need to invoke the phenomenology of seeing-in:
twofoldness.

What in effect most accounts of naturalism do, and how they go wrong, is
that they concentrate on just one of the two aspects of seeing-in, and then try
to explain the naturalistic effect solely by reference to it. More specifically,
they concentrate on our discerning something in the marked surface, or
what I shall call the *recognitional aspect*, and they then proceed to identify the
naturalistic effect with the facility, or with the speed, or with the irresistibil-
ity, with which what the picture represents breaks in upon us. The other
aspect of seeing-in, which is our awareness of the marked surface itself, or
the *configurational aspect*, is ignored as though it were irrelevant to the issue.

I believe that all accounts reached in this way are fundamentally
misguided.[15] Any such account covers only a limited number of cases, and it
covers them only coincidentally. To get an adequate account of naturalism,
or one which covers all cases and explains them, we have to reintroduce the

Plate 45 George Romney. *Sir Archibald Campbell*. National Gallery of Art, Washington; Timkin Collection (probably 1792; canvas; 1.534 × 1.239 (60⅔ × 48¾ ins))

configurational aspect, for the naturalistic effect comes about through a reciprocity, a particular kind of reciprocity, between the two aspects of the visual experience that we have in front of those pictures which we therefore think as naturalistic. It is not any kind of reciprocity: it is, I emphasize, a particular kind of reciprocity. There is no formula for this reciprocity, which is what we should expect, and this is why the naturalistic effect has to be rediscovered for each age: more specifically, for each change in subject-matter, and for each change in technique. The very imprecision of the word 'reciprocity' is a good thing if it allows us to keep the improvisatory character of naturalism to the fore.

It is only an account like this, concocted out of richer materials than are generally used for this purpose, that can accommodate, indeed that can predict, the wide variety in appearance exhibited by paintings all of which are equally naturalistic. This wide variety of look is well exemplified in the paintings by van der Weyden and Romney, which is why I have chosen them: and the same contrast of appearance within naturalism could be illustrated from painters as far apart as, say, Pieter de Hooch and Grünewald (see plates 46 and 47) or Bronzino and Picasso (see plates 48 and 49).

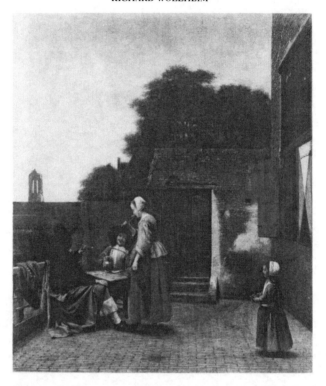

Plate 46 Pieter de Hooch. *A Dutch Courtyard*. National Gallery of Art, Washington; Andrew W. Mellon Collection (*c.* 1660; oil on linen canvas; 0.68 × 0.59 (26¾ × 23 ins))

All these painters, different though they otherwise are, are capable of the naturalistic effect.

The point that I must now clarify is that, in thinking of naturalism as lying in some kind of reciprocity or match between the two aspects of seeing-in, we must be careful not to equate awareness of the marked surface with attention to the brushwork. Attention to the brushwork is just one form that awareness of the marked surface can take, and it is not a form that, for historical reasons, it could have taken before 1500 or so, when the unit mark or stroke came to be thematized. But, long before the stroke became a required object of aesthetic scrutiny, there were plenty of other features of the marked surface that claimed attention: contour, modulation, punch mark, aerial perspective, fineness of detail, as well as, for that matter, smoothness of surface or invisibility of the brushwork.

10 So much for the broad questions that can be raised about representation, and for the contribution that the view of representation that I have been

Plate 47 Mathis Grünewald. *Crucifixion* (central panel from The Isenheim
Altarpiece) (Unterlinden Museum, Colmar)

urging, or the connection with seeing-in, can make to their resolution. And
now I want to bring my view into sharper focus by constrasting it with its
principal competitors. They are:

1 the *Illusion view*, which holds that the picture represents whatever it does
 in virtue of giving the spectator the false perceptual belief that he is in
 the presence of what it represents;[16]
2 the *Resemblance view*, which holds that a picture represents whatever it
 does in virtue of being like what it represents – or, a variant, in virtue of
 producing an experience which is like the experience of looking at what
 it represents;[17]
3 the *Make-believe view*, which holds that a picture represents whatever it
 does in virtue of our correctly making-believe that we see face-to-face
 what it represents;[18]
4 the *Information view*, which holds that a picture represents whatever it
 does in virtue of giving us the same information as we should receive if
 we saw face-to-face what it represents;[19]

Plate 48 Agnolo Bronzino. *A Young Woman and her Little Boy*. National Gallery of Art, Washington; Widener Collection (*c*. 1540; wood; 0.995 × 0.760 (39⅛ × 29⅞ ins))

5 the *Semiotic view*, which holds that a picture represents whatever it does in virtue of belonging to a symbol system which, in the course of laying down rules or conventions linking marked surfaces or parts of marked surfaces with external things and relations, specifically links it or some part of it with what it represents.[20]

Each one of these views can be faulted on points peculiar to it. So it is a grave objection to the semiotic theory that it cannot account for the evident fact of transfer. By the term 'transfer' I mean, for instance, that, if I can recognize a picture of a cat, and I know what a dog looks like, then I can be expected to recognize a picture of a dog. But on the semiotic view this ought to be baffling. It should be as baffling as if, knowing that the French word '*chat*' means a cat, and knowing what dogs look like, I should, on hearing it, be able to understand what the word '*chien*' means.

But the basic divide within views of representation is between those views which ground what a painting represents in the kind of visual experience that the representation will cause in a suitably informed and sensitive

Plate 49 Pablo Picasso. *Dora Maar*, 1937

spectator and those views which do not. Those views which do not ground representation in visual experience disqualify themselves on the spot. Those which clearly do are, my view apart, the Resemblance view and the Illusion view, but both these views misconceive the crucial experience. The Illusion view identifies it with the sort of experience that a spectator is likely to mistake for seeing the represented thing face-to-face, and the Resemblance view identifies it with the sort of experience in which the spectator compares, in some unspecified respect, what is in front of him with something that is absent. The Resemblance view gives the visual experience a gratuitous complexity, whereas the Illusion view denies it the special complexity that it has: that is, twofoldness.

11 If representational seeing, within pictorial art, is required to conform to a standard of correctness, and this standard of correctness goes back to the intentions of the artist in so far as they are fulfilled, then it appears to follow that a spectator will not be able to see a painting properly unless he independently gets hold of a mass of evidence about how it came to be made.

Put in precisely this form, the conclusion doesn't follow. The word

'independently' is out of place. And that is because of an important truth, which is easily lost sight of: that often careful, sensitive, and generally informed, scrutiny of the painting which will extract from it the very information that is needed to understand it. It is a kind of bootstrap operation. But the general point remains: a spectator needs a lot of information about how the painting he confronts came to be made. He needs a substantial cognitive stock.

But, once we allow information in, is there any principled way in which we can decide that some information is legitimate, and some illegitimate.[21] The first point to make is that we cannot do so by referring solely to the source of the information: for instance, by saying that it must be information that we could have – not, of course, that we did, but that we could have – gleaned from the picture itself just by looking at it. For the question immediately arises, By looking at it in conjunction with what other information? To this question we have two possible responses. Either we can say, In conjunction with information that could itself have been derived from the picture just by looking at it, or we can allow ourselves a sudden and unexplained relaxation of standards and can say, In conjunction with any available information. If we go for the latter response, why wait until this moment to do so? If however we go for the former, the question immediately re-arises, Just by looking at the picture in conjunction with what information? Along this route no information ever gets the clearance that we demand for it.

Another way of trying to curtail what can legitimately go into the spectator's cognitive stock is to do so by reference, not to the source, but to the content, of the information. Only information that refers to aesthetic features of the painting or that is aesthetically relevant may be utilized. But the difficulty with this proposal is that there is no way of identifying what information is aesthetically relevant except as that which allows us to discern the meaning or content of the picture. And this is no idle point. For information that might on general grounds seem aesthetically irrelevant can suddenly, in a particular case, prove crucial to understanding the work. As an example of such information, consider the market-price of the artist's materials: surely, we might think, information of no aesthetic relevance. Yet some years ago Michael Baxandall showed otherwise in considering part of the Sassetta St Francis cycle.[22] If we take, say, the *St Francis giving his Cloak to a Poor Knight* (see plate 50) it is to be noted that for the saint's cloak the painter has used lapis lazuli, which is the costliest of pigments. This fact about the painting would have registered with a spectator of the period, and there can be little doubt but that Sassetta presupposed acquaintance with it. For, used as background information, it moulds our perception of the picture. It enhances the liberality, it ensures the grandeur, of the saint's gesture. Therefore, despite its *prima facie* irrelevance, it is information that we need.

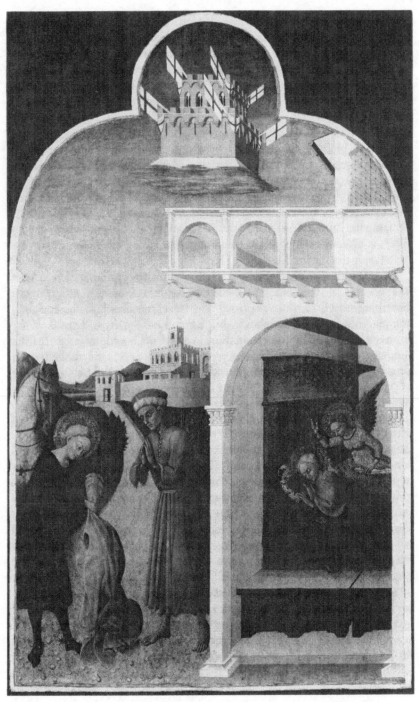

Plate 50 Sassetta. *St. Francis Giving his Cloak to a Poor Knight*

Indeed there seems to be only one limitation that should be placed upon what information can be drafted into the spectator's cognitive stock. It relates, not to the source from which the information derives nor to its content, but to the use to which it is put. The information must be such that by drawing upon it a spectator is enabled to experience some part of the content of the picture which otherwise he would have been likely to overlook.

This point is best illustrated from, though its application is certainly not confined to, pictures that give rise to rival perceptions dependent upon what cognitive stock we employ. A case in point, which I owe to Erwin Panofsky,[23] is Rogier van der Weyden's Blaedelin altarpiece. For someone ignorant of the conventions that governed the representation of religious apparitions might gravely misperceive the right wing of the triptych (see plate 51). Noticing the little child-figure in the sky, he might see the infant Christ, who in fact is directing the royal procession on its way to Bethlehem, as serving as a claypigeon for the Magi.

An actual or historical example of such a misperception, which in turn was general at the time, is incorporated into Goethe's strange and disturbing novel, *Elective Affinities*.[24] The novel narrates how the sprightly domineering Luciane, arriving with a whole house-party of friends at her mother's castle, in her determination to ward off boredom organizes the company into mounting *tableaux vivants*, which are to be modelled on famous paintings, or rather on reproductive prints after the paintings. One of the pictures chosen is a painting by Gerard Terborch, known then as sometimes now as *L'Instruction Paternelle* (see plate 52). Luciane plays – these are Goethe's descriptions – 'the gentle daughter', who is 'suffused with delicate shame' as her father, a 'noble knightly' figure, admonishes her for some minor transgression, while her mother looks down into her glass to conceal her embarrassment. In playing this becoming part, Luciane is at her best. She wins universal applause for her touching portrayal of the young girl, a wag shouts out '*Tournez s'il vous plaît*', which is a play of words on the instructions at the bottom of the page of a letter, 'PTO', and the company is blissfully unaware, as was Goethe himself, that the picture which is being brought to life for their pleasure represents a young aspirant whore coolly bidding up the price for her favours, while the beady-eyed madame of the brothel looks on with simulated indifference.

The Sassetta, the van der Weyden, and the Terborch are all cases where we need to know something in order to see in the picture something else, and my claim is that, so long as the something else is actually there to be seen in the picture – that is to say, provided that it concurs with the artist's fulfilled intention – the use of the information is legitimate, no matter how we come by it. Sometimes however the information that we need is not just information that will, in conjunction with what we already know, enable us

Plate 51 Rogier van
der Weyden. *Vision of
the Magi* (right wing
of the Altarpiece of
Pierre Blaedelin)

Plate 52 Gerard Terborch. *L'Instruction Paternelle*

to see what is to be seen in the picture, but is information that details or
makes explicit what is to be seen in the picture. The knowledge that we
require in such cases has to function not so much as cognitive stock but as
perceptual cash.

The claim that such information is ever requisite provokes widespread
resistance. The objection is that if, without being told what is there to be
seen, we cannot see it, then, when we are told what is there to be seen, we
equally shall not see it. The information will not alter what we see: the most
it will do is alter what we say. The situation where this objection is most
widely employed is in the case of attributions. How often have we heard it
said that, if someone needs to be told that a picture is by Rembrandt before
he can see it as a Rembrandt, then, if he is told that is is by Rembrandt, and
he now says that he sees it as a Rembrandt, we have every reason to distrust
him. Feeding spectators with information of this sort, it is said, ministers
only to snobbery.[25]

The materials for an effective answer to this objection lie within the early experience of most of us. I am thinking of those childhood puzzles which are made up of line drawings in which, or so we were told, rabbits and fish and fishermen lie concealed (see plates 53 and 54). But, turn them this way, turn them that way, we managed to see nothing, until someone pointed out to us the rabbit delineated in the bole of the tree, or the fish standing on its tail amongst the bulrushes. Then miraculously we could see it all, just as we were told. We didn't simply say that these things were there, now they were

Plate 53 *Children's Puzzle*

Plate 54 *Children's Puzzle: Key*

securely in our field of vision. A more sophisticated example of the same phenomenon is provided by Holbein, *The Ambassadors* (see plate 55). I suspect that no one, standing at the proper viewing-point, will be able, innocently, to see anything in the smear that runs diagonally under the table. But once again the moving finger comes to the rescue, and, shown how the smear anamorphically, or in a perspectively highly distorted fashion, represents a skull, most people will see a skull in the smear. They will see it, they won't just say that there is one there.

The point that cannot be too strongly emphasized is that, whether it bears upon representational meaning or expressive meaning, whether it is to serve as cognitive stock or as perceptual cash, any information of which the spectator has need must be information that affects what he sees when he looks at the picture: because it is only through what can be seen when the picture is looked at that the picture carries meaning. What is invariably

Plate 55 Hans Holbein the Younger. *The Ambassadors*

irrelevant is some rule or convention that takes us from what is perceptible
to some hidden meaning: in the way in which, say, a rule of language would.
This is why when, in the case of the Rogier van der Weyden, I insisted that
the contemporary convention about the representation of apparitions was
indispensable information, I did so, not on the grounds that it allows us to
infer from the presence of the child in the sky to the Infant Jesus, but
because (and this is something quite different), if we use the convention as
cognitive stock, we are then enabled to see the Infant Jesus in a certain part
of the marked surface.[26]

Notes

1 I have discussed this issue in my *On Drawing an Object*, Inaugural Lecture,
 University College London, London, 1965, reprinted in my *On Art and the Mind*,
 London, Allen Lane, 1973, and Cambridge Mass., Harvard University Press,
 1974. For bringing out the importance of the question whether the eyes are or
 are not essential to a given activity I am indebted to G. E. M. Anscombe,
 Intention, Oxford, Blackwell, 1957.
2 See Leo Tolstoy, *What is Art?* trans. Aylmer Maude, London, Oxford University
 Press, 1930. This essay originally appeared in 1898.
3 For feedback, see G. A. Miller, E. Galanter, and K. H. Pribram, *Plans for the
 Structure of Behavior*, New York, Holt, 1960.
4 Everything that I have found to say about the artist's posture and about the
 general function that it fulfils and the consequences that can be drawn from this
 for the nature of painting is perfectly compatible with the thesis that, in different
 societies, at different periods, under different ideals of painting, this function
 might be more finely differentiated, which in turn would impose more
 determinate constraints upon the posture itself. For the necessity of making this
 point, I am indebted to Kurt Forster.
5 For seeing-in, see my *Art and its Objects*, 2nd edn, Cambridge, England,
 Cambridge University Press, 1980, Supplementary Essay V, 'Seeing-as, Seeing-
 in, and Pictorial Representation', and my 'Imagination and Pictorial Under-
 standing', *Proceedings of the Aristotelian Society*, Supplementary Vol. 60, 1986,
 pp. 45–60. In the first of these two essays I give my reasons for preferring the
 concept of seeing-in to that of seeing-as, which derives from Ludwig Wittgen-
 stein, *Philosophical Investigations*, trans. G. E. M. Anscombe, Oxford, Blackwell,
 1953, part II, section 11, and which I had used in the first edition of *Art and its
 Objects*, New York, Harper and Row, 1968, and London, Penguin, 1970. For the
 concept of seeing-in, I am indebted to Richard Damann. See also Christopher
 Peacocke, 'Depiction', *Philosophical Review*, 96, no. 3 (July 1987), pp. 383–410,
 for an attempt at a more extended analysis of seeing-in than I am inclined to
 think possible.
6 For twofoldness, see my 'Reflections on *Art and Illusion*', *Arts Yearbook*, no. 4,
 1961, and my *On Drawing an Object*, both reprinted, the former in a much

extended form, in my *On Art and the Mind*. However in both these writings I had conceived of twofoldness as a matter of two distinct experiences occurring simultaneously. I owe the abandonment of this view to Malcolm Budd and Michael Podro. For the relevant considerations, see Michael Podro, review of my *Art and its Objects*, *Burlington Magazine*, 124, no. 947 (February 1982), pp. 100–2, 'Fiction and Reality in Painting', *Poetik und Hermeneutik*, Band X (1983), pp. 225–37, and 'Depiction and the Golden Calf', in *Philosophy and the Visual Arts: Seeing and Abstracting*, ed. Andrew Harrison (The Hague, Reidel 1987).

E. H. Gombrich, *Art and Illusion*, New York and London, Phaidon, 1960, denies the possibility of twofoldness, either in the sense of two simultaneous experiences or (though he does not explicitly consider this possibility) in the sense of two aspects of one experience, and he does so partly by appeal to intuitive considerations, partly by assimilating what I call the recognitional/ configurational distinction, or what he calls the nature/canvas dichotomy, to the distinction between the duck and the rabbit aspects of the duck–rabbit figure. For he then claims that, just as we cannot simultaneously see the duck and the rabbit aspects of the duck–rabbit figure, so we cannot simultaneously see nature and canvas. It is true that we cannot simultaneously see the duck and the rabbit aspects of the duck–rabbit figure. To do so would require, in my terminology, an experience with two recognitional aspects, which nothing – and certainly nothing in my account of twofoldness – leads me to anticipate. But the assimilation of the two sets of experiences on which Gombrich rests his case seems without justification unless it is assumed from the outset that twofoldness is impossible. For what do the two pairs of experiences have in common – if we do not make the assumption that in both cases the experiences are incompatible? Indeed there is one obvious discrepancy between the two pairs. In the duck– rabbit case the two experiences are homogeneous: in both cases I see something in the world. But in the nature/canvas case the two experiences are at least *prima facie* heterogeneous: In one case I see something in the world, in the other case I see something in the picture. Until this heterogeneity is shown to be irrelevant, the assimilation on which Gombrich partially relies lacks plausibility. Gombrich returns to the impossibility of twofoldness in 'Mirror and Map: Theories of Pictorial Representation', *Philosophical Transactions of the Royal Society of London*, 270 (1975), pp. 119–49, reprinted in his *The Image and the Eye*, Oxford, Phaidon, 1982.

In M. H. Pirenne, *Optics, Paintings, and Photography*, London, Cambridge University Press, 1970, there is an empirical argument which in effect supports my view of the matter, for it claims that twofoldness is required in order to explain the fact that represented objects maintain a constant appearance even though the spectator changes his position in front of the painting. This argument is made use of in Michael Polanyi, 'What is a Painting?', *British Journal of Aesthetics*, 10, no. 3 (July 1970), pp. 225–36. It was first formulated by Albert Einstein.

7 See *The Notebooks of Leonardo da Vinci*, ed. and trans. Edward McCurdy, London, Jonathan Cape, 1938, p. 231.

8 I think that it is right to regard the ability to account for this widespread

phenomenon as a requirement upon any satisfactory account of representation. Both the semiotic and the make-believe theories of representation have grave difficulties in meeting the requirement. See Peacocke, 'Depiction'.

9 The story is told in Lucien Daudet, *Autour de Soixante Lettres de Marcel Proust*, Paris, Gallimard, 1928, pp. 18–19.

10 These cross-cultural studies are reported in W. Hudson, 'Pictorial Depth Perception in Sub-Cultural Groups in Africa', *Journal of Social Psychology*, 52 (November 1960), pp. 183–208, and 'Cultural Problems in Pictorial Perception', *South African Journal of Science*, 58, no. 7 (July 1962), pp. 189–95. Hudson's methodology has been considerably criticized in, e.g., G. Jahoda and H. McGurk, 'Pictorial Depth Perception in Scottish and Ghanaian Children: a Critique of some Findings with the Hudson Test', *International Journal of Psychology*, 9, no. 4 (1974), pp. 255–67; and Margaret A. Hagen and M. M. Johnson, 'Hudson Pictorial Depth Perception: Cultural Content and Question with a Western Sample', *Journal of Social Psychology* 101 (February 1977), pp. 3–11. A good survey article of the field is Rebecca K. Jones and Margaret A. Hagen, 'A Perspective on Cross-Cultural Picture Perception', in *The Perception of Pictures*, vol. II, ed. Margaret A. Hagen, New York, Academic Press, 1980. Jones and Hagen distinguish between the perception of pictures of isolated objects and the perception of pictures of spatial relations. For me this can be at best a distinction of convenience, since both kinds of picture fall within the scope of the same perceptual capacity.

 J. Hochberg and V. Brooks, 'Pictorial Recognition as an unlearned Ability: a Study of one Child's Performance', *American Journal of Psychology*, 75 (1962), pp. 624–8, showed that a child of nineteen months, reared with severely restricted access to pictures, could recognize familiar objects in photographs and line drawings, and it concluded that there must be 'an irreducible minimum of native ability for picture recognition'.

11 I owe this information to Jerome Bruner.

12 In this section I am much indebted to H. W. Janson, 'The "Image made by Chance" in Renaissance Thought', in *De artibus opuscula XL: Essays in Honor of Erwin Panofsky*, ed. Millard Meiss, New York, New York University Press, 1961, reprinted in his *16 Studies*, New York, A. N. Abrams, 1973.

13 The most extended and most rigorous discussion of this distinction is to be found in Nelson Goodman, *The Languages of Art*, Indianapolis and New York, Bobbs-Merrill, 1968. Goodman's distinction is made in terms of existential generalization. In other words, for him a picture denotes a particular man (his phrase) just in case it is valid to infer from 'This picture represents a man', 'There exists something that this picture represents'. Otherwise the picture is (his phrase again) a man-representing picture. I prefer to make the distinction in terms of modes of reference as these are employed by pictures. There are two advantages to my method. One is that it allows me to ground the distinction in the nature of pictures rather than in what we say about them. The other is that it enables me to group pictures of Venus and Mr Pickwick together with pictures of Napoleon and Madame Moitessier, which is where I believe they belong, rather than with goddess-, or man-, representing pictures, which is where Goodman locates them. The reason behind this last point is that a picture of Venus employs

the same pictorial mode of reference as a picture of Napoleon, though, of course, 'This is a picture of Venus' does not permit of existential generalization. It is arguable that Goodman, if he wanted, could allow for the same grouping of pictures as I favour by relativizing the existential operator ('There exists . . .') to a universe of discourse. Other metaphysical commitments on Goodman's part would not incline him to this tactic, but that is irrelevant to the point that I am making. For the theoretical underpinning of my method, see Gareth Evans, *Varieties of Reference*, Oxford, Clarendon Press, 1982.

The best discussion of modes of pictorial reference is to be found in Antonia Phillips, *Picture and Object*, forthcoming.

14 For representing-as, see Goodman, *Languages of Art*, chap. 1.

15 Two accounts of naturalism are offered in Gombrich, *Art and Illusion*, of which one is in terms of illusion, the other in terms of quantity of information. Goodman, *Languages of Art*, offers an account in terms of the familiarity, or degree of entrenchment, of the symbol system employed: this account deems it a virtue that it relativizes naturalism, or makes it 'a matter of habit'. All three accounts manifestly appeal to only one aspect of the seeing-in experience – that is, the recognitional aspect – and in this respect they are typical. A fourth account is to be found in Patrick Maynard, 'Depiction, Vision and Convention', *American Philosophical Quarterly*, 9, no. 3 (July 1972), pp. 243–50, where naturalism is explained in terms of vividness. Maynard's account is the only one I know that anticipates the point that I emphasize: that both aspects of the seeing-in experience are properly recruited by naturalism.

16 For the illusion view, see e.g. S. K. Langer, *Feeling and Form*, London, Routledge and Kegan Paul, 1953; Gombrich, *Art and Illusion*; and Clement Greenberg, *Art and Culture* (Boston, Beacon Press, 1961). *Art and Illusion* also contains other views of the nature of representation.

17 For the Resemblance view, see e.g. Plato, *The Republic*, Book X; Monroe Beardsley, *Aesthetics*, New York, Harcourt, Brace, 1958; Ruby Meager, 'Seeing Paintings', *Proceedings of the Aristotelian Society*, Supplementary 40 (1966), pp. 63–84; and Jerry Fodor, *The Language of Thought*, New York, Harvard University Press, 1975, chap. 4. For a variant of this view, which replaces resemblance between the representation and the thing represented with resemblance between the experience that the representation causes and the experience that the thing represented causes, see Roger Scruton, *Art and Imagination*, London, Methuen, 1974.

The Resemblance view can acquire an undeserved plausibility because of the way we often seem to settle what a picture represents by standing in front of it and saying 'It looks like . . .'. What the picture represents is then thought to be given by whatever description, inserted into the gap, makes this sentence true. But the support that this consideration appears to lend to the Resemblance view is spurious because the 'it' in the quoted sentence is so used as to pick out not the picture itself, either in whole or in part, as the Resemblance view would claim, but the object or the event in the picture. So, for instance, we conclude that a picture represents Sydney Freedberg because the man in the picture – not some fragment of the marked surface – looks like Sydney Freedberg. However not only is this not the resemblance in terms of which the Resemblance view claims

to explain representation, but 'the man in the picture' means 'the man that the picture represents'. And this has the consequence that the quoted sentence, so far from being able to explain representation, presupposes it.

18 For the Make-believe view, see Kendall Walton, 'Pictures and Make-Believe', *Philosophical Review*, 82, no. 3 (July 1973), pp. 283–319, 'Are Representations Symbols?', *The Monist*, 58, no. 2 (April 1974), pp. 285–93, 'Points of View in Narrative and Depictive Representation', *Noûs*, 10, no. 1 (March 1976), pp. 49–61, 'Transparent Pictures: On the Nature of Photographic Realism', *Critical Inquiry*, 11, no. 2 (December 1984), pp. 246–77, and *Mimesis as Make-Believe*, Cambridge, Mass., and London, Harvard University Press, 1990.

The distinctive feature of Walton's view is that a picture represents an object or event when we are led, on the basis of its appearance, to make believe that we see that object or event. The requirement that the picture must have this effect on the basis of its appearance differentiates Walton's from a semiotic view, but, since Walton's view holds that there is a conventional link between the appearance of the picture and what we are led to make-believedly see, and therefore does not require that we bring a special kind of perceptual capacity to bear on the appearance of the picture, there is a considerable divergence between the Make-believe view and my view. One way in which this divergence manifests itself is that Walton thinks, and I do not, that the two sentences, 'I see peasants' and 'There are peasants there', uttered in front of a picture of haymakers, require a similar kind of analysis, which amounts to thinking of them as exercises in make-believe. While I am ready to think that something like this analysis is required for the second or existential sentence, I regard the first sentence as expressing a genuine perceptual judgement: it reports, elliptically, the fact that I see peasants in the picture in front of me.

19 For the Information view, see J. J. Gibson, 'The Information Available in Pictures', *Leonardo*, 4, no. 1 (Winter 1971), pp. 27–35; and John M. Kennedy, *A Psychology of Picture Perception*, San Francisco, Jossey-Bass, 1974. The theory is criticized in Nelson Goodman, 'Professor Gibson's New Perspective', *Leonardo*, 4, no. 4 (Autumn 1971), pp. 359–60; and in T. G. Roupas, 'Information and Pictorial Representation', in *The Arts and Cognition*, ed. David Perkins and Barbara Leondar, Baltimore, Johns Hopkins University Press, 1977. Some support is given to the Information view in Gombrich, *Art and Illusion*.

20 The semiotic view is a rather special case. For within one branch of semiotics, which descends from C. S. Peirce, a distinction is made between, on the one hand, signs that are conventional in their application and hence arbitrary in the way they match sign and signified and, on the other hand, those where there is a natural link between sign and signified: the latter are called 'iconic', and pictures are generally taken to be the supreme example of iconic signs. With semioticians who take this line I have no particular dispute, and it would be hard to have one, since they are not associated with any specific positive account of pictorial meaning. It is with radical semioticians who hold that all signs, including pictures, are conventional that I have my disagreement. The boldest and also the most sophisticated version of such a view is to be found in Goodman, *Languages of Art*. For more informal versions of the radical semiotic view, see Gyorgy Kepes, *Language of Vision*, Chicago, P. Theobald, 1944; Louis

Marin, *Études sémiologiques: Écriture, peinture*, Paris, Klinkseick, 1971; Umberto Eco, *A Theory of Semiotics*, Bloomington, Indiana University Press, 1970; and Rosalind E. Krauss, *The Originality of the Avant-Garde and other Modernist Myths*, Cambridge, Mass., MIT Press, 1985.

21 Restrictions upon the spectator's cognitive stock have been most usually discussed in connection with intentionalist criticism and then largely in the domain of literary criticism. The seminal work here has proved to be Monroe Beardsley and W. K. Wimsatt, Jr, 'The Intentional Fallacy', *Sewanee Review*, 54 (Summer 1946), reprinted in W. K. Wimsatt, Jr, *The Verbal Icon*, Lexington, Ky, University of Kentucky Press, 1954 and in many anthologies. The most useful of these anthologies, on account of the related articles that it contains, is *On Literary Intention*, ed. David Newton-de Molina, Edinburgh, Edinburgh University Press, 1974.

For a more general discussion of cognitive stock, see N. R. Hanson, *Patterns of Discovery*, Cambridge, England, Cambridge University Press, 1961, and Fred I. Dretske, *Seeing and Knowing*, London, Routledge and Kegan Paul, 1969. Hanson's thesis that all perception is 'theory-loaded' is a specific variant of the broader thesis that what is visible is relative to background information.

22 See Michael Baxandall, *Painting and Experience in Fifteenth-Century Italy*, Oxford, Clarendon Press, 1972, p. 11. Baxandall originally referred to *St Francis renouncing his Heritage* (National Gallery, London), but, in consultation with him, I have changed the example to another picture from the same series on the grounds that, in the present condition of the two works, it better illustrates his point.

23 See Erwin Panofsky, *Studies in Iconology*, Oxford, Oxford University Press, 1939, Introductory, pp. 9–12, or *Meaning in the Visual Arts*, New York, Doubleday, 1955, chap. I, pp. 33–4.

24 Johann Wolfgang Goethe, *Die Wahlverwandtschaften*, Tübingen, 1807, trans. Elizabeth Mayer and Louise Bogan, as *Elective Affinities*, Chicago, H. Regnery and Co., 1963, part 2, chap. 5.

25 E.g. Arthur Koestler, 'An Essay on Snobbery', *Encounter*, 5, no. 3 (September 1955), pp. 28–39. On the aesthetic significance of attributions, see Goodman, *Languages of Art*, chap. 2.

26 The full text, of which this lecture is an abbreviation, appears in R. Wollheim, *Painting as an Art*, Princeton University Press, 1987, chap. 2

Painting after Art?: Comments on Wollheim

Flint Schier

I have elsewhere tried to find my way around Richard Wollheim's important ideas on representation and seeing-in,[1] so I would like to take up some of the other intriguing points he makes in this present essay.

To start with, Wollheim opens up a truism that we have not fully appreciated: the fact that a painter, as he paints, must face his canvas. The reason for this, according to Wollheim, is not only that a painter must, like any craftsman, see what he is doing, though of course he must. The painter's posture has a deeper significance. As Wollheim puts it, the painter doesn't merely paint *with* the eyes, he paints *for* the eyes. What does this mean? I think the line of Wollheim's argument is a bit condensed at this point, so I want to spell out the implications of this apparently small point, especially as some people have had some difficulty in seeing it.[2]

On Wollheim's view, the artist must look at his canvas in order to see whether it is producing the sort of experience he wants it to – for his aim is precisely to produce a certain sort of experience.

There are, I think, two points here. First, unlike a plumber fitting pipes, a painter's prime concern is with making his work a focus of attention, and with seeing to it that the experience of attending to the work will be an intrinsically worthwhile one. This is one part of what it means to say that the painter paints for the eye.

But there is a second point, though it is concealed by an ambiguity. When Wollheim says the artist is a spectator of her own work, he could just mean that she asks herself whether she finds looking at her product delightful or interesting. But I think Wollheim has something deeper in mind, and that is that the artist wants to know whether her product would evoke a valuable experience in anyone else. And to find out whether this is so, the artist, as she works, must detach herself from her own viewpoint and assume the role of the sort of person she hopes will come before her work. Having occupied this new point of view, she proceeds to look at her work from this fresh perspective, and to ask whether it continues to hold her interest now that

she is 'centrally imagining' her work from the perspective of the sort of person she hopes to reach.

Two points are worth making about this imaginative project. First, it is not necessarily aimed at pandering to established tastes and prejudices. The artist need not imagine a typical, or normal, or academic audience: she may imagine the sort of audience she hopes will be created by her work. She may hope that her work will invent its own community, as the greatest work does: creating new bonds and standards for a new community of taste. Still, she must imagine this new community, and imagine how her work will strike it.

The second point is related to the first, and that is that this process of imaginatively projecting herself into her audience is not a matter of rule-following or adherence to canons, but an alternative to convention mongering. If she merely wished to assure herself that her work met certain standards of genre or whatever, she would merely have to check the standards, she would not have to consult her imagined spectator. This is not to say that rules of form, genre expectations, and so on do not play a role in the creation of art. Of course they do. But the artist is not content with knowing that her work adheres to the rules. She must ask how her adherence to those rules would strike the sort of person she wants her work to touch. And this question, once again, can only be answered by imagining her work from the viewpoint of her desired audience.

I imagine someone might object to Wollheim's point in the following way: surely it is not necessary that the artist face his canvas; if developments in modern art have taught us anything, they have taught us to be very circumspect in making claims about the necessary nature of any artistic enterprise, since so much that had been thought necessary to art has been shown to be, in fact, dispensable. Surely it is quite possible to create a painting without looking at it. The artist could just throw paint over his shoulder.

Of course, the painter could indeed just throw paint over his shoulder. But why should anyone give a damn about what he has done? If he cares no more for what he's doing than simply to toss paint, why should we care about the result? Someone might say: perhaps she is very interested in the results of paint-tossing. Yes, he may be. However, can *we* be interested (modulo some miracle, like Danto's magical *Polish Rider*)? I don't think we can be, not in the way art ordinarily engages our interest, even when it's bad: because the artist in failing to face his canvas has failed to face his audience. He has necessarily failed to exercise the moral imagination needed to contour his work to the experience of his audience. In failing to exhibit care and control of his work, he has failed to show concern for his audience.

If the foregoing has anything in it, then Wollheim's account of the spectator-in-the-artist intimates one way in which the creation of art, however formal or abstract, is necessarily a morally serious enterprise, requiring the operation in the artist of the moral imagination, which for her

consists of taking the viewpoint of others on her project, experiencing it from that perspective, and assessing it from a detached vantage point. Thus we find a capacity that is both a condition for art and a (necessary if insufficient) condition for morality, friendship, intimacy and any serious personal rapport.

I believe we have hit upon something that distinguishes mature art or art *per se*, from the dreamwork of children, phantasists, and dabblers who work simply to please themselves without imagining how their work would look from the perspective of a suitably disinterested, informed, sophisticated and imaginative spectator. True art requires a grasp of the full reality of other perspectives on one's own work: one way in which art constitutes a 'path back to reality'.

Just as each partner in a friendship, for example, must open her imagination to the viewpoint of the other, so there is a necessary reciprocity in our relation to a work of art. Just as the artist must assume the role of his spectator, so the spectator is obliged to envisage the viewpoint of the artist, in order to ask what the work means from this point of view. This process Wollheim has called criticism as 'retrieval'. I want to draw attention to it as the necessary complement to the artist-as-spectator. A reciprocal bond of intimacy is established, between work and viewer, when each side acknowledges fully the importance of the other's viewpoint.

One might begin to detect a whiff of paradox in this account: if the artist is to take the audience's view, and the audience is to take the artist's view, then surely the artist need only take his own point of view, since that will be the proper point of view of his audience. The circuit through 'imagining the audience' will prove otiose. (A symmetrical argument would show that the audience needn't bother with imagining the artist's perspective.)

This paradox is unreal: for the audience's viewpoint incorporates, but is not exhausted by, its attempt to imagine the artist's meaning – and, indeed, one question the artist uses herself is how, given this sort of public, she can make available to it her viewpoint and establish a community with it.

That the relationship a viewer strikes up with a painting is like taking a person seriously, or is a mode of taking a person (the-artist-in-the-work) seriously, is a fact not easily perceived from the wilder shores of postmodern thought, where any arbitrary object – a pile of bricks, say – can be an artwork, if the art grandees deem it so, and where the question of the artist's purpose in creating a work is regarded with, at best, amused tolerance: the sort of thing the New Criticism should have helped us to get over. But if we 'stop making sense' of persons and artworks, we stop seeing them as persons and artworks.

One of the questions people frequently raise is: does it matter whether something is art? Who cares? Perhaps nothing is art, perhaps everything is. So what? For Wollheim it matters, as the title of his book, *Painting as an Art*,

shows; and I believe his remarks on the roles of artist and spectator help to explain why this is so. For if I'm right, treating a canvas as a work of art necessarily involves being prepared to take it seriously, and that means being ready to engage seriously with the actual – actual, not phantasized – point of view of its creator. And this is a mode of taking a person seriously, being ready to shape your viewpoint to his.

Let me spell out a little what this means by trying to relate it to three curious facts about our relationship to works of art: (1) we can respond to a huge variety of styles with apparently conflicting aims and commitments: classical, baroque, mannerist, cubist, abstract expressionist and so on; (2) we can take seriously art which expresses an alien ideology, for example, religious art in a secular era; and (3) many important artistic projects, like cubism or pointillism, don't seem to have any objectively comprehensible rationale, leaving them open to ignorant mockery of the kind deployed in Tom Wolfe's *The Painted Word*.

I believe all of these facts point to the conclusion that the value of art is, largely, agent-relative and not agent-neutral.[3] That is, what gives value to the wide assortment of artistic projects is that some community of artists in fact genuinely cared about them and tried to make others care too. But there is no earthly, objective, impartial reason why these projects should be taken seriously for themselves. Therefore, to appreciate them, we must step into the perspective of the artists who took them seriously, for so long as we retain our perspective, or take a purely impersonal perspective, these projects will appear to have no value.

Take for example what Greenberg says about cubism. Roughly, on his view the cubists were trying to find a way of creating canvases that both created an illusion of spatial depth and fully acknowledged the integrity of the picture-plan. From a cosmic point of view, or even from an impartial human point of view, it is very hard to see why what they were doing, if Greenberg is right, matters. I think it may be this feeling that has moved some writers to hallucinate a more objectively appealing enterprise as the basis of cubism. For example, it has been suggested – crazily I believe – that we should see them as engaged in work on the nature of the sign. What I think is that we should probably see them as Greenberg does: as engaged in an enterprise that we can make sense of only by the use of imaginative *Verstehen*. Viewed from within their perspective, we find interest in their project; viewed externally, we find no interest in it.

It might be thought that my position has drastically relativist consequences, for surely if we take the point of view of any artist, we'll find his work interesting, only provided he did. But this is not so, and for two reasons. First, some projects may be such that we cannot enter into them; they repel imaginative projection. But second, often even though we can enter into the viewpoint of the artist, we still do not find worth in what he has

done. This is because when we enter into his viewpoint, we must take some of our own values and interests with us. We do not wholly abandon our own viewpoint. This is a delicate matter, of course, but I think it's important to remember that we must retain certain basic features of our own nature when we enter into the viewpoint of another. So there are bound to be projects we just can't see the point of. Nor is the question simply whether a project has a point or has no point: it is also a question of ranking. We may see some point in a project but not enough to make it seem worth much effort.

Our friend's projects became important for us because they are our friend's projects. One of the most important forms of agent-relative value is the value we attach to the well-being of those who are our friends. This is a value that greatly exceeds the value that would be attached to their well-being and fulfilment from an impersonal point of view. Likewise, I am claiming that we must form a personal relation with a work as a necessary part of understanding it. We become interested in Picasso's project because that's *Picasso's* project. The interest it has for us, as a result of our entering the artist's point of view, is much greater than the interest it would have from a merely impartial viewpoint. Understanding this artwork, and forming a personal relationship to it, are inextricable parts of the same enterprise.

I believe what clinches this point is the fact that we can appreciate such diverse painters as Bellini and Picasso. If what Picasso and Braque were doing was, from an objective point of view, the right thing for painters to do, then what Bellini does – making us forget the wall of the church on which he has deposited his paintings of a virgin and child – would be wrong. Of course, if you were an historicist, you could save things by saying: what each was doing was right for that moment in the history of painting. You could thus restore some semblance of objectivity. But then you would have difficulty in explaining how we can appreciate such diverse painters in our own time as Lucien Freud, Francis Bacon, David Hockney, Frank Stella and Jules Olitski. Surely they can't all be doing the one sort of thing that a painter should be doing now! The solution is, I believe, to give up the notion of artistic value as being impartial or impersonal. The key feature of an impersonal value is that it must, once acknowledged, engage the will of anybody. But artistic projects aren't like this: one can see their point without feeling obliged to take the project on as one's own.

Acknowledging someone as a person, or an object as an artwork, involves a willingness to take up toward them the sort of attitude Peter Strawson has called 'reactive': praise, blame, outrage, anger, admiration, love, hate and so on.[4] By contrast, to treat someone 'non-judgmentally', or to see an object without feeling ready to respond to it with any reactive attitude, is to strip it of its humanity or arthood. The early critics of Manet (assembled by George Heard Hamilton, for instance)[5] who were infuriated by his work at least showed that they still knew how to live with the full-blown concept of art or,

what is the same thing in the material mode, how to live with art. By contrast, those for whom it is a possibility that a plastic cup or a pile of bricks can be an artwork, simply because of the way they are framed and received, show that they no longer know what they're talking about. They are like the positivist and emotivist philosophers of the first half of this century who thought that calling an act or problem 'moral' was just a way of trying to confer honorific significance on it.[6] But *what* significance? Surely calling something 'moral', or 'art', can only be a way of drawing attention to its significance if it is a way of suggesting a reason for a certain sort of concern. If labelling something 'moral' or 'art' were simply an ejaculation, it couldn't perform the function the emotivists claim for it.

In fact, I think it makes no sense to claim that a pile of bricks could be a work of art. For it is intrinsic to the very concept of art that it has a certain role in our lives, and that applying 'art' to X carries with it certain commitments. In particular, it seems to me internal to the notion of 'art' that in applying it to something, we are offering a reason for a certain sort of interest in, and concern with, that thing. What sort of concern this is is what I've been trying to find my way around in this paper. If we pretend that we can apply 'art' to an object without incurring these commitments, we are simply suffering from a kind of transcendental illusion. No one could seriously think that reasons could be offered for bestowing on a plastic cup the kind of concern that Tom Crow's eighteenth-century connoisseurs and virtuosi bestowed on painting.[7] It's just not conceivable that this kind of world could grow up around plastic cups, piles of bricks, urinals and so forth. Therefore, anyone who applies 'art' to such an object must have ripped the notion of art out of the context of commitments and concerns which alone gives it sense. Such a claim is, in quite the most literal possible sense, nonsense.

This is reminiscent of an important lesson Wittgenstein has taught us in *On Certainty*. Is it possible that, given our presumed epistemic situation, it might be the case that we have no reason to rule out the possibility that we are just brains in a vat, and that our experience apparently as of an external world is just an illusion caused by the stimuli applied to our brain cells by some rogue neurosurgeons or by some Experience Machine? Wittgenstein claims this does not really make sense. Of course, it is conceivable that we are brains in a vat, and we know what might count as evidence for such a claim. But given that we lack such evidence – such internal reasons for believing that this is our predicament – it really makes no sense to claim that we have any reason to worry about this possibility. For it is internal to our conception of this possibility that there are certain grounds for believing in it, and it is therefore senseless to claim, given the absence of these grounds, that there could be any reason to worry about it.

I am claiming that the institutional theory of art is in the same boat as

external-world scepticism: it presents a proposition, or an apparent proposition, which on closer analysis turns out to be nonsensical. The institutional theory is, to revive a useful old tag, a pseudo-proposition.[8]

Notes

1 In my book *Deeper Into Pictures*, Cambridge, Cambridge University Press, 1986, chap. 10; and in a review of Wollheim's *Painting as an Art* in the *New York Times Book Review*, 14 February 1988.
2 See for example, Nicholas Penny's undiscerning comments in his review of *Painting as an Art*, in the *London Review of Books*, no. 4, February, 1988.
3 For this distinction and its importance for a range of issues in moral psychology, see Thomas Nagel's *The View from Nowhere*, Oxford, Oxford University Press, 1986.
4 See P. F. Strawson, 'Freedom and Resentment', *Proceedings of the British Academy*, 1962, pp. 187–211.
5 In his *Manet and His Critics*, New Haven, Conn., Yale University Press, 1954.
6 See Stanley Cavell's discussion of these matters in *The Claim of Reason*, Oxford, Clarendon Press, 1979.
7 See his *Painters and Public Life in Eighteenth Century Paris*, New Haven, Conn., Yale University Press, 1985.
8 The institutional theory is now so pervasive that even the *New York Times* is reporting on its wilder aspects; in a report of 6 January 1988 it quotes a Professor of Literature at an Ivy League institution as holding the view that choosing between Virginia Woolf and Pearl Buck is 'No different from choosing between a hoagy and a pizza'. This same academic is also quoted as saying that if publishers stopped publishing Dickens he would no longer be a part of literature. Surely someone who thinks that choosing between Woolf and Buck is like choosing between different forms of junk food no more has the concept of art or literature than someone could be said to possess the concept of morality and think that the choice between (say) Hitler and Churchill is like the choice between chocolate and strawberry.

For valuable correspondence on these matters, I'm very grateful to Ted Cohen, especially to his unpublished essay 'The Very Idea of Art' which will appear in his forthcoming book, *Art and Other Intimacies*. I am also indebted to conversations with Peter Railton about these matters.

Richard Wollheim's 'Seeing-In' and 'Representation'

Martin Kelly

At first reading, Richard Wollheim's notion of 'seeing-in' might appear to be too simple to achieve very much for understanding what occurs when viewing a painting. For centuries, philosophers have struggled for explanations of perception, and Wollheim's account seems to bypass the traditional discussion. His analysis, however, can move us toward clarity on certain philosophical problems, and, at the same time, introduce some order into discourse around looking at paintings.

As a foundational concept, Wollheim's 'seeing-in' is basically pre-epistemic. He suggests that it is biologically grounded, that it is a particular kind of phenomenological experience, and that babies are probably capable of experiencing it. He lays out a careful, focused psychology of the 'first' look at paintings. While cognitive experience and cultural overlay are important for viewing paintings, they are accretions to the basic ability to 'see-in.' The concept of 'seeing-in' resonates well with 'seeing,' before notions of 'seeing as' or 'seeing that,' etc., arise in a philosophical discussion of perception.

Wollheim's account could be attacked by philosophers precisely at its launching point. It might be said he has asserted what needs to be explained. Actually, his position takes our ability to see for granted, and describes the experience *vis-à-vis* a painting. The way we see may be more amenable to a psychological analysis at a stage prior to traditional philosophical complexity.

To 'see-in' in Wollheim's sense is to have a two-aspect, unitary experience in response to a painting. Not only objects or figures depicted in the painting are seen, but also the surface itself is seen as 'marked.' These two aspects do not oscillate as mutually exclusive experiences, in the manner of figure–ground reversals in Gestalt demonstrations, but rather obtain in the viewer simultaneously.

The claim is not that depicted objects are experienced as objects seen in

real space, for the surface is perceived as containing them. Surely, though, it would be impossible for there to be *no* conjunction between the experience of seeing objects 'in' a painting and in the real world, i.e., there is some 'causal traffic' between real world seeing and 'seeing-in.' If not, then, it isn't clear what it might mean to say that a particular object or type of object were seen 'in' a marked surface.

Wollheim's assertion is that an artist is capitalizing on perceptual capacities common to us all. The painter uses feedback from viewing of the painting-in-progress to modulate his or her artistic intention in the final product. The end result, the artist would have hoped, generates an experience close to the one intended in the rendering of the work.

Although the experience Wollheim is describing could be translated into a phenomenal description of the painting, it does crystallize into a particular kind of phenomenological perception. Given his assumption of biological grounding, it is possible to analyze 'seeing-in' at a pre-epistemic stage of a process. The foundation of 'seeing-in' might be explicated through a filter borrowed from a particular reading of perceptual psychology.

Most treatments by psychologists of the perception of two-dimensional surfaces have not distinguished well between seeing and knowing. For art, these accounts have vacillated between the painted surface and cultural background, and have allowed conventionalist scepticism to disable explanatory power. Wollheim's analysis allows us to enter the viewing experience to discover further grounding for the notion of 'seeing-in.'

In normal perception in the three-dimensional world, where objects are construed as 'lying out' in volumed space, monocular and binocular logic are mutually reinforcing. Whatever registers at some distance, in a particular location, by virtue of monocular logic also computes to the same real world locus by binocular logic. In normal rapid-fire visual experiences, our phenomenology is a smooth amalgamation of contributions from the two perceptual systems.

In the case of viewing a painting, there is a different real world condition. Naturally depth perception is involved. Paintings of a 'representational' nature carry many monocular features which evoke a depth experience in the viewer. The visibility of the canvas *per se* works against those monocular depth features because visible points on the canvas register in the binocular system at equidistance. The scene registers both in depth *and* as flat.

The paradoxical depth condition is significant, for it resonates well with Wollheim's idea precisely because to 'see-in' a surface those objects created by marks on the surface seems to be at odds with seeing the marks at the same time. The 'in' aspect suggests a convincing experience of depth and relief, whereas seeing the marks suggests not having a convincing experience of depth. But if two depth systems give us our everyday world in simultaneity, then they can give us 'seeing-in' smoothly. It is

necessary, however, to take the amalgamated experience apart, analytically, to make a convincing case for the experiential existence of each perceptual aspect.

There seems to be no quarrel against observers' seeing the surface of a painting if there are visible marks. Brush strokes, glare, the density of texture, all serve as indications of a surface and can register pre-epistemically to the binocular system. Viewers report such experiences with two eyes as a matter of fact. What might present a problem is the claim that the monocular array in a spatial painting is perceptually convincing. It could be argued that the sense of depth is only apparent, that the scene could be interpreted as having relief, that the experience is figurative for a possible situation being represented. This settles down to saying there is no depth experience, no psychological 'feel' similar to that in the real world.

The figurative interpretation of monocular depth is incorrect on two counts. The first is that the language of description is begged in a figurative report, for it is unclear what it means to say a scene could be construed to be three-dimensional if no visually similar scenes have previously registered in depth. To argue for previous figurative registrations is to construct a regress. The second is that it is patently false when a viewer looks at a perspective construction with one eye from the proper station point. Renaissance perspectivists understood this well.

If we take an artificial perspective painting and place the viewer at the calculated station point, the case can be made. In single vanishing point perspective, for example, the converging orthogonal lines, the relative sizes of people and objects in recession, the partial occlusion of further by nearer, the direction of shadows, the compression of visual texture as a function of distance, etc., can give a very persuasive experience of three-dimensional volume. These features are called depth 'cues' by psychologists, although the label could mislead one to think depth is inferred rather than experienced by an observer.

There are many paintings or frescoes which demonstrate the truth of the claim. Masaccio's famous *Trinity* in Santa Maria Novella in Florence is as dramatic an example as any. From the station point located opposite the central axis of the fresco, a monocular viewer cannot persuade the senses the painted vault is not hollowed into the wall of the church. It is easy to confirm this perception in observers located at the station point. There is a similar, striking persuasiveness in viewing the *Ideal City* in the Galleria Nazionale delle Marche in Urbino, Italy as well, but because it has no architectural coherence with the wall it is necessary to look through a reduction tunnel formed by the hand.

At both of these sites, I have watched dozens of observers fall prey to the illusion generated by monocular viewing. If the viewer is looking with both eyes, there is the evocation of Wollheim's 'seeing-in'; i.e., the depth experi-

ence arises but does not become illusory in the fullest sense. If the viewer covers one eye, however, the scene takes on a very different 'look.'

Monocular persuasiveness is a fact of our perceptual experience of a painting. If we add binocularity, we are in Wollheim's condition. The paint on the surface is the stimulation to the binocular system and is also the ingredient triggering the monocular system. Since our normal perceptual experience is fed by each system, there is every reason to suppose our perceptual experience of a painting is provided by both systems synthesized smoothly. We might describe differently the depth situation for the painting, but we can only do so if we see it. Wollheim's 'seeing-in,' then, is quite consistent with an experience produced by two depth systems operating at the same time and which produce pre-epistemic visual integrity.

It is important to realize that there is a serious issue in the philosophy of perception at stake here. It is not possible to argue that issue fully here. But it might be enough to say that pre-epistemic seeing is logically and psychologically prior to 'seeing as,' 'seeing that,' and the like.

To see an object 'in,' then, is to be affected by monocular cues. The 'in' of 'seeing-in' is being pushed by the present argument. Wollheim does not elaborate on 'in' other than to say that figures are seen in a marked surface. The argument presented here suggests that depth aspects carried by pictorial monocularity are a sufficient condition for the 'in' aspect of Wollheim's notion.

Wollheim has not discussed 'marked' to any level of detail. In fact, he doubts whether much can be said about it. His notion asserts, baldly, that marks are seen on a painted surface. Questions arise most urgently when one considers Professor Wollheim's example of *trompe l'oeil*. *Trompe l'oeil* paintings do not constitute cases of 'seeing-in.' They are too illusory and do not give a surface perception, much in the manner of Masaccio's fresco under monocular conditions. It remains, then, to give parameters of 'marked' which make it likely for the binocular system to be neutralized by brushstroke trickery.

The explanation is complicated and far exceeds the province of the present commentary. It might be sufficient to say that visual texture is important for the perceptual system in general. Dense textures produce different responses in the neuronal make-up than do sparse ones. Visual scientists refer to visual texture as spatial frequency.

The direction of their argument is as follows: the outline of an object is large compared to the texture of the object. The outline or shape of the object, then, has a low spatial frequency, whereas the detailed texture of the object's surface has a high spatial frequency. There are neuronal channels in the visual system differentially tuned to these spatial frequencies. In a *trompe l'oeil* there are no visible surface spatial frequencies, i.e., no relatively high spatial frequencies.

While there is no evidence yet that the binocular system responds differently from the monocular system to spatial frequency, for years there has been a theoretical dispute in perceptual theory over the unit size of images used in pairing the view from each eye. Is it the size of the object or smaller bits of information on the object? And it is true that critical spatial frequency differences between the eyes produce double vision. It is possible, then, to open up a discussion of the visual nature of a 'marked' surface to give Professor Wollheim's account further support from visual psychology.

Wollheim argues that representation rests on 'seeing-in' rather than the other way round. Given the perceptual grounding of his concept, representation would have to depend upon 'seeing-in' in the way he suggests. If the perceptual systems which give us the real world also give us 'seeing-in,' and if objects must be seen before they can be seen 'as' anything, then it makes little sense to say something must be a representation before it can be seen 'in' the world or 'in' painting. One would have to argue that perception in general is representational to carry the day against Wollheim or the psychological elaboration of his concept.

A final problem arises, however, in dealing with representation. Wollheim asserts that the Resemblance view of representation appears to be incorrect because it rests on comparison between a representation and a real scene and asserts that a viewer is judging a represented scene by virtue of some previous scene. Wollheim's 'seeing-in' disables this view on phenomenological grounds. The pre-epistemic nature of the perceptual analysis presented here argues against a deliberative comparison as well.

To be sure, Wollheim is correct, but there must be some visual similarity between the real world and the depicted world, *in some descriptive system*, if we are to hold on to his suggestion of biological grounding and causal traffic. The cognitive loading might be removed from 'comparison' in the Resemblance view to make it more visual. Or, more attention might be given to the Information view which Wollheim does not discuss in detail, as long as we are willing to accept that the descriptive language used for establishing the foundation of perceptual experience might use terms like linear perspective, spatial frequency, binocular disparity, contrast ratios, etc. Gombrich does a bit of this in *Art and Illusion*.

In any case, as Wollheim cautions us, it seems wrong-headed to say that representation begins with sign or linguistic link-ups, and then to project lexical foundations onto a visual rendition. Wollheim's example of the baby reminds us very well there are hard objects in the world which are seen before we have words to describe them. How else could we come to describe them? So, too, might it be with paintings.

DEPICTION AND THE GOLDEN CALF

MICHAEL PODRO

P AINTING'S own momentum in representing its subject, its control over the aspects of the world which it abstracts and combines – and which it transforms through its own procedures – has been the recurrent theme of critical commentary from Alberti and Vasari[1] to the present. What has varied is the way in which this momentum and transformation have been felt to demand commentary. Among the several ways Alberti conceived this transformation was on analogy with the co-ordination of parts within the structure of a sentence. And this is similar to Vasari's sense of *disegno*, the mind's grasp of things realized in the fluent delineation of them. It is that grasp of things, that continuity and assurance of thought that we find for instance in a drawing by Raphael where the spiralling rhythm registers and connects the complex forms of the Virgin's turning body, her foreshortened arm, the articulation of her wrist, and the torsion of the reaching child, and it does all this without loss of its own graphic impulse (plate 56). That sustained impulse in the drawing implies that all these details have been held in mind and the drawing has subsumed them within its own continuous movement. The thought in drawing and painting may not always be manifested by fluency: it may involve an accumulation of adjustments, self-monitoring, self-revising. Either way the subject is absorbed within the thought of the drawing – not the thought *about* the drawing, but the thought *within* the drawing. This point has been put forcefully by Andrew Harrison:

> How the maker of the picture made his picture becomes a way of seeing how he attended . . . [H]ow the materials were put together – partially re-enacts the pattern of his attention, and the attention to a

* This paper was originally given at a Royal Institute of Philosophy symposium at the University of Bristol and published in its proceedings, *Philosophy and the Visual Arts*, ed. Andrew Harrison, 1987, D. Reidel Publishing Co. In order not to produce variants of a substantially similar paper the text here corresponds to that in those proceedings. This bears upon the form of the paper which was concerned to link problems of critical interpretation in general with contemporary art and concepts of abstraction.

Plate 56 Raphael. *Virgin and Child with Book*. Drawing

possible, imagined, seen object he invites from us. He is at the same
time depicting an object and his attention to how the unorganized
units of his attention could be seen to be related . . . In so far as we can
regard the construction of a pattern or organization of material as a
testimony to the exercise of the thought of a maker, the expression of
his thought in making, we are thus led to see the depicted objects in
terms of that expression of practical thought with materials.[2]

This paper is concerned with a sense of abstraction, both in contemporary
and earlier painting – the sense in which the painting selects from, connects
and reconstructs the subject in the medium and procedures of painting; and,
because these things are indissolubly connected, it is concerned with the
way that the drawing or painting directs itself to the mind of the perceiver,
who sees the subject remade within it, sees a new world which exists only in
painting and can be seen only by the spectator who attends to the pro-
cedures of painting.

This sense of abstraction has had to maintain itself in constantly altering philosophic and other circumstances, just as painting itself has constantly to reconstitute itself under changing pressures and possibilities of pictorial imagining.

In the theoretical literature on depiction during the past twenty-five years – since the publication of Gombrich's *Art and Illusion*[3] – there have been two questions which have been paramount: how is it that we can convincingly show the look of the three-dimensional moving world on what we are aware of as a still two-dimensional surface; and – secondly – how does the presence of the surface and the facture of the paint enter our awareness of the subject depicted upon it. The arguments on the first issue have, I shall argue, been misleading and have confused attempts to answer the second.

What has characterized these arguments is that the two questions have been treated separately. I shall go along with this and suggest how we *can* answer the questions separately, but to answer the two questions separately is not to answer the question: '*what is the painter doing?*' The first two questions are about the conditions which make depiction possible, the critical question – critical in the sense of interpretative and in the sense of crucial – is how those conditions are utilized by the painter. The crucial question becomes the interpretative one immediately we are concerned with the art of painting; and not just some epistemological or phenomenological questions to which painting may give rise. I shall come to the critical question only in the third, fourth and fifth sections of this paper.

HOW EARTH COLOURS REPRESENT GOLD AND FLAT STILL PICTURES THREE-DIMENSIONAL OBJECTS

Let me start with the question of how we can see the three-dimensional moving world convincingly depicted on a still two-dimensional surface. There is the argument which starts off by saying that a flat canvas does not look like people dancing round the golden calf so that representation of the scene cannot be a matter of picture and scene looking like each other. And anyhow, even if two things do look like each other, it does not follow, just because of that, that one represents the other; the chairs we are sitting on are very alike but one does not represent the other. For one thing to represent another it must be intended to do so, and intended to be seen doing so, and this involves some social convention.

How then does likeness or resemblance enter an account of pictorial representation and what is conventional about it? The simple answer to this is that it is a matter of convention that we look at the surface of a painting to see what is represented on it. It is a matter of convention that we use flat surfaces to represent things by showing the look of those things. (The

limiting case would be one surface showing the look of another with edges coinciding and similarly figured, coloured and textured.) There are other ways of representing them by showing the look of things but that is one way of doing so, and it is a matter of convention that it *is* so. What is *not* a matter of convention is that we are *able* to do this. We are able to do this because we can exercise our ordinary capacities for recognition through difference and this is not a convention but the very substrate of our mental life. So our question becomes: how are we to give an account of the way we exercise the capacity for recognition in paintings without being deluded by them?

Let us look at Poussin's *Worship of the Golden Calf* (plate 57). To start with, consider the golden calf itself. The flat lustreless patch of painted canvas is unlike a gleaming three-dimensional piece of golden sculpture. So what kind of adjustment do we make in order to see the golden calf in the picture? First, let us observe, as Alberti would have done, that Poussin has not represented gold with gold.[4] He has not used gold leaf in representing the golden calf but dabs of ochre and umber paint.

This rather simple fact is exemplary of the way depiction works in two closely connected ways. First, by not representing the golden calf by gold, Poussin has restricted the extent to which the depiction can afford us experiences which the object itself would have afforded. For instance, we cannot experience the change of highlights as we change position in relation to the painting. This is something which a real shiny surface would provide. In looking at the painting we make a negative adjustment, restricting the kind of expectation we have of what will appear.

By not representing gold by gold, he has not *isolated* one property of the idol or scene at the expense of the other properties like the modelling of the calf, or its position within the surrounding space, or its brightness relative to other features within that space. So we have, on the one side, a loss of completeness with respect to one property – the goldenness – and on the other a gain in the extensiveness and cohesion with other properties can be shown. In depiction the degree of completeness with which any factor or feature can be represented is constrained by what other factors or features you want to represent. Short of constructing a simulacrum of your subject you have to make an interlocking set of sacrifices.

The adjustment which we make in looking at the golden calf in the depiction may serve as a useful parallel to the adjustment we make when considering the *spatial* relations within the depiction.

It has been a recurrent observation in a criticism of the past hundred years that a painting which appears to be flat yields not only the likeness of objects occupying a three-dimensional space, but even clarifies our sense of volume and spatial relations. There is nothing paradoxical about this. Just as we did not seek a complete experience of the golden surface of the calf at the expense of the idol's other properties, so when looking at a painting we

Plate 57　Nicolas Poussin. *Worship of the Golden Calf*

do not seek, in isolation, the look of the gap left by one thing being further back than another.

When an array of objects is depicted, and one characteristic of the array is that some objects are further back from the viewing position than others as Moses is further back than the dancing figures, those spatial relations of *in front* and *behind* are not given or sought in isolation from other properties. They come together with properties of shape and colour, of relative clarity and size, of the general look of what is going on. To make spatial relations in a painting recognizable and convincing does not require the presentation of actual gaps, any more than the application of gold was required to give the effect of goldenness to the idol. What gives spatial relations in a painting their conviction are changes of scale, the interruption of one form by another, degrees of clarity, the sense that one figure is looking or moving toward another.

These give determination to the spatial look of the array. They do not, of course, *cause* a two-dimensional surface to look three-dimensional, for observation of these features in this way already presupposes that they are being scrutinized to show us the look of – to give determinacy to the look of – a three-dimensional array.

What, then, makes spatial depiction possible is that we scan the surface of the painting to show us how something looks. To do this we follow the convention of making the marked surface the privileged object of our attention, and we adjust our attention to recognize the look of things that the marked surface can yield, accepting the limits to the similarity between the experiences yielded by the surface and by the object itself.

The adjustments we make are a matter of avoiding certain kinds of questioning to which the painting could not respond, restricting our search for experiences of the subject which it was not within the scope of pictorial representation to provide. But our adjustments are not only negative, but also positive. We seek to *use* features of the marked surface in order to resolve the subject.

Thus the figures in the distance on the left of the picture form a series in which each echoes and varies the others, their echoing and turning link the foreground dancing group with Moses. Our sense of the spatial as well as the dramatic relations within the picture is enforced and clarified by such positive relating and not only by avoiding inappropriate questioning.

Let us then take the dancing figures: seeing them in movement does not only require us to *avoid* trying to see the surface as in movement or the figures changing position in relation to each other, it involves our catching a sense of movement by attending to the way one figure echoes another, the posture of one intimating what the posture of another will become, and allowing the visual confusion of legs to suggest the perceptual uncertainties of looking at figures in movement. Even our perception of the golden calf

itself does not require negative adaptation only, we have to look hard to catch the sense of gold. It does not shimmer at all obviously.

But our sense of positive adaptation may be given a wider application. We have observed how a sequence set out in space may be seen as a sequence in time. We may enlarge upon this sense of adaption by considering the structure of Poussin's composition as a whole. There is an implicit movement which may be seen to run from upper right to the foreground and then back toward Moses in the distance. The propensity to see this movement is enhanced when we connect the composition with Titian's *Bacchus and Ariadne* (plate 58). (This was at the time in the Villa Ludovisi, where Poussin certainly knew it. He used features from it in other paintings and drawings. The milieu of Cassiano del Pozzo, in which Poussin worked, was deeply involved in archaeology and comparative religion as well as painting. There, not only would the visual relation to the painting by Titian have been clear, but almost certainly the connection between Bacchus and Apis, the bull-god of the Egyptians, would have been perceived. The fullest

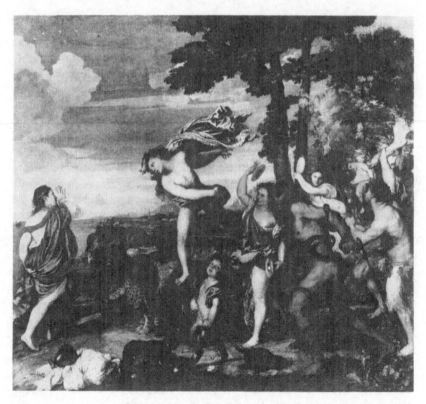

Plate 58 Titian. *Bacchus and Ariadne*

account of the episode of the golden calf relating it to Apis was in Philo
Judaeus' *On Drunkenness*, and that was certainly an available text. We are
thus not being capricious in reading the *Golden Calf* in the light of *Bacchus
and Ariadne*.)[5] In Titian's painting the movement sweeps down from
Bacchus' train on our right and forward to the leaping Bacchus himself,
then to Ariadne as she turns from looking out to sea at the departing sail of
Theseus. We surely have, and are meant to recognize, the echo of Ariadne in
Poussin's blue-clad dancer, and of the figure with snakes in the dancing
man. But I am concerned here first to suggest that we are required to
perceive, in both paintings, a sense of movement through the static
disposition of forms, and in doing so in the *Golden Calf* we draw not merely
on general experience of the visible world, but on our familiarity with
painting procedures and with other paintings.

HOW WE SEE THE PAINTING PROCEDURE IN THE SUBJECT AS WELL AS THE SUBJECT IN THE PAINTING PROCEDURE

We do not look at the painting just to see the look of what is represented on
it, but to observe the feat of painting, the way, for instance, the drapery of the
girl dancing in the centre has a complex articulation of curves and straight-
edged planes, or the way the overall sense of the surface has a leanness in the
handling of paint, with little differentiation of paint surface or distinction
made between the textures of objects. How are we to describe the inter-
penetration of our sense of the marked surface and the subject?

Talk of the surface may here seem problematic. Is the surface not taken
for granted as we look for the depicted appearances? To talk of our sense of
the surface may appear to be returning to the notion that attention to surface
and attention to the represented subject compete or are reciprocally
independent, while in our account we assume the opposite. So how do we
understand the relation of our perception of the painting's surface to the
recognition of what is represented upon it?

We need to conceive of the painted surface in two rather different ways.
First we can think of it as a material precondition of depiction; we scrutinize
the surface to recognize the look of trees, figures, or whatever the subject
may be. But secondly we need to conceive of the surface as itself having an
appearance – an appearance which interpenetrates or interplays with the
look of the depicted subject. But how, we may ask, is that possible? How
could the appearance of the surface be connected with the look of the
subject?

Let us first of all take a drawing by Poussin (plate 59): the look of the
figures is – in the sense we have been using – incomplete: we have to adapt,
negatively, in recognizing the figures in the drawing. We recognize the

Plate 59 Nicolas Poussin. *The Baptism of Christ*. Drawing. Chantilly, Musée Conde

figures in the alternating light and dark patches. These, in turn, also have a presence and rhythm of their own. But the presence and rhythm of the paper left bare and the shadows of ink do not simply co-exist unrelated to the look of the figures. The situation here is just like that in, say, Raphael's drawing of the Madonna with a book (plate 56), where the rhythms of drawing interpenetrated the figures. In such cases we want to say not only that we see the figures in the pen or brush marks, but that we see the pen or brush marks, or the intervals shadow and light, in the figures. There is, we want to say, a *symmetrical relation* between medium and subject.

But is it not perverse to say that seeing the look of figures in the shaded and black areas is symmetrical with seeing the shaded and blank areas in the figures? To start with, those shaded and blank areas are really there and the figures are not. But from this the relevant asymmetry is not shown. It is not shown because we are not talking about figures and patches of light and dark, but about the *look* of figures seen in the picture, and the *look* of the array of light and dark patches.

But this, it may be argued, is still not enough to establish relevant symmetry, because in recognizing the figures in the picture we recognize through difference, and what we recognize are figures in certain limited respects only. But the light and dark areas of the paper are not recognized in certain respects. They are recognized *tout court*. To this we reply that nothing is recognized except under a description – nothing is recognized unless it is recognized as something of a certain kind. Now, the description or kind under which the light and dark patches of Poussin's drawing are recognized is that of being a drawing procedure or a depicting procedure. We see the drawing presenting us with a marked surface of the kind we scan for depictions and scan in a particular way. The overall look of the drawing procedure is a look that is not exhausted or saturated by the recognition of the figures we see in it.

We want to say that the drawing is perceived by us as having a procedure which could revise itself to show different figures or figures in different positions: we recognize in the drawing procedure a consistency in its relation to the visible world, so that we can conceive it as able to pick out different situations in that world.

Just as in our perceptions of the visible world we are aware of a penumbra of features we do not make focal, and a sense of the alterations an object would reveal if seen in different perspectives, so in looking at a drawing we are aware of the procedure which could have other realizations. That is not to say it could have other realizations by our changing our relation to it: but that *it* could have *had* other realizations had it been aligned to an altered world or aligned to the world differently.

This perception of the drawing procedure is something to which we can direct our attention in looking at the figure which it represents to us. We can

look at the drawing procedure in the delineated figure. It is for this reason that it seems appropriate to say: there is a symmetry between seeing the figures in the patches and spaces and lines of the drawing procedure and seeing the drawing procedure in the figures which are represented by it.

HOW THE CONDITIONS OF DEPICTION ARE USED BY THE PAINTER: POUSSIN AND ALBERTI

If we have, at least in a schematic way, outlined answers to the questions how we can have convincing two-dimensional representations of three-dimensional objects, and how the surface can make itself present in the depiction, we now have to face the third question: how do we, the spectators, *use*, or how does the painter use, the interpenetration of the painting's real presence and the projected or imagined world?

Now we cannot regard these two factors as providing two distinct kinds of interest, linked only by their being causally interdependent. They form, in any painting that will concern us, part of a single interest, which we may term the painting's way of holding the subject in mind. We might put it in a slightly exaggerated way by saying that the subject becomes directed to us and we to it by both of us participating in a new kind of world, a world in which the relation between the spectator and subject is mediated by the art and procedure of painting; it requires a particular kind of attentiveness on our part and reveals the subject as it can be seen only in painting.

This may occur in very diverse forms: we see it in the way Poussin, for instance, in the *Sacrament of the Eucharist* (plate 60) leads us to see the lean procedure of painting as distancing the subject from us, as diminishing our sense of its corporeal presence, so that is appears in shadow, intimating its historical remoteness through the way it evades a sense of material tangibility.

In the *Golden Calf* (plate 57) itself we have a remarkable play upon the feat of painting within the content of the painting itself. Earlier in this paper I commented upon the way Poussin had not only *not* represented the gold by gold but had underplayed the sense of lustre. It has been an underlying feature of Alberti's prescriptions for the painter in the fifteenth century (of which we may assume Poussin to have been fully aware) that he must not allow detail to disrupt the coherence of the whole. The painter must not indulge in effects which would disturb the overall dramatic coherence, or deploy colours which, while matching their objects, would not conduce to the harmony of the whole: 'Even in representing snow-white clothing you should stop well on the side of the brightest white. For the painter has no other means than white to express the brightest gleams of the most polished surfaces . . .'[6] Now, in the *Golden Calf*, Aaron's robe is surely snow-white,

Plate 60 Nicolas Poussin. *Sacrament of Eucharist*

but it is not depicted with the brightest white, and this fact is actually demonstrated within the painting. The overall Albertian harmony of the picture is emphasized by the woman in the foreground whose skirt is, as it were, lit by the brightest white in contrast to Aaron's robe which harmonizes as her skirt does not, with the rest of the scene. She is a kind of choric figure looking back at the golden calf and possibly beyond. In one sense she is outside the picture as a whole and enforces the sense of the events being one stage removed from us, a sense which requires our recognition of the painting procedure.

But the mode of imaginative conviction produced by the interplay of subject on the one hand, and painting procedure on the other, may be very different. We have only to think of the way in which Rembrandt and his followers may depict something wrapped in shadow, so that the procedure of seeing the object in the picture (making the transition from objects in the real world including the canvas to the objects depicted on the canvas) is itself like the procedure of discerning objects in real shadow. Our sense of the painting procedure becomes itself an analogue of the efforts of perception in obscure circumstances: seeking the subject in the picture is rehearsed by seeking the subject in the shadows that surround it. (And on occasion Rembrandt will even point this up as when in one etching Jupiter gazes into the shadow that lies across the body of Antiope or leaves us, as in *The Holy Family* now in Amsterdam, puzzling over who is figured in the great cast shadow – plate 61.) Rembrandt, like Caravaggio, makes the very procedure of adjustment – of seeking the subject in the light and dark patches of the surface – take on a representational force; we can imaginatively use it to represent to ourselves the puzzlement of engaging with the obscure material world. In contrast to this, the mode of imaginative conviction achieved by Poussin in the *Sacrament of the Eucharist*, or even the *Golden Calf*, was of being removed, distanced from the graspable material present.

AUERBACH'S VARIATION ON TITIAN'S BACCHUS AND ARIADNE

Finally, let us turn to a contemporary way in which the interpenetration of the subject and painting procedure occurs, and with it another kind of pictorial conviction, that in the painting of Frank Auerbach.

There has been a deeply consistent feature of his painting throughout the past thirty years: he has worked continuously on his subject to produce not a view, but a summation of many perceptions. By the sixties the procedure had established itself of working over the canvas a hundred times or more, as well as doing innumerable drawings, scraping the canvas down more or less fully each time, and starting again, until in one final stage he could hold

Plate 61 Rembrandt. *Holy Family at Night*

the whole thing in mind in one continuous, sustained argument.[7] Let me take one example in which the complexity of the subject and the sustained continuity of the final painting are clear. It is a portrait of a regular sitter, J. Y. M. (plate 62), of 1972. The wide sweep which rises from her neck, through – or rather under – the line of the jaw, re-emerges at the side of the nose. It then bifurcates and defines the deep eye sockets, the edge of the paint catching the edge of the skull's cavity. Our sense of the brush's movement is informed by the volumes and movements of the head – which carry with it a sense of the movement of the whole body – and the head is grasped through following the continuities of the painting.

In some of his first work he had allowed the image to accrete: earlier stages were incorporated in later stages. And in a group of screen prints of the 1960s he sought to preserve an earlier stage and also recast the subject in a dark drawing across it. These are various modes in which he seems to have aimed at the summation of perceptions. The process of constant revision and then a final comprehensive formulation takes a striking form in his variation on Titian's *Bacchus and Ariadne* (plate 63), painted in 1972 as a commission for David Wilke.

Plate 62 Frank Auerbach. *Head of J. Y. M.* Oil on board, 71.1 × 61 cms

Plate 63 Frank Auerbach. *Bacchus and Ariadne*, 1971 (Private Collection)

A series of drawings (see plates 64, 65, 66 and 67) has been, in this case, preserved, which must have run concurrently although in no simple relation to development of the final painting. The sense of summation, of gradual stripping down, of changing the factors which become focal and their reconstruction into a work with its own driving movements can be followed through the drawings. It might be thought, of the painting itself, that it has so insisted on its own procedure as to remove the *subject* of the painting from us, in contrast, say, to the head of J. Y. M. But this would be to misperceive the painting. Rather, we might say that structures within Titian's painting have been excavated, drawn out and made palpable. For the subject of the new painting is not the subject of Titian's painting, but Titian's painting itself; Auerbach once referred to it as a portrait of Titian's painting. With Titian's painting in our mind we catch the twist on the body of Ariadne and the thrust that runs from the snake-man through to the erotic leap of Bacchus which dissolves in an ungraspable flash of movement.

There is a sense in which Auerbach's relation to Titian's painting is not unlike that of Poussin in relation to it: previous works are themselves constitutive of later works and previous perceptions and previous depictions are caught in the immediacy of the new performance.

Plate 64 Frank Auerbach. Drawing after Titian, *Bacchus and Ariadne*

MODERN ABSTRACTION AND OLD REPRESENTATION

But here someone might want to say that there is a gap between this twentieth-century painting and that of the tradition of painting with which I have assumed that it is continuous. It might be felt that I have sustained the sense of continuity between earlier representational painting and that of, in this instance, Auerbach by maintaining a very narrow focus – on the interpretation of the procedure of depiction and the subject depicted. And, so the criticism might run, that in maintaining this focus I have allowed fundamental changes in the appeal and interest of painting to go unremarked. And it might reasonably be asked: is it possible, within the focus that I have maintained, to analyse what has altered, most obviously, the 'more abstract' quality of the later painting in contrast to the earlier?

The view that this paper has so far assumed is that the exertions demanded by major twentieth-century painting are not that much greater or

Plate 65 Frank Auerbach. Drawing after Titian, *Bacchus and Ariadne*

less than those demanded by real attention to great seventeenth- or sixteenth-century or other painting. The gap may appear very great, however, for those who are less interested in how painting's transformation relates us, the spectators, to the subject in a new way. For those whose interest in paintings is in looking through them for confirmation and even celebration of what they already know and value, including what they know and value in painting of the past, the gap may seem enormous. It may even seem emphasized by critical talk about painting in the twentieth-century making a virtue of flatness as opposed to illusion, as if Poussin had not made a virtue of flatness – made the painted surface as surface into a potent psychological factor in establishing imaginative distance. The sense of a great divide between twentieth-century painting and earlier painting might be enforced by a sense that twentieth-century painting, in its demands upon us, no longer involves our social and religious or scientific life. That it has become, if not just mere paint, then mere painting. I do not propose to engage with this problem of the shifting relation of painting to other involvements in this century, but I do feel committed to enlarging on the

Plate 66 Frank Auerbach. Drawing after Titian, *Bacchus and Ariadne*

phenomenological character of painting in a way which may help to chart its diversities – including its diversities in this century – and to do so in a way which will preserve the sense of the continuity of earlier and later procedures.

The content of our perception of, say, a tree, involves not only a view or projection of it from a given position, it includes in its character for us (its *Sinn* in Husserl's terminology) a sense of the other view it would yield from other positions. It also includes a sense of other possible aspects we would fixate, other features we could make focal. These are parts of what Husserl termed a horizon of possibilities which an object of experience would yield, and the indeterminate sense of those possibilities is governed, for each of us, by our own general sense of how the world is; for instance, our sense of how objects are set and perceived within the spatio-temporal, causally ordered world, or our sense of the modifications a person's face or body may be expected to undergo as circumstances alter.[8]

Now, by contrast, let us turn to the perception of the drawing or painting of an object. What we perceive is not the object drawn but the drawing, and what we perceive *in* the drawing is a characterization or look of the object

Plate 67 Frank Auerbach. Drawing after Titian, *Bacchus and Ariadne*

drawn and the 'horizon' of that includes the belief or awareness that it could be used to show other objects, or other views of the same object or other features of the same view as salient.

The sense of the look of the depicted object does not saturate the 'look' of the drawing for us (we always see it as a drawing), any more than a particular prospect of an object saturates our sense of the object. In this way the perception of the drawing has a horizon of possibility that the object itself cannot have, and the contrary is also true. So, to put it summarily, the object (considered independently of the drawing) has as part of its character or *Sinn* one horizon of possibilities, and the drawing has another.

Not only do the drawing and the object have *different* horizons, but there is a clear sense in which neither can absorb totally the horizon of the other. Yet there also seems a sense in which the look of the object in a drawing, since it is the look of that object, must carry within it implications of what the object itself is like. To be a depicted head is not to be a diminished head. If we see it as a head in the depiction, it is seen as having sides that are hidden from us, textures we cannot discriminate, moves it would make if circumstances changed. That is simply a truth about being someone's live head, actual or depicted.

In our ordinary perception of objects, however, we are *free* to alter focus, to make now one aspect, now another salient – even to change position and catch another facet of the object. On the other hand, when we look at an object in a drawing, although we may alter our fixations on the *drawing*, we cannot alter our fixations on the object, because it is not really there. Only the drawing is there. In the case, then, of perceiving the real object there is, in principle, no restriction on how we alter our attention, how we realize other possibilities within the object's 'horizon', in the case of the object in the drawing, there is, and it is a central aspect of the painter's control to elucidate aspects for us.

The perception of a head in a drawing or painting is unlike our non-pictorial perception, not only because we are much less independent as to what aspects of the subject we make determinate, but because we are engaged in looking at something which is meant to be resolved in some particular way, while there is no special way the things themselves are meant to look.[9]

These are *conditions* of the painter's enterprise. And one part of his response to them may be to exercise potentialities of his depicting procedure in such a way that the image of the subject may resolve in a multiplicity of ways. They may be more or less disjoined, fuse more or less into one cohesive appearance, the cohesion may be more or less consistent in a literal sense, and it may elicit more or less ready recognition. At one – usually boring – extreme there is the visual pun, but more centrally and seriously the delineation may sustain a whole range of interpenetrating, reciprocally illuminating or disturbing aspects. A painting or drawing is for our perception an object in its own right. We explore *its* many facets for ways in which they may be revelatory of its subject and of its own internal organization which combines these facets.

REMARKS ON TWO CURRENT ARGUMENTS

Finally, I turn to two accounts of depiction to which I have throughout been indebted and which I have also been concerned to resist. I shall argue that they are accounts not of the art of painting but of the preconditions of that art coming into being.

When Richard Wollheim, in a supplementary essay in the second edition of *Art and Its Objects*,[10] distinguished what he termed 'seeing as' from 'seeing-in', he was distinguishing between the perception of an object's real properties and the perception of what we saw it representing, and this distinction he described as involving two different projects in which our perception may be engaged: scrutinizing what was present and looking at what was present in order to perceive what is represented or suggested.

Wollheim in this paper treated the perception of things represented in painting as a species of the genus 'representational seeing'. Included in the genus representational seeing would be such feats as seeing a landscape in the stains of a damp stone wall. And further, he distinguished the two projects, objective scrutiny and representational seeing, or seeing in, so that one excluded the other except in marginal cases. It must be emphasized here that he distinguished the two *projects*, making one project exclude the other: he did not, as Gombrich had done earlier, assume that there was a psychological incompatibility between seeing the actual surface and seeing the scene depicted on it. For Wollheim the incompatibility between seeing-*in* and seeing *as* was between two purposes. In discussing seeing-in, or representational seeing, Wollheim writes:

> Now in the grip of such experiences, the spectator enjoys a rather special indifference or indetermination. On the one hand he is free, if he wishes, to overlook all but the most general features of the things present. On the other hand, there is nothing to prevent him from attending to any of its features he selects: he may not give them full attention, but certainly he can give them peripheral attention. The source of this indifference . . . lies in the fact that his essential concern is with further visual experience, with seeing the battle scenes in the landscape, discrete from visual awareness of the wall or the stones.[11]

Now he does not think that this 'essential concern' with seeing the battle scenes in the landscape, and 'indifference' to the wall as such, adequately describes our perception of painting. For in our perception of painting we attend, in his account, to both the represented subject and the material which sustains it:

> Twofoldness becomes a requirement upon the seeing appropriate to representations but it only becomes a requirement as it acquires a rationale. For, if the spectator does honour the requirement, the artist can now reciprocate by undertaking to establish increasingly complex correspondences and analogies between features of the thing present and features of that which is seen in the thing present. There are the delights of representation.[12]

In Wollheim's account what distinguishes pictorial representation from our projection of landscapes and battles onto the stains on damp walls are two things. First there is a criterion of correctness, we try to see what was intended to be shown. Secondly, after the stage at which we leave the real nature of the surface or object a matter of indifference, as an added premium, we then follow the artist 'return one experience to the other.

Indeed he constantly seeks an ever more intimate *rapport* between the two experiences . . .'[13]

But this implies that the indifference to the real properties of the object is part of following the fiction, of looking for what is represented. This would contradict what we might term the *disegno* thesis – the thesis that we follow the formulating as a way of perceiving what is represented. Wollheim's account of the feat of representation by the painter, which is responded to in the representational seeing of the spectator, gives a logically secondary place to observing the material procedure of painting, and that procedure's relation to the depicted subject. It is as if this were a second project, which might follow upon the project of representational seeing.

It is *possible* that we may look at some surface to catch, or read off or register, the look of something not really present. In such cases we might, in Wollheim's sense, hold ourselves indifferent to the medium. But this is not a posture we adopt to depictions. For example, does recognizing bodily movement of the figure of the Virgin require or even allow us to be indifferent to the sweep of Raphael's line? To insist that it does would seem intelligible only if the line were thought of as a mere material mark rather than being perceived as the material in use within the representational procedure. We look at the painting as a depiction to resolve, not a surface in which to catch the likenesses.

If we start our consideration of paintings from the question 'how does the brute material world yield depiction?' we might answer, because in that brute matter we catch likenesses of things not present, and this might lead us to posit Wollheim's state of indifference toward the material substrate of the picture. (It is as if we were asking the question 'what is the origin of paintings?' rather than the question 'how do we look at painting?') But once we admit the notion of painting or depictions into our ontology and history, recognition would not imply a moment or mental purpose which was medium-indifferent, because in looking at a painting we would not look at it as a piece of brute matter but as the product of the procedure conducted to show the look of things. We should not have to disregard the material to see the depicted subject in it, for we should be seeing the material as a representational medium, under the concept of depiction.

It might be argued that although perceiving a landscape in a depiction is unlike seeing one in the stains of a damp wall, even when we examine a depiction the subject must still be seen and conceived as seen as distinct from the medium in which it is represented, unless we suffer delusion. But why must it? While aptly perceiving a depiction involves recognition – seeing similarity through difference – the difference is not a screen which we have to penetrate in order to grasp the similarity. We do not have to extract the common factor, for instance, when we see the look of the father in the face of the son. Although the epistemological ground of recognition is

similarity, and this must exclude what is not similar, it does not follow that recognition itself involves such an abstraction or indifference to what lies outside the limits of similarity.

We might rather conceive of recognition, with Merleau-Ponty, as the initial sense of familiarity which leads us to attend to the object before us in a certain way to fill out the sense of the objects upon which the familiarity was based. Similarity serves as the causal basis, but we look at the new object not at that basis.

In depiction, the features of the new object will not correspond in any simple one way with features of the old, but, like the sweep of the pen in Raphael's drawing, or the movement of the brush within the paint in Auerbach's portrait, have aspects which evoke the original in various ways: the pen stroke delineates the outline of the figure but also the sense of movement of the body, while the outline of the body did not itself carry the sense of the body's movement. We discriminate the pen mark to use it in two different ways, it makes two connections with the subject or evokes two different aspects of the subject by what we may term two different routes. Our capacity to do this, to allow aspects of the subject to emerge from the painting or drawing procedure in these diverse ways would seem to show how a sense of the procedure is pivotal and integral to our recognition. I am not offering this as a *proof* that medium indifference is impossible, but as *evidence* that it is alien to the phenomenology of depiction.

Kendall Walton's paper 'Pictures and Make Believe'[14] raises the problem in a rather different way. He took up the theme of Gombrich's paper of 1951, 'Meditations on a Hobby Horse',[15] which had made the basis of representation the use of surrogate objects. Walton's paper insists on the project which depiction serves: to provide an object in relation to which we can conduct games of make believe. These are distinguished from mere imaginative projections because they both depend on objective properties and have rules for what can count as a substitute for what. Walton's argument approaches the problem by distinguishing between literary and pictorial representation:

> A too easy explanation is that paintings or parts of them, look like or resemble what they picture – *Haymaking* looks like fields, peasants at work, haystacks and so forth ... [But] the resemblance between *Haymaking* and any ordinary peasants, fields and haystacks turns out on second thoughts to be exceedingly remote: the painting is a mere piece of canvas covered with paint, and that is what it looks like ... I shall propose a theory of depiction which does not itself postulate any resemblance between pictures and what they depict and so escape the objection to theories which do.[16]

Walton's theory does not go to the length of holding that resemblance plays no role in the games of make believe that constitute the art of painting. For instance he writes: 'What novel characters lack, if they do not happen to be pictured in illustration, is the possibility of being objects of make believe visual actions.[17] We must therefore assume that recognizing peasants in canvases, smiles on faces in pictures and so on are, for Walton, conducted *within* a rule of a game of make believe. To revert to the example Walton used in that paper, such recognition must go beyond initial stipulations like pebbles in globs of mud stand for currants in a children's game of mud pies. What Walton has insisted upon, is that our perception of the subject in painting is governed by a 'convention' of what we are about; furthermore, that convention relies on the notion of resemblance enabling things to serve as surrogates for make-believe activities. But what this leaves out is any role for the procedure, and the perception of the procedure of painting.

One feels the difficulty in Kendall Walton's earlier paper 'Categories of Art',[18] where he introduces the interesting concept of standard as opposed to variable properties of a given category or genre of art. The flatness of a Rembrandt portrait is something we take for granted, and does not therefore disturb our seeing the likeness of the three-dimensional head in the painting. And Walton goes on to consider qualities which are standard in given styles: 'A cubist work might look like a person with a cubical head to someone not familiar with the cubist style. But the standardness of such cubical shapes for people who see it as a cubist work prevents them from making this comparison'.[19] But surely the sense of the sharp planes of a cubist head, while not looking to us like the depiction of someone with an oddly shaped head, are not just taken for granted but enter into our sense of the depicted and transformed head, as the dabs of paint on Rembrandt's canvas enter there into our sense of the head. Walton allows that standard properties may be aesthetically relevant but, with respect to visual representation, appears to allow them only to be transparent or instrumental.

Whereas Wollheim makes the interest of the procedure of painting distinct but considers the need to relate it to what is represented, Walton leaves out of account how the use of the medium figures within our grasp of the subject depicted, and the way the interest of depicting enters into the project of make believe, the imaginative game which focuses upon a picture.

Walton, in his paper 'Looking at Pictures and Looking at Things,' says: 'We see more clearly now how serious a mistake it is to regard Cubism, for instance, as just a *different* system from others, one with different conventions we must get used to. It is a system which affects substantially the nature of the visual games in which the works function as props, quite apart from our familiarity with it. The difference I have described bears out the familiar characterization of Cubism as a more intellectual, less visual pictorial style, compared to earlier ones.' I want to say all pictorial styles

involve their own distinctive visual games and these involve the kind of the relation which we imagine ourselves as having to the subject of depiction by responding to the possibilities of the medium. What may be distinctive about Cubism are, first, that our synoptic view of the depiction may not be a make-believe synoptic view of the subject; second, that it makes our perceptual adjusting a comprehensive theme within the painting.

Notes

1 For Aristotle, see particularly *Poetics*, 1451b; for Alberti, *On Painting and the Sculpture*, ed. and trans. C. Grayson, London, Phaidon Press, 1971, 'On Painting' Bk. 2, and Michael Baxandall, *Giotto and the Orators*, Oxford, Oxford Warburg Studies, Oxford University Press, 1971, pp. 121–39; for Vasari, see particularly *Lives*, Preface to Pt. 3, and, in the technical prefaces, his chapter On Painting (Ch. XV).

2 Andrew Harrison, *Making and Thinking: A Study of Intelligent Activities*, Sussex, Harvester Press, 1978, pp. 184f.

3 E. H. Gombrich, *Art and Illusion, A Study in the Psychology of Pictorial Representation*, 2nd edn, London, Phaidon Press, 1962.

4 See Alberti, 'On Painting', p. 93.

5 *On the Adoration of the Golden Calf*, see A. Blunt, *The Paintings of Nicolas Poussin, a Critical Catalogue*, London, 1969, no. 26. On Poussin's relations to Cassiano del Pozzo, see A. Blunt, *Nicolas Poussin*, London and New York, Phaidon Press, 1967, pp. 100ff., and Francis Haskell, *Patrons and Painters*, London, Chatto and Windus, 1963, pp. 99–114. For Poussin's drawing from Titian's *Bacchus and Ariadne*, see Blunt, *Nicolas Poussin*, p. 59, and Blunt, *The Drawings of Poussin*, New Haven and London, Yale University Press, 1979, plate 115, for an adaptation of the movement of Titian's painting. On Poussin's use of Egyptian myths see Charles Dempsey, 'Poussin and Egypt', *Art Bulletin*, 45 (1963).

6 Alberti, 'On Painting', p. 91. I am indebted here to an analysis of Poussin's thoughts on colour and of his drawings by Oskar Bätschmann in his *Dialektik der Malerei von Nicolas Poussin*, Schweitzerisches Institut für Kunstwissenschaft, Zurich and Munich, 1982.

7 For the clearest account of Auerbach's own views on this, see C. Lampert, *Frank Auerbach*, Arts Council Exhibition, London, Hayward Gallery, and Edinburgh, Fruitmarket Gallery, 1978, pp. 10–23, and M. Podro, 'Auerbach as Printmaker', *Print Quarterly*, 2(4), (December 1985), pp. 283–98.

8 Edmund Husserl, *Ideas Pertaining to a Pure Phenomenology and to a Phenomenological Philosophy*, trans. F. Kersten, vol. 1, The Hague, Martinus Nijhoff Publishers, 1982, paragraphs 44–5.

9 This I take to be the real issue of the distinction marked by the title of Kendall Walton's paper 'Looking at Pictures and Looking at Things', in *Philosophy and the Visual Arts*, ed. Andrew Harrison, Boston, Reidel, 1987.

10 Richard Wollheim, *Art and its Objects*, 2nd edn, Cambridge, Cambridge

University Press, 1980, pp. 205–26. I have discussed this further, *Burlington Magazine*, 124 (947) (February 1982), pp. 100–2, and 'Fiction and Reality in Painting', *Functionen des Fiktiven, Poetik und Hermeneutik*, vol. X, Munich, Wilhelm Fink Verlag, 1983, pp. 225–37. A response to this paper by Max Imdahl, '"Kreide und Seide" zur Vorlage "Fiction and Reality in Painting"', appears in the same volume, pp. 359–63. This prompted the argument in the second section of this paper. The notion of a symmetrical relation between medium and subject is one called for by Imdahl's criticism.

11 Wollheim, *Art and its Objects*, p. 208.
12 Ibid., p. 219.
13 Ibid., p. 224.
14 Kendall Walton, 'Pictures and Make Believe', *Philosophical Review*, 82 (1973), pp. 283–319.
15 Reprinted in E. H. Gombrich, *Meditations on a Hobby Horse and other Essays on the Theory of Art*, London, Phaidon Press, 1963.
16 Walton, 'Pictures and Make Believe', p. 303.
17 Ibid.
18 Kendall Walton, 'Categories of Art', *Philosophical Review*, 79 (1971), pp. 334–76.
19 Ibid., p. 345.

Poussin and the Rhetoric of Depiction: A Response to Michael Podro

Timothy Erwin

> They sat down to eat and drink, and rose up to revel.
>
> Exodus 32:6

In his paper 'Depiction and the Golden Calf' Michael Podro offers the persuasive argument that for several reasons it has become difficult to recognize an inherent symmetry between the subject matter of a painting and our awareness of its medium. That criticism should have arrived at such an impasse is odd, since the symmetrical relation of subject and medium, what Podro calls 'the *disegno* thesis', has always been a basic condition of the artist's enterprise. Podro wants to show how convention, perception, and, especially, technique allow us to recognize the artwork as a meaningful representation and at the same time as a material depiction. Convention alone cannot engage this sort of double vision, nor is it finally a matter of passing through one preliminary stage of looking to attend more carefully to another. What, then, are the technical means through which the viewer not only grasps what the painted surface is meant to depict, but is actually enabled to co-operate with representational compromise in elaborating meaning?

The sheer ambition of this question invites a variety of responses. The essay belongs to a larger project the aim of which is to understand what exactly the art of the artwork is when we define art as in part the demonstration of artistry.[1] It takes what Michael Baxandall terms (with a modifier one is grateful to have glossed) a 'nomological' approach to the artwork, one 'concerned with general laws', as opposed to the teleological approach concerned with the purposive reconstruction of the artwork.[2] The laws invoked here bring a psychological *Gestalt* to bear on aesthetics and describe a double mediation: the relation between the traditional harmony of painting and the tacit strategies adopted by its interpreters is referred back to the prior relation of the thing drawn to the act of delineation, to the

critical stage that Arthur Danto has recently called disinvention. Indeterminacy enters these relations because representational choices are inherently ambiguous, and because viewers with different habits of mind respond in different ways to the artwork. And history comes into play because often the choices artists make are either cast into relief by earlier versions of the same or related subjects, or else are reflected in the visions of contemporaries, ours or theirs.

Suppose we begin by placing the term *indeterminacy* outside history, putting Poussin to one side to create a continuum with, at one end, the Magdalenian bison, and at the other the seeming zero-degree intentionality of a work of abstract impressionism. Anyone comparing these two artefacts would be hard pressed to argue with the assumption, well-worn as Podro remarks, that painting has shifted away from extrinsic and towards more intrinsic concerns. A common-sense way of expressing the difference would be to say that in some mundane sense the action painter is less purposeful in his actions. Where no finished view looms, the artist finds a way of proceeding. Another way of marking the difference is to say that the action painter works with a profound sense of indeterminacy, where *indeterminacy* implies not less intentionality but a difference in the quality of the intentions that enter the artwork. Both positive and negative in its implications, the term refers to the beholder the role of determining meaning by resolving tacit conflict. Where the target practice of the cave artist testifies to an effort to remain within the world, for example, and the action painting of a Joan Mitchell or Jackson Pollock, say, incorporates a personal gesture of turning away from the world, both are nevertheless indeterminate. And in part because the turn to indeterminacy is itself intentional, the categories intersect. The painter of the Magdalenian bison allows the convention of the rough cave wall to prefigure his outlines, making for a somewhat indeterminate purposiveness, and the action painter is at some point satisfied with the visual demonstration of personal experience, making for a purposeful indeterminacy.[3]

One essential aspect our antipodal artists share with the seicento is a movement from the virtual thought or feeling to the actual artefact, a movement from theory to practice or – as mannerism had it – from an internal to an external design. We might imagine a thoughtful and creative vector which extends from the mind of the artist, through the formal outlines of the charcoal sketch, into the space of the finished painting. Where the imagined idea guides the master's hand across the two-dimensional surface, it traces formal designs to be tested first against the rules of perspective and proportion, and then against the artist's own instincts, in confirmation of the persuasive realization of a three-dimensional world. We are left with what a contemporary of Poussin, the poet Lovelace, called contemplation into matter brought. The symmetrical

relation that Podro describes is traditionally located, I believe, where the viewer joins the artist in critically confirming the realization of intention by testing depiction against a regulated nature and again on the pulse of experience. We reach the critical mass of symmetry, an historical constant, whenever the mind of the viewer adopts a vantage from which it can seriously agree or disagree with the painting on some *tertium quid*. Whether we are looking at the subject within the medium, or the story within the subject, the artwork is understood both as rhetoric and as an artful statement about something.

Of course, the historical fact that most viewers limit themselves to the register of appreciation is disappointing, but there is compensation in that rhetoric is most prized as invisible when its descriptive terms are most numerous. If the rhetoric of depiction is most compelling when we are least aware of it, during the brief moment when, in Dryden's phrase, nature comes out to meet the pencil in the draught, the tacit forms of understanding depiction remain for all their momentary transparency numerous and suggestive in the aftermath. The terms may vary according to convention, forging new modes of perception, but some such rhetoric is universal. The handprint of the cave-artist beneath the bison indicates the angle of approach to be taken during the hunt, the signed and completed work of abstract expressionism represents the moving record of a recognizable if complex emotion, the handprint and signature alike reveal the prior ostensivity of use, propriety, intentionality.

One of the most striking features of the *Worship of the Golden Calf* is its literariness. Norman Bryson, Wendy Steiner, and others have brilliantly traced into post-structuralist thought analogies of figural movement or colour in painting to verbal syntax in poetry.[4] On this view the decision to depict the calf without gold pigment rests along the paradigmatic axis of representation, like a metaphorical absence bearing negative implication, one sort of literariness. The same sort of representational choice can be seen to rest along the syntagmatic axis and to carry positive implication. Poussin depicts Aaron in a light-coloured robe, for example, where scripture specifies that his robe be polychrome. Until we learn that it is the robe of the Egyptian priesthood which is the colour of light, the violation of scriptural narrative remains relatively indeterminate. A narrative literariness, in other words, partly determines the extent of the transgression enacted by Aaron. On this view the analogy between painting and poetry shifts away from word and image and towards *ordonnance* and plot, where the central figures are likened to dramatic protagonists, their gestures to speeches, and so on. The view is in fact close to the generic analogy of the French academy between *istoria* and dramatic epic, and our informants are in turn three academicians close to the sensibility of Poussin, each concerned with one aspect of history painting: Giovanni Bellori its iconography, Charles Lebrun its drama, and

André Félibien their dialogical interaction. While the academic approach transposes the interplay of medium and subject to one of subject and narrative, a distinction of primary and secondary forms is maintained on the supposition that iconographic representation is relatively elemental to painting and dramatic narrative relatively removed.

The main narrative problem posed by Poussin's *Worship of the Golden Calf* is the way the dancing figures at center inexplicably intrude on scripture. Poussin interrupts the account in Exodus with a scene of revelry, and he allots the scene a pictorial space wholly disproportionate to the single sentence that authorizes it. An indeterminacy thus comes between the depiction and its narrative source. Like the colouring of the calf, the ritual dance opens onto a breach in the repertoire we bring to the painting. What sort of expressive and narrative rhetoric animates the dancing figures of Poussin's canvas? Is this revelry without a cause? the dance of an undisclosed ideology? the carnivalesque with a vengeance? We should be able to ask the *Worship of the Golden Calf* to tell us what men and gods and maidens these are with some hope of answer. Directly to the right of the dancers is a space crisscrossed by gaze and gesture, and therein lies a tale.

As Podro points out, the scene of revelry draws upon the Serapis cult of Ptolemaic Egypt, a connection already conventional in paintings of the golden calf.[5] In brief, the bull-god Apis represents the soul of Osiris, the god of death and rebirth who had passed into the underworld to be annually restored to life in symbolic ritual. Aaron has evidently adopted the devotion during the absence of Moses. Viewers would recognize that Poussin recounts the story from Exodus as neoclassical tragedy, casting Aaron and Moses as heroic antagonists. Moses has already interceded with Yahweh on behalf of the Israelites, and is about to break the second tablet of the decalogue. Where his recognition is nearly complete, Aaron's has not begun and full reversal is yet to take place. Most viewers would also know that while the episode leads to the destruction of the idol and the death of the unrepentant, it concludes happily with the establishment of the Ark of the Covenant. Indeed, the painting limits its own tragic potential by recognizing that the anger of Moses with Aaron is soon assuaged.

Perhaps the intrusive ritual involves a deeper conflict. Poussin would have learned the rudiments from Cartari: the priest would seclude himself in a cave until before the rising of the moon, and would then emerge to grasp the idol by the horns, symbolically compelling the moon to follow the sun in its circuits. Cartari includes an illustration of the ritual (plate 68) that may have suggested both the bare tree on the right and behind it the elevated rocky outcropping with its cavern.[6] Among Cartari's sources is Plutarch, who relates the myth relived in ritual. When Osiris was murdered by his brother, the body was set adrift in a coffin that settled in a tree. After much searching Isis, wife of Osiris, recovered the body and through their

Plate 68 Vincenzo Cartari. *Priest of the Serapis Cult*

posthumous union a son, Harpocrates, was born. Eventually Isis fashioned
fourteen images of her husband, distributing each as if it were the entire
body and establishing the worship of Osiris throughout Egypt. In the loosely
Dionysian theme of dismemberment, Plutarch recognized the periodic
waning and reappearance of the moon.[7] Poussin makes the same con-
nection: a primary symbol of Apis is the crescent moon emblazoned on his
flank, a detail that Poussin displaces to the crescent swag of the platform,
now coffin-shaped to invoke the death-and-resurrection theme of the cult.
He also departs from the earlier versions in showing the right foreleg of the
bull raised in a sign of strength, and again in setting the effigy further back
on its platform so that Aaron can mount the altar. In all these features, as
well as in dressing Aaron in the robe of the Osiris festival, a robe that
Plutarch remarks is 'the colour of light',[8] Poussin moves in a relatively
determinate way deeper into oriental mythology.
 The iconography is only occasionally so exact. More often it frustrates the
identification of individual figure with mythological character or attribute,
and distributes the allegory in motifs and themes selectively throughout the

scene. Harpocrates was understood to be weak of lower limb,[9] for instance, as the male dancer with his back to us seems to be, and on a slight misreading of Plutarch supported elsewhere might also be understood to be indirect in his gaze, like the same figure. Like the child to the right in the family group, however, he was also traditionally shown with his finger at his mouth.[10] Poussin divides the iconography of Harpocrates between the two figures he places nearest us. According to Plutarch, Harpocrates was the 'patron and teacher of the rational insight concerning the gods, which is still young, imperfect and inarticulate among men'.[11] The implication is that the viewer should share in the docile nature of Harpocrates, entering the dance with tractable reserve or turning away from it altogether.

Likewise, the female dancer with arms outstretched is moved by the proselytizing spirit of Isis, the bride of Osiris, while the woman seated closest to us displays later attributes of Isis, maternal and pacifying qualities. Again Poussin implies that with the return of Moses the ritual power of the goddess will be transmuted into another ideal. If images like these inform a certain theological drift, others resemble perceptual tricks elaborated for their own sake. It is impossible to tell whether the curve of the idol's left hindleg is intentionally lunar, or whether the dancers' limbs fanning outward from the base of the altar are animated by the *disjecta membra* of a lost hymn to the mutilated Osiris, or whether their draped torsos and linked arms do not outline a bull's skull, shaping an image of the clay sculptures which lined temple walls. Finally to lose oneself in the rhythmic dance of the images for what Panofsky termed their intrinsic meaning, iconologically, is to watch interpretation evanesce into indeterminacy and to remain un-settled.

If these mythological ruminations help to answer the Keatsian puzzle of identification, they remain silent about the way the clash of narrative articulates dramatic conflict. For one thing, the emotions are complicated by both the ritual lament of the cult and the joy of deliverance expressed in the pendant of this painting, Poussin's *Crossing of the Red Sea*. For another we have little sense of motivation, of what disturbs these souls, to paraphrase Alberti. For a connoisseur of the intrinsic like Bellori, these are peripheral matters. His ekphrases place us securely within the frame by reading the *affetti* off the faces and gestures of the figures, and by painstakingly translating emotional states into a series of vivid gerundive clauses subordinated to central figures. Bellori remarks on a related occasion that Poussin stores his invention admirably with such emotions.[12] Improbably, Bellori also attributes unity of expression to a wide variety of motives, so that a single emotional complex leads from the anger of Moses to the excited gestures of the figures on the right. According to Bellori, the half-hidden figure in the middle distance on the right, worshipping the idol with arms raised and palms upturned, in the alien sign of the *ka* or ancestral deity,

would be like the crest of a rising wave of emotion wholly involved in the local drama of blasphemous supplication and attendant threat of divine wrath. Clearly, he is not.

Where setting lends emotion probability Bellori often begins and ends in landscape, and here he might observe that Poussin arranges the dance of the revellers and worshippers, together with the biblical wilderness surrounding them, in a circle the furthest rim of which is the horizon. In order to notice more we must step outside the circle of *affetti*. An instrument of oriental worship, the tambourine on the left at once punctuates the ceremony, signifies the organization of the canvas, and connects the *ordonnance* to a cosmology in which the circle of the horizon joins the heavens to the underworld. The three arcs of the proximal semi-circle link Moses and Josue at the foot of Mount Sinai to the dancers on the left, the dancers to the left to the central group, and the central group to the many seated, kneeling, or standing worshippers at right. The arc at right is actually a double one. In one sweep it connects the female dancer poised just beneath the head of the idol to Aaron, and leaping a spatial gap we shall return to, connects the male dancer through the family group to the rest of the Israelites in the other.

Where Bellori charts a choric progress, Lebrun describes an episodic movement that proceeds by a principle of contrast. In an academy lecture Lebrun proposes that we locate the key figure in a group and follow its movement through the other groups, as if passing temporally from event to event.[13] Reading the canvas as dramatic action we take the mother on the right for our beginning; she gazes in the direction of Moses, whose extended stay on the mountain has led to the present dissatisfaction. Iconographically, as we saw, the mother and her charges point towards the future, perhaps even towards the madonna. In her wish that the overdue Moses return, however, the mother embodies the dramatic cause of the ritual, and from the perspective of agency must represent the immediate past. The doubling of the temporal dimension requires a twofold vision at the level of narrative, analogous to the simultaneous awareness of subject and medium which Podro asks us to recognize in painting proper. More than the well-chosen moment with its slight temporal shading, two very different time zones are engaged in a complex narrative *Gestalt*. The result is a vast extension of Lebrun's programme: a single group of figures represents the past as emotional entry onto the main action, the present as continuing resistance to alien ritual, and the future as the allegorical demise of idolatry.

Lebrun was no doubt aware of the irony of the designation 'history painter', and recognized full well that the idealizing conflation of earlier and later events in simultaneous narrative made the painter more poet than historian. Although he never describes the full extent in painting of what Herrick called time's 'trans-shifting', he does provide a complex link

between key figures and the unfolding drama. Among our dancers, for instance, the female figure becomes central because she has the more dramatic role; the male figure only comments upon the action, as it were. To take Lebrun's principle of contrast beyond the strict notion of dramatic unity is to see that both figures actually link the dance to another emotion or action meaningfully. Where the male figure leads us through the maternal group to the worshippers on the right, the female figure refers the gaze through an inner arc to the ritual gestures of Aaron. In separating the hieratic rite from its observers, Poussin underscores the prior conditional promise of God to Moses that 'if you hearken to my voice and keep my covenant . . . you shall be to me a kingdom of priests' (Exodus 19:5–6). Aaron lapses into a foreign ritual that separates the priesthood from the surrounding worshippers. In the negative implication of the spatial gap the two narratives of mythic history and local drama intersect, and the disruption of scripture by oriental myth is in turn disturbed by Old Testament prophecy.

Somewhat paradoxically, the schematic precision of Lebrun has opened the narrative dimension of the canvas onto indeterminacy, the indeterminate extent to which our mythological, dramatic, and allegorical narratives complicate one another in shaping tragic resolution. With its talk of the wandering gaze the discourse of Lebrun can sound remarkably modern; especially welcome is his invitation à la Wollheim to let the gaze enter the canvas and stroll among the figures.[14] Félibien accompanies us since his summary dialogue with Pymandre in the Entretiens recycles the prescriptive rationality of Lebrun in more discursive form. In a caution which glances at Lebrun, for instance, Félibien warns that the claim of discovering intention may be a way of cloaking opinion in borrowed authority.[15]

Now, to move into the space of narrative interruption is to pass among dramatic and allegorical turns of plot, through what both Lebrun and Félibien call 'peripeties', directly into the contest of revelry and scripture, and toward critical symmetry. One concern of the painting must be to censure not so much ritual itself as the modern separation of laity and priesthood in religious observance, understanding observance to consist broadly both of ritual and of the commandments it preserves. Quite as if pointing the lesson, the contested space leads the viewer to a robed deacon who prepares to help Aaron to mount the altar. In terms of the new covenant, the figure implies the positive counter-example of the apostle Peter – already named, incidentally, in the rock on which the tambourine rests.

For the seventeenth-century viewer an allegorical second step into picture plane would have been hardly necessary, so heavily did the present as future function as interpretive counterweight. Signs that the mythic drama concludes with the equilibrium normal to tragedy are all about. The

iconography of the flourishing tree that sprouts from the broken fragments of the tablet, and of the dome-like tent rising on the far right, ensure the conditional continuity of old and new covenant. So assured is Poussin of the narrative conventions of allegory that he inverts them by substituting for the expected closure of allegory a novel allegory of closure. In the twofold way we have been reading the painting, allegorical closure would propose, tactlessly, that Poussin replace Aaron's assistant with a figure identifiable as an apostle. In a reversal of expectation Poussin undercuts convention by introducing a figure who seems at once a deacon and, curiously, a stage-hand. The same figure who prepares to help Aaron to mount the altar also seems about to dismantle the theatrical scenery that is the altar, and to glance back towards a bearded figure for permission to do so. In an unusually performative gesture, the bearded figure indicates that we the viewers are still looking, and tells the stagehand in effect to maintain the dramatic spell for as long as the pictorial illusion lasts. The colloquy takes place in a quiet dialogical *koine*, and its gazes and gestures run like a subplot against the monocular grain of dramatic contest. A figure mirroring the viewer studies the stooping figure with a familiar expression, and his absorption in the theatricality of the scene, to borrow Michael Fried's terms, lends our interest in the figure determination. In another interesting displacement, the female dancer seems inadvertently to crown the deacon-stagehand with a metaphorical laurel like the literal laurel she herself wears.

The French academy named Poussin its laureate partly because his art achieved all the complexity and seriousness of epic poetry. In assuming the role of stagehand and in deferring on the matter of closure to the viewer, Poussin teases us into indeterminacy with a modest yet compelling rhetoric. It would be hard to imagine a more convincing argument for the abiding symmetry between subject and medium than this portrait of the artist caught between the completion of reversal, as technician, and the extension of interpretation, as allegorist. Something of the unique immediacy of painting is inevitably lost in such narrative interplay, but much is also gained in extending the duration of depiction. Considered as a system of symmetrical relations referring finally to the worked surface, the subject may involve many different dimensions of interpretation, ranging from the relation of clergy to laity in seventeenth-century France to the (in)determinate uses of pictorial space and even to distant social commentary. A century after the painting was finished, Alexander Pope criticized the Walpole ministry by conjuring up a scene of universal greed gone mad, a scene also involving revelry and an idol:

> Our youth, all liv'ry'd o'er with foreign gold,
> Before her dance; behind her crawl the old.

The passage is meant to recall Poussin even if it muddles the gender of the calf for the sake of an association with Brittania. No one has taught us more about the way the history of interpretation informs art historical practice than Michael Podro. The lesson that interpretive history always informs our understanding of the artwork, whether we acknowledge it or not, is his, and so is the lesson that we had better acknowledge it. We cannot really know what the full subject of the artwork is until other informing histories, the history of narrative among them, have also had their say. For its part poetic narrative has long felt the fascination of pictorial design.

Notes

1 See Michael Podro, *The Manifold in Perception: Theories of Art from Kant to Hildebrand*, Oxford, Clarendon Press, 1972; *The Critical Historians of Art*, New Haven and London, Yale University Press, 1982; and also his 'Art History and the Concept of Art', in *Kategorien und Methoden der Deutschen Kunstgeschichte, 1900–1930*, ed. Lorenz Dittmann, Stuttgart, Franz Steiner, 1985, pp. 209–17.

2 Michael Baxandall, *Patterns of Intention: On the Historical Explanation of Pictures*, New Haven and London, Yale University Press, 1985, p. 12.

3 On indeterminacy and interruption in literary theory see Wolfgang Iser, *The Act of Reading: A Theory of Aesthetic Response*, Baltimore, Johns Hopkins University Press, 1978, pp. 170–82, in part a revisionist critique of Roman Ingarden, *The Literary Work of Art*, trans. George C. Grabowicz, Evanston, Northwestern University Press, 1973. More historical concepts of indeterminacy or rupture are found in Hans Robert Jauss, *Toward an Aesthetic of Reception*, trans. Timothy Bahti, Minneapolis, University of Minnesota Press, 1983; and in the Marxist perspective of Pierre Macherey, *A Theory of Literary Production*, London, Routledge and Kegan Paul, 1978.

4 Norman Bryson, *Word and Image: French Painting of the Ancien Regime*, Cambridge, Cambridge University Press, 1981; Wendy Steiner, *The Colors of Rhetoric: Problems in the Relation between Modern Literature and Painting*, Chicago, University of Chicago Press, 1982, and also her *Pictures of Romance: Form against Context in Painting and Literature*, Chicago, University of Chicago Press, 1988. On the ideological differential of the sister-arts analogy see W. J. T. Mitchell, *Iconology: Image, Text, Ideology*, Chicago, University of Chicago Press, 1986. The classic critical essay on the timebound nature of rhetorical terms is Paul de Man, 'The Rhetoric of Temporality', in *Interpretation: Theory and Practice*, ed. Charles S. Singleton, Baltimore, Johns Hopkins University Press, 1969. Perhaps the most detailed study of temporality in narrative is Paul Ricoeur, *Time and Narrative*, trans. Kathleen McLoughlin and David Pellauer, 3 vols, Chicago, University of Chicago Press, 1984–8.

5 See the version by Pinturrichio, for example. In 'Poussin and Egypt', *Art Bulletin*, 45 (1963), pp. 109–19, Charles Dempsey traces the ceremony of the Serapis cult in the artist's *Holy Family in Egypt*, and notes that Poussin refers to the ritual in a letter.

6 Vincenzo Cartari, *Imagini dei Dei degli Antichi*, Venice, F. Ziletti, 1580, pp. 71–3. The priest '*teneva con ambe le mani à forza un bue . . . per le corna*' (p. 71). The eye and scepter of the illustration signify Osiris.

7 Plutarch, *De Iside et Osiride*, ed. John Gwyn Griffiths, Cambridge, University of Wales Press, 1970, pp. 173f. The Egyptians, writes Plutarch,

> prepare a crescent-shaped chest because the moon, whenever it approaches the sun, becomes crescent-shaped and suffers eclipse. The dismemberment of Osiris into fourteen parts is interpreted in relation to the days in which the planet wanes after the full moon until a new moon occurs (185).

8 Ibid., p. 241.

9 Ibid., p. 147.

10 Ibid., p. 225.

11 Ibid.

12 '*Di tali affetti*', writes Bellori, Poussin '*riempì mirabilmente la sua invenzione*'. The reference is to the first of the paintings titled *Moses Striking the Rock* in the 'Life of Poussin' from Giovanni Pietro Bellori, *Vite dei Pittori, Scultori, ed Architetti*, 3 vols, Pisa, N. Capurro, 1821, vol. 2, p. 161.

13 Charles Lebrun, *Conférences de l'académie royale de peinture et de sculpture*, Paris, F. Leonard, 1669, pp. 76–107. The sixth lecture treats Poussin's *The Israelites Gathering the Manna*. Lebrun divides his analysis into four parts, devoting most of his lecture to the first, general disposition, and treating the principle of contrast under that heading.

14 Ibid. Of Lebrun the author writes: '*Ce qu'il appelle parties, sont toutes les figures séparées en divers endroits de ce Tableau, lesquelles partagent la veuë, luy donnent moyen en quelque façon de se promener auteur de ces figures, & de considerer les divers plans & les differentes situations de tous les corps, & les corps mesmes differens les uns des autres*' (p. 83).

15 André Félibien, *Entretiens sur les vies et sur les ouvrages des plus excellens peintres*, 4 vols, Trevoux, 1725, vol. 4, pp. 128–9.

6

DESCRIPTION AND THE PHENOMENOLOGY OF PERCEPTION

ARTHUR C. DANTO

FROM whenever it was that sense-perception was accorded a degree of cognitive weight and not merely dismissed as the avenue through illusion, and cognitive disorder infected rational intelligences which would on the whole have been better off without it (as the body itself was regarded as something with which we are afflicted and must merely learn to endure, like a dark presence) until about 1952, when Wittgenstein's thought entered the mainstream of philosophical reflection, perception was regarded as something independent of language, something that furnishes the understanding with its entire content invariantly as to whether that understanding belongs to an intelligence equipped with language or not. The chiefly British, master philosophers of perception, if they thought of language at all, did so in terms of naming: words designated ideas, and ideas by and large were but copies and residues of sense impressions, and so the word – or sign – would be an outward, largely conventional noise or mark which stood for, or expressed what was there, in the understanding, without benefit of verbal representation. The perceptionists, if I may so designate them, did not ascend from names to propositions in their rudimentary reflections on the subject, and so the units of understanding would be components in a mosaic, or the mosaic itself – an elementary concept answering to simple sense-experience, or a higher-order concept consisting in a constellation of these which may, in the aggregate, answer to no actual sense experience at all. A case in point is the concept 'unicorn', whose components indeed refer us to elementary experience but which as an aggregate, and despite having a name associated with it, answers, alas, to nothing experienced in our impoverished zoosphere.

Words, then, were associated with perceptions, and association itself is about as weak a relation as there is. But the higher order concepts – the compound ideas of Locke and Berkeley and Hume – were themselves associations of simple, autonomous experiences which in no sense co-penetrated one another, and varied in absolute independence of one

another. One might think of the sensory array as a matrix, the cells of which answer to the various sense-modalities – sight, smell, taste, sound, the like – and no entry in a given cell determines or is determined by whatever is to be found in a different cell. The content of any given cell consists of things capable of being named but not defined, and these perceptual atoms are, borrowing a term from the formal sciences, primitive, or basic. The thought would have been that a higher order concept is an association of externally adjoined basic concepts, and that any term designating a higher order concept is itself definable, 'without remainder' as the expression went, as a conjunction of basic terms. 'Apple', to use a standard paradigm, is defined by terms (in English) like 'red' and 'round' and 'tart', which in turn designate basic ideas distributed across a matrix. Color does not determine shape, or shape taste: an apple could be red but cubical and sweet, or it could be bitter, but red and round, and so on. The blind man, frequently discussed in seventeenth- and eighteenth-century theory, possessed a matrix reduced by a single cell; and given the externalist view, nothing in the other cells would enable him to understand 'red' – but otherwise his experience of tartness or of texture was in no way affected: his understanding of smoothness was of a piece with that of the sighted.

I suppose the perceptionists were afflicted by what Derrida came to call the 'metaphysics of presence', but so must the Phenomenologists have been, in as much as it was specifically with reference to one of Husserl's *Untersuchungen* that Derrida introduced, diagnostically, this dread epithet. All the metaphysics of presence seems to me to mean is that notion of independence, of atomicity, accepted by the tradition, according to which a given experience could be just as it is, whatever the case elsewhere in the perceptual array. Even so, it cannot have been epidemic among the phenomenologists, for their classical work on the subject, Merleau-Ponty's *The Phenomenology of Perception*, is precisely an attack on the modular conception of the perceptual array. For Merleau, the various modalities co-penetrate to the point where the sounds and smells of the blind must differ from those of the sighted, and, though he is reticent to draw any inferences regarding language, it must equally follow that the language of the blind must differ, in as much as the meaning of 'tart' or 'hollow-sounding' cannot mean the same for the modally deprived as for the modally normal. But in fact Merleau has very little to say about language, though he is innovative in his remarks about speech. So his account merely is what we might call internalist so far as the perceptual array is concerned: any visual perception is penetrated in some way by the other modes, so that one can see the wetness, or taste the shape, or hear the color in at least the sense that sight, taste, and hearing would be different if we were modally deficient, or if our history of perception in other modes were different; but in any case perceptual experience is, according to him, a densely felted fabric in which

the various modalities are always present, even if we lack a good relational term to express the way they are in mutual presence without being metaphorical. All this being said, he was still an externalist in terms of the relationship between phenomenal or perceptual experience, and description – though the gate was open for description to penetrate the array as modalities within the array penetrate one another.

The externalism of classical perceptual theory was carried over into the linguistic version of it that dominated the philosophical representation of meaningful discourse by the Logical Positivists, who of course undertook, as their specific task, the logical reconstruction of science, taken to be meaningful discourse par excellence. The view was that the entire edifice of theoretical science rests on an observational basis, or, in more the idiom of those times, the basic propositions of science would be 'observation sentences' – sentences which could be verified or falsified through some isolated single perception. Here would have been the metaphysics of presence with a vengeance: the observation sentences were independent of one another in a logical way, in that the truth or falsity of a given observation sentence varied in logical independence of the truth or falsity of every other observation sentence. If 'X is red' is verified, it is so whatever other observation sentences may be verified or falsified. One cannot too heavily stress the degree to which a kind of synecdoche dominated the Positivists' view of science: for them, science just *was* observation. This was a view of science which, had it been adopted by scientists themselves, would have left science (as Whitehead once said of a simplistic inductivism he attributed to Francis Bacon) precisely where it found it. Grudgingly, the Positivists allowed that there were scientific propositions other than observation sentences: it is only that they are meaningful just in case they stand in some logical relationship to observation sentences, and often the thought was that some set of observation sentences constitute the *meaning* of meaningful sentences in science that are not observation sentences. What the logical relationship was remained a matter of pitched controversy: did these 'theoretical' sentences entail or were they to be reduced to or translated into observation sentences? Little matter: the entire edifice was a piece of logical architecture firmly based on perceptual foundations. As the metaphor suggests, the higher sentences were not independent of the lower ones – but the lower were independent of the higher ones, and, as remarked, of one another.

A characteristic construction of this architectural order appeared as late as 1946 in C. I. Lewis's *Analysis of Knowledge and Valuation*. There were three strata of judgements: non-terminating judgements which in effect ascribe some property to a material object; terminating judgements, which specify tests, the assumption being that non-terminating judgements are translatable into an infinite conjunction of terminating judgements, implying that the former are always less than theoretically certain or, which came to the

same thing, infinitely testable; and finally what Lewis referred to as 'formulations of what is immediately given in experience'. These are the foundations for the whole of knowledge; they are, in Lewis's view, absolutely certain, and indeed so certain are they that the words we use to express them are all but irrelevant: we know, immediately and intuitively, what we are experiencing. Language is simply by way of handy labelling. It is like knowing perfectly well who someone is but calling him 'Buster', not really giving a damn what his real name is. Or 'watchamacallit'. This was the epistemology I studied as a graduate student. Lewis was the leading American philosopher of the age.

Wittgenstein's *Philosophical Investigations* appeared in 1952, though his views had an underground currency for some years before then. Fundamentally, I think, Wittgenstein's chief thesis was that we cannot as easily separate perception and description as had been taken for granted by philosophers, including himself in his great metaphysical work, the *Tractatus Logico-Philosophicus*. In that work, he defined the world as the sum total of facts, and facts would be there whether they were represented in language or not. When they are represented, the proposition fits them as a picture fits its subject – the proposition is indeed a logical picture of a fact, and the image with which he worked would be a familiar one for those who think about pictures: the picture replicates an external reliability, showing what is there. Oddly, a Wittgensteinian fact has a syntax and a grammar – it is almost as though the world itself is made of language, so that it is almost one and the same thing whether we say a fact is a picture of a proposition or the other way round: as I might be said to represent the class of my photographs. But these are internal difficulties of the semantics of that strange system. By the time he wrote the *Investigations*, Wittgenstein was of the view that we do not have, as it were, the world on the one side and language on the other, but rather that language in some way shapes reality, or at least our experience of the world. And in a way, since we have no access to the world save through our representations of it, there is room here for a kind of linguistic idealism; the view, in effect, that we cannot even intelligibly draw the distinction between description and reality in order, for example, to say that the one fits the other. Experience is indelibly linguistic.

I have stated a view rather more extreme than Wittgenstein himself expressed, meaning to give drama to his thought. In fact I have stated something rather closer to the thought of philosophers not ordinarily brought forward in these contexts – Nietzsche and Schopenhauer. Schopenhauer said, flatly, 'The world is my representation' – and if we give a linguistic reading to this, it comes out to say 'My language and my world are one.' And this is almost exactly Nietzsche's theory, for whom linguistic, or at least grammatical, considerations were naturally central, given his identity as a philologist. As a metaphysician, Nietzsche argued precisely

that the world in which I live and I myself am a shadow cast by the grammar of my language, so that if we change languages (however this is to be done) our worlds will be different and we will be different (in fact he saw in this the only real hope for humankind). Because there would be no common grammar from language to language, the languages, and indeed the worlds they respectively specified, would be radically incommensurable – a view that has currency today in some of the radical philosophies of science that have been generated by Wittgenstein's thought as modified and expressed in the writings of Thomas Kuhn.

Now Wittgenstein did not, I think, draw these extreme consequences. The discussion in the *Investigations* of seeing-as, and especially of 'aspect-blindness', however, did suggest to a number of subsequent thinkers, most particularly those who evolved a new philosophy of science, the thought that observations in science are, as the expression goes, 'theory-laden', so that in an important respect, observers with different theories do not perceive the same thing. Or, if there is a common perceptual content, it is, without theoretical qualification, irrelevant to science. This philosophy of science was set forth in a very important book, *Patterns of Discovery*, by N. R. Hanson, who was my classmate at Columbia. Hanson, with whom I discussed Lewis's views on knowledge, contributed to what a BBC series somewhat self-congratulatorily designated 'The Revolution in Philosophy'. The Revolution was precisely the teaching that language penetrates perception, at least in the practice of science. In the immediate post-Wittgensteinian analytical philosophy that evolved in England and America, the formula that a given thing has a given identity 'only under a description' was widely applied. The basic orientation came from the philosophy of science, according to which what we observe is a matter of description, and description itself a matter of the location of a term within a total theory. But the horizons were expanded in such a way as to include the theory of action, the philosophy of history, and a variety of other fields and forms of philosophical investigation. It might not be energy misspent to dwell on a few examples, because it is interesting to identify the degree to which in fact perception is phenomenologically affected according to new views.

Kuhn wrote, in 1962, 'What a man sees depends both upon what he looks at and also upon what his previous visual conceptual experience has taught him to see.' And, using the paradigm of the Gestalt switch, employed to such effect in the duck–rabbit example of Wittgenstein, Kuhn went on to argue that working under different paradigms, scientists inevitably see the world differently. And Hanson, the previous year, wrote 'that to say that Tycho and Kepler, Simplicius and Galileo, Hook and Newton, Priestley and Lavoisier, Soddy and Einstein, De Broglie and Born, Heisenberg and Bohm all make the same observations but use them differently is too easy.' If the 'too easy' way is wrong, the right must be – and the list of weighty names

makes the rhetorical point almost without effort – that they see *different* things. In discussing what the physicist sees in looking at an X-ray tube, Hanson says: 'He sees the instrument in terms of electric circuit theory, thermodynamic theory, the theory of metal and glass structure, thermionic emission, optical transmission, refraction, diffraction, atomic theory, quantum theory, and special relativity.' And not even Roentgen could have seen the X-ray tube in this way.

Now the question is the degree to which, what he sees this object *in terms of*, penetrates what he in fact sees when he perceives an X-ray tube: the degree, that is, to which his physical knowledge penetrates perception phenomenologically. Hanson clearly believed, as Kuhn did, that the answer must be that it does so totally, which implies that the perceptual system is itself of a high degree of plasticity. But is it?

Consider G. E. Anscombe's claim that a bodily movement is an action 'only under a description'. What are the truth-conditions of such descriptions? Can the movement of a bough be an action under a description, and if not, is this simply a matter, as they used to say at Oxford, of our not allowing such a description to apply to boughs; or is it, rather, a matter of certain things being presupposed by something being an action that rules out trees performing actions? Suppose we say, to be sure controversially in the context of first-generation post-Wittgensteinian discussion, that a bodily movement is an action if caused by an intention that it satisfies – then in truth all that we observe is the bodily movement, but describing it as an action means that some condition we do not observe holds. If someone's arm just flew up, because of a spasm, the description of it as an action would be false. So do we see just bodily movements or do we see actions? The answer, I suppose, is that we see bodily movements, but we see them as actions only against the assumption that certain unobserved conditions hold: we see them 'in terms of' (to use Kuhn's idiom) intentions, motives, beliefs, and the like. But do these background beliefs and definitions penetrate perception or not?

I used the concept of narrative sentences in my work on history: these are descriptions of events in relationship to later events which I presumed observers of the early event could not know about: like Correggio anticipating the Carracci. This true, art historical sentence is not one under which a patron in Parma in 1525 could have perceived a work of Correggio, but because the future is hidden. Suppose, though, I could travel back in time to Parma *circa* 1525: I would perceive Correggio in the light – 'in terms of' once again – my knowledge of subsequent art-history. Would this knowledge penetrate what I perceived? Or would it only be that my knowledge about what I and a native Parmesan of 1525 saw in common was different? Do we see different things, or the same thing under different descriptions – but the descriptions themselves are as it were external to what I see?

The internalists want to say we see different things, the externalists that we see the same things but against the background of different sets of beliefs, so that we may have different expectations, but the phenomenology of perception is otherwise neutral to the beliefs. In terms of a theory of painting, the issue may be joined as follows. Ruskin was clearly an externalist:

> the whole technical power of painting depends upon our recovery of what may be called the *innocence of the eye*; that is to say, of a sort of childish perception of these flat stains of colour, merely as such, without consciousness of what they signify, – as a blind man would see them if suddenly gifted with sight ... (vol. 15, p. 27)

It is of course a matter of great controversy, and has been so since Locke voiced what has been known ever since as the Molyneaux question, what a blind man would see if suddenly gifted with sight, and whether he would at all see what we see when, by conceptual erasure, we suspend whatever corrupts the eye's innocence. I have seen a fair amount of what artists, looking at the world through what they believe to be innocent eyes, believe they see. I refer to the American Pre-Raphaelite painters, much under the influence of Ruskin, who compared themselves to cameras. This has two meanings, I now realize. The first is that the camera sets up an ideal of replicative fidelity to which they may aspire. The second is that the camera simply and mechanically records what is set in front of it, without the intervention of any of the sort of things that are incompatible with ocular innocence. No doubt there are plenty of problems with this, not least of which is that what these artists show is what they believe the innocent eye discloses. The important point is that for internalists, like Nelson Goodman for a particular recent example, there is no innocent Ruskinian eye. The eye is tainted by the original sin of cognition, and we may as well be conscious of the fact. Though it seems forced and strange to yoke them, it is difficult to think of two philosophers more precisely in unison on such a point than Nietzsche and Goodman. For Goodman there is an absolute plasticity in the world, there is no way the world is, there are only the conventions of its organization. Hence nothing is, so to speak, true in the sense of answering to objective structures. And Nietzsche said: there are no facts, only interpretations. But this odd couple raises questions far beyond the horizons of this paper. I have only sought to juxtapose internalism and externalism in such a way as to make the contrast vivid, and to make plain that there are significant thinkers on either side.

The issue before us is whether description and perception are logically separable, if not indeed logically separate, or if they co-penetrate as the various sensory modes do according to Merleau-Ponty. Or, put in another

idiom, to what degree are perceptual processes cognitively penetrated by conceptual or descriptive structures? I don't think anyone really knows the answer to this, but there is a current in contemporary psychology, some-times referred to as Nativism, according to which, as Jerry Fodor puts it, there are 'innate and unalterable architectural features of our mental structure'. And if there are 'innate and unalterable' features of *perceptual structure*, well, they clearly cannot be altered by what we come to know or believe and, at least so far as these features are concerned, something like externalism seems to be the truth. Let me give at least one example, and connect it with a body of art to give it some pertinence to our preoccupa-tions.

The interesting fact is that almost the precise kinds of examples on which internalists like Wittgenstein based their views of penetration give us the best examples of impenetrability. I refer to the well-known optical illusions, the Necker Cube, say, or the Muller-Lyer illusion. Or perhaps the duck–rabbit. The point is that our knowledge, in the Muller-Lyer case, that the lines are identical in length does not penetrate our perception of them as of different lengths. The Muller-Lyer, in this respect, is like the stick in water that we persist in seeing as bent even though we know it to be straight, or like the moon which looks larger on the horizon than when straight above, when we know that in fact it is the same size in the sense of subtending the same angle. Or like a body of water which feels cold to a hand which has been in warm water and warm to a hand which has been in cold water, even though we know it is not both but a given temperature we can measure by a thermometer. These examples are standard examples in a famous tendency on the part of philosophers from the ancient Eleatics down to discredit the senses because they are contradictory to one another as well as to reason itself. No matter how much we know, we continue to see things as we do see them, as if our perceptual system were here invincibly resistant to know-ledge.

Now at least the work of Bridget Reilly is of this order: whatever we may know about the *moiré* effect, her paintings twitch before our eyes, and the received view is that they gain a kind of sub-cognitive entry into conscious-ness, and perception is almost convulsive, as if seized by spasm. It is not an effect we can cause to subside; it is not subject to the interventions of the will, and the question immediately arises as to whether much the same thing is so wherever artists employ optical tricks to induce illusion. My sense is that we are wired up in such a way that parallel lines verge toward the horizon, even though we know that they are parallel, yet the painter Brian Nissen once told me of asking a Mexican carpenter to make a table for him which Brian drew in perspective – and the result was a trapezoid with uneven legs.

There are illusions we do live through, and these figure prominently in

Oriental philosophy by contrast with the Western illusions which really do seem modular and sealed off – I refer to the rope seen as a snake or the mother-of-pearl seen as silver. In the West, once we know it is rope, we cannot any longer see it as a snake, nor the oyster shell as silver. But I find it hard to think of examples like this in painting – though there are of course examples in literature, where the true identity of someone is revealed and we can no longer see him or her as we did. In any case, there is reason to suppose that a certain amount of painting is optical or at least makes adjustments for optical effects, and we seem to see them this way whatever we know, suggesting that some art is non-controversially theory-neutral, not a matter of culture or language, but genuinely, as artists sometimes like to say, non-verbal. So innocence is not something we need to work toward.

There is a second class of cases where it seems to me we have theory-neutral perception, mainly in pictorial perception itself – my evidence for this being the observed behavior, in connection with pictures, of animals that cannot be supposed in the first instance to *have* language. Herrnstein's work with pigeons is a good example: the pigeons are easily trained to identify and classify pictures by their content, and do about as well, statistically, as we would at border-line cases. The suggestion that they are able to do this because of wiring is prompted by the fact that they can sort out pictures of fish, which they once shared an environment with (albeit millions of years ago), but are unable to sort out pictures of man-made objects, whose environments they have shared for too short a time for evolution to have done its work. So they draw blanks when it comes to the identification of pictures of chairs or automobiles. They evidently do better with photographs than line-drawings.

In monkeys, a region of the temporal lobe contains cells that respond 'preferentially' to monkey faces and human faces, as well as, selectively, to individual faces and specific facial expressions. This region of the brain plays some role, evidently in recognition and in the social behavior contingent upon recognition. It has recently been discovered that the same thing holds true of anesthetized sheep: presented with life-size pictures of faces – of other sheep, of dogs, humans, pigs – their relevant cortical cells respond selectively (these cells do not respond to pictures of sheep without the faces showing). The same effect was achieved with drawings of faces: the cells were more excited by sheep faces with large horns than small horns or no horns, though not being fetishists, the sheep were not turned on by drawings of horns *per se*. What is striking is that pictures of things have evidently the same effect that the things themselves do, and evolution plays a role in that, unlike monkeys, sheep do not respond to rotated pictures – unlike monkeys, who must recognize the world hanging from their tails, the sheep are not adaptive to inverted simulacrae. Still, evolution cannot account for their adaptiveness to pictures, for these do not figure

prominently in their environments. The best guess is that whatever in evolution accounts for the range of their perceptions accounts for their heretofore unrealized pictorial competence. And this is an argument that much the same physiology – much the same hardware, to be up to date – serves for the perception of pictures of things as account for the perception of things themselves. And since theoretical neutrality must be presupposed in the one case, it must be presupposed in the other. (I know of no animal that draws a picture, not even highly sophisticated primates like Sarah at the University of Pennsylvania, who likes, as it were, to dabble in art-making.) So there is a reasonable inference that the phenomenology of pictorial perception, so far as there are relevant isomorphisms between pictures of things and the things themselves, may be theory-neutral. If art were imitation, the independence of art from theory would fall out as a mere corollary.

A considerable amount of art-historical inquiry is given over to questions of influence and of iconography, and it might be worth a brief diversion to see whether either of these falls within the pictorial competence of pigeons, primates, and sheep.

1 No one has tried to find out whether pigeons can sort pictures out by style, so the issue is empirically open. But pigeons are able to sort pictures containing a specific individual person, without being put off by differences in costume or context. Monkeys have no problem identifying pictures of individual monkeys, or, for that matter, individual humans, and will respond with erect hair and scream at a photograph of a leader showing anger. To identify faces and facial expressions comes close to what is involved in recognizing style. Of course this takes us no special distance towards ascribing the concept of influence to animals, largely because it is in the first instance an explanatory concept and in the second instance an historical one. We explain Carracci through Correggio rather than the other way round because we acknowledge temporal constraints on explanantia. Do we, on the other hand, 'see the influence of Correggio in the work of Annibale Carracci?' Or do we, rather, see similarities of style and explain their presence in the one case through Annibale having seen and admired Antonio, etc.? There is room for an internalist as well as an externalist account. All I want to insist on is that the ability to note minute differences is innate, probably for good adaptational reasons, and we can be conditioned to make finer and finer discriminations, much as the pigeon can, when suitably reinforced, say, by the merit system of graduate school of art history and then a museological or auction house system. The grounds of connoisseurship are wired in, but I stand mute on the question of whether causal schemata are. Kant thought this an *a priori* structure of the under-

standing, and it may be true that one can say, with as much justification as in saying a bodily movement is an action only under a description, that an event is a cause (or an effect) only under a description. What do we perceive when we perceive an event as a cause that we don't perceive when we see it as a mere event? At least a responsible answer is: we see it the same way, except that a variety of beliefs and expectations are activated when we see it as a cause.

2 The entire history of operant conditioning testifies to the fact that animals see things as signs for other things (usually food). And these signs are non-natural, e.g., a light stands for the food behind the door over which it is illuminated. Recent work on the structure of animal representational systems suggests strongly that animals are masters of the 'standing for' relationship, and that they may even manufacture signs for *ad hoc* designations, as when a rat learns a sunburst maze. So the basic skill of signification lies well within the hardware of animals, primitive iconographers well down along the evolutionary ladder. I say nothing about primates able to operate abstract pictograms on keyboards. Like Odysseus when he masquerades as one of the lower social orders, rubbing his belly and saying 'The Belly, the Belly', it is unclear that animals can rise above the alimentary. Signs are not, as a general rule, penetrated by their significations; they have to be learned one at a time, and the basic mental operation is association. But of course the significations language enables us to grasp are abstract beyond the animal's means: the bird for the Holy Spirit, for example. To see the bird and to know that it means (signifies) the Holy Spirit may not be phenomenologically distinct from seeing the bird *tout court*. What further takes place may not take place at the level of perception but at the level of interpretations and connotation. The entirety of what Hegel calls Symbolic Art is in external relationship to its meaning: we don't see the meaning through the symbol, but connect it with the symbol.

But there may be a more internal connection than this, as Hegel acknowledges in his category of Classical, and especially of Romantic Art, where what we see is determined by what we don't. Paul Klee said, beautifully and movingly, that art does not render the visible but renders visible, which means that we see by means of art something not to be seen in other ways, something in effect that must be made visible. So art attains here the level of thought, and the artwork is a thought given a kind of sensuous embodiment. This, if true, means that there is more to visual art than visual perception can account for, and on this I want to say a few concluding words.

In my own investigations into the philosophy of art, I have taken as my point of departure the method of juxtaposed indiscernible counterparts – pairs of

objects perceptually indiscriminable but which have different philosophical identities and, in consequence, different properties. This is a possibility suggested by certain developments in the history of contemporary art, chiefly through certain experiments of Duchamp and Warhol. It is a method that was always, in principle, available, and would indeed have been used had the prevailing philosophies of art not been blinded by the absolutely contingent circumstance that most works of art just looked distinctive enough from ordinary objects so that it never occurred to philosophers that the problem was not to state the difference but to accept the difference virtually as categorical, and go on to characterize artwork in absolute terms. But once one accepts the possibility that a Brillo box by Warhol is a work of art, while an ordinary Brillo box is not, it is plain that the differences are not of a kind that meet the eye, and that the phenomenology of perception cannot be appealed to to effect the differences, which are philosophical. The point is that Warhol's box acquires, in virtue of being art, properties ontologically unavailable to its counterpart, and the problem of the philosophy of art is to explain not just how this is possible, but what the status of these properties is, in as much as the properties would not be present to the eye if you did not know you were looking at a work of art. I have taken over a view of Hegel's (above), that art has the power of thought, and that what makes something a work of art rather than a mere thing is that it gives embodiment in a sensuous idiom to a thought, the grasping of which is like understanding a proposition. The proposition in the artwork explains the properties that would be, if you wish, invisible without reference to the thought. And that, I take it, is the sort of thing the highly cerebral artist, Paul Klee, must have meant by 'rendering visible'.

Let me offer an example. I have been pondering a marvelous painting by Guercino of *St Luke Displaying a Painting of the Virgin*, recently exhibited at the Metropolitan Museum (plate 69). There are a number of art-historical considerations – the influence upon Guercino of Correggio and the icono-graphic identification of the ox – that are both continuous with the perceptual skills of animals and which do not penetrate the essence of the painting as a piece of art, expressing a thought. A somewhat more complex attribution lies in identifying the gesture Saint Luke makes toward his finished painting as an example of *displaying* – but again I think this is not outside an animal's repertoire, or not far outside. The most striking feature of the work is the disparity in style between the painting of the Virgin by Saint Luke and the painting of Saint Luke by Guercino. Saint Luke's painting is archaic. It is not, evidently, a copy of an existing icon but a visual conjecture of what would have been accepted as a likeness at the time of Saint Luke, which of course is not Guercino's time. So the artist expresses a knowledge of historical differences, of changes in iconic convention, or shifting standards of representational adequacy. The picture is full of

Plate 69 Barbieri, G. F., called Guercino *Saint Luke Displaying a Painting of the Virgin*, 1652–1653. Oil on canvas, 87 ″ × 71 ″. The Nelson-Atkins Museum of Art, Kansas City, Missouri (Nelson Gallery Foundation Purchase) F83–55.

touching unconscious anachronisms – Saint Luke is painting in oils, which of course would not have been invented in New Testament times, but the deliberate anachronism refers us from the painting in the painting to the painting of the painting. It is as though Guercino was displaying the difference between how the ancients painted and how the moderns paint. Perhaps there is a bit of boasting, of visual crowing, on Guercino's part. It

makes Saint Luke's proud gesture of display very touching, that he should
be proud of this wooden, lifeless image. Well, Guercino seems to say, it was
the best he could do. An angel stands behind Saint Luke, somewhat as the
model stands behind the artist in Courbet's *Atelier*. The angel is Saint
Luke's audience, as the model is Courbet's. The angel is really impressed,
and profoundly moved. Her – or his – hand is spread open in signification
of some powerful relationship to the Virgin herself. In admiring Saint
Luke's painting, she is not showing herself to be a connoisseur of what
Guercino displays as archaic art. She sees through the painting to the Virgin
and Child, made present in the picture. No one is going to take that attitude
toward Guercino's painting, not itself an icon. Whatever his powers as an
artist, they do not compare with those of Saint Luke, who had the power of
making a holy presence present, for which we have the testimony of the
angel. So, he is a better painter than Saint Luke, to be sure, but Saint Luke
achieved something he could never hope to achieve. Guercino's is the lesser
achievement.

The painting is then a sustained meditation on painting, *resemblance*, the
power of art, the meaning of icons, the nature of representation. That is the
thought it expresses, or something like that. It is a philosophical exercise.
That is what makes it a great work by contrast with a stunning likeness. The
thought it expresses is not one an animal could grasp. It makes no appeal to
neural pathways or the phenomenology of perception. It makes reference to
rather more abstract considerations like expression, embodiment, thought,
grasping. I know no philosophical analysis of perception adequate to such
things. My sense is that, as I point these features out, one after another, the
work assumes a form it did not have before. My sense is that the experience
of art description really does penetrate perception, but that is because
perception itself is given the structure of thought. What the painting says is
totally different from what the scene itself contains, supposing, for a
moment, that we could be another member of the audience, stand, like the
angel, while Saint Luke showed us a picture of the Virgin and the Holy
Child. If we were in the painting, we would have a very different experience
from the one we have standing outside the painting. It therefore, as a
painting, has a set of meanings its subject is incapable of expressing.
Pictorial perception activates the same mechanisms that perception itself
does. Artistic perception is of another order altogether. With artistic
perception, we enter the domain of the Spirit, as Hegel said, and the visible
is transformed into something of another order, as the Word is when made
flesh.

The enfleshment of the word: I find that a stirring formulation of the
relationship between the visual and the non-visual exemplified in art and, in
my view, in every exemplar of art. Stirring but, at the present stage of my
own thinking about art, dark and as obscure as the theological tenet it

echoes. In less portentous terms, it points out a caution that the visual has to count for something in a work like Guercino's – there has to be a philosophical reason why something happens with the enfleshment of words beyond what the words themselves express. So the temptation to see art just as language and the object of visual perception just as thought when it is art, has to be resisted. But it also points out some of the reasons why works of visual art cannot be understood against the models of pictorial perception, which apply to animals as to us. A work like Guercino's – but any work at all really – is a great deal more than a picture, and its philosophical structure has its closest parallel in the structure of a human being – not that we are a great deal more than flesh – we are not – but flesh is a great deal more than meat if, as I believe, it incarnates thought.

When he first exhibited the exceedingly minimal works on which his early reputation was based, Frank Stella asserted an equally minimal philosophy of art. 'What you see is what you see.' I think that it was a wrong philosophy for even those works, scaled down as they were. Stella evidently thinks this as well, for in his beautiful lecture on Caravaggio, he wrote: 'What is not there, what we cannot quite find, is what great paintings always promise.' If epigraphs can stand at the end of a paper, let this be the epigraph for the paper it closes.

Minding the Animals — or, Can Pigeons be Hopeful?

Martin Donogho

Professor Danto, in his typically rich and provocative paper, 'Description and the Phenomenology of Perception', opens up all sorts of avenues for philosophical exploration, some neatly kept, others dense and overgrown. In fact so many avenues are indicated that even though he ranges over often familiar territory – made familiar by his past interpretations – one hardly knows where to start, let alone where to stop.

Danto begins with a brief history of recent philosophy; a history, that is, of the so-called 'linguistic turn' away from the empiricist legacy. It is almost autobiography, since Danto is himself part of that paradigm shift: his analytic philosophy of action and of history, for example, demonstrate how action and the historical 'event' can be identified only 'under a description,' not as something simply given, fixed, in itself. Thus, to speak of actions is simply to deem it appropriate to link observer behavior with talk of motives, intentions, beliefs, and the like; we see behavior *as* action, bodies *as* persons, etc. Similarly, when he turns to consider art it is to show how the criteria for identifying objects *as* artworks reside less in the empirical appearance of the object than in the convention-governed activity of description.

In the second part of his paper Danto asks about the limits of interpretation: whether and how far cats, dogs, sheep, or pigeons could not merely *enjoy* art (as cows enjoy Schubert or whoever) but also understand it *as* art. His answer is that artistic perception involves interpretation, putting under a description, or in short, an allegorical perception. A thing may well be what it is and not another thing. But art is allegory: both a 'real object' *and* another thing, an artwork, constituted as such by the 'is of artistic identification.'[1] And when push comes to shove pigeons are incapable of allegorizing – let alone interpreting Guercino's painting in Kansas City *as* allegorical in theme.

I shall in what follows briefly review the historical narrative, and then raise some questions about the animals.

1 A preliminary remark: There is some poetic justice in Danto's trajectory from the empiricist psychology of perception to artistic representation. For modern epistemology *begins* with the mistrust of artistic illusion (in the novel, say, or the theatre) and the attempt to salvage (with God's help) some cognitive truth from the unreliable senses.

In any event, where Danto follows a narrative scheme of 'before and after Wittgenstein,' one could tell the story differently, under a different description. I suggest substituting Ian Hacking's three-stage division of what he calls 'the heyday of ideas,' 'the heyday of meanings,' and 'the heyday of sentence.'[2] During the first era a mental discourse of ideas is surmised, to which language and the senses attach in some external and perhaps causal way; Locke speaks of a 'semiotic,' but it is not a theory of meaning that he propounds. The second stage, by contrast, does speak in terms of a theory of meaning, where meanings are understood as public and transmissible, not (as with ideas) private and psychologistic. The third stage does away altogether with what Derrida calls 'the transcendental signified' and we are left only with the signifier – 'words, words, words' as Hamlet says. The meaning or translation of these words is ultimately undecidable, whether because over- or underdetermined.

Quine, as much as Wittgenstein, could be seen as the hero of this particular paradigm shift, especially in his 'Two Dogmas of Empiricism' (1951),[3] which attacked the notion of a rigid separation between truths of fact and 'truth by convention.' But the shift was best dramatized in T. S. Kuhn's account of scientific revolutions (1962),[4] and it is his influence that can most clearly be seen in Danto's early work on the artworld. Kuhn supposed that 'normal' science (observation and verification) is always conducted in terms of a theory of paradigm (or more precisely, disciplinary schema), but every so often there are revolutions or breaks which change the very conventions, terms, meanings, and indeed the facts (or what counts as a fact). Analogously it is easy to see that what counts as an artwork depends on a prior theory (an artworld, an atmosphere, a history).

Here, though, lurk some ambiguities. On this analogy it is not clear whether artistic activity should be seen as normal or as revolutionary. If the former, we understand it (and what it is to *be* art) grammatically as it were. If the latter, the meaning of the gesture comes from its deviating from the norm, like the 'making-strange' prized by Russian Formalists. The 'is of artistic identification' can be taken in both ways. Duchamp's *Fountain* can be interpreted as a conventional gesture within the borders of the artworld, or as a redrawing of the borders themselves, or even perhaps their very dissolution. If its meaning is revolutionary, paradoxically it soon changes; looking back we can no longer gauge what all the fuss was about.

A second, related, ambiguity concerns the mode of change: whether it is continuous or (as Kuhn seemed to imply) a complete break with what went

before. The first consorts well with Danto's Hegelian tendencies, whereby he takes the status of works as art as deriving from their internalizing reflection on previous works. Change is never absolute but always a 'determinate negation' (as Hegel would have it) of some previous code or schema. Art in short is always about the past (Danto could well entitle his next book 'Art and Allusion'). If instead the history of art proceeds by discontinuities and breaks, then meaning itself changes with the defining terms and can in no sense be defined as the interpretation of previous meanings. It is not clear for which alternative Danto would opt. Nor is it clear whether his Hegelian version of the history of art can be brought into line with the 'heyday of sentences.'

Danto terms the account of meaning that sees it as an effect or function of language 'internalist': there is no innocent eye, no theory-neutral observation, no 'way the world is'; no facts, only interpretations, conventions and codes in terms of which we perceive different objects and different worlds. Opposed to this would be the old 'externalist' account, which supposes that different versions refer to the same basic object or world – somewhat like the blind men and the elephant.

These two accounts are literally worlds apart. Yet I wonder whether the alternatives are exhausted, and whether the internalist position (as Danto presents it) is even coherent. For what would it *mean* to say that there are several worlds or correlative 'ways of world-making' (as Goodman phrases it)? Donald Davidson's pithy essay 'The Very Idea of a Conceptual Scheme' (1972)[5] challenges any attempt to say that there are incommensurable schemata or worlds schematized: we can only say what that scheme or world would be for us, in our scheme or world. Translation may be difficult, practically impossible, but in principle it can be done.

To suppose that there are radically discrete ways and worlds is to adopt what Hilary Putnam calls a 'God's-eye-view' of things, a vantage from which to impose our conceptual *cordons sanitaires*. If, however, we have only the sentence to go on, then all we have are language games and communities of language users, with their own histories, but quite able to communicate with (as well as misunderstand) one another.

2 To turn from the issue of the God's-eye-view to the issue of animal perception – what we might call the dog's-eye-view: Danto raises the question whether and how far our understanding (e.g., of paintings) is 'always already interpreted,' and how far it may be 'externally' linked to a perceptual matrix which is theory-neutral. Are description and interpretation inseparable, in practice and in principle?

Danto mentions recent attempts to account for mental states in terms of physical conditions – he instances Jerry Fodor's psychosemantics.[6] It seems clear that 'propositional attitudes' and representations intervene in human

affairs: the question is whether an external, naturalistic account is possible, and that is what Fodor tries to sketch. The idea goes like this: Any representation – expressed as a string of symbols in the 'belief box' – can in principle be correlated causally with physical causes; a picture of a sheep triggers the sentence 'There is a picture of a sheep,' or perhaps even a misrepresentation ('It's a horse'). Danto would allow that such an account might work for some examples (the Necker cube, or the 'hard wiring' of animals' recognition of sheepish features), but *not* for 'more complex' phenomena like the Guercino painting, for which detection of influence, iconographic meaning, and so on, are crucial. (True, Danto admits that there is an aspect of operant conditioning in graduate student 'pigeon-holing' of schools and styles.) Yet why should not *all* our perceptions and representations, however complex, be 'hard-wired' in this way? Danto might reply that though there is no *a priori* reason why Fodor's sketch could not apply across the board, experimental evidence is sparse, and a verdict should not be prematurely brought down.

What happens if we approach the question from the other side and ask whether an internalist account can be extended to pigeons? Danto holds that pigeons cannot discriminate between indiscernibles because they lack the ability to use language and frame interpretations. For the same reason he would prefer to say of Sarah the chimpanzee that she likes to 'dabble in art-making.' This is a Wittgensteinian position: we do not know what it would *be* for a pigeon to pick out stylistic features, even if it could recognize pictures of food, or doves or oxen. Can we imagine animals – a dog, say – being hopeful? asks Wittgenstein,[7] clearly assuming that our language does not stretch that far. Can pigeons hope? – we might echo, not being as sure of the answer. Thomas Nagel in a famous article poses the question 'What's it like to be a bat?';[8] he supposes that we have intuitions of what it *would* be like for some entities to have a subjective life.

So, what is it like to be a pigeon? I am not sure; but we should not dismiss the question out of hand just because not one has passed its art-history comprehensives. Oddly enough Danto allows that a dog can perceive (interpret?) the light above a refrigerator door as signaling food; it is, he says, master of the relation 'standing for.' But this is a complex capacity, and seems not far removed from the allegorical or metaphorical mode of inter-pretation that transfigures real objects into art. Without holding a brief for animal rights, I think there is more to be said. And given the tentative and exploratory nature of Professor Danto's remarks, he will surely have more to say.

Notes

1 See Danto's 1964 essay, 'The Artistic Enfranchisement of Real Objects: the Artworld', in *Aesthetics. A Critical Anthology*, ed. G. Dickie and R. J. Sclafani, New York, St Martin's, 1977, p. 27.

2 Ian Hacking, *Why Does Language Matter to Philosophy?*, Cambridge, 1975. This is a Foucauldian account, and itself under the aegis of the sentence (discourse, discontinuity, etc.).

3 In Willard Van Orman Quine, *From a Logical Point of View*, Cambridge, Mass., Harvard University Press, 1953, pp. 20–46.

4 T. S. Kuhn, *The Structures of Scientific Revolutions*, Chicago, Chicago University Press, 1962.

5 In Donald Davidson, *Inquiries into Truth and Interpretation*, Oxford, Clarendon Press, 1984.

6 See his recent *Psychosemantics: The Problem of Meaning in the Philosophy of Mind*, Cambridge, Mass., MIT Press, 1987.

7 *Philosophical Investigations*, trans. G. E. M. Anscombe, Oxford, Blackwell, 1958, p. 174.

8 'What's it like to be a bat?', in *Mortal Questions*, Cambridge, Cambridge University Press, 1979.

The Aesthetics of Indiscernibles

Garry Hagberg

Philosophy itself was transfigured by Wittgenstein's reflections on the nature of linguistic meaning, and these reflections had, in so far as they were intertwined with problems of perception, an epistemological aspect. With characteristic insight and lucidity Professor Danto has encapsulated that intellectual revolution. However, as I shall argue, it appears that he has, perhaps unwittingly, both concealed and preserved within his own aesthetic methodology a good deal of the old ways of thinking beneath the more attractive surface of the new, and this implicit theoretical preservation is symptomatic of the powerful grip of those old ways. Wittgenstein himself did not, in the later philosophy of the *Philosophical Investigations*,[1] merely decide to change his mind on conceptually fundamental questions, answers, and the very formulations of the questions themselves that he had so forcefully elucidated in the *Tractatus Logico-Philosophicus*.[2] He *struggled* against those earlier, and more theoretically accessible, views.

Danto has shown us that until the mid-century conceptual turmoil, perception was regarded as epistemologically fundamental or, to use a term we shall return to below, *basic*, and that language was regarded as only an acoustical adjunct, an *ex post facto* representation, of the primary perceptual event. One *sees* first, one *says* – if at all – only later. Given this perceptual primacy, it is only natural to then identify the essential function of language as that of naming, where a word gets its meaning through direct reference to a simple or basic perception, i.e., a perception which is unanalysable and thus, as Danto succinctly puts it, 'capable of being named but not defined.' With this perceptual atomism, one would recognize any familiar object as a composite of basic perceived data collected through the five sensory modalities, and if required, one could (although this would be in almost any context unusual) list the basic perceptions out of which the object is, on this model, constructed. Thus the apple is 'round,' 'red,' 'tart,' and so on through what would be, *in toto*, a very long list of basic perceptions. Of course, linguistic atomism closely follows perceptual atomism; just as one is

led to the conception of language as naming, one is led to the idea of correspondence, where a given word stands for a given perception and the truth of any utterance is then a function of the match between word and world. As Locke and his twentieth-century successors believed, we generally trouble ourselves to name only composites in actual spoken language. Thus, if I hold up an apple, study it, and say 'avocado,' I've uttered a falsehood; the language following the perception does not refer to the composite 'round, red, tart . . .'.

Now, having glimpsed only this one example in which truth is construed as a function of correspondence, one can already see that spoken, or natural, language is a rather messy affair. Although atomistic in structure, it is systematically imprecise, because the linguistic name, the word, does not refer, through referentially clean one-to-one correspondences, to perceptions. They refer, imprecisely, to clusters. At this point one can both feel the motivation for the *Tractatus* and at least minimally appreciate its modernistic elegance. It describes, not a makeshift and even chaotic natural language, but a logically perfect language, inside which there are no such things as ambiguity, vagueness, metaphorical undertones, allegorical overtones, or even simple misunderstandings. In the *Tractatus* a proposition is a picture of a state of affairs in the world, and at the most fundamental level of significance, basic perceptual atoms are directly and precisely represented by basic linguistic atoms. The only possibility is that of absolute clarity; owing to the presence of corresponding atomistic basics, confusion and interpretive disagreement cannot arise. Thus in the pre-revolutionary philosophy of science we arrived, as Danto reminds us, at the idea of 'observation sentences,' i.e., those sentences 'which could be verified or falsified through some isolated single perception.' Analogously, pre-revolutionary philosophy of art would insist on the possibility of aesthetic 'observation sentences'; these would be, of course, *ex post facto* descriptions of properties exhibited in works of art which could be verified or falsified through a single perception, or through checking the correspondence between word and work. Although the problem of verifying criticism ranges considerably beyond the specific concerns of this commentary, it seems clear that contemporary discussions of critical objectivity and of its possibility still rest squarely on atomistic foundations. Stated directly, if a critical observation is thought to be a proposition about properties the work exhibits, where the conception of the meaning of criticism reduces in the final analysis to naming, atomism is still exerting a powerful influence, and atomism's full manifestation is seen in the often-employed but rarely stated definition of critical truth as a verified description of a prior perception. These are, in summary fashion, the old ways of thinking.

Wittgenstein's search for a new philosophical method was carried out in large part as a struggle against himself, against the ways of thinking given

expression in the *Tractatus*. This exorcism of atomism is what Danto is referring to as Wittgenstein's 'chief thesis,' the claim that 'we cannot as easily separate perception and description as had been taken for granted by philosophers.' On the early view, the claim that a proposition is a picture of the world itself implies that perception and description are wholly separable and only contingently related – when in fact they are related. Reminding us of the historical affinities with the views of Schopenhauer, who solipsistic-ally asserted that 'the world is my representation,' and with Nietzsche, who made the related claim that if we change languages (meaning here a radical exchange of the structure of language) we change worlds, Danto character-izes Wittgenstein's later view as a denial, a repudiation of the distinction thought to exist between 'the world on the one side and language on the other.' Indeed, as our epistemological access to the world runs exclusively through representation, we can never, as a logico-epistemological impossibility, arrive at an independent position from which to assess the accuracy of the representation against its original, or the description against the perception. Nor can we take the first step toward such a position, because it is a departure from the linguistic that is, not only impossible, but in fact inconceivable. And, of course, it is crucial to any elucidation of the later Wittgenstein to distinguish between an assertion which is false and one which is unintelligible; Danto accurately identifies Wittgenstein's repudia-tion as concerning not the falsity of a specific theory concerning the distinc-tion between perception and description, but rather as concerning the very intelligibility of that distinction. If perception does not precede description, and if perception within any sensory modality or combination of modalities (as in synaesthetic perception) is ineluctably linguistic, then any discussion of the *relation* between perception and description is as otiose as it is misleading. If the new way of thinking is a repudiation, then it is, at bottom, a repudiation of the explanatory function of the *basic*. Atomism, in both its perceptual and subsequent linguistic forms, is the theoretical consequence of an illusory epistemological distinction. Here, too, a full elaboration of this point would take us far beyond present purposes, but a few passages of Wittgenstein's will suffice to suggest the general direction of the newer thought as it opposes the old.

Very early on in the *Philosophical Investigations*, among preliminary reflections on the old conception of meaning, Wittgenstein says 'When we say "every word in a language signifies something" we have so far said nothing whatever.'[3] Slightly later he adds to that repudiation of naming as the origin of meaning the very well-known remark 'To imagine a language means to imagine a form of life.'[4] To imagine a language is not, presumably, to imagine a network of correlated basic objects or an assemblage of perceptions and names. A little later he is at a position from which the oddity or remoteness of the naming model can be sensed, and says 'And you

really get such a queer connection of a word with an object when the philosopher tries to bring out the relationship between name and thing by staring at an object in front of him and repeating a name innumerable times.'[5] Indeed, even from the very beginnings of an overview of the multiple functions of language that he has at that early point in the *Philosophical Investigations* achieved, the dream of the ideal or logically perfect language and its method of reduction to basics seems impossibly alien to actual linguistic practice. Much later in the same work he makes a pointed inquiry: 'Can I not say a cry, a laugh, are full of meaning?'[6] Such utterances are, at least in certain contexts, both intensely meaningful and beyond the explanatory reach of the naming theory of meaning.[7]

These few passages serve to illustrate the attack on the conception of language as a system of names which signify basic or clusters of basic perceptions. The second site of battle with the old ways of thinking is the collection of remarks on aspect-perception or 'seeing-as.'[8] Danto reminds us of both the irrepressible duck–rabbit[9] and the reversing Necker cube; if one comes to the first of those visually ambiguous figures with the concept – or perhaps more accurately, the context – of a duck, then that is what one sees, and if one comes with, say, Beatrix Potter rather than Walt Disney in mind, one sees not Donald but Peter. Of course, this variety of visual ambiguity, an ambiguity resolved by a description seeming to reach into and transform a perception, has more than trivial consequences. These consequences, identified by Danto, can in the philosophy of science generate the idea of radically incommensurable world-views, each carrying its own internally generated criteria for verification and certainty, and in the philosophy of art one could develop the analogous theory of radically incommensurable interpretations, where it would be not only inappropriate but in fact impossible to argue against one interpretative scheme employing the discourse of another. But these consequences, as suggested here as both the scientific and aesthetic implications of a deeper philosophy of language and perception, were, as Danto says, not drawn by Wittgenstein himself but by some of his first-generation followers, and I believe this is more than an incidental fact.

The result of the above reflections was, as Danto explains, the widespread belief in analytic philosophy that 'a given thing has a given identity "only under a description",' and Anscombe's[10] claim that a bodily movement is an action only under a description was, as part of a thorough analysis of the concept of intention, the most focused of these post-Wittgensteinian claims. To hold this view, one must hold a number of prerequisite beliefs, beliefs which are often left unspecified. And it is, I believe, these prerequisite beliefs which both underwrite Danto's method in aesthetics of juxtaposed indiscernibles[11] and which preserve as well as conceal those elements of the old ways of thinking Wittgenstein was, in the later work, opposing.

If one claims that a human action is a bodily movement under a description, one is implicitly claiming that the bodily movement is constitutive of that action; i.e., that the bodily movement is present as the physical component of a more complex ontological entity, i.e., an entity possessing both physical and psychological or intentional aspects. It is helpful, in seeing the central relevance of this analytical scheme to Danto's aesthetic methodology, to underscore the extent to which this is a dualistic (or, as the post-Wittgensteinians called it, 'Cartesian') theoretical enterprise. Physical events in the external world are classified as bodily movements or as human actions according to whether they correspond to mental events, mental events which the descriptions under which the movements fall encompass. This, then, is the first prerequisite belief, namely that bodily movements are components of human actions, or more generally that the intentional will include a component of, or in a sense rest just above, the physical.

Although one can see at this juncture the method of indiscernible counterparts waiting to present itself as a corollary to those views, let us first state directly the second prerequisite belief. Closely allied to the first, it is that there are, beneath the human action and behind the perception of the duck and of the rabbit, *uninterpreted* constants upon which or over which the concept, context, or description is placed.[12] There are movements behind actions,[13] events behind causes,[14] perceptions behind descriptions, and – here we arrive at the aesthetics of indiscernibles – objects behind artworks.[15] That this is a natural way of thinking, especially after the philosophy of perception developed in the first half of this century, is beyond dispute; it is. But its truth is another matter, and here one is reminded of a remark of Wittgenstein's from *Zettel*, 'It is very difficult to describe paths of thought where there are already many lines of thought laid down – your own or other people's – and not get into one of the grooves'.[16] We saw that the way in which, on the old way of thinking, the search for the basic, in both perceptual and linguistic form, was a manifestation of the desire to originate an epistemology at a point of absolute and indubitable certainty, a point immune to Cartesian doubt. Perceptually, those basic atoms are uninterpreted givens of experience, and in language they were corresponding linguistic simples that could be named but not, under the delimitation of atomistic simplicity, described. And in art, they are not *interpreted* works, but rather, to employ Danto's phrase, mere real things.[17] They are the objects behind the works, the basics over which an interpretative scheme is superimposed.

There are, I believe, serious problems with the *post*-Wittgensteinian analysis of basic actions that range into philosophical logic; to abbreviate them one might simply point to some of the extremely odd conclusions resulting from such an analytical program. Among countless such examples one finds the unembraceable conclusions that what takes place as a knee-

jerk in a medical examination is part of what a soccer player does under the description of kicking a goal; that pretending to participate in a ritual is, at least in part, what the authentic participant does; and, moving to the linguistic case, that the sounds a parrot makes in 'saying Hello' are, in part, identical to what a person does under the description of saying Hello. But these are, again, problems internal to this method of analysis;[18] more important in the present case is to suggest, first, that such an analytical program is alien to Wittgenstein's later thought and, second, that the program, as a method in aesthetics, unwittingly reiterates the old ways.

Consider then this remark: 'Nothing could be more mistaken than to say: seeing and forming an image are different activities. That is as if one were to say that moving and losing in chess were different activities.'[19] In fact, if actions are basic movements performed under descriptions, then precisely such a claim *is* being made. And, in the parallel visual case, if one insists on the existence of the uninterpreted basic as the perception behind the description, then one is saying precisely that seeing and forming an image *are* different activities. The affinity between this and the strategy of assembling indiscernible counterparts is clear; first identify the perceived entity common to both a mere real thing and an artwork, and this yields, through an act of conceptual subtraction, the isolated descriptive or inter- pretive essence of an artwork, an essence which exists, as an ontological intangible, above and beyond the physical object and its uninterpreted perception.

From this vantage point one can well understand Danto's admiration – his *theoretical* admiration[20] – for snow shovels, porcelain fixtures, and Brillo boxes. They satisfy the requirements of this analytical program perfectly. But we have already seen the deeper affinities of this theoretical program with the old ways against which the revolutionary thought concerning perception and description was opposed, and hence its actual distance from Wittgenstein's later thought. To state the matter bluntly, this aesthetic method perfectly exemplifies the very atomistic analytic strategy against which the later Wittgenstein was struggling.[21]

There are two questions remaining. The first concerns the applicability of the method of indiscernible counterparts to central or non-controversial cases in art, quite apart from the question of its affinities with an earlier stage of analytic philosophy, the second task is that of sketching more fully the later Wittgensteinian view as it applies to the relation between description and perception.

It is clear that the method of juxtaposed indiscernibles fits 'found' art as well as any conceptual apparatus could; Duchamp's bottlerack is not identical to a non-Duchampian bottlerack. But this fittingness allegedly extends far beyond such specific cases, and it is, as Danto claims, the achievement of Duchamp and Warhol to have brought the question

concerning the essence of art to this focal point. Their achievement is not, then, to have drawn our attention to the otherwise unnoticed formal features[22] of commonplace objects, but to have brought the history of art to a stage of development[23] from which it can itself engender acts of conceptual subtraction among its percipients; i.e., it provokes the focused question 'What is left over when we subtract the object from the artwork?' Now, in order for the method to apply generally, as Danto clearly believes it does, we must, as a contextual necessity, have a kind of ambiguity present. We must have, in a way closer to the spirit of the later Wittgenstein, a contextual *occasion* for the asking of this focused question. And such an occasion is, in the non-controversial cases, precisely what we are quite clearly lacking. It is true that, as a way of insisting on the implicit applicability of the question, Danto invites us to engage in the *Gedankenexperiment* in which an accident involving paints and canvas produces an object phenomenally indistinguishable from the *Polish Rider*.[24] Such an imaginative act, he believes, will secure the relevance of the Duchampian question because we are, through the side-by-side comparison of these indiscernibles, provoked to search for an ontologically less solid entity, such as a description or an interpretation, which explains the difference. Danto admits that such para-aesthetic accidents are unlikely – to which one might feel compelled to say *very* unlikely – but any such reaction is beside the point; it is, Danto insists, logically possible, and that is enough, i.e., it is not a *Gedankenexperiment* which refutes itself in self-contradiction or internal incoherence. But the function of any theory is, presumably, to *explain*, and the method of indiscernibles can demonstrate an explanatory force only within the context of a problem or set of problematic particulars which that theory covers. And, again, what we lack in central, or more specifically 'non-readymade,' art, is the very visual ambiguity that obtains between a mere object and an artwork.[25] Whatever the answer to the question posed by those specific indiscernibles, that answer cannot illuminate until its contextual necessity, in the form of the Duchampian question, is first established.

These remarks concerning context lead to the final task, that of saying a word about the late Wittgensteinian view in connection with perception and description. Surely the most widely known project in the later philosophy is the repudiation of linguistic atomism as a viable theory of meaning. This is related, however, to a parallel repudiation of visual atomism or an epistemology based on sense-data, and this relation can now be explicitly stated. To say of the duck–rabbit that we *first* see an unanalyzed basic and *then* give it one descriptive interpretation or the other is still to insist on the distinction – in both logical and psychological terms – between perception and description. To say then that the 'rabbit' description can reach into or 'suffuse' (as a Kantian might put the matter) the unanalyzed basic figure, is in this way also to still remain within the very categories from which the later

Wittgenstein was trying to escape. Indeed, we would be developing a theory of the relationship between perception and description rather than, in a manner consistent with the new ways of thinking, be denying that distinction's intelligibility. In the repudiation of linguistic atomism Wittgenstein shows at great length and in a way deeply resistant to summarization the significance of context as a determinant of, and occasion for, meaning. The assertion that a bodily movement is an action when it is performed under a description only superficially acknowledges the significance of context; as we have seen, this way of putting the matter pretends that 'bodily movement' is not *itself* a description which has its use within rather specific meaning-generating contexts. It pretends, as we have seen, that the brute perception of the movement comes first and that its descriptive interpretation follows. In the parallel aesthetic case we are presented with an ingeniously developed conceptual template of indiscernible counterparts, and to put this template to explanatory use we must presume that we see the mere thing first and that its descriptive interpretation follows. But 'mere thing' is no more a descriptively inert phrase than 'bodily movement,' and to be led to believe that it is interpretively vacuous is to conceal within the aesthetics of indiscernibles precisely the conservative epistemological categories against which the struggle was carried out. Conversely, to insist on the significance of context is to deny the intelligibility of a fundamentally misleading distinction, to insist on a view which seems at once radically untraditional and, in so far as it delivers us from reductionist atomism, theoretically liberating.[26]

To point one final time beyond the reach of this essay, Danto quoted Nietzsche to the effect that there are no facts, only interpretations. Some have suggested that one way of encapsulating Wittgenstein's remarks on aspect-perception is to assert that all seeing is seeing-as, and these remarks, conjoined, illustrate both the anti-reductionist affinities between Nietzsche and Wittgenstein as well as their shared antipathy to the perceptual and linguistic foundationalism at the core of the old ways. In any case, it is clear that atomistic analysis, in perception, in language, and in their intersection in aesthetics, is a theoretical program, or as Wittgenstein characterizes it, a 'picture,' not easily left behind. One might still insist that there *must* be a way of separating perception from description and of theoretically capturing their complex inter-relations. Against such insistence, such theoretical captivity, one might place Wittgenstein's remark about his own earlier philosophy, 'A picture held us captive. And we could not get outside it, for it lay in our language, and language seemed to repeat it to us inexorably.'[27]

Notes

1 *Philosophical Investigations*, 3rd edn, trans. G. E. M. Anscombe, New York, Macmillan, 1985; 1st edn, 1953.
2 *Tractatus Logico-Philosophicus*, trans. D. F. Pears and B. F. McGuinness, New Jersey, Humanities Press, 1974; 1st edn, 1922.
3 *Philosophical Investigations*, section 13.
4 Ibid., section 19.
5 Ibid., section 38.
6 Ibid., section 543.
7 This of course connects to the much-discussed 'private language argument'; for an elucidation of the significance of this argument for the naming-theory, see John Cook, 'Wittgenstein on Privacy,' *The Philosophical Review*, 74 (1965), pp. 281–314; reprinted in G. Pitcher (ed.), *Wittgenstein: The Philosophical Investigations*, Notre Dame, University Notre Dame Press, 1968, pp. 286–323.
8 *Philosophical Investigations*, part 2, section 11.
9 A few of the discussions of this visually ambiguous figure in connection with artistic perception are E. H. Gombrich, *Art and Illusion*, Oxford, Phaidon Press, 1977, 1st pub. 1960, p. 5; Roger Scruton, *Art and Imagination*, London, Methuen, 1974, pp. 107ff.; Richard Wollheim, *Art and Its Objects*, 2nd edn, Cambridge, Cambridge University Press, 1980, pp. 205–26; and for an employment of this type of visual ambiguity within discussions of the 'period eye' and a cognitive style, Michael Baxandall, *Painting and Experience in Fifteenth-Century Italy*, Oxford, Oxford University Press, 1972, pp. 29ff.
10 G. E. M. Anscombe, *Intention*, Ithaca, Cornell University Press, 1969, 1st pub. 1957.
11 This method is of course primarily developed in *The Transfiguration of the Commonplace*, Cambridge, Mass., Harvard University Press, 1981, and extends through many of the essays in *The Philosophical Disenfranchisement of Art*, New York, Columbia University Press, 1986.
12 In this connection see Wittgenstein's discussion of what one *really* sees in Norman Malcolm, *Ludwig Wittgenstein: A Memoir*, Oxford, Oxford University Press, 1958, pp. 49–50.
13 See Danto's *Analytical Philosophy of Action*, Cambridge, Cambridge University Press, 1973, for this analytical scheme applied to deliberate human action.
14 See Danto's *Analytical Philosophy of History*, Cambridge, Cambridge University Press, 1965.
15 See *The Transfiguration of the Commonplace*, chap. 1, 'Works of Art and Mere Real Things', pp. 1–32.
16 *Zettel*, ed. G. E. M. Anscombe and G. H. von Wright, trans. G. E. M. Anscombe, Oxford, Basil Blackwell, 1967, section 245, p. 64e.
17 *The Transfiguration of the Commonplace*, chap. 1.
18 The problems intrinsic to this kind of analysis are shown in detail in F. B. Ebersole, *Language and Perception: Essays in the Philosophy of Language*, Washington, DC, University Press of America, 1979, chap. 5, 'The Analysis of Human Actions', pp. 199–222.

19 *Zettel*, section 645, p. 112e.

20 That this admiration is a function of the theoretical fittingness of readymades is made explicit in *The Philosophical Disenfranchisement of Art*, p. 35, where Danto writes of Duchamp's *Fountain*, 'I confess that much as I admire it philosophically, I should, were it given to me, exchange it as quickly as I could for more or less than any Chardin or Morandi . . .'

21 For Danto's reading of Wittgenstein as an atomistic analyst of human action, see *The Transfiguration of the Commonplace*, pp. 4–6. For a competing interpretation, where Wittgenstein is interpreted as disputing the very possibility of the atomistic analysis of action, see B. R. Tilghman, *But Is It Art?*, Oxford, Basil Blackwell, 1984, pp. 96–8.

22 See Danto's discussion of George Dickie's institutionalist conception of Duchamp's *Fountain* as a candidate for appreciation, an object exhibiting a 'gleaming white surface' and a 'pleasing oval shape,' in *The Philosophical Disenfranchisement of Art*, p. 33.

23 For a concise expression of this philosophy of art history see *The Philosophical Disenfranchisement of Art*, Preface, pp. ix–xv.

24 *The Transfiguration of the Commonplace*, pp. 31–2.

25 To see more clearly the lack of contextual necessity for this method, and its consequent minimal explanatory capacity, one might try to image the formulation of questions concerning non-readymade indiscernibles: 'Is that an actual Kandinsky portrait or is it rained-on Pollock leftovers?'; 'Is that Klee's geometric design or a blotter for small sponge pads?' etc.

26 A clear demonstration of the significance of context in connection with the elucidation of the concept of artistic intention is found in Michael Baxandall, *Patterns of Intention*, New Haven, Yale University Press, 1985.

27 *Philosophical Investigations*, section 115.

REAL METAPHOR: TOWARDS A REDEFINITION OF THE 'CONCEPTUAL' IMAGE

DAVID SUMMERS

O F all the terms in the vocabulary of the history of art, 'conceptual image' is one of the broadest and most inclusive. That it is also one of the least examined is surprising in view of the scrutiny to which the discipline of the history of art has been subjected in recent years and in view of the work done by the category of the 'conceptual' in art-historical discourse. An unambiguous example of the use to which this idea may be put is provided by the question asked by E. H. Gombrich toward the end of his 'Meditations on a Hobby Horse.' 'How, then,' he asks, 'should we interpret the great divide which runs through the history of art and sets off the few islands of illusionist style, of Greece, of China, and of the Renaissance, from the vast ocean of "conceptual" art?'[1] Gombrich put quotation marks around the word 'conceptual,' suggesting that he found it problematical. The division he wishes to make, however, is clear, and is the same division that governs the organization of his *Story of Art*, in the first chapter of which – a chapter entitled 'Strange beginnings' – Gombrich puts everything from palaeolithic painting to ancient American sculpture.[2] In this case the distinction between 'conceptual' and illusionistic art serves to separate Western classical and neoclassical art and the art of China from all the rest of the art of the world. In other instances the distinction has been used to separate archaic art from later art (as it provides the basis for Gombrich's account of what he calls the Greek revolution in *Art and Illusion*). An idea capable of implementing such sweeping divisions deserves the most careful scrutiny.

*Con*ceptual art is the opposite of *per*ceptual art, and thus is a psychological way of distinguishing art that is not imitative from art that is. Conceptual images are made, so the argument goes, not by looking to things perceived but by looking to some inner image, a memory image, or an image formed by the mind itself from many experiences. If perception and

conception, from *percipere* and *concipere*, preserve something of their original etymological force, then perception is the means by which the outside world is taken in, and conception is the means by which it is taken to be the mind's own. Perceiving makes possible the mind's conceiving. On such a view, concepts are closer to words, and if they are images they are images 'before the mind's eye' rather than before our physical eyes in space and time. Whether they are words or images, concepts are like whatever it is by virtue of which we recognize individual things and are thus closely related to *genera*. Concepts are thus generic or general, and are opposed to the particular, which is perceived. Calling concepts to mind requires memory and imagination, with both of which conceptual images are often associated. The distinction between perceptual and conceptual also harbors something like the difference between natural and conventional signs, and conceptual images might thus bear the negative critical burden of the conventional. At the same time, the concept, as more abstract and as closer to the verbal or to the ideal, might also have positive critical connotations.

Plates 71, 72 and 73 are examples of images that might be referred to as conceptual. Plates 71 and 72 are recognizable as generally anthropomorphic and are minimally descriptive. Their recognizability is based upon order among their parts rather than descriptive proportions. Frontality is often a sufficient criterion for inclusion in the category. Frontality raises the issue of planarity, which may be developed in more complex ways in painting and relief sculpture. Plate 70 is representative of such planar organization; axiality, uniform linear contour and areas of color (or in this case, texture) are coupled with an organization achieved by rotation of shapes, producing symmetry. (The second major planar operation of translation would yield series.) Planarity minimizes space in the image itself – what will be called virtuality – thus denying the most general conditions of illusion. Plate 70, although its forms are modelled and set on a stage of space and are therefore virtual, is governed by planar organization. In general, virtual images describable in planar terms such as frontal and axial (like Duccio's *Maestà*) also fit the category, or might be described as at least *relatively* conceptual.

It is difficult to separate what is defined negatively as *not* descriptive and illusionistic from what about images might correspond to the 'conceptual' itself, and given only the two categories, what does not fit in one must go in the other. At the same time, the characteristics in question are so widespread as to seem to demand a general principle of explanation, which, when the category of conceptual images was formulated, was assumed to be provided by human psychology. Just as we make thought out of perception, so we may depict the thought rather than the perceived, and into the category of the 'conceptual' might be lumped so-called primitive art, children's art, archaic art, provincial or popular art, certain modern art, the art of the mad, Egyptian art, medieval and even Byzantine art.

It is obvious that the idea of conceptual art is deeply and dialectically related not only to perception, but to the classical notion of mimesis, which it naturalizes in psychological terms. When the polarity was used to plot stylistic change (as in the example of Greek art) the development was from conceptual to perceptual. This is what happened both in classical and neo-classical Western art. But development could also go the other way, as in the change from Roman to early medieval art exemplified in the famous contrast between the earlier classical and Constantinian reliefs on the Arch of Constantine. As suggested above, it was also possible to turn the old Platonic and Aristotelian tables on one's opponents by saying that conceptual art was higher and more spiritual or intellectual than the optical. Such arguments were made by some of the early pioneers of modernism.[3] Simply because of the categories in which they were set, these ancient critical arguments had the paradoxical effect of justifying the inclusion of kinds of art that had always been excluded from the classical canon.

If the notion of conceptual images is called into question, this questioning may be immediately extended to ask whether or not it is desirable to have such a category at all. I will argue that it *is* desirable, that the term 'conceptual image' represents the defensible demarcation of fundamentally significant characteristics of large and important classes of images, but that the principle of explanation should be changed and the category itself substantially modified. I also think that not to have such distinctions (even if the ones I offer are amended or rejected) implies the semantic neutrality of the conditions of being an image, and further implies that, in so far as anything is an image, it may be separated from the significance of the conditions of its presentation. The assumption implicit in the desire to eliminate such distinctions is really the 'common sense' assumption that all art is naturalistic, that styles of images are incidentally different ways of showing the same thing, that the Egyptians and the Aztecs and everyone else just happened to represent the things they saw in different ways. Similar objections might be made to a simple 'contextual' point of view, according to which means of representation neutral in themselves simply are at hand to illustrate whatever social conditions dictate, 'social reality' taking the place of 'nature' in the old scheme. What follows is based on a contrary premise: that the conditions of presentation themselves point to the most fundamental issues and must be examined as the prelude to any thorough-going interpretation. As the argument unfolds, the old category of conceptual images will become the category of images the meaning of which is rooted in the real space shared with them, leading to the general principle that the conditions of presentation of images, rather than 'expressing' social reality, are major means by which social reality is actually constituted as real places and activities.

The polarity conceptual–perceptual is of course psychological, as I have

already remarked, and I wish to begin my analysis not by asking whether this
is the right polarity, or whether there should be any polarity, but rather by
asking whether images must be explained in psychological terms at all. We
see things and we see images, and we may see that things and images are
alike in certain respects, but in my view it is not possible to say therefore that
the structure of images is defined by seeing. It does not follow just because
works of art are visible, or recognizable as referring to something, that they
are essentially 'visual.' Such a claim immediately raises the question of
formal or visual analysis. I have argued elsewhere that formal analysis, the
method of description that developed integrally with the development of the
history of art itself as an intellectual discipline, is no longer adequate in the
simple sense that it no longer allows us to ask or answer the kinds of
questions that most interest us.[4] It is not simply the case that art-historical
concern with presumedly essential form diverts attention from other
historical issues, it is also just plain hard to get from 'form' to any context at
all, social-historical or intellectual-historical, and the idea of form, to my
mind, decidedly favors the now discredited physiognomic expansion from
individual to collective style that made art history a centerpiece of the
history of the spirit. But to return to the problem at hand, the attempt to
explain the appearance of works of art in other than formal or perceptual
psychological terms removes the first springs and wheels from a very large
and intricate watch.

Having driven a wedge, at least provisionally, between the visible and the
'visual,' I wish now to state a second major theme of this paper: the rejection
of what W. J. T. Mitchell calls linguistic imperialism, which I understand to
be the assumption that the paradigm of language is adequate to the explana-
tion of art, or, more simply, that art itself is a kind of language.[5] Although
what we mean by art and what we mean by language are in various instances
continuous, parallel or overlapping relative to one another, I wish to argue
that in crucial respects they are, to use a strong term, absolutely different
from one another, and that at the deepest levels the significance of art is to
be found in an area of prelinguistic certainty I shall try by various means to
indicate. It is at this level that I shall look for the explanation of the category
of conceptual images, and it is at this level that what have been called
conceptual images will emerge as an important paradigm for all images.

In *Art and Illusion* E. H. Gombrich makes a crucial change in the meaning
of conceptual images, a change which seems to me very much to favor the
understanding of art in linguistic terms. In 'Meditations on a Hobby Horse,'
as I shall presently discuss in detail, the conceptual end of the scale of
images is discussed as 'substitution,' which belongs to the realm of what
Gombrich would later call 'making.' In *Art and Illusion*, however, sub-
stitutive or magical images are relegated to the chapter on the 'power of
Pygmalion,' and in general are absorbed under the formula 'making comes

before matching.' The sequence of schema and correction might be set in terms we have already examined to say that the artist must have a culturally defined concept before addressing the problem of transcribing appearances. But Gombrich also changes the meaning of conceptual images – and a version of this idea is obviously central to the whole project of *Art and Illusion* – calling them 'relational models.'[6] A conceptual image in the old sense of the term – an archaic image, say, or a child's drawing – is a relatively simple relational model, and its simplicity is fitted to the uses to which it is put. Rembrandt's *Night Watch*, or Leonardo's *Last Supper*, or any other naturalistic painting, is a more complex relational model, again suited to the uses to which it is put. This formulation gets rid of the absolute distinction between what had been the conceptual and the perceptual or illusionistic, giving each a position in a continuum. Gombrich sums up his argument by stating that *all* art is conceptual, meaning that all images are based on previous images *and* that they are some kind of a relational model.

The notion of a continuum of relational models seems to me to achieve a higher level of simplicity at the cost of inevitably implying that all images are at base naturalistic. A 'schema' is suitable for correction only in so far as it *is* naturalistic, so that one end of the scale – the naturalistic end – defines the other, and anything about the origin of 'schemata' that is not representational falls through the cracks. This is partly because Gombrich is explaining the rise of naturalism; the Greek artists who took simpler images as hypotheses to the interrogation of appearance must on such an argument have been interested principally in the correspondence of these images to the appearance of what they represented. Such interest, however, need have nothing to do with the reasons for the making of the simpler image in the first place. The simpler image on Gombrich's view merely conveys simpler *visual* information. Although possible value judgments hidden in comparisons of 'simple' and 'complex' are sidestepped by rooting differences in the social function of images, the function is in an important respect always the same, namely the transmission of visual information.

At the same time that it presupposes a norm of naturalism, the location of all images along the same continuum of representation also seems to me to be potentially radically conventionalist, thus pushing representation strongly in the direction of the linguistic paradigm. Even though Gombrich himself has resolutely opposed the gathering of such implications from his arguments – an opposition perhaps most visible in his dispute with Nelson Goodman over the question of the conventionality of perspective, Goodman might be seen only to have followed up Gombrich's new definition of the conceptual image in formulating his notion of denotation. Reference, Goodman argues, it not defined by resemblance; in fact, he says, 'almost anything may stand for anything else. A picture that represents – like a passage that describes – an object refers to and, more particularly, *denotes* it.

Denotation is the core of representation and is independent of resemb-
lance.[7] The elements of a representation, in other words, stand to what they
represent as do the words in a description. Here we have the linguistic
analogy stated in the simplest terms.

I shall return to the question of the linguistic paradigm at the end of the
paper and for the time being it will perhaps be sufficient to follow Good-
man's arguments a little farther. Goodman argues that visual representa-
tions possess a characteristic that language does not, which he calls
'density.' Images are 'dense' in that every mark (in a painting, which is
certainly the example Goodman has in mind) is dependent upon relations to
other marks for meaning, so that the whole worked surface is continuously
and interdependently significant. Written language is not dense and is
fundamentally discontinuous. This distinction to my mind has the effect of
making visual representations into a certain kind of 'text' which is 'read' in a
different way. Here Goodman comes close to one of the writers he acknow-
ledges in the preface to *Languages of Art*, Meyer Schapiro. Schapiro has
written that what he calls 'pervasiveness of semantic function' is 'distinctive
for the picture sign'; 'even with the arbitrariness of the qualities of the
image-substance, the picture sign seems to be through and through
mimetic.'[8] It might be noted that the paragraph in Schapiro's essay
beginning with the enunciation of this principle is concerned with the
devices of optical naturalism – hatching to show light and dark, for example
– ending with impressionism, in which marks make sense in relation, and
not in isolation.

The generality of this principle notwithstanding, however, Schapiro also
treats in detail images which he calls 'hierarchical,' and these cannot easily
be accounted for in terms of the modified 'textuality' we have been
examining. The structure of hierarchical images is governed by the relative
size and position of figures in the plane of the surface, of the support of the
image itself rather than by their sizes in spatial relation to one another and to
a viewer, which perspective and photography have made us feel to be
normal. Hierarchical images are thus not optical, and, to take up our theme
and the old opposition from which we began, they are *conceptual* images in
the sense in which the term was used before Gombrich's transformation of it
in *Art and Illusion*. Schapiro does not use the word 'conceptual,' and,
although his remarks are brief, he must have wished to avoid the
psychological explanation implicit in the term in favor of an explanation
according to which the order of such images is rooted in what he calls 'an
intuitive sense of the vital values of space, as experienced in the real world.'[9]
This significance, Schapiro maintained, is 'not arbitrary,' but is instead
'readily understood by the untrained spectator since it rests on the same
cues that he responds to in dealing with his everyday visual world.'[10]
Schapiro's is a kind of reversal of the old notion of conceptual images; rather

than saying that conceptual images *are not* imitative, or even that they are more 'mental' than the optical, he is saying that hierarchical images make more sense to more people in more places and times than do optical images. And the appeal, it is important to note, is not to the correspondence between image and mental or conceptual image, it is rather to the spatial order of the image itself. To the imagination, he says, such images are what he calls 'natural and self-evident' – shocking words in contemporary critical discourse.

Let us consider what Schapiro is saying. Plates 70 and 71, Duccio's *Maestà* and a Benin bronze plaque, are examples of hierarchical images. In both works the major figure is central, larger, more ornate, frontal, and commands a flanking symmetrical order. And the important thing is not simply that the two figures have a similar order, but that this order has a similar value, evidently distinguishing the Virgin Mary in one case and the chief in the other. Moreover, the fact that this order occurs in culturally distinct images – and many examples from many cultures might have been used – should be explained on Schapiro's argument by the fact that people everywhere are normally upright, oriented, handed, of a certain size, and by the further fact of the significance we find in and give to the simple physical conditions of our existence. Schapiro has in effect claimed that hierarchical order is more than a code because in itself it is not conventional, even if it necessarily takes historically specific forms. The explanation of this non-conventionality is based in the experience of the conditions of our own embodiment.

Schapiro's arguments lead us back to the problem from which we began, which may now be restated more clearly and forcefully. How, if visual orders are arbitrary and altogether culturally determined, are widespread structural similarities like bilateral symmetry to be accounted for? This question is all the more pressing if these similarities are not just formal but semantic, if the centrality of the Virgin means not that she is 'on the axis' but that she is 'central' to the meaning of the image taken altogether, and that in many cultures symmetry may have this same meaning. Schapiro's arguments are very pithy and assertive and it is not clear what it means to speak of relations as natural and self-evident 'to the imagination,' or what is entailed by 'an intuitive sense of the vital values of space.' I believe, however, that these indications may be followed to a better definition of what have been called conceptual images and beyond that to a more useful definition of images taken altogether.

It was argued at the beginning of this paper that the category of conceptual images is overly general, owing in large part to the fact that it was defined negatively in opposition to the perceptual or optical. Certainly the category of the conceptual has been used for a wide variety of works and styles of art and has tended to suppress evident differences between them. In

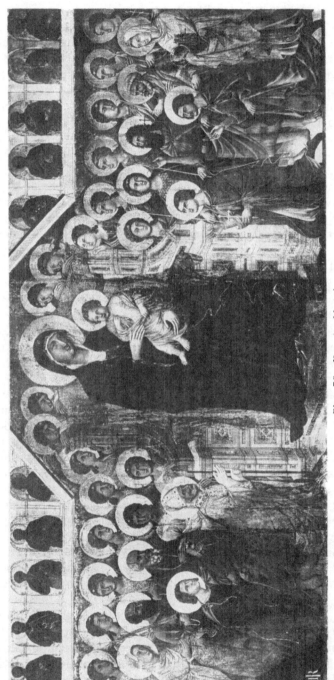

Plate 70 Duccio. *Maestà*

Plate 71 *Oba with Attendants*. Bronze plaque, Benin

what follows, I will divide the category into two parts. I shall first consider
what will be called *substitutive images*, which raise the fundamental question
of real metaphor promised by the title of this paper. I shall then briefly
consider what will be called *planar images*.

I shall begin by trying to sort out and formulate just what it is that distin-
guishes an image among the more general characteristics of an artifact. An
Olmec hand axe (plate 72) is an artefact which, rather than simply *being* an
image, provides the immediate context for an image (and not incidentally, a
'conceptual' image). It is not a simple tool but rather an implement used in
ritual, or in the ritualized present or future life of some important person.
The distinction of both the artefact and its user is made evident in a number
of ways. There is the intrinsic (and magical) value of the material of which it

Plate 72 Hand axe. Olmec, first millennium BC

is made. There is also the very fine finish, which seems to remove the artefact from the realm of simple use; and there is finally the elaboration of the artefact by the addition of an image. These last two are not so easily separated. The image may be viewed as embellishing or envaluing the object just as its finish does, and both finish and image, which, like the precious material, raise the implement above the level of the routine and functional, show the implicit possessor either to have had the time, or to

have had the time of others, necessary for such superfluous labor. But the image also empowers the tool in another, fundamentally different way. It makes something present in the tool, or, to put it in another way, it makes the tool into the means by which something more than the tool itself is present. Whatever the Olmec deity may have been, it is present in the axe by virtue of its image, and gives the axe a kind of power over and above the distinction given to it by material and facture.

From this example I wish to draw two general and interlocking conclusions. First, images make present what they show; and second, they do this by placing the absent in the already present. In this case, the image makes the deity present in the axe and does so by making the deity, which was formerly by implication somewhere else, present together with the presence of the axe. By this means the presence of the deity is not only identified with the artefact and its uses, it is also brought into, and made integral with, the ritual space and time of which the artefact is part.

The importance of the second of the above conclusions, that images make present by placing the absent *in the already present*, must be stressed. In one or another sense, making an image is always a change of something already at hand. It is moreover a change in what is already at hand made in the face of absence, and this points in the direction of a general principle regarding images. Things may be absent in many ways. The far away in space and time, the dead, the gods might all be said to be not among us differently. These differences determine corresponding differences in kinds of images, but in all cases images involve the transformation of the present. The irreducible and untranslatable significance of images, then, is finally rooted in the intersection and inevitable contradiction between the world's always being present to us and its seldom being present to us as we desire it to be. Desire for the absent constantly transforms the present.

I wish now to pursue these issues by examining a well-known and much explicated story told by Sigmund Freud in *Beyond the Pleasure Principle*.[11] Freud tells of a game invented by an eighteen-month-old boy, a normal child of normal intelligence, able to make a few articulate sounds. He was a 'good child' who did as he was told and never cried when his mother left, which she often did, sometimes for extended periods. Although obedient, he had the habit of throwing his toys in out-of-the-way places, an activity accompanied by evident satisfaction and interest, and by a sound discernible as the German *fort* (gone). He used all his toys only for the purpose of this game, the meaning of which became clear, Freud argues, when the boy was observed playing with a reel to which a piece of string had been tied. The toy might have been used in a number of ways – as a carriage, for example, to be drawn along behind him – but instead it was always incorporated into a more revealing amplification of the original game of throwing away. Holding on to the string, the boy would toss the reel into his

242 DAVID SUMMERS

crib, where it could no longer be seen. He would then pull it out and, when it re-emerged, joyfully shout *da!* (there!) The whole game, then, was what Freud called 'disappearance and return.' It was repeated endlessly, there always being more satisfaction in its completion than in the act of its initiation. When he recounted this story, Freud was considering the problem of the relation between pleasure and non-pleasure in the regulation of human mental events, defining non-pleasure as an increase in excitation, pleasure as a lowering of excitation tending toward a basal stability. It is the work of the mental apparatus to maintain this stability and the child's play provides an early and normal example of this work. How does the game of disappearance and return square with the pleasure principle if what is always enacted is the painful event of the mother's departure? It cannot have been the anticipation of the pleasure of her return that spurred his behavior because the departure alone was first and most often repeated. Freud suggested that the game be explained as pleasurable because it allows the child to change from passive to active. *In the game*, the child is able himself to make the mother absent and retain or reclaim her as he wishes, rather than simply being the victim of her leaving. The game might also be explained as a kind of suppressed revenge, with its consequent satisfaction. But whatever the case, play permits a situation in which control is exercised over a substitute. Freud is thus able to explain his example in terms of the economy of the pleasure principle, and he concludes that it is not necessary to posit an imitative instinct in order to account for play. The child takes up a substitute into a kind of self-initiated drama, a construction of space, time and movement within which re-enacted nonpleasure is subsumed in a higher pleasurable resolution. The game, Freud observes, was generated not just by circumstances but by the suppression and transformation of psychological energy, by the child's 'great cultural achievement,' his denial of instinctual satisfaction in not protesting his mother's departure. In substitutive re-enactment nonpleasure becomes the occasion for pleasure in a process which is integral with socialization.

E. H. Gombrich perhaps had Freud's exemplary story in mind when he set out to make a fundamental reassessment of images in his 'Meditations on a Hobby Horse.'[12] Freud explicitly rejected the idea that play is primarily imitiative, and Gombrich rejects the idea that images must be regarded as primarily imitative. Gombrich reserves the term 'image' for icons, signs that refer by resemblance, and he distinguishes them from what he calls 'representations,' like a hobby horse, for which he seems to have had in mind a simple stick. Representations are defined by system and context, somewhat as words are. That is, because the word 'horse' is arbitrary with respect to horses (which might be and have been called any number of things), it takes value from its systematic relation to other words, their uses and the behavior to which these uses are linked. The hobby horse thus does not refer to the

appearance of a horse, nor does it refer – and this is central for the matter under discussion – to the mental *concept* of a horse but rather its relation is in a certain sense to some real horse, for which it is a substitute. *In context* the stick becomes a horse, which may have a proper name and any number of character traits as play unfolds. Substitution (which is, in my view, a better term for what is being described than the more general 'representation') might be called a relation of identity under certain conditions. The conditions are in fact absolutely correlative with the substitution. These conditions *are* the game, which is still Gombrich's example, although he expands it, at least implicitly comparing the rules of the game to the structures of language, but beyond that also to social context.

If a child wishes to play 'horse', a stick will do. In such circumstances it *is* a horse, and substitution bypasses the sort of difference implicit in the notion of icons in general, again understanding icon in the sense of a sign that refers by resemblance. So defined, an icon is always *of* something and cannot be that thing. It is for this reason that some of the simplest images – like a broomstick horse – may be the most magically real for those who make and use them; they simply *are* what they represent in the context of use by which they are defined. At the same time, change in context also changes this absolute reality. What might have been a stick among several standing in a corner may suddenly become a horse, and might at another time become something utterly different, a doll, say, or an elephant. For Gombrich substitutions fulfill desires, either innate or induced. Desires are innate when they have some biological or psychological basis, the desire to see other faces, for example, and they are induced when their origin is social or cultural. Children are more likely to pretend to ride horses and therefore to find horse substitutes in cultures in which there are horsemen and horsemen are admired. It is at the level at which the nonrepresentational substitute assumes value, that is, in the game, that art becomes imitative, and imitation becomes a major means of socialization.

Freud's story has been used to exemplify the psychological foundation of language.[13] The word itself is a substitute, but it is not what it signifies and in the great differentiation of presence and absence a leap is made by the child at once into selfhood and into the symbolic world of language. In such a reading emphasis of course falls on the formative and then more definite words accompanying the child's game. But the substitution of a *word* for the mother cannot simply be equated with the substitution of an *object* for the mother. That is, the relation to the mother of the object taken as a substitute cannot simply be assumed to be that of a symbol. To make this assumption is precisely to avoid the issues I would now like to begin to raise. The transformation from absence and formative word to the differentiation between absence and presence was accompanied by the substitution of a *present* object for the mother, and in actuality the opposition of presence and

absence was yoked by the activity of *making* the already present absent, and then making what had been already present present again. This activity – and the transformation of the present necessary for it – *is* in fact the game in which control is exercised, in which the substitute is magical, in which what is desired may be lost and reclaimed. However closely the development of Freud's game may parallel the development of language it is essential to account for all the parts of his story. Just as there is no reason to assume that the substitution of objects and words is the same, there is also no reason to suppose that the actual substitution of objects is simply developmentally earlier than language, so that once language is attained such substitution is no longer necessary, and necessary in the strong sense of being constitutive for human behavior. Even if the nature of substitution is fundamentally changed and endlessly enriched and complicated by the possession of language, the two kinds of substitution are still both separate and inter-active. If, for example, the actual substitute were to become the object of supplication and tending, this behaviour would have the significance not only of the verbal and linguistic, it would also have the significance of the spaces and actions through which this supplication and tending occurred.

Freud's child used all of his toys for his game. Practically any object could be used for it, the stress being on the word 'practically,' because only manageable objects – the stress here falling on the root *man-*, as in *manus*, hand – could be substitutes and thus become part of the game. Most toys are similar at least in being of manageable size, and the interchangeability of substitutes means that iconicity, the resemblance of the substitution to the other, is not the issue, as Gombrich also insists. But the criterion of manageability for the inclusion of objects in the game, which might seem an incidental qualification, is instead also vitally important. It implies a scalar relation, a relation of fit, between player, object and game, one in which the size of the child's acts and strengths, the actual size of his capacity to grasp, lift and toss, become congruent in a geometric sense to the space of the game itself, which is similar to the space of the child's control, and thus the actual basis of the magical value both of the substitution and the game. This very manageability, it may be noted, is itself significant and implies a foundation for the meaning of objects that are possessable and manipulable.[14]

The simpler, earlier version of the game Freud describes is the repetitive staging of the mother's departure, which is consistent with the game as a means by which control is exerted over the substitute. With the reel and the string, however, the situation has become more complex. The string is a means, a device, by which the child's desire might be realized, his control extended and the situation apparently resolved through his will and effort. It is in fact a more elaborate manipulation and it is upon the integral relation of this manipulation to the actual space and time of the game that I wish to insist.

The simple conclusion may be drawn that substitution is more than the fulfillment or projection of desire, even if every substitution is a response to some desire. Substitution is also at once an accommodation to existing circumstances and a transformation of them. There must in the first place be a certain fit between desire and what comes to hand to fulfill the desire. Only certain things might have been used in the game Freud recounts, and fewer things still may be 'ridden' in the manner of a hobby horse, and if a number of things might serve as 'horses' each would do so in a way that would state 'horse' in a specific manner. Only a certain kind of thing, in other words, might be a substitute for a horse, or might be *made* into a substitute for one. This point is as important as it is simple. However widely the appearance of substitutes for the same thing might vary, they are not therefore utterly arbitrary because they must be suited to human use before they are 'like' a horse, or before they can 'stand for' a horse. This simple conclusion serves the centrally important purpose of linking substitution to the space of human action. This principle may be very much expanded.

Something present at hand able to be a substitute in the way I have just described is potentially a *real metaphor*. Real metaphors are to be contrasted with metaphors in language much in the way that I have just distinguished between substitution for something by an object and substitution by a word. In such terms, *real metaphor* might be called the analogy underlying metaphor. However we may come down on the question of metaphor in language, all discussions turn around the definition preserved in the etymology of the word itself, from *metapherein*, to carry over or beyond, to transfer. This is obviously a spatial analogy. It implies that when we use one word for another we move something from one place to another. A real metaphor actually does that. It is the movement of something from one place to another such that it replaces something else and stands for it.

Real metaphors thus must be manageable and they only entail resemblance in so far as they must possess one or more characteristics that permit them to be treated as like what they represent. Manageability, which might be more generally defined as the potential of something to be subject to human action, should not be thought of simply as linked to action in the abstract, but rather as integral with specified and structured uses, that is, with the actual space and time of the game, or to expand the metaphor of the game, with the actual space and time of the definition and use of any substitute. That is to say that the definition of real metaphor is dependent upon function understood as the specific use and construction of real spaces.

Substitution thus transforms the present, the term 'transformation' being used in a special sense. We are accustomed to think of transformation as 'material' being made 'subject' to 'form,' as when stone is chipped away to make a statue, or clay is shaped, or bronze poured into a mould of whatever

shape the sculptor wishes it to be, a bull, say, or an athlete. But there is also a kind of transformation that occurs simply by displacement. The correlative space entailed in a thing's becoming a real metaphor, the space consequent to its literal re-placing, will be called *subjunctive*. The notions of *real metaphor* and of *subjunctive space* are mutually implicative at the deepest level. A *subjunctio* is a joining under, a yoking or bracketing, and it must be stressed again that the use of this term, like the use of the term *real metaphor*, is meant to appeal to the analogies underlying their use in language. Just as metaphors are contextual, that is, just as a word refers to another thing in grammatical and syntactical circumstances that signal its transposition, so real metaphors are contextual, but the contexts are unique dispositions of real space. Substitutes are effective in the space in which they are put because they are only 'real' in that space. It follows from this that we cannot interpret them without giving equal attention to their correlative spaces.

It is appropriate at this point to summarize the argument by explaining the title of the larger manuscript from which this paper is adapted, *The Defect of Distance*. It was observed in passing that things may be absent in many ways, and that these various ways correspond to images of various kinds. In the examples from Freud and Gombrich we have examined the absences to which the children's desires responded in making substitutes were trivial and everyday. But the literal and metaphorical language of distance is much more portentous than this example indicates, and the injuries or absences to which desire responds are in innumerable instances more absolute and irrevocable. There is a simple distance of absence, of being away, out of sight, diminished by distance and occluded by things, and there are the final 'absences' of death or of invisibility. Distance and metaphors of distance thus lead to the issue of human finitude. The phrase 'defect of distance' was used by Gabriele Paleotti in his *Discourse on Images*, published in 1582.[15] According to Paleotti, images were invented so that

> we might be able to represent the similitudes of things and with this to make up for the defect of distance – *il difetto della lontananza* – not because images may not be used for things present, that we have before our eyes, but because for the most part they come to restore the loss suffered through things distant and separate from us; because if we might see everything at our convenience and always look at things at our will, then representing them would not be necessary at all.

Paleotti understood the making of images in terms of imitation and his examples all concern Christian narrative. But Paleotti's claim is a much broader one, which can be made without reference to iconicity at all, as I have followed Gombrich in doing throughout this paper. In most of the traditions of world art (only Western modernism seems to offer an

alternative) images have served to correct the 'defect of distance', in the terms of the present discussion, to transform the present in such a way as to make the absent present. The present becomes absent in becoming the past. Loved ones depart and separate, as Pliny accounted for the origin of painting with the story of the maiden of Corinth, who traced on the wall the shadow of her departing lover.[16] The dead are gone, the gods are in heaven, or their epiphanies are in the past, or they act from elsewhere and are only known in signs of their grace or displeasure. In our terms, all of these are brought into our space by substitution, which involves the positing of subjunctive spaces in which images and what they represent have efficacy and power and in which they may be addressed.

All of these examples have to do with things that arise and vanish in the experience of an individual, things to which the individual is passive. But there are also more active and equally fundamental sides of spatiotemporal finitude in which images also figure. One may also leave images – as many have done – to posterity, to a time in which one no longer exists, or exists only as the image. This projection into the future has a spatial counterpart finally rooted in the simple fact that no one can be more than one place at a time. Images may also correct this limitation, acting as surrogates. The image of the emperor in the provinces is a literal embodiment and extension of the emperor's power. Power is potency, the ability to act, to dictate, judge and punish, and the image stands for that power. Conquest is not simply military subjugation and pacification, it is the imposition of rituals and patterns of life, the making and setting up of images of gods and rulers. Because an image is 'of' the emperor, that is, both from his likeness and by virtue of his power, it is ultimately authored by the emperor and states his authority. In such a case the subjunctive space sustaining the image is enforced and asserted. Because a subjunctive space is necessarily a real space, such images may become objects of desire in the various senses considered in the last paragraphs. But the same images may also be destroyed and mutilated for reasons entirely consistent with their having been set up in the first place; they are destroyed as ways of destroying imposed and alien order and authority, or they are destroyed for the purpose of asserting and imposing new order and authority by means of new images. The destruction of our imaginary emperor's image thus goes far beyond the mere slaying or humiliation of a double, or even of the emperor himself.

The choice of a substitute implies not so much simply 'this is that' as it implies 'this be that,' or 'let this be that,' and what actually states this condition contrary to fact – that is to say, what actually states the substitute's not being what it is but rather another thing – is the subjunctive space involved in its use. Subjunctive space is the construction of desire that states and preserves the identity of its object. Real metaphor and subjunctive space not only entail one another, they corroborate one another. If the stone

is the desired presence, its reality as that for which it stands is maintained in its space; at the same time, the value of the space is maintained by the presence of the substitute. A subjunctive space is a qualified region within which certain rules hold – the space, say, of play or ritual – and in which things are governed by those rules, in which the irrelevant is either ignored or appropriated and itself transformed.

The paradigmatic examples we have examined so far both happen to have concerned the play of solitary children. However, once these examples have served the purpose of prying images away from their presumed definition as like either percept or concept, and once the significance of images has begun to be located in the realm of the space of human action, these simple examples will have done their work, providing the basis for more general formulations. It is not hard to see that complexities multiply as these simple examples are left behind. If *two* children decide to play horses, then they must *agree* that the stick is a horse within mutually accepted rules. If a third child is *introduced* to the game it must be explained and again agreed that the stick 'is' a horse. At a more useful level of generality, that is to say, at a level of generality corresponding to real situations, most substitutive images respond to collective rather than individual 'desires.' (These last quotation marks are intended exactly to raise the question of the relation between such individual and collective demands.) In general, it may be said that as the context of substitution becomes more complex the maker becomes a communicator and the substitute itself a means of communication. These questions demand their own studies, but may be at least indicated here.

Subjunctive spaces are precincts, more or less large, from the boundaries of a game to the precinct of a religious building, to the reach of an empire. A precinct is not only an area in which laws hold or languages are spoken, it is also an area within which images are respected and presented as if efficacious. Subjunctive spaces are inherently inclusive (and exclusive) and are thus both social and architectural. In so far as they are social, subjunctive spaces demand agreement, or 'convention.' One must implicitly or explicitly accept the rules according to which the spatiality of one's own experience is qualified. This of course is not in most cases an initiation; instead it is the learning of the spaces into which one is born and within which one learns to live as the member of a group. It is within such already qualified spaces that images (and here we are still speaking of substitutes) have a similarly culturally specific value.

Subjunctive spaces may finally and most generally be defined as culturally specific constructions of human spatiality. Both terms of this definition must be stressed, because while space may be culturally shaped in all the many ways preserved in some traditions of architecture and lost in more fugitive ritual and habit, all these endless variations are fitted in one way or another to the living human body, to its orientations and movements,

as surely as it is absolutely important that the child's hand may close around the toy that becomes the substitute, or the stick allows itself to be ridden like a horse.

At the same time that subjunctive spaces are social they are also inevitably and intimately involved with power. Taken altogether, substitutive images and subjunctive spaces, in being specific constructions of human spatiality, are *ipso facto* realizations of power, not expressions of power, but the actual forms taken by power in one or another place and time. In the simplest examples substitution brings or retains something felt to have power into the space of use, and this act itself implies control. Making images implies the power to make what is shown (the power of the maker) but it may also imply the power to have them made, to have them brought into the space of use ('patrons'). Patrons state through images their own relation to greater powers, and their control of whoever makes images of these powers; but they also make power evident in more immediate ways. It is the ruler, the final maker of images and their spaces, who commands large stones to be quarried and moved, and that exercise of power is as visible and as effective in social spaces as the actual images made by sculptors. The space of the squaring and moving of these stones, the labor of their transport is evident in them, and is a sign of dominion.

I wish now to continue to try to define the relation between images and human spatiality before presenting my conclusions. Umberto Eco ends the discussion of 'iconic signs' in *A Theory of Semiotics* by saying that 'iconism is not a single phenomenon, nor indeed a uniquely semiotic one,' extracting from this the further conclusion that 'it is the very notion of sign which is untenable.'[17] I think it is fair to say that the paradigmatic 'sign' in prevailing scholastic discussion is the linguistic sign, what Peirce called the symbol, or arbitrary sign, and if Eco's misgivings about 'verbocentric dogmatism'[18] are justified in relation to the literature of semiotics itself, they are many times over-justified in other fields to which the terminology of semiotics has been appropriated, the history and criticism of art not least among them. If the careful parsing out of what is and is not word-like in non-linguistic regions of human meaning has not been pursued with much interest by semioticians, vocabularies simply derived from semiotics cannot in the nature of the case correct this deficiency, even when the objects to be explained through the use of this language would seem to demand analytical categories of their own, as do the works of art.

Under the category of 'pseudo-iconic phenomena' Eco discusses the example of Gombrich's hobby horse, the sign value of which he wishes to distinguish from that owing to a kind of least similarity.[19] That is, if it is believed that some signs are icons by virtue of their embodying some of the features of that which they signify, then, according to such a view, the hobby horse displays a minimal formal similitude. Instead, following Gombrich's

argument, Eco wishes to say that 'the impression of iconism' arises from the 'constitutional operations' of making a stick into a horse, and that the stick is analogous to the horse not in appearance but in function; it is the making of a stick into a horse that suggests or implies its iconicity. The stick itself might become a sceptre or a sword, and what makes these alternatives possible is the stick's possession of 'linearity' (which may be horizontality or verticality). But again we are mistaken if we suppose that 'linearity' is a minimum quality of 'horse' in the way that 'square' might be a quality of a red flag. 'Linearity' (and horizontality and verticality) belong to 'a mode of perceiving and choosing space, while a square is already a *figure constructed in space.*' Eco uses the example of Kant's distinction between the trans-cendental aesthetic and the transcendental logic to clarify the distinction he is making.[20] 'The spatial dimensions are not an intellectual construction, but the *constructive conditions* for a possible object, and as conditions they may be reproduced, equal to themselves, in various circumstances.' Spatial determination in other words can give rise to what Eco calls 'an intrinsically coded act,' that is, it is able to 'be a sort of concrete experience capable of being used as the sign of itself.' The square on the other hand 'is already an object constructed within the framework of such [spatial] conditions, and it cannot be reproduced as equal to itself, but only as an abstraction similar to previous constructions.'[21]

It is important to insist that Eco is not saying that a thing that may be vertical is not a sign, rather he is trying to describe the way in which it *becomes* a sign. The potentiality of a stick to 'be' a horse or a sceptre or a sword is rooted precisely in the basic spatial value of what in one circum-stance or another might become one sign or another, and might even be developed as the representation of one thing or another. The 'arbitrariness' of a stick relative to the appearance of a horse, then, is not primarily the 'arbitrariness of the signifier' in any way that phrase might be understood; rather the distance in appearance between horse and hobby horse is a reflection of the endless number of significant uses to which an object with one or another potential spatial value may be put in one or another circum-stance. In terms of the present argument, all this means that at a fundamental level the spatial character of things and of images made from them is irreducibly significant. Moreover, it is always necessarily significant because we are always in real relations to real things and people all of our lives. This does not mean that basic categories of spatial meaning always have the same significance. Such fundamental determinants of human space as left and right, for example, might have exactly contrary meanings in one culture or another, or even within one culture. It is not important to be able to argue that left and right, up and down, back and front always have the same meaning, as a tonsured man in a yellow robe holding keys is always Saint Peter. But it *is* important to insist that these are categories for meaning

and that cultural choices between them or about them are integral to the construction of meaning taken altogether. If the blessed are on Christ's right and the damned are on his left, if dextrous is a much more positive word than sinister, or if right in English is the opposite of both left and wrong, all that might be exactly the opposite in another system. But if it were the opposite, the value of meaning would still be rooted in spatial experience. If the significance of such determinants in artefacts may change, this does not happen randomly. To say that most images have presumed an upright viewer is also to attribute to them a certain value in common; and when, to cite an extreme example, twentieth-century artists began to devise images in which this value was denied in traditional formats, so that the opposition of up and down was neutralized, this was a shift of great historical importance. To say that art articulates the spatiality of human experience, that in a fundamental way the history of art *is* the actual articulation of human spatiality, is only to say that art and human purpose reach into the construction of human spaces, which are never 'pure' and abstract but always qualified and historical. This is only to say that art is the constructor and inventor of human space, which is always significant and therefore always demands interpretation.

To take up once again the theme of 'conceptual images,' a certain number of conclusions may now be drawn. All of the arguments presented have been meant to cut the broad category of the 'conceptual' away from its old psychological moorings. In the manuscript from which these preliminary arguments have been adapted, the categories of substitutive and planar images, which replace the old category of conceptual images, are grouped together as kinds of images primarily significant in terms of the 'real' space they share with those who see and use them. The opposite of real spatial images is virtual spatial images, the kind of illusionistic images to which we are most accustomed. Real space, being subjunctive space, is always culturally specific and the 'reality' and 'certainty' it possesses in practice is that naturalized reality and certainty within which we all enact our lives as participants in one or another construction of things. But virtual images are also rooted in the values of real space in basic ways. In the old classification, perceptual (or optical) images are usually prior or normative, but in the one I am proposing that relation is reversed simply because every virtual image is situated in a real space and is presented under conditions consistent with the values of real space. At the same time substitutive and planar images are relatively without virtuality and the assumption that they are proto-virtual or proto-naturalistic is an immediate foreclosure of the possibility of their interpretation. An illusionistic altarpiece – the van Eyck Ghent altarpiece, to take one of any number of possible examples – is not just defined by the apparent space in which its figures seem to stand; it is also defined by the real space in which the altar itself stands (or stood) which is the specific

space of its use, the ritual space to which the particularity of the painting's illusion is in fact accommodated.

I wish now briefly to consider some of the relations between substitutive and planar images. Throughout this discussion I have kept to the simplest possible examples, like Gombrich's hobby horse, a thing that became something else in becoming the object of human desire. Once this first displacement has occurred, once the real metaphor has been established, then the properties of whatever has come to hand may, by a kind of extension of this original metaphor, become properties of that of which the image is an image. According to the argument so far, any stone might stand for a departed chieftain, serving as the center for a space the ritual appropriate to which sustains the new significance of the transposed stone itself. In his same space, and with its new identity, the specific character-istics of the stone or wood – volume, weight and color – which already bear some similarity to that for which the material is a substitute, take on new significance and may be developed in many ways. The volume of a stone (plate 73) may at once restate the volume of the chieftain's body and become significant as the permanent opposite of his impermanent flesh. This simple development having been made, the stone may become, say, the container of the chieftain's spirit, released from his body by death. If this is so, then the

Plate 73 Akwanshi monoliths, Nigeria

initial substitution is given a new dimension, and double power. It not only is what it stands for in its context, but its existence is made more specific through identification with the life force of the person for whom the stone stands. By the same logic, the uprightness given to the stone – grounded in the simple physical stance of the stone upon the earth – may mean the permanent uprightness and virility of the chieftain, an erectness and an erection standing in magical contrast to the horizontality and absolute impotence of death. Again, all of this may be said – which is to say that a definition of a monument may be given – without any reference to resemblance at all. This argument implies that real metaphor, the transposition of objects in the space we share with them, engenders fundamental comparisons between these objects and that for which they stand. The comparisons can be extended to the point of actual resemblance, which need not, however, imply anything like portraiture. In the example we are considering, the addition of bearded faces specifies these monuments as men, or men of rank, and it might be supposed that the markings refer to the identifying and distinguishing facial and body markings of individuals.

As an extension of its metaphorical development, then, a substitutive image may thus be specified and empowered by the addition of recognizable elements. A stone standing for a person is given 'eyes,' not so that the stone will resemble the person in question but rather so that the stone will possess powers of sight as its counterpart did. It was stated previously that socially more complex contexts for substitution entail questions of communication. When recognizable elements are added to a substitution its semantic character takes on a new dimension. The recognition of 'eyes' is already determined by context (the stone 'is' a person) but at the same time that very context makes certain demands of order and arrangement (that the 'eyes' be in the upper part of the stone, that they be side by side). As such features are added to the substitute, the problem of communication changes simply by virtue of their recognizability. Considered as a sign, the substitute itself is thus made less 'arbitrary' by such additions, and at least in principle, becomes less dependent upon context for definition and less in need of explanation by someone who understands its meaning. Such simple steps toward resemblance on the part of an image as a whole scarcely alter the real metaphorical core of the image, which there are obvious reasons to maintain. Were such alteration to be pressed further to actual transformation, and the whole stone to become a naturalistic representation, the tie of the image to its sustaining space, with all its significance for human use, would inevitably be altered or broken, much as a precise copy of a horse might be useless in the game to which a simple stick is perfectly fitted. The significant values of the real metaphor itself would also be significantly altered. There is all the difference between substitutive stone, which means that stone *is* flesh, and stone that has been made to seem like flesh.

The question of resemblances, those aspects of images that are 'of' things rather than 'for' them, obviously has many more parts than can be discussed here. The conditions of the actual presentation of resemblant elements leads us to the next category of real spatial images, to planar images. We may again consider the example of the placement of eyes. Virtually any mark or object might become an eye if two such objects are placed as a horizontal pair near the top of an object, but it is essential that this *order* be observed if there is to be resemblance. As a relation, order – and this can easily be extended to the relations of all the parts of the body, to take by far the most common example – can be stated on many surfaces, but it is stated with maximal clarity on a plane surface. The placing of eyes also immediately yields relations of up and down, makes the figure clearly 'face' so that it has orientation, back and front, left and right. Such making articulates these relations and literally makes them actual and evident *as* relations. The plane is the generalization of these relations. Any plane surface (or surface able to be treated as a plane) is of course a real surface and is therefore of a specific size, shape and orientation; that is to say, it has a definite relation to any space, and to the use of any space, in which it is set. Division of a plane takes on the real spatial values of its size and orientation, its relation to the space of its use, and the vertical axiality of an image along such a division may refer to the value of verticality in such concrete spatial circumstances. But a surface able to be treated as a plane has the further characteristic, upon which all the values arising from division depend, of absolute uniformity. In principle, the circumstances of real size, shape and orientation aside, every point is equal to every other. *Planar images* are those in which the parts of the image are identified with the uniformity of the plane surface itself. Such definition places the image uniformly at the limit of the space upon which it faces and states everything with the positivity of the surface itself. Each part of a planar image is as definite as any other, and this definiteness is tantamount to substitution. It is for this reason that planar images might still be called 'conceptual,' not because they are like mental concepts, whatever these might be, but because they *ex-plain* what they show, making each part of the image clearly resemblant, clearly and maximally recognizable. Planar images, being two-dimensional and radically oriented, necessarily sacrifice half the value of substitution because forms, which can only be shown in their most defining aspect (that is, full-face or profile), can only be shown from one side or the other (left–right, back–front).[22] This limitation is compensated by the positivity of the plane and by the more definite relation between the image and the space of its use. The plane also allows more kinds of relations to be articulated. To return to Schapiro's category of the 'hierarchical,' the plane provides the means by which relations among recognizable forms can be clearly established in relation to the space of the use of the image. Relative importance, as center–periphery, large–small,

right–left, higher–lower, frontal–profile, can all be stated with a higher degree of definition comparable to the higher degree of articulation of the spaces of the wall city architecture in which such planar images first make monumental appearance. Again, to make such an argument is not to say that these categories have univocal meanings, only to insist that they are deep categories of significance and of its actual construction, categories the specific meaning of which must be shown in each instance.

In these arguments I have been concerned not so much with dismantling or discrediting the notion of 'conceptual images' as with trying to formulate, and gather some of the implications of, a principle of explanation for the kind of similarities among images to which the category of the 'conceptual' points. Such similarities are more than simply 'formal,' and, as suggested by Schapiro's notion of the 'hierarchical,' are also irreducibly semantic. That such a simple configuration as hieratic symmetry is to be seen in the art of so many periods and cultures demands explanation. If we assume that what we call art is simply plastic to its cultural and historical circumstances, then similarities must be explained either as coincidences or as the consequences of similar circumstances. I am arguing that in a real sense art *is* those circumstances. In the general terms with which I am concerned, art 'expresses' nothing; there is no 'content' of which art is merely the 'form.' Art is rather the always concrete and historical region of the construction of social meaning, which is consistent and continuous with other modalities of meaning, but not reducible to them.

Just as we must explain both diachronic and synchronic relations when we do history, so it is necessary to explain both similarities and differences among styles of art. This may be the only legitimate way of approaching the question of the 'nature of art' itself, or, to put the matter in other terms, to avoid such questions may be to avoid some of the most fundamental inter-pretive issues raised by human spaces and artefacts. When we attempt to explain either similarities or differences among works of art it is centrally important to examine the principles of explanation we must either take for granted (as is usually done) or posit in order to do so. Where exactly is the principle to be found? In accounting for the basic characteristics of what have been called conceptual images I have tried to depsychologize their explanation, to explain them neither in terms of conception or perception. I have tried instead to locate these widespread characteristics – which may be seen as universally available options for the presentation of images – in the significance and the potential for specific cultural significance of the basic modalities of our finding ourselves in the world with other things and people, and of confronting them in the way we normally do: of a certain size, upright, handed, facing. We inevitably confront art, not just substitutive and planar images in this way, and when we do, we are not just looking into a realm of imagination or into a world incidentally shaped by some other

meaning, we are rather before part of a world of significantly transformed reality different from our own. To put this another way, we confront in our own space, in meaningful relation to ourselves, the once integral inhabitants of other spaces, and our interpretive task is in large part that of reimagining the actual significance of that integration.

I wish to conclude by taking up as promised my second major theme, the question of 'linguistic imperialism.' I have argued in several ways that human making is fundamentally significant in what might be called the preprepositional realm of human real spatiality. The principal case in point has been real metaphor. This argument suggests that art is schematically isomorphic with language, but that finally the two belong to very different spaces. Language works within the metaphorical 'spaces' of grammar and syntax, or in the literal spaces of script and print, with their lines, columns, paragraphs, pages, tablets, books or scrolls. These last are spaces of use and point in the direction of the significance of art I have tried to indicate (as in fact writing and painting or engraving, marking, are closely related both etymologically and technically), but it is immediately evident that written language only accounts for some of the spaces of use. The reader is also in a building with ornamental surfaces, with images, all of which demand and shape other culturally specific behavior in ways that are their own. I would like briefly to suggest why it is that we make the analogy between texts and images so readily, especially when it leaves so much that is obvious about images unsaid or unsayable. To sum up the argument I am going to make, I believe this analogy seems so 'natural' to us because Western images are relatively textlike in a way I shall try to define in the terms of this argument. The deep comparison of art and text to my mind immediately conceals much of the art of the world from our adequate or even sympathetic understanding and, just as importantly, conceals from us much of the cultural and ideological significance of our own art.

In order to address this question I wish finally to introduce the notion of what I shall call *double metaphor*. Double metaphor arises from the transformation of material into an indication of another material, as when pigment becomes the 'color' of the flesh of a painted figure. Double metaphor involves displacement, as does real metaphor, but even if this displacement – putting pigment on a surface – may have a kind of substitutive directness, the presence of what is painted is always only suggested, and demands completion on the part of a viewer. The paradigm of double metaphor is of course painting. Whenever an image is painted it must be seen as more than it is, simply because, although it is material, it is not the material it represents. A colored surface is bounded by line and implies a volume, and its visibility implies half a volume bounded by a line and half a volume that cannot be seen bounded by the same line. Painting of whatever kind thus involves a high and essential degree of virtuality, of

'seeing-as.' In Western painting a further step was taken by the introduction of modelling. Modelling is meant actually to depict implied volume by making virtual space into virtual light. The front visible half of volumes implied by contours on surfaces to be painted are described as if turning in this light, a description achieved by analysing the surfaces of apparent volumes into light–dark constrasts. Pigment on a surface imitates things depicted by imitating the behavior of light on the surfaces of those things. The resulting resolution of painting into light–dark contrasts, an endlessly flexible binary system able to be developed without reference to actually existing things, means that in comparison to real metaphor, this Western development of double metaphor, basic to the whole undertaking of Western optical naturalism, is relatively doubly articulated, using that term as Roland Barthes defines it in passing, 'as founded on a combinatory system of digital units as phonemes are.'[23] Even if the system of representational elements in paintings – always the examples in such discussions – is 'dense,' and therefore operates in ways different from those of language, it is language-like in that the presumed elements of construction are in principle equivalent and interchangeable, and prior to anything that might be represented. A Western painting – at least a classical or neo-classical Western painting – is made up of touches of pigment that indicate light and dark, out of which anything visible might be made, and this basic characteristic gives force to the analogy of image and text, perhaps even to that of painting and poetry. From such a base it is easy to pass on to a comparison between construction of these units and the rules of combination in language.

According to Barthes, the most important problem facing the semiology of images is the following: 'can analogical representation (the "copy") produce true systems of signs and not merely agglutinations of symbols?'[24] Barthes' 'Rhetoric of the Image,' from which I have been quoting, argues that images do in fact do more than present simple agglutinations of symbols, but such conclusions aside, there are difficulties in this formulation of the problem, which I believe is not only influential but representative. Analogy is narrowly defined by the semiotic idea of the icon, which is compared unfavorably to language. The question might be rephrased to say 'can images equal language, or be meaningful as language is?' Once again language is the paradigm for all signs whatsoever. I have tried to argue instead that there is an absolutely important distinction to be made between any sign and the conditions of its presentation. These conditions of presentation necessarily occupy the space we share with them, and it is in this space that images (and architecture, although that has not been my major theme) uniquely articulate and create meaning. Seen from such a standpoint, 'linguistic imperialism' begins to look more like what I think it is: an episode in modernist formalism, and therefore in modernist iconoclasm.

Notes

1 E. H. Gombrich, 'Meditations on a Hobby Horse or the Roots of Artistic Form,' in *Meditations on a Hobby Horse and Other Essays on the Theory of Art*, London and New York, Phaidon, 1963, p. 9.
2 E. H. Gombrich, *The Story of Art*, New York, Phaidon, 1972, pp. 19–30.
3 I have examined the notion of conceptual images in 'This is not a Sign; some Remarks on Art and Semiotics,' *Art Criticism*, 3 (1986), pp. 30–45. As discussed in that article, the notion of the conceptual is deeply involved in some of the fundamental ideas we associate with modernism. See for example Sir Herbert Read, *The Philosophy of Modern Art*, New York, Noonday Press, 1953, p. 148, on Emile Bernard's 'synthetism,' according to which the imagination retains essential form, a simplification of the perceptual image, a 'schema.' 'To synthesize is not necessarily to simplify in the sense of suppressing certain parts of the object; it is to simplify in the sense of rendering intelligible.' This, for all its attention to popular art, stained glass and Japanese woodcuts, is a traditional description of the mind's power of abstraction. Or Apollinaire, in *Theories of Modern Art. A Source Book by Artists and Critics*, ed. H. B. Chipp, Berkeley and Los Angeles, University of California Press, 1969, p. 219; Cubism 'was the art of painting original arrangements composed of elements borrowed from conceived reality rather than from the reality of vision.'
4 'The "Visual Arts" and the Problem of Art Historical Description,' *Art Journal*, 42 (1982), pp. 301–10; and ' "Form", Nineteenth-Century Metaphysics and the Problem of Art Historical Description,' *Critical Inquiry*, 15, 1989, pp. 372–406.
5 W. J. T. Mitchell, *Iconology. Images, Text, Ideology*, Chicago and London, University of Chicago Press, 1986, p. 56.
6 E. H. Gombrich, *Art and Illusion. A Study in the Psychology of Pictorial Representation*, Princeton, Princeton University Press, 1969, p. 89.
7 N. Goodman, *Languages of Art. An Approach to a Theory of Symbols*, Indianapolis, Huckett Pub. Co., 1976, p. 5.
8 M. Schapiro, 'On Some Problems in the Semiotics of Visual Art: Field and Vehicle in Image-Signs,' in *Semiotics: An Introductory Anthology*, ed. R. E. Innis, Bloomington, Indiana University Press, 1985, p. 222. (This essay was first published in *Semiotica*, 1 (3) (1969), pp. 223–42.)
9 Ibid., p. 220.
10 Ibid., p. 221.
11 S. Freud, *Beyond the Pleasure Principle*, in *The Standard Edition of the Complete Psychological Works of Sigmund Freud*, ed. J. Strachey and A. Freud, London, Hogarth Press, 1955, vol. 18, pp. 14–17.
12 Gombrich, 'Meditations'; A. C. Hasenmueller, 'The Function of Art as "Iconic Text": An Alternative Strategy for a Semiotic of Art,' *Semiotica*, 36 (1981), pp. 135–52, argues for the metaphoricity of Gombrich's hobbyhorse, which 'participates in two normally distinct spheres of action – linked actually by the device of iconicity, and to the ideal by the interpretive nature of representation'; it refers (however conventionally), but is also in its essential non-mimetic aspects linked to a symbolic level of social order and function.

13 See for example A. Rifflet-Lemaire, *Jacques Lacan*, trans. D. Macey, London, Routledge and Kegan Paul, 1982, p. 51.

14 To this large class of artefacts belong all kinds of amulets, charms, relics, fetishes, souvenirs and mementoes, the value of which is irreducibly based in their being able to be 'owned,' transported and, in both literal and metaphorical senses of the term, manipulated.

15 G. Paleotti, *Discorso intorno alle imagini sacre e profane*, Bologna, 1582; in *Trattati d'arte del cinquecento fra Manierismo e Controriforma*, ed. P. Barocchi, Bari, G. Laterza, 1961, vol. 2, p. 141.

16 Pliny the Elder, *Natural History*, xxxv.15 and xxxv.151. In the second text it is specified that painting (and then relief sculpture) was invented by a Corinthian maiden who traced the shadow of her departing lover. See R. Rosenblum, 'The Origin of Painting. A Problem in the Iconography of Romantic Classicism,' *Art Bulletin*, 39 (1957), pp. 279–90.

17 U. Eco, *A Theory of Semiotics*, Bloomington, Indiana University Press, 1979, p. 216.

18 Ibid., p. 213.

19 Ibid., p. 209.

20 Ibid., pp. 210–11.

21 Ibid.

22 These issues are admirably discussed by L. Steinberg, 'Picasso: Drawing as if to Possess,' *Artforum* (October 1971), pp. 44–53.

23 R. Barthes, 'Rhetoric of the Image', in *Images—Music—Text*, trans. S. Heath, New York, Hill and Wang, 1977, p. 32.

24 Ibid.

On the Critical Value of Categories: A Response to David Summers

David Radcliffe

David Summers considers two related themes in his essay: the tendency of critics to regard mimetic art as the norm for all art, and their tendency, in consequence, to interpret visual art by means of linguistic models. At issue is a categorical distinction used by critics to articulate the works which articulate the world. Summers finds the opposition between perceptual and conceptual art problematic in so far as it is grounded in peculiarly modern and Western concerns with language and mimesis, and seeks to give the two categories a new foundation in the universal human conditions of desire and spatiality. His project is to replace the opposition between conceptual and perceptual with an opposition between images primarily significant in terms of the space we share with them and images possessing their own spaces.

No question has preoccupied modern critics more than that of the nature of representation. In adopting, with Schapiro, a phenomenological view, David Summers rejects epistemological and linguistic models of representation which have dominated critical discussions for the past two centuries. At the same time, he shares with his opponents the view that critical categories should have a universal ground. A great deal is at stake in this dispute: the categories one adopts determine both the relation of a discipline to its special objects of study, and the relation of the various disciplines to each other. Categories, we can all agree, have consequences. Where 'art' is conceived as imitation, non-mimetic or imperfectly mimetic art becomes secondary – 'primitive art,' popular art, medieval art, decorative art, and architecture. By displacing 'iconicity', David Summers challenges the discipline of art history to reconsider its norms by considering a wider variety of works and by reinterpreting canonical works in the light of others previously excluded. The decentering of language as the universal model for hermeneutic method challenges the status of philosophy and literature as normative disciplines in the humanities.

'Language' is here to be understood in the widest possible sense, as communication through signs. If, as Summers believes, the articulation of desire in space is a primary human experience, works which articulate this space, and the discipline which articulates those works, acquires a primacy of its own.

If recent history is any indication, such arguments are unlikely to find much support. Those committed to the 'linguistic turn' will not be persuaded that pre-linguistic experience is a tenable notion. The desires which Summers regards as 'fundamental' will seem to them communal and derivative; the subjunctive space in which the meaning of the work resides will seem permeated by linguistic practice. Since makers of art are also users of language, the question of priority, it seems to me, is moot. Rather than disputing priority, wouldn't it be more valuable to inquire into the various ways in which linguistic and non-linguistic modes of behavior combine, intersect, and resist one another? Before such a project could be undertaken, however, 'linguistic imperialism' must be resisted. Summers' insistence on the difference of visual art from other forms of expression is a legitimate concern; whether these differences may be regarded as foundational is more problematic. As Summers readily acknowledges, visual works share many elements in common with non-visual works, may usefully be studied as artefacts or documents, and so on. Is there, however, something essential about 'artworks' which makes them fundamentally and not relatively different from other works?

I am not inclined to agree, since the differences within what has been called art at any one time are as great as the differences that distinguish art from non-art. In taking a nominalist and historical view, I am of course differing from David Summers at the level of fundamentals. But there are none the less ways in which nominalist and essentialist views can be usefully engaged, particularly on the pragmatic value of categories. Just as categories conceal as well as reveal, so categories of categories conceal as well as reveal. What do essentialist categories reveal about 'art'? The mode of defining foundations in Summers' essay is a venerable one – to look for origins. Just as champions of mimesis looked to myths of origin – the stories of Zeuxis and Pygmalion – to enable and legitimate one conception of art, so Summers looks to the modern version of the origin myth – tales of the nursery – to legitimate another. Stories of origin inscribe essences, in this case 'the centrally important purpose of linking substitution to the space of human action' (p. 245).

Such a procedure calls attention to 'conditions of presentation' overlooked in traditional interpretations (p. 233). It supplies the discipline of art history with its own primary domain: 'the conditions of presentation of images, rather than "expressing" social reality, are major means by which social reality is actually constituted as real places and activities' (p. 233). It

offers an alternative to a formalism 'no longer adequate in the simple sense that it no longer allows us to ask or answer the kinds of questions that most interest us' (p. 234). And it establishes the 'crucial respects' in which language and the visual are 'absolutely different' from one another, and 'that at the deepest levels the significance of art is to be found in an area of prelinguistic certainty' (p. 234). These are large, important, and controversial claims which I would not presume to pursue here. What might such a phenomenology of origins occlude?

As a consequence of taking origins for essences, those aspects of art not related to substitution or spatiality (notably the ways in which it is like writing or photography) become marginal, accidental, or derivative. This, of course, is just what David Summers intends when he inverts the primacy accorded perceptual art. But inverting rather than displacing the duality still leaves the problem of establishing differences between types of conceptual art; as Summers remarks of the traditional distinction, 'given only the two categories, what did not fit in one had to go in the other' – child art, 'primitive' art, and abstract art lumped together. It remains to be seen how Summers' categories, or any such essentializing categories, could be made flexible enough to handle such differences. Also concealed in the move toward phenomenal 'origins' is the problem of history. 'Real metaphor' and 'subjunctive space' may be 'mutually implicative at the deepest level,' yet both have a necessary relation to pre-established meanings and patterns of behavior. It is also unclear how the category of 'conceptual art' would apply to works which have transcended their origins while maintaining their status as art in a new 'subjunctive space.' Today most artworks have their being not in temples, dwellings, or museums, but in warehouses; is this a negation of their status as art or merely a displacement via the rituals of the marketplace? Finally, the implicit distinction between essential and accidental attributes conceals differences in the constitution of the work itself. Summers denies that because works of art are visible, they are therefore essentially 'visual' (p. 234). Does it follow that because works of art articulate desire in space, they are therefore essentially spatial? This claim is made to distinguish the plastic arts from language, yet Summers himself admits that language has an (incidental) spatial dimension. A vast number of works, perhaps even the majority, combine images with written texts in a variety of modalities. It is entirely common for both verbal and plastic works to combine real and virtual spaces in constituent elements drawn from painting, architecture, costume, dance, poetry, and landscape.

Rather than seizing on one aspect of the work as 'central,' 'deepest,' most 'fundamental,' most 'essential,' it may be desirable to think of art as constituted by a variety of different elements – space, color, material, meaning, function, reference, facture, and so on – elements which are neither *sine qua non* for art, nor the exclusive properties of artistic objects. If

so, a means of establishing categories without recourse to essences (conceived phenomenally or otherwise) becomes requisite. Such a procedure would involve giving up the search for fundamentals, but it would have the advantage of facilitating the study of historical and cultural difference.

The artist fashions the work out of materials ready to hand. These materials include not only the stuff on which he works, but other works which he knows, some of which he incorporates literally or figuratively into the work, as when the Olmec craftsmen copies an image of his god onto the axe, or when the Renaissance painter incorporates into his work a classical text or the orders of architecture. The physical presentation of such things is not more fundamental than the configurations of knowledge which makes this presentation possible. The 'origin' of the work lies not only in the desires of the maker or commissioner, but in the other works with which it takes its place in the world. To explain the striking continuities between the art of different periods and cultures, we have recourse not only to the 'universals' of the human condition, but to the diffusion of art itself.

To my mind, the observation of continuities and discontinuities between the elements one finds in these works offers a surer principle of interpretation than the projection of phenomenal origins. How can we confirm Freud's, Gombrich's, or David Summers' interpretation of children's behavior? Only by observing the like behavior in other children, or by observing a deviance in one child's behavior under other circumstances. Because we do not have access to the mental life of another, we resort to reasoning on the basis of continuities and discontinuities. The meaning of the boy's gesture resides, for us, not in the action itself, but in its relation to other gestures. In order to establish this meaning, we resort to categories which allow us to establish relevant similarities and differences. No procedure is more familiar to art historians, who have developed terminologies for describing genres, styles, oeuvres, movements, and periods. David Summers is himself engaged in a process of redefining these categories.

But if the use of categories is fundamental, the use of fundamental categories is not. No set of categories, whether grounded in nature, language, epistemology, economics, or the human condition has ever been generally accepted as foundational by working critics. Nor has any one definition of art ever proven quite broad enough to include all which in various times and places has been considered 'art.' One need not conclude from this that definitions of art need to be made broader still, or that such definitions are pointless, or that any one definition of art is as good as any other. One might well conclude, however, that definitions of art are relative, historical, and ultimately heuristic. Their value lies in the working insights they are able to produce for critics and their readers. If I have grave reservations about the essentializing tendency of David Summers' reasoning, I

none the less believe that his project of recasting the opposition between conceptual and perceptual art into spatial rather than referential terms can produce valuable results for practical criticism. The prospect of shifting art history away from reliance on epistemological and formalist paradigms is as exciting as it is ambitious, and warrants careful attention.

Real Artefacts: a Comment on 'Conceptual Art'

Shelly Errington

Basic to both *The Story of Art* and *Art and Illusion* is Gombrich's admiration for, and desire to explain, 'The Greek Revolution' – the Greek and Renaissance achievement of an illusionistic, perspectival art. His famous argument about the distinction between 'conceptual' and 'illusionistic' art suggested that both rely on schemata or patterns, but only the art that strives to be realistic and illusionistic both 'makes' schematic images and also 'matches' the schemata with what is seen, in a continual dialectic. Obviously, the issue of resemblance or iconicity looms large in his discussion, and much of *Art and Illusion*[1] and Gombrich's subsequent many debates with psychologists and philosophers struggles to clarify the nature, sources and import of resemblance in art and perception. (I use the terms 'resemblance' and 'iconicity' interchangeably. Markings can be said to be iconic or have iconic content if they can be read as referring through resemblance – even if that 'resemblance' is extremely schematic and does not pretend to achieve optical realism or a naturalistic effect.)

But Gombrich's essay 'Meditations on a Hobby Horse' takes a very different tack: a stick may function as a 'horse,' thus *become* a horse for the child, regardless of whether the stick resembles a horse or not, he says; in this view, the artefact is a substitute for the real rather than merely an illusionistic representation of it. In fact, in 'Meditations,' Gombrich downplays the difference between 'conceptual' and illusionistic art, writing that the contrast between them can be overdrawn, for in the end all art is 'image-making' and all image-making is rooted in the creation of substitutes.[2] Yet a few paragraphs later, Gombrich asks how we should interpret the 'great divide' between the few 'islands of illusionist style' and the 'vast ocean of "conceptual" art.' And it is this latter view – that there is a great divide – that informs *The Story of Art*[3] and *Art and Illusion*, where 'conceptual art' is made to work mainly as a foil for what came before, and what is the opposite of, illusionist art. As David Summers puts it in his paper 'Real Metaphor' above, the category 'conceptual' contains for Gombrich 'everything from

palaeolithic painting to ancient American sculpture.' He points out that such an inclusive category, even if it has possibilities, deserves a lot of examination – at least, for those of us who are interested in non-Western images and artefacts, most of which do not strive to achieve optical illusionism.

But, of course, it has gone largely unexamined. For one thing, the discipline of art history is overwhelmingly concerned with Western art, especially with those several centuries in which objects consisting of flat surfaces, with clear boundaries, marked in ways such that the surfaces are conventionally read as resembling three-dimensional objects, and having very little use except to be bought and sold and contemplated, become the paradigm of what counts as Art. Therefore 'conceptual art's' role as a foil for illusionism is quite adequate for the vast majority of art history's practitioners. For another thing, even a person wanting to make use of the notion 'conceptual art' may wonder where Gombrich's schemata (on which conceptual art is based) exist: In the artist's mind? In the images produced previously, which the artist copies? Or in the habits of movement patterned deep in the artist's muscles? (This last one is implied by Franz Boas's argument in *Primitive Art*.[4]) And then too, the notion has become quite psychologized, made into an issue of individual perception, making it less useful for the study of art traditions where individual psychology, individual artists, and idiosyncratic perception and styles are not really the issue. The upshot of all this is that the term/idea 'conceptual art' does not take us very far in understanding non-illusionistic images or other sorts of artefacts that lie outside Western art traditions – even though one feels vaguely, or even strongly, that it has possibilities.

As an anthropologist I teach about non-Western symbolic forms, including plastic and visual ones, and my work focuses on how things mean. I find Gombrich's distinction between conceptual and illusionistic images both inadequate and useful. Inadequate: for the reasons sketched above. Useful: because, however much the idea of schemata has been criticized, the idea that some arts consist of the making and remaking of images based on schemata, and were never intended to imitate optically perceived reality, is a useful one.

Stated so baldly, it sounds idiotically obvious; but the naturalistic prejudice is deep in Western readings of other humans' artefacts. Here are two examples concerning sculptural non-Western artefacts. Bill Holm has written a useful book on how designs are made and applied by stencil to items like blankets, totem poles, hats, bracelets, etc. in Northwest Coast American arts. In a section called 'Degree of Realism,' he divides designs into three types, depending on whether the animal parts remain of a piece, very little distorted or separated ('configurative'), or are distorted and split somewhat, but still recognizable ('expansive'), or finally are 'so distorted

that it is difficult or impossible to identify the abstracted animal or the exact symbolism of the parts' ('distributive').[5] Holm's categories may be useful for some purposes, but, obviously, even to raise the issue of 'degrees of realism' and to create a typology based on them suggests that Holm's readers share an implicit notion that art is primarily mimetic. For the same reason, I think, non-Western arts are often deemed 'stylized' or 'abstract,' terms that make sense only if one imagines that the *natural* way to depict the world is in optical realistic styles. Here is a second example. In the 1984 exhibition *'Primitivism' in 20th Century Art* at the Museum of Modern Art in New York, Giacometti's 'Tall Figure' (1949) was juxtaposed with an elongated figure from Nyamwezi, the label claiming that both of them 'rejected realism.' The label makes no sense as a historical statement: how could one of the pair reject realism when its makers never tried to achieve realism in the first place? The only way that sense can be made *of it* is if we recognize the implicit assumption, a very deep one in Western art-thought, that Art seeks to make optically illusionistic copies of 'reality.' If an African artefact is really 'Art,' it, too, *ipso facto* seeks to imitate reality. If it does not, it must be because the artist rejected his self-evident mission (the 'liberal,' generous view, taken by Rubin; illiberal views also abound). In short, the naturalistic prejudice – the idea that art (whether flat or in the round) means by resembling something in the world, and that it strives to do so in a way as optically realistic as possible, even if it does not always achieve it – is very deep. In the nineteenth century, optical illusionism or at least some degree of naturalism stood as the explicit or implicit criterion by which non-European images or artefacts were judged to be 'art' at all, and, if they were, their quality or type. Even in the twentieth century, this criterion persists as a mode of organizing understanding and knowledge of other humans' 'arts.'

A corollary of this assumption about meaning is the belief that Art is not 'real' (that adjective is reserved for the world it imitates) and therefore stands outside it, a thing apart. This way of reading artefacts designated as Art is also very pervasive. Arthur Danto, for instance, states it succinctly, not to say baldly, in his recent piece in the catalogue of the exhibition 'ART/Artifact': anything, he writes, *can be* an object of 'detached aesthetic scrutiny,' even something that is not Art at all but only some bit of the world, and he gives some examples. But, he continues, '[t]hese of course were real things, in contrast to works of art or artifacts, but whatever the appearances, the line between art and reality, as the line between artwork and artifact, is absolute'.[6]

These two ideas – that Art imitates reality illusionistically, and that it itself is not 'real' – go together. I find plausible Gombrich's speculation in 'Meditations' about how the two are linked: he suggests that the invention of virtual space in flat illusionistic art opens the possibility that the image can

exist in itself, and that it is fictional, something made-up, not 'real.' That the two notions of how objects designated 'Art' mean, go together, is quite over-determined, resonating as they do with certain ways of reading Plato on mimesis and with Art's social construction and definition since the eighteenth century's separation of Art (which is useless, hence unreal, the subject of contemplation) from craft (which is in and of the world). But that does not make them especially enlightening, especially when we con-template the meanings of artefacts and images made in worlds alien to this epistemology and metaphysics.

David Summers, who has a well-developed interest in non-European arts, tries in 'Real Metaphor' to sort out some of these issues. Briefly, Summers wants to retain 'conceptual art' as a classification, since he thinks there is a difference between illusionistic images and those that are not; but he wants to modify it by de-psychologizing the notion and liberating it from 'linguistic imperialism.' He offers in its stead 'an opposition between *real* and *virtual* space, "conceptual images" now corresponding to the first category' (p. 251). Conceptual images ('now defined as real spatial images') in turn he divides into two types, *substitutive* and *planar*. Substitutive images are those that substitute for something, like a stick for a horse or a rock for a chieftain, and they need not have an iconic content. (What is an 'image' without iconic content, though?) Citing Paleotti's phrase of 1582, Summers suggests that substitutes make present what is absent and therefore correct the 'defect of distance' (by death, loss, transcendent impalpability, etc.). Inspired by Gombrich's 'Meditations,' he points out that these substitutes live in real human space (rather than, like illusionistic perspectival images, creating their own virtual space) and only in that human context (of ritual, placement, or whatever) can be recognized as 'horses' or 'chieftains,' since they are really merely sticks or stones. Summers calls substitutes 'real metaphors,' which are linked to the space of human action ('subjunctive spaces'). By 'planar images' he means 'those in which the parts of the images are identified with the uniformity of the plane surface itself' (p. 254), i.e. they do not represent three dimensions in two, are not optically illusionistic. The planar images on which Summers focuses are largely hieratic not perspectival in structure, in which the large size and central placement of figures within them indicate the figures' importance; citing Schapiro as precedent, Summers argues that these similarities are due to our common human embodiment – balance, bilateral symmetry, etc.

Like most art historians, Summers implicitly equates art-objects with images; consequently his taxonomy takes 'images' as the most compre-hensive category of art, introducing 'practice' and 'substitution' as a way to understand 'images,' so-called, that were not created on flat surfaces such as walls, triptychs, or canvases. In fact, I think this piece should be read as a companion and extension of his 'The "Visual Arts" and the Problem of Art

Historical Description,'[7] in which he argues that we habitually bring to flat images depicting virtual space (perspectival pictures) an 'assumption that works of art are models of perception' and impose upon them 'an abstract optical naturalism or a corollary expressionism.'[8] These assumptions are inappropriate, he shows, for reading flat images of the sort he calls 'planar' here (most though not all of which are outside European image-making traditions). His purpose in 'Real Metaphor' seems to be to extend his reading of non-Western artefacts, forging theories of meaning more appropriate to them than the theories and habits of viewing we bring to perspectival pictures. Planar pictures probably constituted his starting-point, but, of course, many non-Western images do not exist on flattish surfaces, such as temple walls or the flat sides of stele. Many images are inscribed on wholly three-dimensional objects: they are statues or masks or ancestral figures or designs on ritual knives or vessels. And so he introduces another class of 'image,' the substitute, which does not so much denote but *is*; it need not even have iconic markings, although it can be made more powerful by being marked with spots for eyes, etc. In these two articles, then, he has dealt with three types of images: flat ones creating virtual space, flat planar ones, and images inscribed on three-dimensional objects.

I think he obscures what he is doing by calling them 'categories,' which implies mutual exclusiveness, whereas many substitutive images may be iconic as well (Byzantine icons come to mind immediately); nor should he call them two types, illusionistic and conceptual, rather than three. And by making 'conceptual images' correspond to real space, and illusionistic ones correspond to virtual space, he seems to me to have reinstituted the divide he was trying to bridge: even de-psychologized and placed in space, 'conceptual art' in his typology emerges as a radically different kind of creation from illusionistic art. This divide between the West and the Rest – for that is largely what is is – obscures the continuity between the two, or rather, between the multiplicity of ways that humans make objects and put marks on them and make them meaningful to themselves.

With the gesture of this paper, Summers has entered the realm of artefacts, which are clearly a more inclusive class than 'images.' Some human artefacts are flattish, some are roundish; some have iconic markings, some do not; some roundish ones and some flattish ones aim for naturalism, some do not. All of them mean something to their users. All of them exist in real space, even images depicting virtual space – a point Summers makes in passing in this article but drops – so how can it form the basis of the great divide? (Flat things depicting other things illusionistically are also things – in Heidegger's immortal observation, a picture hangs on the wall, like a gun or a hat.) It strains the idea of images to think of artefacts as primarily images, especially if the point you are making is that they need not have iconic content to mean something (even if 'eyes' dabbed on a rock make it a

better substitute for something that has eyes). In some respects, then, 'Real Metaphor' retains the iconocentrism that inhibits our understanding of non-Western arts, and which Summers himself begins to correct.

Why do our (Euro-American) readings of artefacts from other humans' traditions so emphasize iconicity? Although not all iconic signs are perspectival, all perspectival illusionistic pictures have an iconic content. We tend to privilege iconicity as a way of meaning, I think, partly because our paradigm of Art and certainly of an image is a flat thing with marks that denotes something in the round and tries to depict its appearance; it is framed, therefore marked as outside and different from the world it points toward by resembling, and therefore its relation to the world is merely and necessarily denotation, pointing or referring. (I am not arguing that these objects do mean primarily by resembling, or that they resemble at all, issues that are knotty, to say the least. But I think it is fair to say that we tend to believe so.) In sum, because optically illusionistic pictures stand as paradigmatic examplars of all 'Art' for us, and those exemplars have an iconic content, iconicity assumes an overlarge place in the unconscious assumptions we make when looking at other humans' artefacts we have designated 'Art.' (It is also true, I am sure, that when we survey the artefacts produced by other human cultures, we tend to select those with an iconic content over and above those without it to designate as 'art.') Once selected, we tend to read them as though their iconic content were their main mode of meaning in the world. Hence iconocentrism works overtime to inhibit our understandings of the other ways that humans' artefacts may mean.[9] A second reason for the dominance of iconicity in theories generated in the post-Renaissance West of the meaning of 'artworks,' I suspect, is the combined influence of Panofsky, both his theory ('Iconography and Iconology,' among other works) and his objects of study, primarily Renaissance pictures. Reading – one might almost say 'decoding' – a Renaissance picture requires identifying its iconic content, which is basic to understanding what it is 'about.' Iconicity becomes a kind of minimal criterion for identifying Art, and decoding iconic signs the first step in understanding it.

What is an icon? C. S. Peirce defines an iconic sign as one that functions *as* a sign by resembling. An iconic sign's 'resemblance' need not aim for optical illusionism, but that does not inhibit us from reading it as denoting things outside itself. A blueprint and a photograph of a house are both iconic signs of a house, though the latter's resemblance is said to be resemble illu-sionistically, while the former's does not. Is iconicity – resemblance – necessary for a sign to mean? Certainly not. C. S. Peirce discusses many ways that signs mean, but the main ones are iconic signs, 'indexes' (which have an intrinsic relation to the referent, like smoke to fire), and 'symbols,' whose relation to the referent is arbitrary. In *The Languages of Art*, Nelson

Goodman, of course, tries to do away with iconicity and replace it with arbitrariness, insisting that

> a picture, to represent an object, must be a symbol for it, stand for it, refer to it; and . . . no degree of resemblance is sufficient to establish the requisite relationship of reference. Nor is resemblance necessary for reference; almost anything may stand for almost anything else. A picture that represents – like a passage that describes – an object refers to and, more particularly, *denotes* it. Denotation is the core of representation and is independent of resemblance.[10]

Like Goodman, Summers offers a correction to the idea that things mean by resembling – which is ironic, since his main concern is images – but his corrective is the opposite of Goodman's: rejecting arbitrary, conventional denotation on the model of one type of language theory, Summers insists on the non-arbitrariness of artworks' meanings. One of his main efforts is to locate meaning in relation to human embodiment: objects are used in human spaces; their weights, shapes, etc. make them 'manipulable' by humans, on a scale humans can perceive, appreciate, and comprehend; and even planar hieratically organized pictures reflect certain pan-human body tendencies (centeredness, verticality, bilateral symmetry, and so forth). And he almost suggests that all art is 'substitutive,' a substitute for that which is absent. These ideas downplay both denotation and iconicity as the primary ways to approach understanding how an artefact means since they imply there is little if any gap between the artwork and the world: art is 'real,' it is not a mere denotative reference. All this is to the good. Yet, while the idea of substitution is a corrective to pure iconicity as a theory of the meanings of artefacts (and here I betray myself as thinking that artefacts, not just images, are the issue), artefacts mean in many other ways, too. An artefact may be itself, not a substitute for anything, but may be a vehicle through which the spirit world enters this one, or by which humans in this one have access to a spirit world. It may mean iconically in ways that are apparent only in its use and attributed meaning: for instance, a granary may be shaped like a womb, and its shape and use express and reinforce for its users associations between women, fruition, and nurturance.[11] Or, Blier[12] has argued, an artefact may mean by juxtaposing internally contradictory elements, allowing the verbally unthinkable to be none the less expressed powerfully as a plastic or visual image. Not to sound like a linguistic imperialist, but rhetoric long ago invented and discovered figures of speech, metaphor, metonymy, synecdochy, allegory, contrastive opposition, and many other ways that sentences can mean other than by univocal denotative reference. While the idea of substitution is a welcome corrective, it only begins to explore the myriad ways that artefacts can mean, even those with overtly iconic shapes or markings.

Summers also makes a useful point in insisting that to understand meaning we must examine the practices surrounding an object designated 'art,' the practices in which it is enmeshed and which define it and constitute it as 'art.' Most art historians tend to look within the frame for meaning (hence their preoccupation with iconicity, which takes one a long way for several centuries of Western art). A few – very few: I am thinking mainly of Baxandall – look behind the frame, so to speak, elucidating the kinds of optical habits, metaphysical theories, and daily practices that were poured into the object. And a few more, but still very few, look in front of the frame, to see performative context, the practices and categories of the people who handle it, within which the object, art or otherwise, is constituted as the kind of object it is. Summers calls this the 'subjunctive space' – not really in front of the object but surrounding it, constituting it. Why do we tend to discount practice as a constitutive element of the art-object? At the philosophical-psychological level, it is probably due to our habit of reading artworks as depicting virtual space, hence standing outside the world and referring to them (as Gombrich pointed out). But it is also due to the habits of looking we bring to artworks due to our own practices concerning those objects our culture has designated Art. Since most of what counts as Art in Euro-America lies within a frame, whether it is four-cornered, a pedestal, or the walk-in frame of the museum or gallery itself, and since 'art' since the late eighteenth century has been thought to be appropriately viewed as an object of disinterested aesthetic contemplation, we tend to discount the 'real space' or 'subjunctive space' within which 'art' exists.

These three related issues – the non-arbitrariness of 'conceptual art' in relation to human embodiment, its 'reality' by substitution, and its existence in real space – are Summers' main issues and points. I take the real (if I may use this weighty term) intention of 'Real Metaphor' to relocate artworks from the never-never land of 'unreal' aesthetic optical contemplation into real human space, the space of use and the space of human size and manipulation. This effort is all to the good. I would only add that these points apply not only to 'conceptual art' but to illusionistic art. Gombrich asks, and Summers quotes him, how we should 'interpret the great divide which runs through the history of art and sets off the few islands of illusionist styles, of Greece, of China, and of the Renaissance, from the vast ocean of "conceptual" art?'[13] It seems to me that there is no great divide; that it could seem so is due to an optical illusion (if I may so put it) of our own cultural-historical location in relation to the works we call 'Art.' We might better see illusionist art not as islands protruding from a vast ocean, but as islands lying off a vast continent of human artefact- and image-making.

Notes

Thanks to Suzanne Preston Blier and Catherine M. Soussloff for conversation and references, and to David Summers for conversation about his ideas.

1 E. H. Gombrich, *Art and Illusion: A Study in the Psychology of Pictorial Representation*, Princeton, Princeton University Press, 1960.
2 E. H. Gombrich, *Meditations on a Hobby Horse, or the Roots of Artistic Form*, Chicago, University of Chicago Press, 1963, p. 9, my paraphrase.
3 E. H. Gombrich, *The Story of Art*, 14th edn, Oxford, Phaidon Press, 1984.
4 Frank Boas, *Primitive Art*, New York, Dover Publications, 1955 (1927).
5 Bill Holm, *Northwest Coast Indian Art: An Analysis of Form*, Seattle, University of Washington Press, 1965, p. 13.
6 Arthur C. Danto, 'Artifact and Art', in *ART/Artifact*, New York, Center for African Art and Preston Verlag, pp. 18–32, see p. 20.
7 David Summers, 'The "Visual Arts" and the Problem of Art Historical Description', *Art Journal* (Winter), pp. 301–10.
8 Ibid., p. 301.
9 Shelly Errington (forthcoming), 'Artifacts into Art', in *Collections and Culture: Museums and the Development of American Life and Thought*, ed. Michael Lacy and Sally Kohistedt.
10 Nelson Goodman, *The Languages of Art: An Approach to a Theory of Symbols*, Indianapolis, Hacket Publishing Company, 1976, p. 50.
11 Labelle Prussin, 'West African Mud Granaries', *Paideuma*, 18, pp. 144–69.
12 Suzanne Preston Blier, 'Paradox and Mystery: On the Role of Antipathy in Dahomey Art', paper presented to the College Art Association Annual Meeting, Houston, February 1988.
13 Gombrich, *Meditations on a Hobby Horse*, p. 9.

Notes on Contributors

The members of the institute were all saddened by the untimely death of Flint Schier in 1988, whose liveliness and sense of humour we all came to appreciate.

Norman Bryson, Department of Art History at Harvard University

Arthur C. Danto, Department of Philosophy, Columbia University

Martin Donogho, Department of Philosophy, University of South Carolina

Shelly Errington, Department of Anthropology, University of California at Santa Cruz

Timothy Erwin, Department of English, Rutgers University

Garry Hagberg, Department of Philosophy, Bard College

Michael Ann Holly, Department of Art and Art History, University of Rochester

Ludmilla Jordanova, Department of History, University of Essex

Martin Kelly, Department of Psychology, Hobart and William Smith Colleges

Rosalind Krauss, Department of Art, Hunter College/City University of New York Graduate Center

Stephen Melville, Department of English, Syracuse University

Keith Moxey, Department of Art History, Barnard College/Columbia University

Linda Nochlin, Department of Art, City University of New York Graduate Center

Michael Podro, Department of Art History and Theory, University of Essex

David Radcliffe, Department of English, Virginia Polytechnic Institute and State University

Flint Schier, Department of Philosophy, University of Glasgow

David Summers, Department of Art, University of Virginia

Ellen Wiley Todd, Department of Art, George Mason University

Richard Wollheim, Department of Philosophy, University of California at Berkeley

INDEX

NOTE: Page references in **bold** indicate illustrations.

Popper, K. 62
positivism, logical 203
post-modernism 153
post-structuralism 80, 85, 87, 92,
 192
Poussin, Nicolas
 Crossing of the Red Sea 195
 Drawing of Baptism 170–2, **171**
 Sacrament of the Eucharist 173, **174**,
 175
 Worship of the Golden Calf 166–70,
 167, 173–5, 192–8
power
 and context 56–7, 58
 contingency 57
 as culturally defined 2–4
 and force 17–18, 43 n.9
 and ideology 13–14
 and image 247, 249
 language 57–8
 and patriarchal ideology 1–2,
 13–43, 47, 50
 and perceptualism 2–3
 and semiology 4
 of women 17–18, **19**, 34–6, 50–2,
 59
 see also images, and power
pragmatics, and interpretation 4,
 73, 77
Pre-Raphaelites, American 207
presence 87–8, 89, 93, 202–3,
 241–7
presentness 5, 87, 88, 90
primitivism 81–2, 84–6, 99–100
properties, standard 187
Proust, Marcel 109
psychology
 cognitive 62
 perceptual 8–9, 62, 103, 109–14,
 158, 159–62
 visual 161–2, 234
psychosemantics 208, 217
Putnam, Hilary 217
puzzle pictures 8, 143–4, **143**
Pygmalion legend 30

Quine, W. V. O. 216

Radcliffe, David 260–4
Railton, Peter 157n.
Raphael, *Virgin and Child with Book*
 6–8, 163, **164**, 172, 185, 186
rationalism 81, 82, 85–7
Read, Sir Herbert 257 n.3
realism
 in literary theory 76, 92–3
 and reality 97–9, 129–34, 266–7
reciprocity 88–9, 133–4, 153
recognition
 as identification 7–9, 64, 132,
 172, 185–7
 native ability for 109–14, 147
 n.10, 166
 as social 65–6, 68–71
Reilly, Bridget 208
relations, spatial 166–8, 196–7, 236
Rembrandt van Rijn 187
 The Holy Family at Night 175, **176**
 Night Watch 235
representation, verbal 96–7, 99,
 186–7
representation, visual
 as accessible to all 1
 definition 115–23
 dual aspect 6–7, 105–7, 122,
 132–4, 137, 158–61, 165–73,
 183–4, 190–9
 and essence of art 1
 as exclusive 1
 and language 96–7, 99, 235–6
 and lifelikeness 97–9, 118,
 129–34
 and nature 10
 varieties 123–9
 see also seeing-in; semiology
resemblance 8, 97–100, 135, 137,
 162, 165–6, 186–7
 and conceptual images 10,
 235–6, 242–3, 245, 253–4, 265,
 270–1
 and culture 99

Index compiled by Meg Davies

Lightning Source UK Ltd.
Milton Keynes UK
UKOW03f1347050813

214894UK00008B/549/P